THE SHÔGUN'S SOLDIERS

The Daily Life of Samurai and Soldiers in Edo Period Japan, 1603–1721 Volume 1

Michael Fredholm von Essen

'This is the Century of the Soldier', Fulvio Testi, Poet, 1641

Helion & Company

Dedicated to Per-Olow Leijon (1938–2011), Senior Curator, China and Japan, of the Museum of Far Eastern Antiquities and the National Museum of Ethnography, Stockholm

Helion & Company Limited
Unit 8 Amherst Business Centre
Budbrooke Road
Warwick
CV34 5WE
England
Tel. 01926 499 619
Email: info@helion.co.uk
Website: www.helion.co.uk
Twitter: @helionbooks
Visit our blog http://blog.helion.co.uk/

Published by Helion & Company 2022
Designed and typeset by Serena Jones
Cover designed by Paul Hewitt, Battlefield Design (www.battlefield-design.co.uk)

Text © Michael Fredholm von Essen 2022
Colour plates by Giorgio Albertini © Helion & Company 2022

ISBN 978-1-915070-33-3

British Library Cataloguing-in-Publication Data.
A catalogue record for this book is available from the British Library.

For details of other military history titles published by Helion & Company
Limited, contact the above address, or visit our website: http://www.helion.co.uk

We always welcome receiving book proposals from prospective authors.

Contents

Preface

At the beginning of the seventeenth century, three military campaigns took place in Japan which concluded the long period of civil wars that had characterised the country for generations. The first was the campaign and decisive battle of Sekigahara in 1600, in which Tokugawa Ieyasu's eastern army defeated a coalition of predominantly western lords. The battle confirmed Ieyasu's position of military supremacy, resulted in his assumption in 1603 of the position of *shôgun* (generalissimo) of Japan, and inaugurated what nowadays is known as the Edo period (1600–1868), so named because Ieyasu after the battle established his capital in Edo (modern-day Tôkyô).

However, a contender to the Tokugawa shogunate remained alive. This was Toyotomi Hideyori, the son of Toyotomi Hideyoshi who was Ieyasu's predecessor as military ruler. Hideyori controlled Ôsaka in western Japan. In 1614–1615, Ieyasu and his eldest son Hidetada laid siege to Ôsaka Castle, captured it, and put an end to Hideyori and the Toyotomi family.

By then, Japan was an advanced, outward-looking country. Previously preoccupied by internal warfare, Tokugawa-ruled Japan was unified, strong, and technologically developed to a degree inferior to Europe only in certain sciences, such as shipbuilding and artillery. Japan was indeed technologically superior in some disciplines, including aspects of military science, such as the production of firearms, an import the Japanese had mastered very quickly. The Japanese were mature and self-confident in their dealings with foreign countries, and Japanese traders, mercenaries, and adventurers were a common sight in South-East Asia. There were flourishing Japanese overseas colonies, especially in the Philippines, Siam (now Thailand), and Java. One Japanese merchant adventurer, Yamada Nagamasa (*c.* 1590–1630), even managed to set himself up as a minor king in southern Siam.[1]

Japan was a strong military power as well. Although seapower was its weakest element, the Japanese leaders knew this, and under Hideyoshi, the country's naval forces in 1592 proved that they were capable of landing a large invasion force in Korea. The armies of Japan were a match for any enemy, well-armed and with considerable combat experience. If, in the early 1600s,

1 Michael Fredholm von Essen, 'The Japanese-Siamese Army of Yamada Nagamasa', *Arquebusier* 32: 6 (2012), pp.20–34. See also Stephen Turnbull, *The Lost Samurai: Japanese Mercenaries in Southeast Asia, 1593–1698* (Warwick: Helion, forthcoming).

Japan had claimed a respected place among the world's leading nations, there would have been little contest. In hindsight, it is easy to imagine a century or two of Japanese expansion and increased international trade throughout the Pacific and East Asia, at a time when European influence in the region was still limited, and virtually no other Asian or Pacific nation was sufficiently powerful to seriously challenge Japan.

However, history then took a different course. In 1635, the government of Japan retreated into enforced seclusion, a seclusion aided by the geographical situation of the Japanese islands. Ocean-going ships were prohibited, and Japanese subjects were forbidden from leaving the country or, having left it, ever to return. The seclusion laws were rigorously enforced. Even the unlucky fisherman who was driven by a storm to foreign shores was forever excluded from his family and community, and only death awaited him if he dared return home. As the Age of Enlightenment, the Industrial Revolution and the subsequent global expansion of the European nations transformed the world, Japan chose isolation and stagnation.

A major reason for this policy decision was military weakness. Yes, the Tokugawa army under Ieyasu had been numerically large, experienced, and well equipped. But since then, things had changed. The 1615 victory over the Toyotomi family at Ôsaka Castle was simultaneously the last war of the Tokugawa clan army and the first war of the Tokugawa shôgun's army. Having defeated the Toyotomi clan, the shogunate warriors settled down in the castle towns of their lords, and many of the Tokugawa retainers settled permanently in Edo, where they soon lost the military edge they had once enjoyed. Although there was a third and final military campaign in seventeenth-century Japan, that of the Shimabara Uprising in 1637–1638, the fighting took place far from the political centres of Japan, and Tokugawa rule was never at serious risk. The uprising, inspired respectively by the harsh treatment of the local peasants, millenarian Christian beliefs, and bitterness towards the Tokugawa shogunate among those who had been defeated in the previous campaigns, broke out in the western island of Kyûshû. However, it was crushed within months by local military forces, under lords loyal to the shogunate. Except for a few men, the shôgun's army did not take part in the campaign.

After 1615, the shôgun's soldiers were no longer needed for war. Technically there was no demobilisation, however, with no more wars to fight, the shôgun's soldiers became townsmen in all but name. They retained samurai status but were no longer called up to fight. As a result, a transition from warrior to townsman took place. Aware of its military decline, the shogunate felt a need to protect itself from internal and external enemies. The former could be taken care of by regulatory means and strict domestic surveillance, while the second was perceived as best handled through enforced seclusion, hence the sudden policy change. In the light of Hideyoshi's costly Korean campaign in the previous century, a campaign in which the Tokugawa clan had declined to participate, these means were regarded as preferable to attempting to retain a powerful army which in any case was no longer there, except on paper.

Yet, a Tokugawa army of sorts still existed. This book and its companion volume describe the organisation, arms, armour, dress, and daily life of

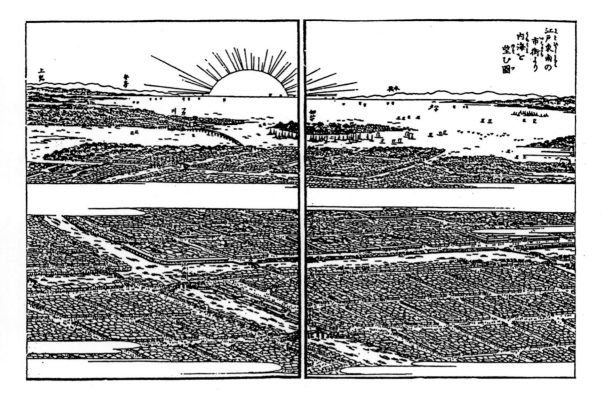

Fig. 1. The city of Edo as seen from Edo Castle. The Nihonbashi bridge is seen in the lower centre of the picture, and the Sumida River in the upper left.

samurai, soldiers, and commoners in the Tokugawa shôgun's capital of Edo. The story begins in 1603, when the first shôgun, Ieyasu, established the shogunate, and continues until about 1721, when the first results became apparent of the comprehensive programme of judicial and administrative reform initiated by the able eighth shôgun, Yoshimune. Some later events will be described as well, when they help to illustrate the theme of the book. During these years, Japan enjoyed a long period of peace; no significant mobilisation of military troops took place anywhere in Japan from 1638 onwards. Indeed, in the time period under consideration here the shôgun's personal army really only mobilised twice: first, for the 1614–1615 Ôsaka campaign in western Japan, and second for the third shôgun Iemitsu's march to Kyôto in 1634 which was a peacetime show of force. Yet, the shogunate maintained its military in later years as well, and it occasionally had to intervene, mostly against bandits but occasionally during more serious military incidents. These included conspiracies against the shogunate by disgruntled masterless samurai (*rônin*) and the celebrated raid carried out in 1703 by 47 *rônin* who aimed to take revenge for the death of their lord. Moreover, the shôgun's soldiers had to assume a major role in law enforcement and firefighting. The focus of the present books is a military and social history of how the formerly so powerful Tokugawa clan army rapidly lost its combat preparedness after 1615, and how this persuaded the Tokugawa shogunate to initiate a policy of enforced seclusion. The books are not intended as a comprehensive history of Edo period Japan. Nor will they describe the armies and fighting methods employed in the sixteenth century, before Ieyasu pacified Japan under his

personal rule. Although memories and traditions of this martial legacy lived on in Edo period Japan, few samurai found the opportunity, or had the inclination, to profit from them. Large-scale fighting was a thing of the past and soon neither mobilisation nor unit manoeuvres took place.

Research in the daily life of the Edo period is fraught with danger. As an unusually large number of seemingly 'ancient' customs and observances in modern Japan do not go further back in time than the subsequent Meiji period (1868–1912), it is risky to begin, as many researchers do, with current practices and then extrapolate back in time. Otherwise excellent books on the subject frequently suffer from this problem.[2] The situation is to some extent similar in current Japanese literature. The present work undoubtedly also suffers from such errors, although I have striven to eliminate them. A safer method, and the one I adopted, is to learn the customs and ways of life of Edo period Japan from the primary sources, especially Japanese and European literary works. A few European visitors to Japan were trained observers and writers, and the Japanese popular literature of the times provides plenty of information. Examples include the witty poet and novelist Ihara Saikaku (1642–93), who was born in Ôsaka as the son a merchant. Not only did he produce an astounding volume of poetry – Saikaku's record was the frankly miraculous number of 23,500 verses in 24 hours, attested to by witnesses – but he also wrote some two dozen books. These books form a goldmine of information about early Edo period Japan. There will be references to other contemporary novelists as well, among them Jippensha Ikku (1765–1831), who was born a samurai but renounced his status. Jippensha's writings, although from the late Edo period, aptly describe the situation earlier as well. Jippensha also symbolises the transition in Japan from warrior to townsman, and how the shôgun's soldiers lived their lives in the long era of peace which was the Edo period.

2 For example Charles J. Dunn, *Everyday Life in Traditional Japan* (London: Batsford, 1969), a book that nonetheless inspired me and in many ways is the foundation on which I have continued the work.

Introduction

The Origins of Edo

The city of Edo, the old name for what is now Tôkyô, was the administrative capital of Japan during the entire Edo period (1600–1868). At the time, Japan was ruled by the Tokugawa *bakufu* (literally 'tent government' by which was meant a military government), more commonly known in English as the Tokugawa shogunate, a term derived from the title *shôgun* ('commander-in-chief'), which was held by successive heads of the Tokugawa family since 1603, when Tokugawa Ieyasu (1543–1616, r. 1603–1605) united Japan under his personal rule and became the first of his line to assume this by then quite ancient title.

In 1603, Edo (meaning 'estuary' or 'river gate') was merely a minor castle town held by Ieyasu, a powerful feudal lord from eastern Japan who found himself controlling most or all of the country after the battle of Sekigahara in 1600. Edo was chosen as the new capital of Japan partly because the town was in the Tokugawa heartland, and thus safely surrounded by Tokugawa Ieyasu's supporters, and partly because the puritanical Ieyasu, like other military rulers before him, realised that the sophisticated living and fine arts of the Imperial capital, Kyôto, would corrupt the simple warrior virtues of his trusted retainers. The new capital grew quickly, following detailed instructions and a large-scale plan laid out by the newly established shogunate.

Edo already had a long but undistinguished history as a country village. It began as a small coastal hamlet near the mouth of the Sumida River. A little way upriver was Asakusa, where the Sensôji temple had been founded in the seventh century. Edo made a brief but slightly questionable entrance into the pages of history in 1180, when local warriors switched sides in the struggle between the Taira and Minamoto clans, helping Minamoto no Yoritomo (1147–1199) to become the first shôgun. They were led by a minor warlord of Taira descent named Tarô Shigenaga. He built himself a fort by the river mouth and named himself and his family Edo, after the location of his residence. Soon after the victory, Asakusa craftsmen were recruited for shrine construction at Kamakura, the shôgun Yoritomo's new capital. After Shigenaga's death, his sons expanded the clan's territory, but they also split up, starting new families taking the names of their new residences, among them Shibuya, Maruko, and Ikura, names that remain to this day in the geography of Tôkyô.

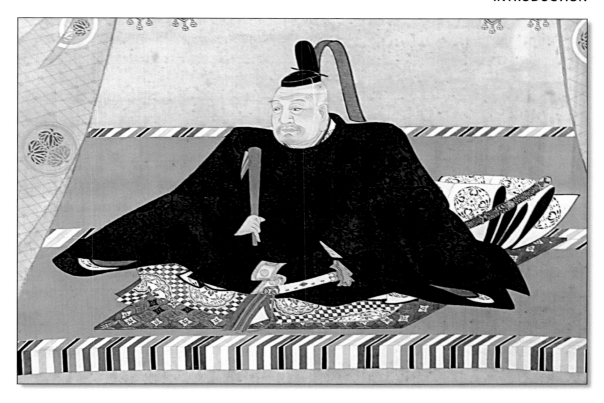

The first stone castle in Edo was completed only in 1457 by Ôta Sukenaga (also known as Ôta Dôkan; 1432–1486), a vassal in the service of the powerful Uesugi family. Work had begun in 1456, so the structure cannot have been large. Sukenaga controlled the nearby area, combining a talent for military affairs with a renowned literary sensibility, until he was assassinated in a power struggle. For the next 100 years, Edo Castle changed ownership several times until Tokugawa Ieyasu received it in 1590 from Toyotomi Hideyoshi (1537–1598), the then ruler of Japan. By then, Edo was a small fishing village with about 100 houses. Ieyasu had the castle completely rebuilt and considerably enlarged. He also enlarged the city of Edo itself (Map 1), centring it on the castle, which served as the shogunal residence (and whose site is now occupied by the Imperial Palace).

Fig. 2. Tokugawa Ieyasu, the first shôgun (1543–1616, r. 1603–1605)

Until the sixteenth century, warriors had usually lived on their farms, only going to the castle of their lord when summoned. From then on, however, the vast majority of the warriors were required to live in the towns that soon grew up around the castles, leaving their estates to be managed by bailiffs or servants. Decrees to this effect were issued and enforced by various great lords since the second half of the fifteenth century. Edo was no exception to this trend. About 80,000 warriors were soon relocated to the new city, together with numerous craftsmen. A *jôkamachi* ('town below the castle') soon grew up. In 1613, Edo's population is estimated to have been 150,000. In its origins Edo was thus quite different from many older cities, such as the Imperial capital of Kyôto and the fundamentally mercantile town of Ôsaka.

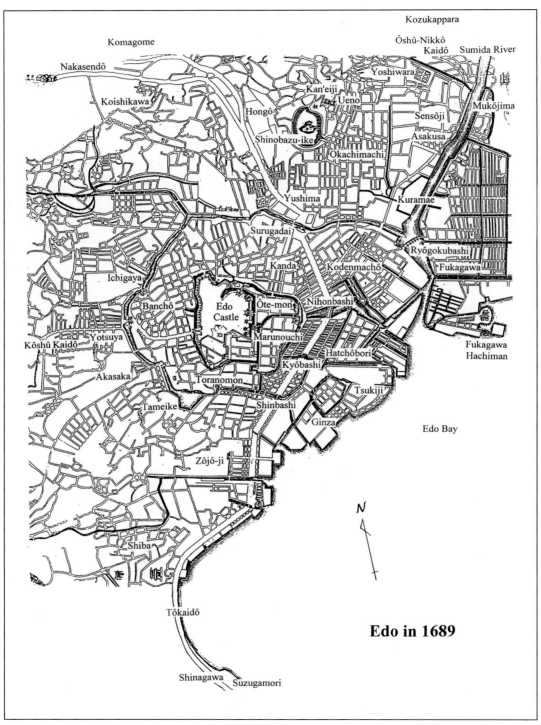

Map 1. The City of Edo in 1689. (Map: author)

A castle town usually included the town in its defences, and again, Edo was no exception. Existing waterways were rearranged to form a series of moated areas. The outer ones were not primarily seen as a deterrent to an enemy, but would slow down an attack as well as keep the townspeople where they belonged. The innermost one naturally comprised the actual castle. Around the castle, a large area was reserved for the residences of samurai (warrior retainers of the Tokugawa) and *daimyô* (feudal lords). This was necessary, as the shogunate soon required all feudal lords to live in Edo in alternate years and also to leave their wives and heirs in Edo as hostages while they returned to their provincial fiefs (Map 2).

To serve the needs of the huge warrior community, a corresponding number of merchants and craftsmen moved to Edo and were allocated the outer moated area, down towards the bay. Many merchants came from Mikawa Province (now Aichi Prefecture) and Tôtômi Province (now Shizuoka Prefecture), which had been ruled by Tokugawa Ieyasu before he became shôgun. Soon merchants also came from Ôsaka, Ômi Province (now Shiga Prefecture), and Ise Province (now Mie Prefecture). All opened markets for their own particular products. The last two groups in particular were so numerous and successful that they were frequently called 'Ômi Robbers' and 'Ise Beggars' by their rivals. In the early eighteenth century there was even a saying, 'The commonest things in Edo are Ise merchants, Inari shrines, and dog muck' (*Iseya, Inari, inu no kuso*). And indeed, there was a boom in temple and shrine construction, especially of the small Inari shrines – dedicated to rich harvests and commercial success – that could be found in almost every neighbourhood. The city grew quickly. Edo was fundamentally completed as early as in the Kan'ei year period (1624–45).

At first, the city was restricted to the west side of the Sumida River for strategic reasons, and no bridge was built across the river. This soon proved to be too small an area. However, nothing much changed until after the great Meireki fire (Meireki Taika) of 1657, which destroyed most of Edo and caused great loss of life. After the fire the shogunate put into effect plans for urban renewal and, naturally, fire prevention. In 1659 the Sumida River was spanned with bridges to facilitate eastward expansion, at first into Fukagawa and Ryôgoku. These areas on the east bank of the Sumida soon grew into a settlement for wealthy merchants.

Fires, Earthquakes, and Floods
Because of the construction of Japanese town houses – built of resinous timber a-nd with many paper-covered partitions – Edo was very vulnerable to fire. Even a small fire could start a city-wide disaster, and the strong winds common in the region could quickly fan a blaze out of control. The city regularly burned down and had to be rebuilt. From 1600 to 1868 there were more than 800 recorded fires, including some 20 major ones. There were also innumerable smaller fires that were kept under control, both inside the castle and in the city itself.

The first great fire occurred in 1601. Many more followed. The three most serious fires were those of 1657, 1772, and 1806. In 1657 the fire burned for three days, 60 percent of the city was laid waste, including parts of Edo

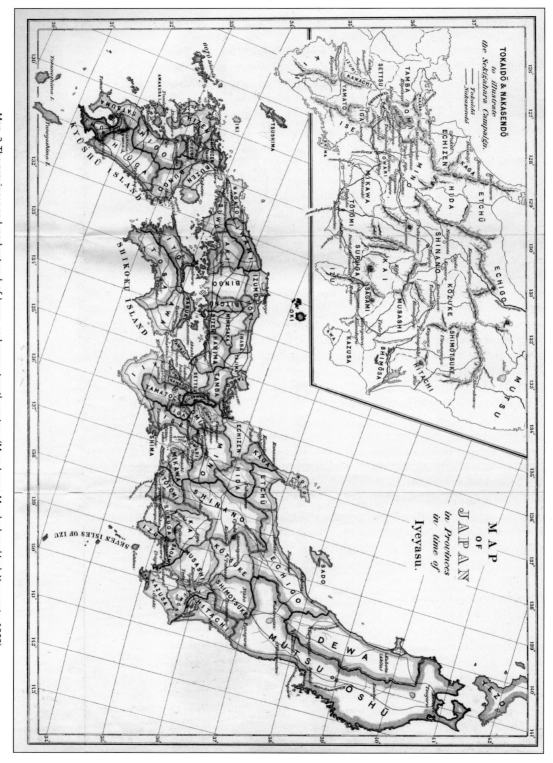

Map 2. The provinces and road network of Japan, early seventeenth century. (Map: James Murdoch and Isoh Yamagata, 1903)

Castle and the mansions of the great lords, and some 108,000 people died.[1] In 1772 the fire was started deliberately by a robber as a diversion, but it quickly destroyed more than half the city and killed around 15,000 people. In 1806 fire wasted the eastern part of Edo including nearly all the residences of the samurai. Other especially destructive fires took place in 1621, 1668, and 1845.

Fire was by far the most serious hazard, but not the only one. Earthquakes also occurred regularly, and their massive destruction was always enhanced by fire, as stoves and braziers turned over and glowing charcoal came in contact with the flammable houses. Of the vast number of fires mentioned above, at least 13 were caused by earthquakes. Serious earthquakes occurred in 1633, 1650, 1668, 1694, 1703, 1707, 1781, 1782, and 1855. The earthquake in 1703 led to the death of an estimated 150,000 people in and around Edo. Following the great earthquake of 1855 much of the city again burned down, floods hit the city, and more than 10,000 died.

Earthquakes, especially those centred out to sea, often caused tidal waves. An especially damaging one occurred in 1854, when 200,000 people are believed to have perished. Entire neighbourhoods were sometimes swept away by such disasters, but severe water damage was also caused by ordinary floods, for instance in 1742 and 1791. Floods often caused epidemics, as drinking water became polluted and corpses temporarily overwhelmed the city's ability to dispose of them. It should be remembered that although the townsmen's quarters in the city were most affected by disaster, the castle and the lordly residences were not immune. Even the Yoshiwara pleasure quarter was often affected. Because of numerous lights and, one may assume, drunken behaviour on the part of its patrons, Yoshiwara regularly burned. Fires destroyed the quarter in 1630, 1640, 1643, 1646, 1654, 1657, and 1677. Other great Yoshiwara fires took place in 1768, 1771, 1772, 1781, 1784, 1786, 1800, 1812, 1816, 1824, 1855, 1860, 1866, and 1871, and there were at least 20 more great fires by the end of the nineteenth century. At these times the courtesans had to move to temporary lodgings in tents or similar accommodation and wait until their quarter was rebuilt.

Population Growth

The population of Japan is generally believed to have remained remarkably stable during the Edo period, ranging from approximately 25 million in 1700 to slightly under 30 million for most of the remaining period.[2] About six percent, or less than two million, were samurai. About 80 percent, or 24 million, were farmers. The farmers had little if anything to do with the cities, unless they ran away to live in them.

1 Actually, 107,406 people according to official accounts, but this number hardly included transients and vagrants.

2 Estimates of the Japanese population in 1600 range from 12 to 18 million, which means that subsequent population figures may need to be revised downwards. See, for example, Conrad Totman, *Early Modern Japan* (Berkeley: University of California Press, 1993), p.140, with references.

But despite the many natural disasters, the population of Edo grew steadily. The geographical area of Edo also gradually expanded, and by the early eighteenth century the city numbered around a million inhabitants. By the middle of the century this number had reached 1.3 to 1.4 million, and in the first half of the nineteenth century the population probably exceeded 1.5 million, of whom as many as 200,000 were considered poor in 1832. There is little doubt that Edo was one of the largest urban areas in the world, probably the largest.

The rapid growth of Edo's population is somewhat difficult to explain, as the city did not have any important industries. All over Japan there was a steady influx of younger sons from rural areas into the towns. They had indeed no other place to go, as the social structure prevented any son but the designated heir, usually the eldest son, from heading the household (*ie*) and continuing the family line. If they stayed in their home village, younger sons were likely to become servants or hired hands, unless they could arrange to be adopted into another family with no son of its own. In a town, they would also have to start from the bottom, but unlike the situation at home, there was the prospect of some day setting up a household and new family line of one's own.

This explains why young men streamed into the nearest town. But why did they go all the way to Edo? For young people, the free-spending life in Edo was a great attraction, and has remained so ever since. Edo's growth may well be explained simply by the long-lived fad of moving to Edo. A poem gave this vision of the ideal life: 'To be born in Edo, to be born a man, and to be able to eat the first bonito of the year' (*Edo ni umare, otoko ni umare, hatsuo-gatsuo*). This widespread feeling led to such an influx of people that another saying became 'Edo is the nation's rubbish heap' (*Edo wa tenka no hakidamari*), and around 1720 the well-known Confucian teacher Ogyû Sorai (1666–1728) complained similarly that 'Edo is the dumping-ground of the domains'.[3] It has been suggested that net immigration into Edo averaged 10,000 per year during the Edo period.[4]

Edo was not an industrial city, nor was it a commercial centre like Ôsaka. The inhabitants of Edo, the Edokko (the term first appears in a 1771 poem), was not a producer but a consumer. The huge population of Edo therefore depended for supplies of food, building materials, and other necessities upon other parts of Japan. Most of these needs were supplied from the Kamigata area (Kyôto and Ôsaka). Special ships transported goods from Ôsaka to Edo. Kamigata products were sold in Edo by wealthy merchant houses. By the end of the eighteenth century, the rural areas around Edo, both fishing and farm villages, and the smaller towns around Edo, were also connected to the city by strong economic ties. For instance, the castle town of Kawagoe in Musashi Province (now Saitama Prefecture), which protected the northern flank of

3 J. R. McEwan, *The Political Writings of Ogyu Sorai* (Cambridge: Cambridge University Press, 1981), p.56.

4 Gilbert Rozman, 'Edo's Importance in the Changing Tokugawa Society', *Journal of Japanese Studies* 6: 1 (Autumn 1974), p.100.

Edo, was a great producer of rice. Trade with Edo was handled by boat using the Shingashi River.

Edo itself was divided into neighbourhoods (*chô* or *machi*), each consisting of a major street and the houses located on both sides along it. Until the very end of the Edo period and beyond, each neighbourhood was for administrative and practical purposes a self-contained village-like community, often distrustful of neighbouring areas. Shops lined the streets, while crowded behind them were the 'split row houses' (*munawari nagaya*) in which the ordinary people lived. As all townsmen lived within these urban neighbourhoods (*chô*), they became known as *chônin*, or 'neighbourhood people'. During the Edo period, the term *chônin* actually had the more specific meaning of an urban landowner or householder. A more general term for townspeople, including those who did not own property, was then *machikata*.

Edo Society

At the beginning of the Edo period, Japanese society was already divided into a rigid class hierarchy. Almost every Japanese was either a warrior, a farmer, a craftsman, or a merchant – in that order of importance. There were some anomalies: a few courtiers in Kyôto, as well as clergy, physicians, and certain intellectuals. These groups were outside the main divisions of the class system, and generally benefited from this. Others were not so lucky, such as the hereditary outcast group known as *eta* ('pollution abundant' or 'heavily polluted'). Although not even considered to be human beings, they formed a group necessary for the performance of a variety of lowly tasks. Many others were temporarily excluded from mainstream society by the nature of their occupations, for instance actors or inmates in the brothel districts. These were known as *hinin* ('non-humans'), though they could, in theory, gain readmission into respectable society by giving up their trades.[5]

Each class also had numerous multiple gradations, from the great lord down to the lowest rank of samurai; from the comparatively few rich farmers down to the numerous agricultural labourers; from the master craftsman down to his lowest apprentice; and from the wealthy merchant down to the impoverished street peddler.

The top class was of course the warrior class, the samurai. Members of this class enjoyed a number of privileges, including the right and duty to carry two swords. But the samurai were also expected to set a good example for the inferior classes, and failure to do so was sometimes severely punished. Each proper member of the warrior class lived on a rice stipend from his lord, expressed in *koku* of rice. One *koku* (180.39 litres) was an amount considered sufficient to feed one person for one year.

5 This was not always easy, however. Even in modern Japan, the descendants of outcast groups, and especially the descendants of *eta*, make up the social class known as *burakumin*. The name derives from the fact that they used to live in designated hamlets (*buraku*). Although in theory no longer discriminated against, their offspring still find it hard to marry outside their limited social group or make a life for themselves outside the hamlets.

The next class, and the bulk of the population, consisted of the farmers. Although generally poor, without any kind of political influence, and condemned to a lifetime of hard work, they received the honour of second place in the hierarchy of classes because their warrior overlords depended on them for the production of rice. For this reason, there were severe restrictions on the farmers' liberty to leave their farms. In 1643 the sale or mortgage of arable land became forbidden. Farmers were also prohibited from changing their occupation, and from travelling outside their own district (unless a certificate was obtained from the proper authorities).

Below the farmers came the class of craftsmen, who generally lived in towns or cities. During the Edo period, they became increasingly intermixed with the class of merchants or traders, who were considered the lowest social class, since merchants produced nothing and were solely concerned with the accumulation of wealth. Such a way of life was frowned upon by the puritanical shogunate. But their wealth soon caused the power of the merchants to grow, and also enabled them to create the distinctive culture of the Edo period. As time passed, the merchants flourished, while the lower-ranking samurai became increasingly impoverished and often came to depend on loans from wealthy merchants. This frequently led to intermarriage, and at times even the selling of samurai status for money through the practice of adoption.

During the centuries of civil wars before the Edo period, and especially during the early sixteenth century, there had been considerable mobility between the various social classes. Numerous farmers had entered the warrior class. The civil wars had been a period of *gekokujô*, a time when inferiors beat down their superiors. However, to promote stability in society, Toyotomi Hideyoshi, the military ruler who preceded the Tokugawa family and who himself was born a farmer or low-ranking warrior, decreed in 1586 that samurai could not become townsmen and farmers were not allowed to leave their land. To further enforce this decree, Hideyoshi in 1588 ordered all farmers to surrender their weapons (an event known as *Taikô no katanagari* or 'Hideyoshi's Sword Hunt'). From then on, only samurai were allowed to carry the long sword made for war. Townsmen were at times allowed a short sword for personal protection, and occasionally certain individuals or professions were granted the privilege to also carry the long sword together with the short one. The set of a long and a short sword therefore distinguished the samurai from the rest of society. Farmers were not even allowed the short sword.

Samurai did not only carry two swords; they also carried two names. Only samurai used family names along with their personal names. Personal names varied among the classes to some degree, but not excessively so. As in ancient Rome and many other early societies, a common practice was to name the male children according to their order of birth: Ichirô ('first son'), Jirô ('second son'), Saburô ('third son'), Shirô ('fourth son'), Gorô ('fifth son'), and so on were common names among all classes. Females were often named after flowers, qualities, or even objects: Kiku ('chrysanthemum'), Take ('bamboo'), Haru ('spring'), Yuki ('snow'), Toshi ('goodness'), Sei ('purity') are typical examples. Samurai daughters often added the suffix -ko ('child') to their given name. Servants often received special servant nicknames (*tsûshô*), such as Gonsuke, Gonshichi, Kyûza, and Kyûshichi for

men, and Osan, Tama and Rin (the two latter often preceded by the syllable O-) for women. In Edo, the names Gonsuke and Osan became virtually synonymous with manservant and maidservant, respectively.

Edo Culture

As the shogunate retained its political supremacy until the very end of the Edo period, it was a time of peace. Despite the political dominance of the warrior class, the culture of Edo soon grew into a townsman's culture. A major reason was the rapidly disappearing boundaries, at least in the cities and the larger towns, between the classes of craftsmen and merchants. Both groups rapidly ended up as townsmen rather than members of artificial classes imposed on them by the early military rulers of Japan. To Toyotomi Hideyoshi, it had made sense to regard the craftsmen as pure manufacturers of articles (other than food) that were required for the life of a warrior, whether these articles had practical or decorative function. That the same craftsmen also would provide similar goods to rich commoners was of no immediate concern, as there were considerably fewer wealthy commoners in Hideyoshi's time, and as an order from the warrior class in any case naturally took precedence. After all, the craftsmen of the early castle towns had been brought in only to fulfil the demand for goods of the feudal lord and his men.

Fig. 3. Man wearing an *amigasa*

In Edo, however, the vivacious workers at lumber yards, construction sites, and warehouses had other interests than the supposedly refined samurai class. Edo popular culture soon developed into a spicy mix of drinking places, cheap publishing, Kabuki theatre, and the 'floating world' of the pleasure quarters. Samurai were not supposed to spend their spare time on the leisure activities of the townsmen, but most did. Many a samurai donned a disguise or at least hid his face by wearing some sort of wide-brimmed hat, or the deep, basket-like *amigasa*, in order to take part in the townsman's culture without losing face in front of his peers (Fig. 3). Sometimes more than face was at stake: various official edicts forbade such activities (in particular attending the Kabuki theatre), and when enforced, penalties were severe.

Other sources of amusement were the shows and public performances held at popular and therefore very crowded spots near Ryôgoku Bridge and in many other areas around Edo. More serious pursuits also existed. The enforced social order of Edo did not completely stifle intellectual freedom, especially in cultural pursuits and the arts. Many cultural groups made up of feudal lords, samurai, and select commoners flourished in Edo. Intellectuals, writers, and poets were to some extent allowed to float outside the rigid class system, which greatly increased their impact on Japanese culture and

civilisation. Although art, literature, poetry, the tea ceremony, and the Nô drama had evolved long before the Edo period, participation had formerly been limited to a small aristocratic and religious elite. Commoners, and indeed most lower-ranking samurai, had been left out, as they had generally been too busy simply surviving in a world of civil war with its ever-recurring dangers to crops and trade. The peace and stability of the Edo period, however, led to a flourishing of the arts. This had begun even before the Edo period, after Oda Nobunaga (1534–1582), predecessor of Toyotomi Hideyoshi and Tokugawa Ieyasu, assumed control of virtually the whole of Japan in 1573, but it reached its peak in the Edo period. This upsurge of popular culture was not limited to Edo. In Kyôto, the old Imperial capital, the great annual festivals of the courtiers had been abandoned during the long years of warfare. Now these festivals were revived, but this time by the townspeople, not the aristocrats.

Although Japan from 1637 was closed to most forms of contact with foreign countries, there were still various way in which foreign influences entered the country, stimulating the emerging Edo culture. A vast share of Japanese culture had been derived, and indeed was still being derived, from China, in two major waves of cultural influence: the first taking place from the seventh century to the end of the ninth century and the second continuing from the beginning of the fifteenth century throughout the Edo period. The earliest confirmed European visitors, António de Motta, Francisco Zeimoto, and António Peixoto, three Portuguese passengers on a Chinese junk, arrived at the small island of Tanegashima off the shore of southern Kyûshû in 1543 (Japanese documents suggest an even earlier Portuguese visit in 1534). They were quickly followed by many more, including a Jesuit mission led by Francis Xavier in 1549. The mission was at first very successful, especially around Nagasaki, where numerous loyal converts soon followed the Christian priests. Foreign dress, and especially foreign hats, became very popular among fashion-conscious entertainers and the upper classes. So, for a time, were foreign influences in ornaments and emblems.

However, obvious foreign influence was not allowed to last. Although churches were established even in Kyôto and Ôsaka, Christianity was destined to fall into oblivion with the rise of the Tokugawa family. Persecution of Christians and numerous prohibitions on contact with foreigners became the rule of the Tokugawa shogunate. The reason was not religious but political. Together with Christianity, the non-conformist Buddhist Fuju Fuse sect was also proscribed. Foreign influences were deemed to be a threat to the stability of the Tokugawa rule, and must therefore be suppressed. A policy of seclusion was initiated. All overseas Japanese, whether traders in Siam or wives and prostitutes in Java, were forbidden to return, tainted as they were with foreign ideas. Japanese were forbidden to leave Japan, and even the construction of ocean-going ships was officially prohibited. Available navigational data was destroyed. By 1616 European shipping was also strictly limited.

Despite these bans, the Dutch were allowed to maintain a small colony on the artificial island of Dejima in Nagasaki harbour, and this led to the import, translation, and distribution of a small number of foreign books, mainly scientific works. At times the Dutch, or other Europeans who came

with them, were expected to visit the shôgun's court in Edo. In this way, various cultural influences were brought directly in touch with the capital. Among such visitors were the German physician Engelbert Kaempfer (1651– 1716), the Swedish physician and botanist Carl Peter Thunberg (1743–1828), who was a disciple of the famous botanist Carolus Linnaeus (1707–78), and Philipp Franz Balthasar von Siebold (1796–1866), a Bavarian scientist and physician. Other delegations arrived from Korea, with which diplomatic relations were retained. The Chinese, too, were allowed to keep a trading station in Nagasaki. Silver, copper (for minting coins), gold, camphor, sulphur, lacquerware, porcelain, shark fins, sea slugs, and other delicacies were exported. Silk (up to the middle of the Edo period), cotton goods, medicine, indigo dye, books, sugar, deerskins, and woollen goods were imported. Not only books and fashion influenced Edo culture; it also became popular to build mechanical toys, such as automated archer dolls, styled on European models.

But there were other joys, too. It was fashionable among the sophisticated city-dwelling Edokko to appreciate natural beauty. In spring, he would go to see the cherry blossoms at Ueno. In summer, he would enjoy the fireworks at Ryôgoku, where in 1733 the Japanese tradition of summer firework displays was born; in autumn he would gaze at the moon over the Musashino plain, and in winter he would go to Nippori to see the snow. All these occasions were good reasons to invite many friends and get gloriously drunk together, often without even noticing the falling cherry blossoms around the celebrating party. Annual festivals formed a great source of enjoyment and a chance to let off steam, both in Edo and elsewhere.

The package tour was a concept that already existed in old Edo. Many people travelled to famous shrines and temples, making pilgrimages that combined sightseeing with religious observances. As it was only natural for neighbourhood friends to travel together – and that agents of the temples organised the itinerary – such a group formed a natural package tour.

The Edo period was in many ways paradoxical. The government, both on the local and central level, found it continuously necessary to issue sumptuary edicts to restrict the freedom of the commoners. On the other hand, the mere existence of these numerous and always very similar edicts indicate that people did more or less as they pleased. In the towns, edicts were issued purporting to control everything from the dress a commoner was allowed to wear to what he was allowed to eat, and almost anything else in between. Yet fashion reigned unchallenged regardless of edicts to the contrary, and the merchant class, in theory the lowest in the social order, did more or less as it pleased because of its wealth, including producing many of the leaders in fashion. In the country, farmers were not allowed to leave their land, yet they constantly left for the towns.

Bribery was rampant, vastly encouraged by a tradition of gift-giving to patrons, officials, and everybody else of superior rank. In the towns, merchants and craftsmen paid cash to be adopted into samurai families. In the country, farmers – if they had the money – bribed the officials to overlook their new fields. Although the castle towns were supposed to be strictly controlled, and Edo was merely the biggest castle town, the city almost at once became

too vast and populous to control properly. In Edo, accordingly, the control was paradoxically less obtrusive than in the provinces. Ôsaka enjoyed the same level of freedom, as few samurai were allowed to reside there. Edo culture, developed by townsmen for anyone who could afford it, grew up in an atmosphere that curiously combined a puritanical, nearly obsessive desire to earn money with an equally strong demand for amusement of the most expensive, exotic and lavish kind. The vast and hugely profitable entertainment industry of Japan had its beginning in the Edo period.

Tokugawa Ieyasu had moved his capital to Edo so that his retainers would not be softened by the easy life and numerous pleasures of the ancient capital of Kyôto. Little did he know that the new city of Edo soon would produce the same effect.

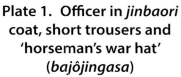

Plate 1. Officer in *jinbaori* coat, short trousers and 'horseman's war hat' (*bajôjingasa*)

(Illustration by Georgio Albertini © Helion & Company 2022)

With the civil wars concluded, many officers abandoned the use of battle armour. Nonetheless, the *jinbaori* or 'war coat', originally designed to be worn over a full set of body armour, remained in common use. The short trousers tied under the knees, too, were a remnant of the dress earlier used with full armour.

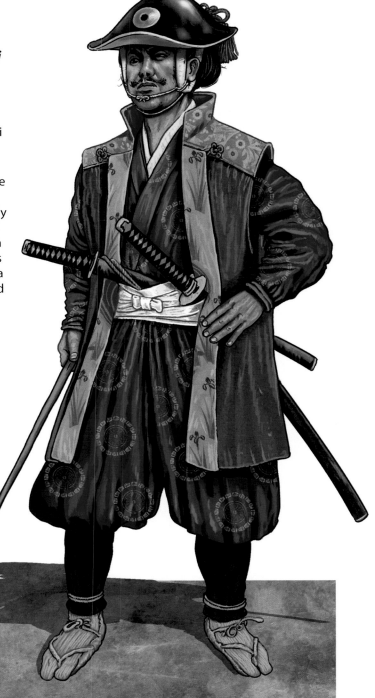

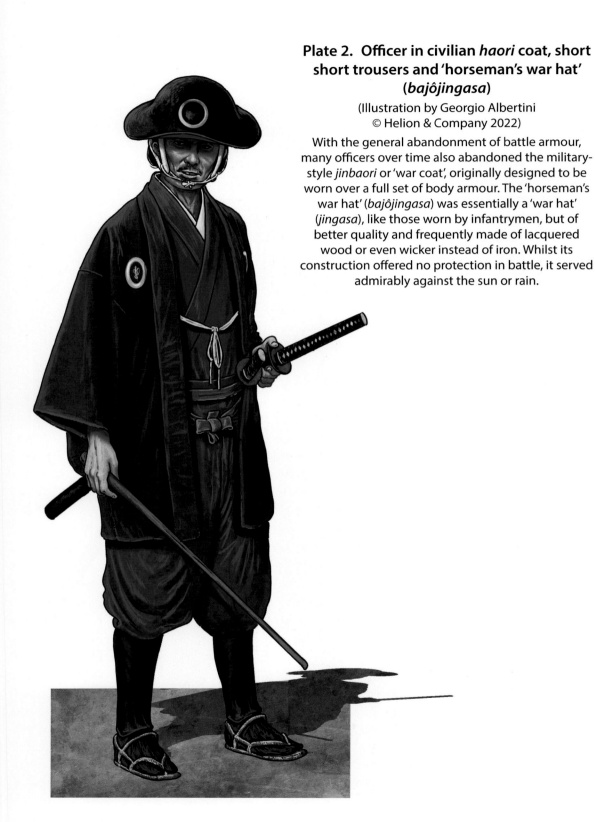

Plate 2. Officer in civilian *haori* coat, short short trousers and 'horseman's war hat' (*bajôjingasa*)

(Illustration by Georgio Albertini
© Helion & Company 2022)

With the general abandonment of battle armour, many officers over time also abandoned the military-style *jinbaori* or 'war coat', originally designed to be worn over a full set of body armour. The 'horseman's war hat' (*bajôjingasa*) was essentially a 'war hat' (*jingasa*), like those worn by infantrymen, but of better quality and frequently made of lacquered wood or even wicker instead of iron. Whilst its construction offered no protection in battle, it served admirably against the sun or rain.

1

The Shôgun's Army

The Social and Military Structure of Shogunate Japan

The Bakuhan System

Edo period Japan was a feudal society ruled by a military dictatorship, the shogunate, with the ethics of a police state. Although the source of power in theory remained with the emperor in Kyôto, the top level of the national government was made up of the Tokugawa family. The emperor bestowed the title of shôgun ('commander-in-chief'), but it was bestowed upon the person chosen by the head of the Tokugawa family. Lesser titles could also be bestowed by the emperor but only on persons nominated by the shogunate. Formally, the emperor in Kyôto stood above the shôgun, but the Imperial family played no part in government and the shogunate prevented its members from having contacts with the shôgun's vassals or, for that matter, anybody else of importance. The court nobility was physically confined to Kyôto and the emperor was excluded from affairs of state. The emperor remained a mere figurehead during the entire Edo period, spending his time in literary and ceremonial pursuits. The needs of the Imperial court were met by a grant of land, but all his activities were supervised by an official known as the Kyôto Steward or Deputy (*Kyôto shoshidai*), appointed by the shogunate.

The three great cities of Edo, Kyôto, and Ôsaka, as well as the vast and rich estates of the personal fief of the shôgun, were administered directly by the shogunate. The rest of Tokugawa-controlled Japan was split up in lordly domains and allotted to the feudal lords in exchange for an oath of allegiance.

The system of government which Tokugawa Ieyasu introduced, and which lasted until the very end of the Edo period, is currently referred to as the *bakuhan* system (*bakuhan taisei*). This term derives from the words for shogunate (*bakufu*) and clan domain (*han*), respectively. Ieyasu never attempted to abolish the lordly domains. Instead, he used the domains, and the clans which ruled them, as a means to provide provincial government. As a result, government functioned through two quite separate political mechanisms: the *bakufu* or shogunate and the *han* or clan domain. An unintended consequence of this division was that not all Tokugawa directives were adopted completely or uniformly throughout Japan. Domain rulers were pragmatic and did not always respond to the shogunate's initiatives

until when, and if, it suited their purposes to do so. The central authority's influence was accordingly indirect rather than direct. The most powerful *daimyô* retained a degree of independence, despite the centralising ambition of the shogunate.[1]

The national government was organised along feudal lines, with the shôgun at the top and every man linked to him by ties of direct or indirect vassalage. Directly subordinated to the shôgun were two distinct groups of vassals, the great lords on the one side and the shôgun's direct vassals on the other. The senior group in terms of prestige was the great lords (*daimyô*), some 260 in number, who nominally served as the shôgun's vassals but headed their own clans and, as noted, in this position handled most provincial government. There were three subcategories of *daimyô*, known respectively as *shinpan*, *fudai*, and *tozama*. The *shinpan* ('related domains', from the two words *shin* and *han*), eventually 23 in number, were the collateral or cadet lords, that is, lineages descended by birth or adoption from the Tokugawa family itself. The *fudai* ('successive generations'), eventually 145 in number, were the hereditary vassal houses of the Tokugawa clan and the descendants of those *daimyô* who had served Ieyasu before the battle of Sekigahara in 1600 and who had fought for the Tokugawa cause in the battle. These two subcategories – the relatives and loyal followers of the shôgun – were regarded as the lords most likely to serve the shogunate loyally. They were given lands in strategic positions around Edo, forming a buffer between the personal estates of the shôgun and those of the third subcategory of *daimyô*. The latter were known as the *tozama* ('outside' lords) and consisted of those lords who had been independent at the time of the battle of Sekigahara, fought against the Tokugawas in the battle, or submitted only after the Tokugawa victory. The 'outside' lords also swore an oath of allegiance but their loyalty to the Tokugawas was less certain. They in most cases remained great landowners, even if no single lord could match the shogunate. Their domains were also generally far away from the central government.

For these reason, the *tozama* lords were less trusted and, with the exception of those who were too powerful to be deprived of their domains, accordingly less secure in their positions vis-à-vis the shogunate. The *tozama* lords were kept under close surveillance. If suspected of treasonous activities and deemed not to be too powerful, they were punished and deprived of their lands. The prevalence of such punishments is apparent from the gradual reduction of their number. While there were 117 *tozama* lords in 1602, by 1795 only 98 remained. Although the *tozama* lords due to their independent origin generally held larger domains than the *fudai* lords, the latter were more trusted and accordingly held any powerful hereditary posts in the shogunate. A *daimyô* held lands rated for a revenue of no less than 10,000 *koku* of rice. However, many *daimyô* enjoyed significantly higher revenues than this; in the case of some *tozama daimyô* such as the Shimazu and Date clans, based respectively in westernmost and northernmost Japan, in excess

1 Philip C. Brown, *Central Authority and Local Autonomy in the Formation of Early Modern Japan: The Case of Kaga Domain* (Stanford: Stanford University Press, 1993), pp.221, 225, 233, 240.

of 600,000 *koku*. Even wealthier was the Maeda clan, with a *koku* rating of more than a million.

Life was more difficult for the *shinpan* and *fudai* vassal lords, and for the poorer *tozama* lords. Of minor importance and often impoverished, they had to remain loyal as they lived under the constant threat of dispossession or transfer as punishment for misconduct or disloyalty. Misconduct was easy; the shogunate imposed strict controls on, for instance, the amount of fortification permitted and levels of social exchange allowed with other lords. Every lord was encouraged to spy on his neighbours and report any suspicious activities. In addition, dedicated government inspectors had the sole function of keeping an eye on the feudal lords and their activities. Besides, garrisons had to be provided for the Tokugawa castles and certain types of public works had to be undertaken.

The direct vassals (*jikisan*) or personal retainers of the shôgun constituted the second-highest group of shogunate vassals and consisted of the descendants of the warriors who had served in the Tokugawa clan army. These consisted of two classes, known respectively as *hatamoto* ('bannermen') and *gokenin* ('housemen'). Collectively, the *hatamoto* and *gokenin* constituted the Tokugawa clan army, together with their own respective vassals, who accordingly were secondary vassals of the shôgun. In the Edo period, the *hatamoto* were defined as hereditary vassals under the shôgun whose revenues were more than 100 *koku* of rice but less than 10,000 *koku*. Most of them had considerably less than the maximum allowance, and few had a revenue of more than 3,000 *koku*. Those with less than 500 *koku* were the most numerous. *Hatamoto* had the right of direct access to the shôgun, and when on active service, served as officers (with an obligation to pay for their own subordinate troops). Most of the time the *hatamoto* were idle, however, and the shogunate frequently reduced their income by various means. It became especially common to deprive those with less than 500 *koku* of their fiefs in exchange for fixed stipends. After 1635 the *hatamoto* numbered slightly more than 5,200, of whom only about 250 had stipends of 3,000 *koku* or more. This number remained fairly constant. In 1722 the number of *hatamoto* totalled 5,205.

The *gokenin* were an even lower grade of direct retainer of the shôgun. *Gokenin* was a medieval term for a favoured personal vassal, but by the Edo period the title had been debased in rank. Unlike the *hatamoto*, the *gokenin* never had fiefs. Their stipends ranged from four *ryô* of gold, that is, a simple cash stipend, to 260 *koku* of rice. Most *gokenin* received less than 100 *koku*, and some received far less, in effect being unable even to support a family. They numbered between 17,000 and 20,000. It was not unusual for *gokenin* to fall into impoverishment and lose their warrior status. By 1722, the number of *gokenin* was 17,399. Since the shôgun's soldiers – *hatamoto* as well as *gokenin* – were no longer needed for purposes of war after 1615, hardly anybody was called up for military service, and those who could not adjust to civilian life had to search out other pastimes, including organised crime. However, many former soldiers unable to find other suitable careers were incorporated into the Edo police and the fire brigades, respectively (for more on which see below).

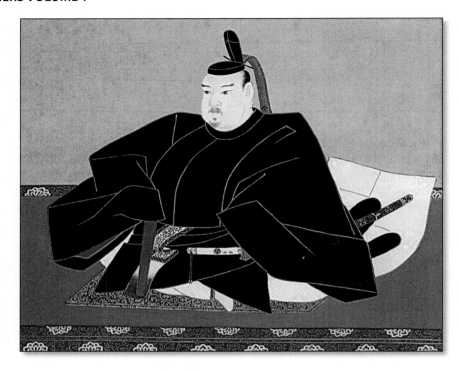

Fig. 4. Tokugawa Iemitsu, the third shôgun (1604–1651, r. 1623–1651)

Then there were the religious communities of Japan. As in particular the Buddhist sects and large temples had played a key role in the civil wars of the past, the shogunate also kept them under strict control. Arrangements were made so that their income was allotted from central or local sources that could be cut off, if any religious establishment appeared to cause trouble. If any sect was too powerful or too much opposed in policy to the central rule of the shogunate (for instance the Buddhist Jôdo-Shin sect, which had formerly organised commoners into autonomous communities), then the shogunate ordered it to be split into separate branches, so that the sect had to waste its resources by maintaining separate groups of temples.

Although the Tokugawa family itself held agrarian lands assessed as some four million *koku* out of Japan's total of 30 million *koku*, and the Tokugawa clan's *hatamoto* held another three million *koku*, these figures (which refer to the land's capacity to produce rice) illustrate that while powerful, the shogunate did not control a majority of either land or population. To remain in control, the shogunate accordingly had to take radical means to prevent the *daimyô* from joining forces against the Tokugawa family. The stability of shogunate Japan depended on maintaining the balance of power between its constituent parts so that no coalition could be formed against the ruling Tokugawa clan. It will be shown that a variety of means were introduced for this purpose, including measures to reduce the available revenues of the lords and the introduction by the third shôgun, Iemitsu (1604–1651, r. 1623–1651), in 1635–1642 of the *sankin kôtai* system, which enabled the shogunate to retain the immediate families of the lords as hostages in Edo, under shogunate supervision. In other words, the shogunate relied on legislative and what might be termed fiscal means, not military force, to impose control.

Which was wise, since it will be shown that with the transition to peace, stagnation had soon set in and the shogunate army had lost its edge.

The National Government

The basic machinery of administration was built up during the rule of the first three shôguns, during the first half of the seventeenth century. The top level of the shogunate had three principal offices: the *Tairô* (Great Elders); the *Rôjû* (Senior Councillors); and the *Hyôjôsho* (Judicial Council). The *Tairô* advised on national policy and acted as regents during the minority of a shôgun. They – at first two, but later only one and at times none – acted in effect as alternate prime ministers. The *Rôjû* had several advisory and administrative functions. Their duties included, but were not limited to, relations with the Imperial court; supervision of the great lords; supervision of the internal affairs of the shôgun's personal domains; financial matters such as gold and silver coinage; public works; enfeoffments; control of temples and shrines; and compilation of maps and charts. The four or five *Rôjû* served in rotation, each for one month. The administration also included from four to six *wakadoshiyori* (junior councillors), subordinate to the *Rôjû*. These oversaw affairs relating to the shôgun's personal retainers (*hatamoto* and *gokenin*). For communication with the shôgun, the *Rôjû* relied on functionaries known as *sobayônin*, grand chamberlains in personal attendance. When the *Rôjû* were weak, the chamberlains had plenty of opportunities to enrich themselves by taking bribes.

The *Hyôjôsho* functioned as judicial council or high court. It met three times a month in a special office located in the part of Edo known as Marunouchi. There was no distinction between the executive and legal functions of the council, and the same individuals held posts with both functions. The Judicial Council was composed of the *Rôjû* and certain other high officials (*bugyô*) in charge of executive departments of the shogunate administration:

- The Edo Town Magistrates (*Edo machi-bugyô*), responsible for city government, police, and justice
- The Commissioners for Temples and Shrines (*jisha bugyô*), four in number, serving in rotation at monthly intervals, responsible for the control of religious establishments throughout the country and some other duties including the supervision of professional musicians, linked-verse (*renga*) poets, and *go* players
- The Finance Commissioners (*kanjô bugyô*), four in number, who supervised the administration of the Tokugawa domains

These three offices were collectively known as the 'three magistrates' (*sanbugyô*).

The Judicial Council also included the Chief Inspectors or Censors (*ômetsuke*). Their duty was to keep a close watch on the great lords. The shogunate administration included four or five chief censors and 16 subordinate censors (*metsuke*). The latter kept an equally close watch on

the shōgun's personal retainers (*hatamoto*). The *metsuke* were created in 1617 and were under the authority of a *wakadoshiyori*. The first *ōmetsuke* were appointed in 1633 (under the name *sōmetsuke*). Later their number was increased to five and their name was changed to *ōmetsuke*. The Judicial Council was mainly involved with questions of succession, territorial disputes involving great lords, and incidents of a political nature.

The shogunate also appointed a number of lower local officials who administered Tokugawa estates throughout Japan. They were known as deputies (*gundai* or *daikan*). There were also a number of castle governors (*jōdai*), one of whom controlled the important Ōsaka Castle (*Ōsaka jōdai*). Important towns including Nagasaki and its resident foreigners were governed by magistrates (*bugyō*).

The rest of the population, whether in cities or rural areas, was controlled by government officials appointed either by the local authorities or by the central government. These officials worked through a network of several different types and levels of police officers. The well-informed German physician Engelbert Kaempfer aptly summarised the legal system of Edo period Japan: 'The more laws the more offenders'.[2] To break a law, intentionally or unknowingly, was easy.

Direct police supervision was not the only means of controlling the population. Another, yet more important method of control was the establishment of a system of mutual responsibility. No ordinary Japanese could break the accepted code of behaviour without causing others to also be punished. Every family head answered for his relatives, every group of households answered for each individual household, the headman answered for his village, the landlord for his tenants, and any other recognised group for all of its members.

Japan had no constitution, and indeed no unified code of law. In criminal justice, the magistrates were guided by the criminal code, but this code was never published in its entirety. Public notices about certain crimes were often posted in busy areas, but this was all. The criminal code, such as it was, could be changed without warning. Almost any behaviour which was not near-universal could be construed as a crime, if the official was so inclined. Thus, it was always held safest to live exactly the same life as everybody else, and to never rock the boat. A quiet and non-outstanding life was the best method to avoid punishment. The nail that sticks out higher than the rest is the one that is first hammered down, it was generally agreed. It is no wonder that a mentality which emphasises the need to behave exactly the same as everybody else developed in Edo period Japan. How else could you avoid breaking the law? In Edo, it was no longer deemed possible, or even desirable, to rise above one's social class, feats achieved by the military leaders Oda Nobunaga and Toyotomi Hideyoshi in days of yore.

The fundamental, Neo-Confucianist doctrine of the shogunate also agreed most emphatically that people should be content to do what they

2 Engelbert Kaempfer, *The History of Japan … Together with a Description of the Kingdom of Siam* (London: Thomas Woodward, 1728), 2nd vol., p.415.

were told. There was no need to teach the law to common people, it was believed. To obey any authority was sufficient. This attitude held true also within the family, something eloquently expressed in the saying that recalled life's four most frightening things: 'Earthquake, thunder, fire, and father' (*jishin, kaminari, kaji, oyaji*).

The Town Magistrate and the City Administration

In Edo, and in every other major town or city, the administration was organised in a system of magistrates (*bugyô*) and policemen. This system was fully developed by 1631, when the first two Edo magistrates were appointed, and no major changes took place for the duration of the Edo period. The function of the town magistrate was that of chief of police, judge, and mayor. He was a man of many and diverse responsibilities. His title, *bugyô*, can be translated as either commissioner or magistrate. The title dated back to the Heian period (794–1185), and its original meaning was 'to carry out orders received from a superior'. For most *bugyô*, 'commissioner' is therefore an adequate translation. However, the *machi-bugyô* had such wide responsibilities, including administrative, judicial, as well as police duties, and as his function unlike those of the other 'commissioners' was of pure Chinese origin, the term 'magistrate' seems more appropriate.

The basic concept of the town magistrate's duties was imported from China, but the paranoia of the shogunate led to a major adaption. In China, the post of town magistrate was held by only one person; the shogunate, however, found it safer to nominate two individuals, so that they could report on each other. Edo accordingly had two (at one time even three) town magistrates, who worked out of the North Town Magistrate Office (*Kitamachi bugyôsho*) and the South Town Magistrate Office (*Minamimachi bugyôsho*), respectively. The 'northern' office was located in northern Marunouchi, while the 'southern' office was located in southern Marunouchi. Although they had separate offices, each magistrate was on duty for one month and off duty for the next. Nonetheless, both magistrates had to sign all reports submitted to the government. The shogunate understood the importance of the Edo town magistrate and usually only nominated a very able retainer to the post. The position was accordingly a prestigious one, but the duties were not light and the posting was no sinecure. As in China, the magistrates were constantly overworked, and as the population of Edo grew, the duties of the magistrates grew sufficiently to demand that the off-duty month was required merely to catch up on the work relating to the previous one month of duty.

The town magistrates were charged with keeping the peace, enforcing the laws, and supervising the police, which came to incorporate many former soldiers. The town magistrates also had to deal with civil disputes, enforce the city building regulations, issue travel passes, and supervise the city civil administration, city prisons, public relief agencies (mainly concerned with the distribution of rice in times of need), and fire brigades. The fire brigades were well organised and, like the police, gave a new career to many former soldiers. The first organised force of firefighters, with one fire brigade provided by each *daimyô*, was established by order of the shogunate in 1629. Soon afterwards, this force was supplemented by firemen recruited

from the commoner class who served under shogunate samurai officers. Finally, in 1650, additional fire brigades were established to protect the castle and the samurai residences, with firefighters recruited among the *hatamoto*. The coordination of all these brigades became another duty of the town magistrates. Yet, the town magistrates had lesser duties as well, which included, for instance, to locate and evaluate suitable commoners as candidates for government awards in filial piety and good conduct. Any other problems that concerned the city also became the responsibility of the town magistrates. The magistrate on duty had to go to Edo Castle every day at 10:00 a.m. There meetings followed with the senior councillors, the officials who headed the shogunate administration and were directly responsible to the shôgun. The magistrate reported any action he had taken and then received his orders. The meetings ensured that the magistrate was not free to leave until about 2:00 p.m., and upon his return to his office he had to deal with the paperwork and other routine matters.

For administrative purposes, the magistrate was assisted by a small staff. He could also rely on the city administration. The lower level of this administration consisted of town officials known as *machi yakunin*. These were minor functionaries who served as intermediaries between the rulers and the urban populace. Their main duties consisted of, for instance, maintaining censuses, guard patrols, and fire brigades. These functionaries were the most important lower members of the administration. There was also an upper level of the city administration, consisting of the three 'town elders' (*machi doshiyori*) named Taruya, Naraya, and Kitamura. These men held hereditary offices because their merchant ancestors had been brought from Sunpu (now Shizuoka) by Tokugawa Ieyasu. The positions of town elders were retained until the very end of the shogunate. Originally appointed to receive the orders of the magistrate, levy taxes, nominate community headmen, supervise business and trade, and take responsibility for waterways, fire precautions, and public health, their duties eventually grew increasingly ceremonial and separated from the daily administration. The town elders had to appear at court at the beginning of each new year. They also had to take part in other, similar ceremonies. Besides, the town elders too alternated their duties. The three town elders resided in Honchô, near Nihonbashi, and since they had been elevated to the warrior class, they had the right to wear the two swords of the samurai and keep family names.

While the position of town elder gradually distanced itself from the populace, the technically inferior position of 'neighbourhood chief' or 'community head' (*nanushi*) remained considerably more close to the Edokko. This position soon grew into the de facto senior level of the town administration under the town magistrate. A community head was appointed for each city neighbourhood or village. These administrative units varied in size, and the community head's authority varied likewise. He had numerous duties. He had to keep a close eye on the inhabitants of his district, maintain files and write reports on them, reprimand those who lived immorally, identify criminals, supervise the fire brigades, and maintain the roads. The vast majority of civil suits, business disputes, and lawsuits were examined and if at all possible also judged in the office of the community head. In

recognition of his status, a community head had the right to a residence with a gateway (*genkan*) and an attached office, and was indeed often referred to as *genkan*. He was not, however, allowed to run a personal business. The office was hereditary, and he too had the right to wear the two swords, since he had been elevated to the warrior class. Each community head was responsible for the inhabitants of five to eight blocks (*chô*). The number of community heads increased as the city grew. In about 1640, Edo counted 300 neighbourhoods (*chô* or *machi*), and only 40 years later (some say already by 1658), 808. Eventually this number seems to have almost doubled.

The community heads were assisted by the 'five-man groups' (*goningumi*). The establishment of these was a means of enforcing social control by mutual responsibility. The idea of such groups had originally been introduced from China, where the system has been enforced until recent years and still remains in use to some extent. The shogunate made the five-man groups a formal part of the local administration in Edo in the first half of the seventeenth century. Although optimally it was made up of five households, the heads of which formed the actual five-man group, a group could be composed of as few as one to more than a dozen households. Each group had a leader, either appointed or elected. The group was collectively held responsible for obligations, such as tax and corvée labour, and for any broken laws or regulations. The group was also responsible for supervising the behaviour of all members as well as maintaining statistics on births, deaths, marriages, and adoptions. The five-man group, in its turn, was assisted by the local house owners (*yanushi*), each of whom was responsible for his tenants.

Within the boundaries of Edo, only samurai and priests remained outside the town magistrate's jurisdiction. Other officials (see above) dealt with them, meeting the Edo magistrate three times a month in the Judicial Council (*Hyôjôsho*). As the post of Edo magistrate was of vital importance to the shogunate, it was reserved for personal retainers of the shôgun (*hatamoto*) with a lowest rating of 500 *koku*. The post carried with it an allowance of 3,000 *koku* and a court rank that equalled some great lords. The allowance and the rank counted more as necessities for successfully fulfilling the important duties of the post than as a source of personal reward. The magistrate had to cover many work-related expenses out of his personal wallet. The Edo magistrate not only needed to be very loyal, he also had to be an outstanding man of high integrity. More than once, notable holders of other posts, technically regarded as equal in status, were promoted to the post of Edo magistrate.

One well-known Edo town magistrate was Ishigaya Sadakiyo (1594–1672). As a young man he took part in the siege of Ôsaka Castle in 1615. Later, in 1637–1638, he also distinguished himself and was wounded fighting Christian peasant insurgents in Shimabara, Kyûshû. Ishigaya's fame as a magistrate came when he exposed and arrested the leaders in a serious plot to overthrow the shogunate, the Keian Incident (see below). This plot, and also the two wars in which he participated, were to some extent caused by the severe financial straits of Japan's numerous unemployed masterless samurai (*rônin*). We have seen how difficult it was for the shôgun's personal retainers, the *hatamoto* and *gokenin*, to find military employment after 1615. Yet, the

Fig. 5. Edo town magistrate Ôoka Echizen no kami Tadasuke

rônin had it far worse. Ishigaya understood the difficulties of their situation, and besides arresting plotters, he also succeeded in finding employment for more than 1,000 *rônin* during his 20 years in official service, thus removing from Edo one serious cause of discontent and public disorder.

The most famous Edo magistrate was Ôoka Echizen no kami Tadasuke (1677–1751). Serving as Edo town magistrate from 1717 to 1736, he is remembered for his uncanny, nay legendary, ability to pronounce just decisions and solve difficult crimes. Many of his cases were fictionalised in the popular Edo book *The Judgements of Ôoka* (*Ôoka meiyo-seidan*). Ôoka is also credited with bringing in humanitarian reforms in the Edo police corps, especially with regard to the interrogation of prisoners.

Ôoka first served from 1712 as magistrate of Yamada, Ise Province. In this position he impressed Tokugawa Yoshimune, then the powerful lord of Kii, with his impartiality when he decided a boundary dispute against Kii despite the great power of its Tokugawa lord. When Yoshimune became the eighth shôgun, he appointed Ôoka magistrate of Edo (*Edo Minamimachi bugyô*). In Edo, Ôoka's many reforms included the introduction of boxes for suggestions to the shôgun (*meyasubako*), placed in courtrooms in 1719 (in 1721, boxes were also posted in Edo, Kyôto, and Ôsaka to receive commoners' appeals to the shôgun); the establishment of a hospital and medicinal herbarium in Koishikawa (modern-day Koishikawa Botanical Gardens); and the systemisation of the neighbourhood fire brigades. In 1717 Ôoka had recommended the codification of the law as it was then interpreted. Tokugawa Yoshimune, an able ruler, agreed, and an order to this purpose was issued by the shôgun in 1720. Completed in 1742, this work became known as the 'Code of One Hundred Articles' (*Hyakkajô*, the second and last part of the administrative and legal code the formal title of which was *Kujikata Osadamegaki*). In fact, it consisted of 103 articles. Limitations were placed on the use of torture, and punishments were less severe than earlier. In principle the code remained secret, however, and was only issued to certain designated officials.

Many of the stories of Ôoka are purely legendary and made up after his death. Although not historical, they nevertheless show that the public appreciated his keen sense of justice. In one such story, two men disputed the ownership of three gold coins (*koban*). Ôoka solved their dispute by voluntarily taking one more such coin from his own funds, then handing the two men two coins each. Everybody involved, including Ôoka himself, thus suffered the loss of one gold coin. The fairness of the proceeding was

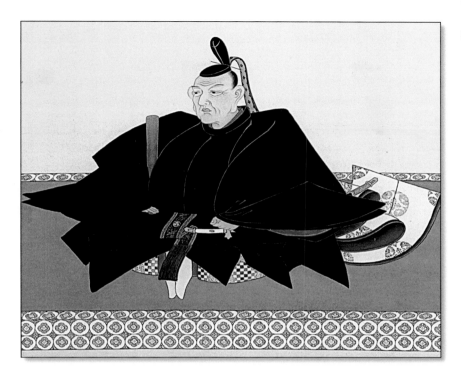

Fig. 6. Tokugawa Yoshimune, the eighth shôgun (1684–1751, r. 1716–45)

ensured. In another story, two women quarrelled over who was the mother of a particular child, a young boy. Ôoka ordered the two women to grab the child's hand, one from this side and the other from the opposite side, and try to pull the child away from the other contestant. The victor was to be awarded the child. However, when the tug-of-war began, the child naturally cried with pain. One of the two women involuntarily let go of his hand. Ôoka then pronounced his true verdict, declaring the woman who had let the child's hand go as he was crying with pain the child's real mother. She was awarded the child, and the other, more callous woman was sent away.[3]

In 1736, Ôoka was promoted to Commissioner for Temples and Shrines. He was also awarded the title Echizen no kami. In 1748 he was raised to the rank of lord (*daimyô*) with a rating of 10,000 *koku*.

Law Enforcement

The town magistrate, in his capacity as head of the Edo police, had a large police force at his disposal. With the lack of military tasks, the Edo police came to incorporate many former soldiers. Immediately under each town magistrate served 25 *yoriki* ('offered strength') or assistant magistrates. They were samurai, retainers of the shôgun of the *gokenin* category. Each had a rating of 200 *koku*. Originally, the word *yoriki* had signified a lord's military

3 Compare the Old Testament King Solomon's use of a sword to solve a similar problem. The Bible, 1 Kings 3:16–28.

aide, but from the sixteenth century the meaning of the term changed to a military commander of low rank. In Edo, the office of *yoriki* was hereditary. The heir of a *yoriki* entered a form of apprenticeship at around the age of 13. All *yoriki* of Edo were thus true Edokko, and it is likely that a new town magistrate had to rely extensively on the *yoriki*'s local experience.

The *yoriki* formed a tight group. They all lived in the same quarter, Hatchôbori, and their samurai status prevented them from mingling freely with the townspeople. However, they were also considered unclean because of their connection with death (a Shintô concept) and executed criminals. They were accordingly never permitted to enter Edo Castle and were often shunned by ordinary samurai. A *yoriki* accordingly had no hope of promotion out of his hereditary profession and therefore had a reputation of being very haughty and proud of his appearance, which at least was that of a samurai. Feudal lords commonly bribed *yoriki* with expensive gifts so that the *yoriki* would overlook the behaviour of the lord's retainers whenever they got drunk and caused trouble, thus avoiding any unnecessary embarrassment. Clothing, usually with the family crest of the donor, was a common gift. Gifts and bribes formed a considerable part of the annual income of a *yoriki*. It was reported that a *yoriki* income, bribes and gifts included, could amount to no less than 3,000 *ryô* of gold. To offer a gift was not strictly regarded as bribery, however, even though the intention was to ensure some advantage for the giver. In Japan, any superior – and any official, the vast majority of whom regarded themselves as superior to everybody not of blatantly higher rank – expected to receive gifts from inferiors and individuals approaching in search of assistance.[4]

Regardless of the *yoriki*'s association with death, members of the samurai class never carried out any actual execution of a condemned criminal. Executions were always carried out by outcasts. The ranks of police also included many who were not of *yoriki* rank, but nevertheless of vastly higher status than the outcasts of the execution grounds. Most important were the regular police officers (*dôshin*, see below). They were samurai policemen who together with their assistants made up the bulk of the law enforcement force. Akin to uniformed police, they were highly visible on the streets of Edo. The town magistrate also had other investigative units at his disposal. Especially in the later years of the Edo period, a kind of secret police was often relied upon, consisting of paid informers (*onmitsu*). Some of these were trained undercover agents (of the type eventually known as *ninja* or *shinobi*), often disguised as merchants, priests, or fortune-tellers. There was a widespread belief that *ninja* from Iga Province (now Mie Prefecture) resided in Kubomachi, a commoner's neighbourhood in Aoyama. Others were ordinary informers who merely relied on their ears and eyes. There were such informers all over Edo and Ôsaka, and they included many male servants in the brothels. Yet others simply mingled with the crowds in busy areas, to arrest anyone who made remarks critical of the government. Informers

4 This habit remains in modern Japan, in less blatant cases in the form of mandatory gifts to one's boss but also as widespread political corruption.

even sat in the public baths, disguised by their nudity. Many informers accepted bribes as a means to get away with some careless remark. Yet more informers were therefore gradually brought in, to keep an eye on the other informers. In true police state tradition, everybody spied on everybody.

The celebrated Edo magistrate Ôoka Tadasuke may also have been the magistrate who formed the corps of secret police known as 'Guards of the Inner Garden' (*okuniwaban*). The first head of this corps was Yabuta Sukehachi, who had been hand picked by the eighth shôgun, Tokugawa Yoshimune. The position of chief of secret police soon became hereditary in his family. Members of this corps apparently spent most of their time spying on the great lords and often managed to find undercover employment in lordly households. Spies and informers were frequently sent out to keep an eye on the great 'outside' lords, as these usually were of dubious loyalty. It was said that not many spies came back alive from the powerful Satsuma domain in distant Kyûshû. The Shimazu clan, lords of Satsuma, was reputed to employ a private counter-intelligence service. One of the few who did return was the geographer and shogunate agent Mamiya Rinzô (1775–1844). He had spent his younger years as an explorer in the far north of Japan. The rest of his life, he spent as a shogunate informer and secret agent, among other places also infiltrating Satsuma.

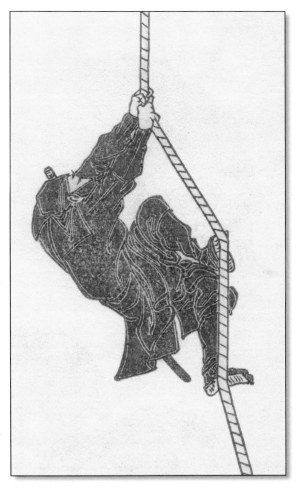

Fig. 7. The popular image of the *ninja*. (Katsushika Hokusai, from the late Edo period *Hokusai manga*)

If the law was secret, how did the populace know the current regulations? The need soon arose to display at least the most fundamental laws, in particular those concerning trade. To inform the public of current rules and regulations, noticeboards (*fuda*, *takafuda*, or *kôsatsu*) were frequently displayed. A noticeboard was protected against rain by a small roof and against crowds of people by a wooden rail. The major ones were set up on a stone base. One such group of public notices at Nihonbashi, first displayed in 1601 and from 1744 protected by the special roof and rail, listed the most important rules.

The important Nihonbashi collection of rules began with an admonition to help each other within the family; not indulge in gambling; always put the family business first; inform on thieves and criminals; and not sell human beings (for instance into brothels). Another sign within the same cluster admonished citizens not to buy and sell poisonous medicine, as this brought severe punishment unless one gave oneself up; not sell counterfeit money; and follow the current money exchange rates (which were specified on the board). The third sign prohibited hunting. The fourth sign prohibited Christianity, and promised a reward for informing on any practicing

Fig. 8. A major public noticeboard (*takafuda* or *kôsatsu*), set up next to an important street on a stone base and protected by a roof and rail

Christian. The fifth sign specified transportation charges for goods, and the number of porters or horses required for any particular load. The sixth sign specified other transportation charges. The last sign warned against fire, admonishing each individual to inform on any act of arson. A practical law in this context, also spelled out on the board, was that you were not allowed to carry long spears and bulky objects when escaping from fire, as streets would be crowded. In Edo, there were six such major noticeboards of rules – the most important being the one at Nihonbashi, with similar displays at Asakusa and other popular locations – and 35 smaller ones. Supervision of the sites for noticeboards were the responsibility of barbers, as a barber shop was often located at the entrance to a neighbourhood.

The Policeman

Below the assistant magistrates (*yoriki*) served the regular policeman, known as *dôshin* ('shared heart' or 'companion'). These, too, were samurai of the *gokenin* category, but of lower rank than the *yoriki*. They lived in the same quarter, Hatchôbori. The *dôshin*, too, was a closely knit, hereditary group. Each magistrate nominally had 100, 120, 125, or 128 such policemen serving under him, and these made up the basic police force. Most investigations and emergencies were handled by *dôshin*. The *yoriki* generally considered himself too superior himself to take part in routine work. Only in the most spectacular or important emergency would the *yoriki* deign to turn up – and then on horseback, dressed in chainmail armour beneath his clothing, with

armoured sleeves and gloves, and a war hat (*bajôjingasa*; more on which below). Even so, the *yoriki* generally contented himself with directing the operation from a distance.

The income of a *dôshin* was 30 *koku* of rice, but he, like his superior, could count on receiving gifts from the feudal lords whose retainers got into trouble in Edo. According to one story, the *dôshin* would receive a coat (*haori*) from each feudal lord, emblazoned with that lord's family crest. He accordingly had to be careful to choose the right coat whenever calling on one of his benefactors. Although the *dôshin* was classified as samurai, he wore his personal clothes and might carry one or both swords. However, he never pretended to be a plain-clothes policeman. A *dôshin* always wore the symbol of his office, the *jitte* ('ten hands', so named because in the right hands it was deemed a powerful weapon). This weapon was a 25–65 cm steel baton, usually with an L-shaped hook near the handle (Fig. 9). A skilful *dôshin* could catch the sword blade of an attacker on this hook, thus disarming him. Government-issue *jitte* were frequently silver plated and decorated with red tassels as a badge of office. Most *jitte* were carried in the sash, but a few (known as *kabutowari* or *hachiwari*) were shaped like iron sword blades with a dull edge and therefore carried in a sword scabbard (Fig. 10).

In the same way as the *yoriki* delegated the work to the *dôshin*, the latter usually delegated the actual investigative work to his own assistants. Each *dôshin* had two or three assistants (of the lowest military class, which was known as *chûgen*, 'in between'), with whom he patrolled the streets. The *chûgen*, as their name implies, were regarded as between the classes of samurai and commoners. They are commonly referred to as valets, which term is used here as well. They were technically not samurai, hence had no right to family names and were not allowed the two swords, but they carried one sword and were regarded as soldiers. When serving in law enforcement, they too carried the *jitte* as symbol of their official status. The total number of these assistants was set at 540 to 560, and they served under three 'valet headmen' (*chûgengashira*). The assistants not only patrolled the streets; they also acted as informers to the regular police. Edo was divided into four police patrols, so each patrol had to cover a large area. The *dôshin* and his team would call at the various checkpoints that were established in the subdivisions of the city, each manned by a representative of the local residents' association. If there was cause for trouble, the *dôshin* did not generally take part himself. He rather sent his assistants with some local men to capture any criminal.

The assistants were part of the large group of men known as *meakashi* ('open eyes'), agents hired by the magistrate. In Edo, these were also known under the nickname *okappiki* ('close to criminal'). Many were former offenders and they accordingly were wise in the ways of the underworld. They generally had a bad reputation and were notorious for taking bribes,

Left, Fig. 9. *Jitte*, Edo period. (Photo: Samuraiantiqueworld)

Right, Fig. 10. Steel baton shaped like an iron sword blade (generally referred to as *kabutowari* or *hachiwari*), intended to be carried in a sword scabbard. Edo period. (Photo: Samuraiantiqueworld)

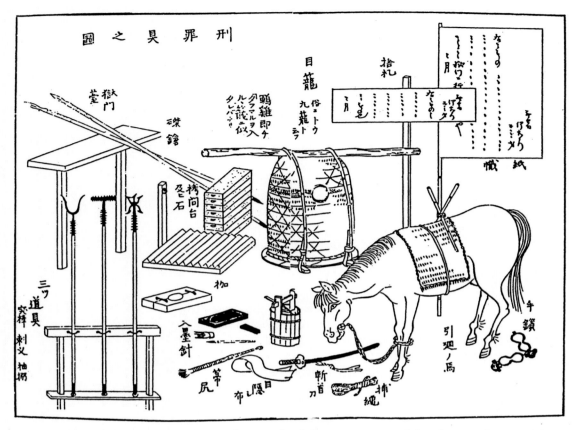

刑罪之具之圖

Fig. 11. Various implements of the Edo police, including the barbed pole-arms to the left, the handcuffs to the bottom right, the covered palanquin for transportation of criminals in the centre, and the instruments of torture in the rear left

extracting confessions by dubious means, and for abusing their position in various ways. For these reasons, the use of *meakashi* was at times prohibited, for instance by the end of the eighteenth century. However, without them the magistrate had little if any chance of catching any hardened criminal. In 1867, there were 381 *meakashi* in the regular employ of the Edo magistrate. Earlier the number seems to have been higher, around 400–500.

Police Equipment, Control Measures, and Civil Patrols

In the early history of Edo, crime was particularly violent. Means were developed to locate and capture criminals without risking the death of the apprehending police officer. First the criminal had to be located. Wanted criminals were searched for with the help of wanted notices, with the painted portrait of the criminal (often not only his face but also his entire appearance, including clothes). Such a wanted notice would be brought along whenever a *dôshin* or informer made his rounds in search of a fugitive or suspect.

After a suspect was located, he had to be captured. The *dôshin* and his assistants relied on an extensive amount of special equipment to deal with crime in its rougher forms (Fig. 11). Apart from the *jitte*, whistles, and ordinary handcuffs, special chains with two steel weights attached were also used against an enemy sword. The wielder of such a chain weapon allowed the chain to wrap around the sword of his adversary. Hooks, similar to fish-hooks, connected to a hemp rope were also used, aimed for the collar and

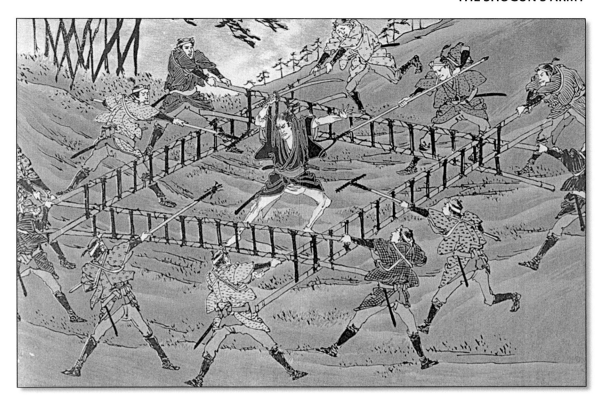

sash of the criminal. After the criminal was hooked, he was soon immobilised, restrained by the hooks and the rope. An especially violent and ferocious criminal, for instance a sword-wielding masterless samurai, could be boxed in by a number of men holding four ladders on their sides, locked into each other in the shape of a box-trap (Fig. 12). The criminal was then worn down by the use of long pole-arms furnished with spikes and barbs, which inflicted minor wounds without killing, entangled themselves in his clothing, and prevented him from seizing the polearm. Meanwhile, the criminal was kept at a distance, so that he could not use his own sword against the officers of the law. Most notable were the *mitsudôgu* ('three weapons'), which consisted of the *sodegarami* (sleeve entangler, used to entangle the clothing of the criminal), *sasumata* (fork spear, used to immobilise him), and *tsukubô* (push staff, used to push, pull, or trip). Around two metres in length, these weapons also functioned as symbols of office for the police (Figs 13–15). The special police weapons and devices, although potentially lethal, were designed according to the principle that a suspect should be taken alive (Fig. 16). But weapons were not everything. To keep the captive alive but incapacitated, the special martial art of tying up a prisoner with ropes developed.[5]

There were also other measures to deal with violent crime. In 1628 watchers were placed at all crossroads in an attempt to deal with the

Fig. 12. Shogunate policemen capturing a particularly violent swordsman by boxing him in with ladders. (*Tokugawa bakufu keiji zuroku*, 1893)

5 This technique is still taught at the Tôkyô Metropolitan Police Department's martial arts training classes.

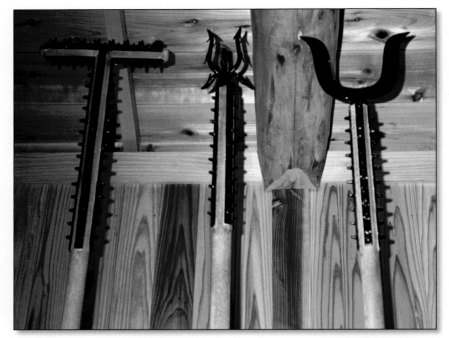

Right: Fig. 13. Modern reproductions of the *mitsudôgu* ('three weapons'). L–R: *tsukubô, sodegarami, sasumata*. (Photo: Fg2)

Below: Fig. 16. Shogunate policemen immobilising and capturing troublemakers in a variety of ways. (*Tokugawa bakufu keiji zuroku*, 1893)

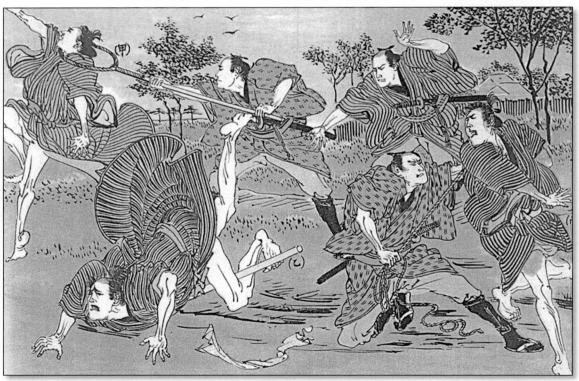

rampant gang warfare. In 1645, in a final attempt to control the various gangs that roamed the streets, the authorities set up gates to the various neighbourhoods of Edo. The local inhabitants' organisation (the aforementioned *goningumi*) had to provide gatekeepers, and at 10:00 p.m. the barriers were closed for the night. From then on, people were restricted in their movements at night to their immediate neighbourhood. The gates opened again only at dawn. If any inhabitant had urgent business, a small side door at the gate could be opened. This door had a bell. Anyone who needed to enter or leave had to talk to the gatekeeper (*kidoban*, 'gate-guard' or – nicknamed – *bantarô*) to open this door, and when outside, carry a paper lantern with his name written on. The introduction of gates as street barriers turned out to be a highly successful control measure, and they were successfully employed until the very end of the Edo period.

Night-watchmen were also employed (Fig. 17). Each had to go his rounds with wooden clappers to sound that all was well. This was not only to protect against burglars but also to spot any fire. The watchman would strike his clappers twice and call out *hi no yôjin, hi no yôjin* ('beware of fire!'). Likewise, the barrier gates were never left unattended because of the risk of fire. In such a case, each gate had to be quickly opened. This precaution, strangely enough, was the direct cause of one of Edo's many fires. In 1682, a greengrocer's daughter named Oshichi (*c.* 1667–1682) fell in love with the young temple page Ikuta Shônosuke when her family took refuge in the latter's temple, Shôsen-in, after a fire had destroyed their home. After the family's house had been rebuilt, Oshichi continued to correspond with her lover. Once he managed to visit her. However, because of the closed gates, a repeat visit was not easily arranged, and the young lovers were hence unable to see each other. Oshichi foolishly concluded that if she started a fire, then her house would again be destroyed and the two could unite anew. Oshichi tried to set fire to a nearby building. However, she was soon caught and arrested. Arson was punished with the death penalty, and Oshichi was burned at the stake later in the same year, at the execution grounds of Suzugamori near Shinagawa. The temple page later entered the priesthood to atone for his part in the affair. Arson was common in Edo at this time. Five other convicted arsonists died together with Oshichi.

As another means of control, Edo had two major forms of neighbourhood civil patrols. *Jishinban* ('self-guard') were patrol groups with official approval, manned and supported by the commoners' neighbourhoods. In Edo, such patrols were already in place in the late 1600s. By the end of the Edo period, there were some 990 *jishinban* posts in Edo, strategically located throughout

Above, left:
Fig. 14. *Sasumata*, Edo period. (Museu Militar, Lisbon. Author's photo)

Above, right:
Fig. 15. *Sodegarami*, Edo period. (Museu Militar, Lisbon. Author's photo)

Fig. 17. Edo night-watchman, sounding his wooden clappers

the commoners' sections of the city. Originally, the members of the *jishinban* were ordinary members of the neighbourhoods, serving on a rotating basis. Later the neighbourhoods instead employed staff for these functions, and the quality and efficiency of the *jishinban* deteriorated. The *jishinban*'s main duties were to provide night patrols, serve as fire lookouts (*hinoban*), and arrest and escort suspicious people to the magistrate's office.

From 1629 another type of civil patrol, the *tsujiban* ('crossroad-guard'), was established in Edo to counter the prevalent street violence and gang warfare. Some 890 *tsujiban* were positioned at strategic points in the samurai residential areas. These patrolmen had similar duties to the *jishinban* but were manned and supported through regular levies imposed on the warrior class, from the lowly *gokenin* all the way up to the great lords.

Another means of social control was the establishment of the *goningumi* ('five-man groups'), described above. The group was collectively held responsible for any and all obligations, and for any violated law or regulation.

Criminal Gangs

The extensive law enforcement system was not merely a means to find employment for soldiers out of work. There was a great need for policing. Violent crime was naturally unavoidable in a great city such as Edo and particularly rampant in the seventeenth century. Japan had, after all, just emerged from decades, if not centuries, of civil war. Despite the recruitment of some soldiers into law enforcement, former soldiers constituted more of a problem than a solution.

In the early seventeenth century many of the *hatamoto*, samurai who had direct access to the shôgun, were young men. Although their income was comfortable, their duties were very light. Many of the more violent members of this group formed street gangs and roamed the city. The lack of occupation and – for them – meaningful activities in times of peace caused them to seek excitement in street-fighting and robbery. The way of life within the street gangs required attention to outrageous costume and hairstyle, unusual jargon, obedience to leaders, and a code of loyalty within the gang. The members were therefore known as *kabukimono*, meaning roughly 'crazy ones' or 'eccentrics' (*kabuku* means to 'to incline' or 'to lean').

Some gangs included both samurai and commoners. Around 1645, two *hatamoto* of high rank (rated at 10,000 and 3,000 *koku*, respectively) were well-known leaders of gangs of *yakko* (servants, who often compensated for their low status by wearing stylish dress), for this reason known as *hatamoto yakko*. At night, the gang members robbed and killed people in the street. Their leaders wore fanciful costumes, and their hair was dressed in fanciful

styles (Fig. 18). Unlike ordinary samurai, they grew side-whiskers, something even today associated with gangsters. One of these gangs, the 'White Hilt Gang (*shiratsukagumi*) was arguably the most eccentric. The members of this gang wore white sashes and white fittings to their swords, which also were longer than was ordinary. From this, they derived their name. Their dress was also highly eccentric, reputedly a single short kimono in winter, and three long ones in summer. To appear even more stylish, they put lead weights along the bottom edge of their clothes, to make them swing when walking. If without money, the gang members refused to pay their bills, and when they had money, they paid in large coins and became violent if any change was offered.

Another similar street gang was the 'Great and Small Heaven and Earth Gods Gang' (*daishôjingigumi*). The samurai in this and other gangs were in most cases men of 500 *koku* or less, who had been separated from their land and instead given fixed stipends. These stipends were not always adequate, so some took to robbing to make up the difference. The activities of the samurai gangs were favoured by the still remaining custom of *tsujigiri* ('cutting down at the crossroad'). As samurai had the right to kill any commoner who lacked in or did not pay him sufficient respect, it was common for ruthless or bloodthirsty samurai to attack innocent passers-by to test one's swords, practice martial techniques, or simply to rob. Such killings generally took place at night, and were quite common in the early Edo period. The custom of *tsujigiri* was eventually strictly prohibited by the shogunate, which set up the previously mentioned *jishinban* and *tsujiban* patrols to combat this malpractice. From then on, the custom was severely punished.

As if the existence of the *hatamoto* street gangs were not enough, there were also gangs of low-class soldiers and common townsmen. As early as 1612, a small group of *chûgen* (valets), the lowest rank of soldier, killed a high officer in revenge for the murder of one of their numbers. It was soon found out that there were several gangs of low-ranking soldiers throughout the city, under leaders known by such fancy names as Arashinosuke (roughly meaning 'Captain Storm' although, ingeniously, an alternative rendering had the meaning 'Captain Valet' as another word for valet was *arashiko*). The members had sworn to protect each other in any circumstances. Several hundred members of the gangs were subsequently captured or killed in battle with law enforcement forces. Most of these gangs, however, were made up of manual labourers, porters, and so on. As they took to wearing long swords, they often came into direct and very bloody conflict with the samurai gangs. Among the many townsman gangs, it may be sufficient to mention the following sample: the 'Gun Gang' (*teppôgumi*), the 'Bamboo Sieve Gang' (*zarugumi*), the 'Yoshiya Gang' (*yoshiyagumi*, named after a place), the 'Wagtail Gang' (*sekireigumi*, named after the bird which according to legend taught the two – male and female – deities Izanagi and

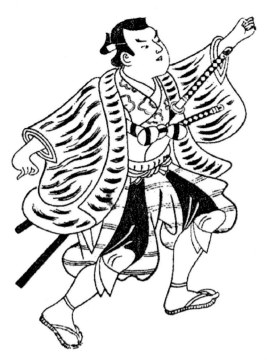

Fig. 18. Member of a *hatamoto yakko* gang, in typical flamboyant dress. This samurai appears to carry his *katana* in the position of the *wakizashi* (short sword) and instead carry a *nodachi* (long sword) in the *katana*'s position, unless this is artistic license. Certainly, a *hatamoto yakko* gang member might have made such a choice.

Izanami to unite sexually), and the 'Chinese Dog Gang' (*tôkengumi*, named after its leader, Tôken 'Chinese Dog' Gonbei, a very strong man who assumed this name after killing – by hand – two fierce, imported fighting dogs).[6]

The townsmen gangs generally wanted to attract attention as much as enrich themselves, so they frequently resorted to extremes, such as violent robbery and fighting in the streets. These young townsmen became known as *machi yakko* (*machi* signifying town, marking them as townsmen rather than samurai). Their behaviour and dress were similar to the *hatamoto yakko*, whom they followed in customs and behaviour, but their leaders usually came from the commoner class, being the sons of shopkeepers or craftsmen. In later literature, these men were styled *otokodate*, meaning brave men who stand up against injustice. They were reputed to remedy injustice and to punish evil-doers. This valiant reputation was far from contemporary, however, and originated chiefly in eighteenth-century Kabuki plays in which gang members of the previous century frequently figure as heroes.

In popular literature, the most famous of the *machi yakko* was Banzuiin Chôbei (1622–1657). The real facts of his life have largely been mixed up with legend. Chôbei appears to have been born into a masterless samurai family in southern Japan. Around 1640 he first came to Edo, where his brother seems to have been the abbot of a Buddhist temple. Chôbei set himself up as a labour broker, recruiting and organising workers to build roads around Edo and to repair the stone walls of Edo Castle. Chôbei recovered part of the wages he paid his workers by opening a gambling den where they could spend their free time and, incidentally, their wages. Chôbei's gang, the Roppôgumi (a word of dubious origin and meaning, which later came to mean a Kabuki stage exit with bold gesticulation), soon became the leader among the *machi yakko*. By moving up in the gang hierarchy, Chôbei's gang became the enemy of several other gangs, including the Great and Small Heaven and Earth Gods Gang (Daishôjingigumi), the *hatamoto yakko* band of Mizuno Jûrôzaemon (died 1664), the offspring of a well-known warrior family. It was in a fight with them that Chôbei seems to have met his fate, possibly – the story goes – as a guest treacherously invited into Mizuno's house.

Chôbei's lieutenant and successor, Tôken 'Chinese Dog' Gonbei, is said to have avenged his leader by slicing off Mizuno's ears and nose, as well as taking away his swords. Whether this is true or not, Mizuno Jûrôzaemon met his fate in 1664, when he was captured and sentenced to death by the authorities. One theory for the cause of enmity between the two gangs is the grudge between the two gang leaders, Chôbei and Mizuno, over a Yoshiwara courtesan. According to what little is known of the incident, she was eventually won by Chôbei. True or not, Yoshiwara was a favourite playground of the gangs. Tôken Gonbei, too, married a popular Yoshiwara courtesan, Tamakatsura. He was also famous for his imaginative hairstyle. A certain type of shaved forehead is even nowadays known as the Tôken style among old-fashioned gangsters, who still use it from time to time.

6 The name 'Tôken' is sometimes read as 'Karainu'.

The samurai gangs were eventually suppressed by the authorities. In 1686 gang activities were declared illegal, and close to 200 or possibly even 300 gang members were rounded up by the authorities. The leaders, including Tôken Gonbei, were executed. By 1687 the gangs were finally suppressed. The townsmen gangs, however, survived in the shape of gambling gangs. From this point in Edo history, gambling gangs developed wherever there was an opportunity to organise gambling.

The shogunate never took means to completely eliminate the townsmen gangs. Although belligerent and (what was worse) undisciplined samurai never could be tolerated by the government, a symbiosis developed between the shogunate and the townsmen gangs. The shogunate tolerated their activities in order to sometimes profit from their existence. The gangs often assumed responsibility for – and the profits from – the provision of day labourers to the shogunate and the great lords. The urban unemployed often found themselves completely under the rule of the gangs, a fact that was advantageous to the authorities. After all, the government desired nothing more than quiet commoners who did what they were told, and preferably without the necessity of actually administering to their needs. The shogunate at times even used the gangs to hunt down wanted and undesirable criminals, that is, unorganised or particularly wild desperadoes who harmed the interests of the government. Close cooperation between government and organised crime thus became a fact of life in old Japan.

Despite the often violent crime, real threats against the state were uncommon. One of a few serious attempts to overthrow the shogunate was the Keian Incident in 1651, an unsuccessful coup d'état attempt by a group of masterless samurai led by Yui Shôsetsu (1605–1651). Yui Shôsetsu was a man of humble origin (his father was apparently a dyer), who had first displayed his talent in the village school. The boy had therefore been taken up by a masterless samurai, from whom he had learned military skills. Yui accordingly grew up to be a teacher of military science. Yui Shôsetsu planned, among other things, to set fire to Edo and blow up the shôgun's arsenal. In the subsequent confusion, Yui's men would raid Edo Castle. Such, at least, was the plan. However, things turned out quite differently. Yui Shôsetsu's main follower was Marubashi Chûya (c. 1607–1651), a spear fighting instructor of good family, immense physical strength, and moderate talent. Marubashi Chûya claimed that his father had been captured and executed by Tokugawa soldiers in 1615. Despite precautions, Marubashi Chûya's part in the conspiracy was exposed, apparently through his own boastfulness or (according to another story) in his delirium during a sudden illness. He and 33 other plotters and their relatives were arrested, tortured, and executed. More might have been implicated, had not Marubashi Chûya's faithful wife destroyed all documents before she was arrested.

Yui Shôsetsu and several other followers, who by then were in Sunpu (now Shizuoka), realised that all was lost and committed suicide when they received the news of Marubashi Chûya's capture. The aged parents of Yui Shôsetsu and many other close relatives were crucified. The wives and children of Marubashi Chûya and his men were decapitated. The man who uncovered the plot and arrested Marubashi Chûya, by the way, was the previously mentioned

Ishigaya Sadakiyo, the Edo magistrate. Although the magistrate was known to understand the problems and misfortunes of masterless samurai, a plot against the shogunate could not be ignored and had to be punished severely.

The Keian Incident was not the only conspiracy by masterless samurai. In the following year (1652), another conspiracy against the shogunate was discovered, and several hundred *rônin* were implicated. Moreover, in the same year disturbances involving masterless samurai also took place on the island of Sado, the location of the shogunate's most important gold mine and several silver mines.

The Shogunate Army

Military Structure

Even without mobilisation, shogunate Japan still had an army of sorts. However, as a result of the bakuhan system of government introduced by Ieyasu, Japan had no unified national military forces. Each feudal clan mustered its own private clan army, and from a strictly military point of view, the Tokugawa shôgun could only fully rely on his own clan army. This conclusion is crucial to understanding the military forces of shogunate Japan. Technically, the shogunate army encompassed all clans, not only the Tokugawa. Formally, the vassals of every *daimyô* were simultaneously secondary vassals (*baishin* or *matamono*) of the shôgun, and the shogunate had the right to call them to arms. However, for obvious reasons this would not have worked if the clans had risen against Tokugawa rule. As a result, the Tokugawa shogunate primarily relied on the shôgun's direct vassals which constituted the Tokugawa clan army. Most modern historians assume that the shogunate could rely on all clans, because no clan rose against it before the nineteenth century. However, such an assumption is ahistorical and can only be made if we examine events with the benefit of hindsight. Seventeenth-century shogunate officials could not have known that the great lords would fail to rebel against the shogunate for more than 200 years. For them, the question of whether the shogunate at any particular moment could take the support of the truly powerful *daimyô* for granted remained open.

The geopolitical situation of early modern Japan was far more complex than terms such as Tokugawa shogunate or Edo period Japan would seem to indicate. Although Tokugawa Ieyasu had unified the warlords of Japan under his personal rule, Japan was in no way a politically unified country in the modern sense of the word. Tokugawa Japan constituted a multi-state system of government. Internally, most domains, and in particular the more powerful ones with hundreds of thousands of inhabitants, did not refer to themselves as *han* (domain) but used the term *kuni* ('country'). Japan was not one country, but a collection of some 260 states and statelets, each with its own castle and

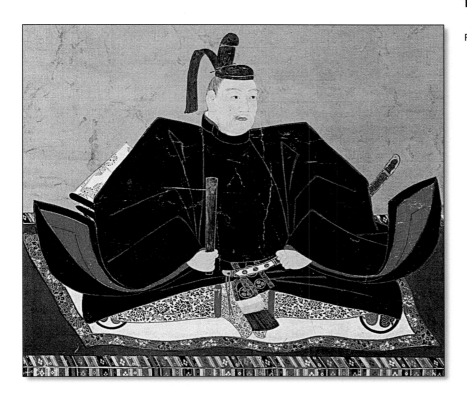

Fig. 19. Tokugawa Hidetada, the second shôgun (1579–1632, r. 1605–1623)

clan army and each ruled by a lord who was well aware that he descended from men who had gained political power on the battlefield (Map 3).[7]

Hence, the continuing need for a reliable Tokugawa clan army, even when the country was at peace. And if the clan army was not strong enough, then other measures would have to be taken. It will be shown that in due time, the shogunate had to turn to measures quite different from a powerful army to control its position of power.

A clan army might consist of anything from a few hundred to several thousand men. At the battle of Sekigahara in 1600, Tokugawa Ieyasu had commanded some 30,000 men. Another 30,000 marched under his eldest son, Hidetada (1579–1632, r. 1605–1623), but they failed to arrive in time for the battle. The Tokugawa clan army had been the largest single clan army on the field on that day. But it had not fought alone. Several other clans had fought for Ieyasu, including the Honda, Hosokawa, Ii, Matsudaira, Asano, Kuroda, and others, and each had fielded its own clan army. Most had consisted of a few thousand men. The Tokugawa clan army remained considerably larger than those of most other clans in the years following the

7 The geopolitical situation of Japan has aptly been compared to its contemporary, the Holy Roman Empire in Europe, whose numerous constituent parts although nominally united under an emperor remained politically and militarily autonomous, or in practical terms even independent which characterised many of them during the Thirty Years' War. Martin W. Lewis, 'Mapping Early Modern Japan as a Multi-State System', *GeoCurrents* web site, <www.geocurrents. info/geopolitics/mapping-early-modern-japan-as-a-multi-state-system>.

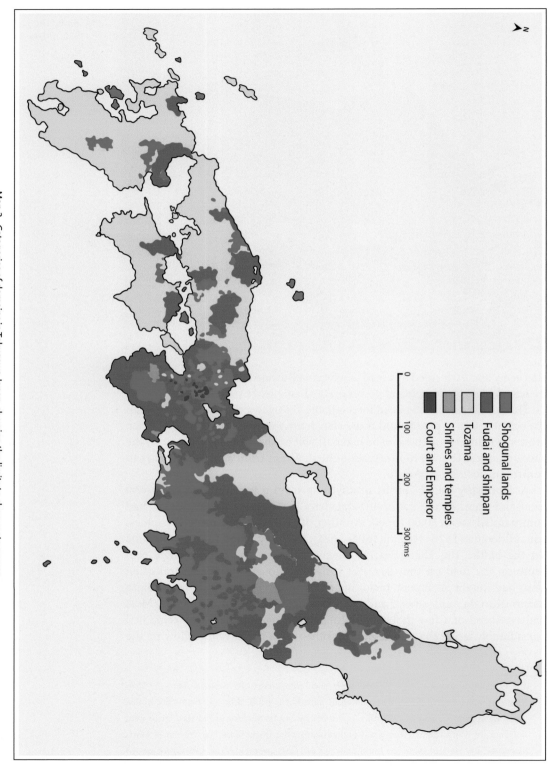

Map 3. Categories of domains in Tokugawa Japan, showing the limits to shogunate power.
Although the central, economically most important regions were in shogunate hands, other significant territories were not.

Shogunal lands
Fudai and shinpan
Tozama
Shrines and temples
Court and Emperor

0 100 200 300 kms

victory at Sekigahara. At the end of 1614, for instance, Ieyasu and Hidetada led a clan army of some 50,000 men to Ôsaka. In this campaign, too, the Tokugawa clan army fought together with several subordinate clan armies. Although all fought on behalf of the shôgun, it can be argued that it still was the Tokugawa troops who constituted the core of the army.

Troop Types and Logistics

By the Edo period, most samurai (also called *bushi*) were based in the cities and no longer controlled fiefs. Instead they drew salaries. The foot soldiers (*ashigaru*; 'light feet') of former times had been elevated to samurai rank. There was no longer much difference between the two groups, except in disposable income where the wealthier *hatamoto* enjoyed an advantage yet for some time to come. Then there was the aforementioned class of soldiers known as *chûgen* (valets), a group which made up the lowest rank of soldier and only to some extent were regarded as combatants.[8]

Wealthier samurai, primarily *hatamoto*, served on horseback as officers (Fig. 20). Some might have served as cavalrymen armed with spears and the occasional matchlock carbine or pistol. However, the majority of samurai served on foot, as musketeers, spearmen, or archers. A very few served as artillerymen.

By the time of the battle of Sekigahara in 1600, matchlock muskets had already become the most important battlefield weapon (Fig. 21). Those who fielded units of archers, like the Shimazu clan from distant Kyûshû, were regarded as old-fashioned, since the longbow by then was obsolete as a

Fig. 20. Complete suit of Edo period armour (*gusoku*) including helmet and elaborate face mask, signed Yukinoshita Sadaie. (Metropolitan Museum of Art, New York. Photo: Marie-Lan Nguyen)

battlefield weapon. Although it will be shown that the production of muskets fell rapidly in the Edo period, it can be assumed that the shogunate armouries still contained sufficient numbers of usable matchlock muskets to field substantial numbers of musketeers. Despite this, we will see that the shogunate in its regulations insisted on the raising of samurai archers, too. This probably had more to do with encouraging a martial spirit among the shôgun's retainers than any particular value believed to be gained on the battlefield.

Artillery was the weakest arm in the shogunate army. By the time of the 1614–1615 Ôsaka campaign, cannons had been obtained from English and Dutch traders and were used during the siege. Some cannons were also used

8 For easily accessible books on samurai and *ashigaru* at the time of the civil wars, see the numerous books by Stephen Turnbull and the late Anthony J. Bryant, in particular Bryant's *Samurai 1550–1600* (London: Osprey Warrior Series 7, 1994) and Turnbull's *Ashigaru 1467–1649* (Oxford: Osprey Warrior Series 29, 2001).

Fig. 21. Musketeers in straw raincoats (*mino*). (Utagawa Kuniyoshi, 1855)

against the Shimabara Uprising in 1638, but then a Dutch ship had to be called in to provide artillery support.

Another weak link was military logistics. The actual provision of supplies to an army in the field was often difficult, due to the lack of wheeled vehicles and only limited use of pack horses. Most armies brought supplies from home, and when these ran out, they lived off the land which they passed through. Each soldier carried his own rice supplies. There were no dedicated structures for military logistical support beyond what the valets and the occasional quartermaster, of low samurai rank, could provide. Merchants and sutlers would seek out the army to sell foods, but only as long as they had merchandise to sell. However, the provision of rice and some other supplies were under government control already in times of peace, and this civilian logistics system worked well. In fact, the shogunate administration operated a well-functioning logistics system for fiscal, not military, reasons. On the few occasions when the shogunate had to mobilise, such as during the Shimabara Uprising, such means were taken into full use to provide rice subsidies to the participating *daimyô*. Yet, logistics for other supplies, including gunpowder and spare weapons, had to be handled by each lord separately, according to his own means and ability.

Mobilisation and Manpower

The shôgun's clan army consisted of the direct vassals of the shôgun, the *hatamoto* and *gokenin*, but it also consisted of the men – the secondary vassals – whom these personal retainers brought into the field. In times of mobilisation, each direct vassal was required to bring a certain number of soldiers according to a fixed set of quotas, calculated based on the vassal's revenue in *koku*. The quotas indicated the mandatory minimums; the vassal could bring more men, if he was able and wanted to show his loyalty. There were also fixed ratios regarding the type of armament which these soldiers had to bring. The quotas and ratios were revised in 1605, 1616 (based on a decree issued in 1615 by Tokugawa Hidetada during the Ôsaka campaign), 1633, and 1649. No later revision took place until the end of the Edo period. For the quotas and ratios according to these regulations (known as *Gun'yaku*, 'military service'), see Tables 1 to 3. The regulations, reprinted in many Japanese-language monographs and general histories, are sometime obscure and not all historians agree on the reading of all details or even figures. They also include several inconsistencies, even though the fundamentals of the system are well-understood.[9] The regulations

9 No definitive scholarly edition seems to have been published. The tables presented here are abbreviated and primarily depend on Ritta Nakanishi, *The History of Japanese Armour* 2: *From*

of 1605 and 1616 are straightforward and focus on the raising of fighting men. In those years, any senior samurai would have known roughly how many support personnel he would require in the field. In the regulations of 1633, the shogunate perceived a need to regulate the number of servants, porters, and so on in greater detail for the shôgun's direct vassals. Due to inexperience, the latter may not always have known what to bring, and perhaps they were also unwilling to bear the extra expenses, hence the detailed regulations. However, the regulations are obviously incomplete; the total number of men as well as porters are missing, at least for the *hatamoto*. Also, the number of foot samurai is lacking. Complete ratios of men may not have been issued for the *daimyô*. However, the missing figures can roughly be extrapolated from the regulations of 1649, which are the most complete of the lot and give full details for all vassals below the rank of *daimyô*.

Table 1. The number of men to be raised according to the regulations of 1605 and 1616

Keichô 10 (1605)					
Koku	Musketeers	Archers	Spearmen	Cavalrymen	Std.-bearers
500	1		5		
1,000	2	1	5	1	
2,000	3	2	20	3	1
3,000	5 (est.)	3	30	4	1
4,000	6 (est.)	4	40	6	2
5,000	10 (est.)	5	50	7	3

Genna 2 (June 1616)					
Koku	Musketeers	Archers	Spearmen	Cavalrymen	Std.-bearers
500	1		3		
1,000	2	1	5	1	
2,000	3	2	10	3	
3,000	5	3	15	4	1
4,000	6	4	20	6	1
5,000	10	5	25	7	2
10,000	20	10	50	14	3 (est.)

the *Warring States Period to Edo Period* (Tôkyô: Dainippon Kaiga, 2009), citing Shinmi Kichiji, *Hatamoto* (Tôkyô: Yoshikawa Kôbunkan, 1967); with additional materials from Mizuki Shûhei's Edo website, <http://sito.ehoh.net/gunyakukitei.html>. In a few cases, the presented figures have been estimated because of uncertainty about the originals or lacunae in the texts. Men indicated by a plus sign are described as supernumerary men (*tegawari*).

Table 2. The number of men to be raised according to the regulations of 1633

Kan'ei 10 (February 1633)											
Koku	Total	Musk.	Arch.	Spear-men	Cav.-men	Std.-bearers	Armour-bearer	Sandal-bearers	Box-bearers	Grooms	Porters
200	8			1			1	1	1	2	1
300	10			1			1	1	1	2	2
400	12			2			1		1	2	2
500	13	1		2			1	1	1	2	2
600	15	1		2			1	1	1	2	2
700	17	1		2			1	1	1	2	2 (+1)
800	19	1		2			1	1	1 (est.)	2 (est.)	2
900	21	1	1	2			1	1	2	4	2
1,000	23	1	1	2							
1,100	25	1	1	3							
1,200	27	1	1	3							
1,300	29	1	1	3							
1,400	31	1	1	3							
1,500	33	2	1	3							
1,600	35	2	1	3							
1,700	37	2	1	4							
1,800	39	2	1	4							
1,900	41	2	1	4							
2,000		2	1	5							
3,000		3	2	5	2						
4,000		5	2	10	3	1					
5,000		5	3	10	5	2					
6,000		10	5	10	5	2					
7,000		15	5	10	6	2					
8,000		15	10	20	7	2					
9,000		15	10	20	8	2					
10,000		20	10	30	10	3					
20,000		50	20	50	20	5					
30,000		80	20	70	35	7					
40,000		120	30	70	45	8					
50,000		150	30	80	70	10					
60,000		170	30	90	90	10					
70,000		200	50	100	110	15					
80,000		250	50	110	130	15					
90,000		300	60	130	150	20					
100,000		350	60	150	170	20					

Table 3. The number of men to be raised according to the regulations of 1649

Keian 2 (October 1649)										
Koku	Total	Sam.	Musk.	Arch.	Spear-men	Cav.-men	Std.-bearers	Armour-bearers	Armour-bearers add.	Sandal-bearers
200	5	1			1			1		
250	6	1			1			1		1
300	7	1			1			1		1
400	9	2			1			1		1
500	11	2			1			1		1
600	13	3	1		1			1		1
700	15	4	1		2			1		1
800	17	4	1		2			2		1
900	19	5	1		2			2		1
1,000	21	5	1		2			2		1
1,100	23	5	1		3			2		1
1,200	25	5	1		3			2		1
1,300	27	6	1		4			2		1
1,400	28	6	1		4			2		1
1,500	30	7	2		4					1
1,600	31	7	2		4			2		1
1,700	33	8	2		5			2		1
1,800	35	8	2		5			2=		1
1,900	36	8	2		5			2		1
2,000	38	8	2		5 + 1			2 + 1		1
3,000	56	8	3	2	7 + 1	2		2 + 1	2	1
4,000	79	9	3	2	5 + 2	3		4	3	1
5,000	103	9	5	3	15 + 3	5	6	4	5	1
6,000	127	10	10 + 2	5 + 1	15 + 5	5	6 + 1	4	5 + 2	1
7,000	148	11	15 + 3	10 + 2	16 + 5	6	6 + 1	4	6 + 3	1
8,000	171	12	15 + 3	10 + 3	27 + 8	7	6 + 1	4	7 + 3	1
9,000	189	14	15	10 + 3	28 + 8	8+3	6 + 1	4	8 + 2	1
10,000	235									
20,000	415									
30,000	610									
40,000	770									
50,000	1,005									
60,000	1,210									
70,000	1,463									
80,000	1,677									
90,000	1,925									
100,000	2,155									

Table 3 cont.

Keian 2 (October 1649)									
Koku	Total	Box-brs	Grooms	Amn.-bearers	Arrow-bearer	Q'mstrs.	L'bow-bearers	Naginata-bearers	Large banner-bearers
200	5		1						
250	6		1						
300	7	1	1						
400	9	1	1				1		
500	11	1	2				1		
600	13	1	2				1		
700	15	1	2				1		
800	17	1	2				1		
900	19	2	2				1		
1,000	21	2	2			1	1		
1,100	23	2	2			1	1	1	
1,200	25	2	2			1	1	1	
1,300	27	3	2			1	1	1	
1,400	28	3	2			1	1	1	
1,500	30	3	2			2	1	1	
1,600	31	3	2			2	1	1	
1,700	33	3	2			2	1	1	
1,800	35	3	2 + 2			2	1	1	
1,900	36	3	2 + 2			2	1	1	
2,000	38	2 + 1	4			2	1	1	
3,000	56	2 + 1	6	1	1	3	1	1	2
4,000	79	4	4 + 3	2	2	4	1	1	3
5,000	103	4	4 + 5	2	2	4	1	1	3
6,000	127	4	4 + 5	2	2	4	1	1 + 1	3
7,000	148	4	4 + 6	2	2	4	1	1	3 + 1
8,000	171	4	4 + 7	2	2	4	2	2	3 + 1
9,000	189	4	6 + 8	2	2	5	2	2	3 + 1
10,000	235								
20,000	415								
30,000	610								
40,000	770								
50,000	1,005								
60,000	1,210								
70,000	1,463								
80,000	1,677								
90,000	1,925								
100,000	2,155								

Table 3 cont.

Keian 2 (October 1649)									
Small banner-br	Pyro. signaller	Footwear-box-brs	Raingear-bearers	Nagamochi-bearers	Tea-and-meals-brs	Porters	Servants	Pages	Priests
						1			
						1			
						1			
						1			
						2			
						2			
						2			
		1				2			
		1				2			
		1				2			
		1	1			2			
		1	1			3			
		1	1			3			
		1	1			3			
		1	1			3			
		1	1			3			
		1	1			4			
		1	1			4			
		2	1			4			
		2	1			4			
		2	1			4	2		
		2	1	4	1	5	3		
	1	2	1	4	1	5	3	3	1
2	1	2	1	4 + 1	1	6	5	4	1
2	1	2	2	4 + 1	1	7	6	4	1
2	1	2	1	4 + 1	1	8	7	5	1
2	2 + 1	3 + 1	2	4 + 1	1	9	8	8	1

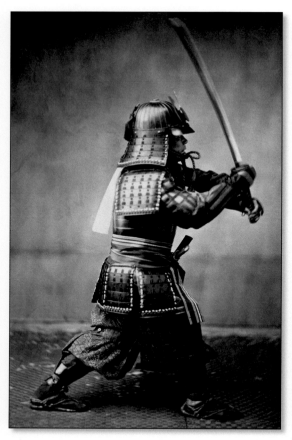

Fig. 22. Samurai serving on foot (*kachi*), as staged in a mid-nineteenth century photograph. (Photo: Felice Beato)

The quotas for low-level retainers are most instructive for our understanding of the mobilisation potential and military structure of the shôgun's clan army. In 1605, a *hatamoto* with a rating of a mere 500 *koku* had to provide one musketeer and five spearmen. He was also expected to serve himself. In 1616, after the conclusion of the Ôsaka campaign, the quotas were slightly reduced, so that henceforth, he only had to show up himself together with one musketeer and three spearmen. The situation changed again in 1633, when Iemitsu began preparations for mobilising the shogunate army for the march to Kyôto in 1634, intended as a show of force. This time, our *hatamoto* of a rating of 500 *koku* would have to provide 13 men (or even 15, since the numbers do not add up). This was not an increase in fighting men, however, since the 1605 and 1616 quotas specified fighting men only. In 1633, our *hatamoto* actually only needed to bring one musketeer and two spearmen. In addition, however, each *hatamoto* would have to bring several servants. These were not listed in the 1605 and 1616 quotas, perhaps because it by then was obvious to every *hatamoto* that he needed servants when going into the field. Perhaps it was not quite as obvious a generation later. Be that as it may, the 1633 quotas ensured that servants and other support personnel would be mobilised as well.

We can get an idea of which kinds of servants were brought by comparing the quotas in the 1633 and 1649 regulations. In 1649, a *hatamoto* with a rating of a 500 *koku* had to serve himself but also provide 11 additional men: two samurai on foot; one spearman; one armour-bearer; one sandal-bearer; one box-bearer who carried his lord's clothes; two grooms; one longbow-bearer; and two porters who carried all the general goods, on a pack horse or on their own backs.

Most or all of these men would have served in a feudal combat team (*sonae*). The *hatamoto* or lord would ride a horse, but unlike those listed as cavalrymen (*bajôzamurai*), he would not serve in a unit but lead his own feudal combat team, possibly also as officer over a unit made up of other soldiers. The foot samurai (*kachi*) would be direct vassals, in the shôgun's army usually *gokenin*, who served on foot together with their lord (Fig. 22).

The musketeers, archers, and spearmen (Figs 23–26) held samurai rank and would probably expect to fight in their master's feudal combat team, but some may have instead have been detached for service in a unit of foot (*ashigaru*). Some soldiers would have been regarded as more important, and hence occupied more vulnerable positions, than others. The armour-bearer (*katchû-mochi*) carried his lord's armour in a sturdy box on his back, but in battle he also fought as an infantryman. Higher-ranking lords would bring additional armour-bearers (then known as *gusoku-mochi*) for their

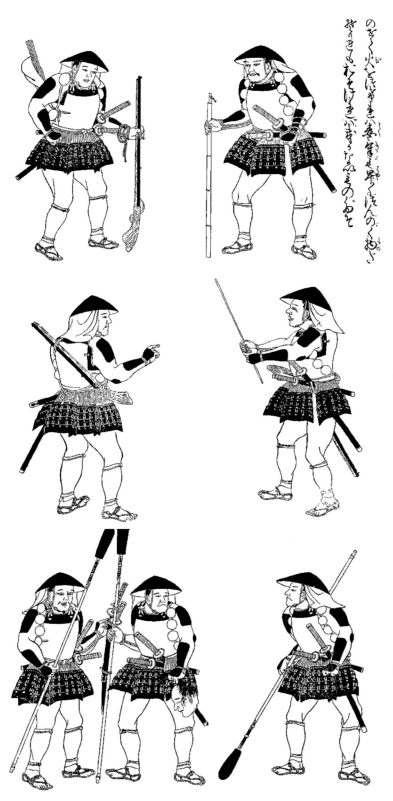

Fig. 23. Samurai musketeer (left) and musketeer lieutenant (*kogashira*; right). The musketeer carries a matchlock musket, slow-match coiled around his left wrist, and wrapped in a cloth thrust through the sash on his back, a set of spare wooden ramrods. Since ramrods were made of wood, they tended to break in action. The lieutenant is equipped in essentially the same manner, but instead of a musket he wields a bamboo cane which contains a spare ramrod. He, too, has tied slow-match around his left wrist. Both men have tied their long, working-class trousers or breeches (*momohiki*) below the knee and at the ankle. Both carry provisions in a cloth tube, tied at intervals, in which each section contains a day's ration of rice. The cloth tube is worn around the shoulders and tied at the back. (*Zôhyô Monogatari*)

Fig. 24. Two samurai musketeers, one with the musket slung over his shoulder, not from a shoulder strap but merely pushed through two convenient cords, and the other with the musket pushed through his sash, like a sword, with the butt up. One musketeer holds a ramrod in both hands. (*Zôhyô Monogatari*)

Fig. 25. Samurai spearman lieutenant (*kogashira*; right) and two spearmen (left), one of whom carries battle trophies in the form of a severed enemy head and two captured swords, which he has tied to his spear (*yari*). All carry their spearheads in protective scabbards (*saya*). (*Zôhyô Monogatari*)

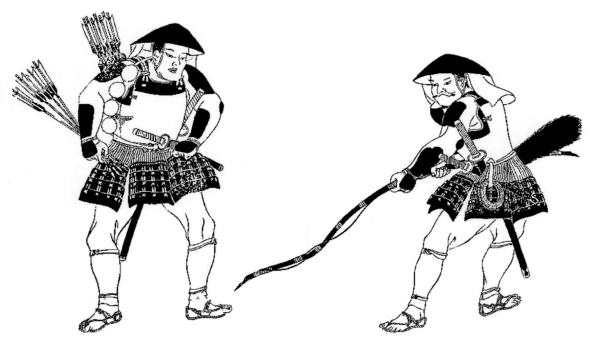

Fig 26. Samurai archer lieutenant (*kogashira*; left) and archer (right). The archer is fitting the string to his longbow (*yumi*). He carries a quiver (*ebira*) covered with black bear fur on his right side and a spare bowstring on a reel on his left. The lieutenant is equipped in essentially the same manner as the archer, but he carries a spare quiver on his back, essentially fulfilling a support role in addition to leading the unit. (*Zôhyô Monogatari*)

foot samurai. Even more important was the standard-bearer (known in the regulations only as *hata*, banner).

The ammunition-bearer (*tamabako-mochi*) carried additional supplies of gunpowder and musket balls in a sturdy box on his back. Likewise, the arrow-bearer (*yabako-mochi*) carried additional supplies of arrows in a box-sized quiver on his back (Fig. 27). The primary role of the sandal-bearer (*zôri-mochi* or *zôri-tori*) was not in war but to safeguard his lord's sandals when he took them off to enter a house with indoor tatami mats (Fig. 28). In war, he also carried other personal items of his lord and certainly might find himself in combat. Then there were those attendants known as *chûgen* (valets), a group which made up the lowest rank of soldier. While technically combatants, they were not really expected to fight. The *chûgen* also included the groom (*kuchitsuke* or *kuchitori*), whose duty it was to take care of his master's horse, but in addition a wide variety of porters who carried various items as part of the supply train (Figs 29–32). An important valet was the box-bearer (*hasamibako-mochi*), who carried his lord's clothes in a travelling case carried on a pole across his shoulders. The valets (*chûgen*) and servants (of the types known as *wakato* and *komono*) were commanded by what can perhaps best be translated as a quartermaster (*osae-ashigaru*), who was a low-ranking samurai.

For higher-ranking *hatamoto* and *daimyô*, a number of soldiers with special duties were required merely to maintain an adequate degree of dignity.

These included the longbow-bearer (*tateyumi*), who carried his master's longbow; the *naginata*-bearer, who carried his master's glaive; the bearers of large and small banners or battle standards (*umajirushi* and *koumajirushi*) which, carried on the back of experienced soldiers, signified the location on the battlefield of a senior commander; and the pyrotechnics signaller, who carried *tezutsu*, hand-held pyrotechnics for signalling which consisted of a cylindrical cartridge made of a hollowed-out bamboo tube wrapped in rope and filled with gunpowder so that when lit, it blasted flames and sparks high into the air. These soldiers were samurai, important members of the lord's retinue and were expected to fight to protect him and his dignity (Figs 33–35).

Then there were the designated and general porters. In addition to the ones already mentioned, designated porters included the footwear-box-bearer (*kutsubako-mochi*), who carried extra footwear for his lord; the raingear-bearer (*amagu-mochi*), who carried his raingear; the *nagamochi*-bearers, who always came in pairs and carried their lord's oblong, legless wooden chest (*nagamochi*) slung from a long pole between them; and the tea-and-meals-bearer (*chabentô-mochi*), who provided cooked meals to his lord. In contrast, low-level soldiers had to cook for themselves, and most seem to have done so individually or in small groups (Fig. 36).

General porters also included the pack horse grooms (*konida*) who carried all the general goods needed for the campaign on the back of their horses, or on their own backs if no pack horse was available (Fig. 37).

Hatamoto rated at 3,000 *koku* and above were also expected to bring non-combatant servants (*wakato*), while those ranked at 5,000 *koku* and above had to bring additional non-combatant pages (*komono*) and even priests (*bôzo*).

The *Gun'yaku* regulations were not arbitrary. They took into account the presumed higher wealth of those with lands of greater relative value, that is, a higher *koku* rating. Vassals with smaller land grants were expected to supply relatively more spearmen and, early in the period, archers, while relatively more musketeers and cavalrymen were demanded from those with lands of greater value. These ratios were directly related to the higher cost of providing muskets with ammunition and trained cavalrymen with warhorses. The threshold appears to have lain with those *hatamoto* rated at 3,000 *koku*, since only they and those of yet higher *koku* ratings had to provide trained cavalrymen. Even these were provided individually, not in units. It is only within the far wealthier tier of *daimyô* that we find regulations to raise a sufficient number of soldiers possibly to provide entire units. Most men who served in accordance with the *Gun'yaku* regulations did so within feudal combat teams only, without any known unit structure.

Based on the *Gun'yaku* regulations, attempts have been made to calculate the total strength of the shôgun's army. In Japan, conventional wisdom soon held that the shogunate army had an estimated strength of some 80,000 men (based on the number of *hatamoto* and the retainers they were supposed to raise). Contemporary foreign observers, too, made attempts to estimate the military strength of the shogunate. The possibly most well-informed of them was François Caron of the Dutch East India Company, who spent considerable time in Japan, knew Japanese, and met Iemitsu more than once. Caron used what he learnt of the quota regulations to estimate the total strength of the

shôgun's army in 1636 as 100,000 foot and 20,000 horse, which the shôgun used to garrison his own castles. In addition, Caron estimated, the *daimyô* could muster 368,000 foot and 36,000 horse.[10] Since the strength reported by Caron is higher than that which became conventional wisdom in Japan, we may perhaps assume that Caron's Japanese informants exaggerated the military strength of the shogunate. This would have been in their interest and in line with shogunate policies. Yet, the fundamental problem of these calculations – both that of Caron and what conventional wisdom claimed – is that neither was more than an estimate of the establishment strength of the shôgun's army. There was no way of knowing whether all his vassals actually could bring the men they were supposed to raise. Besides, there was also no way of knowing how many of them were fit for combat duty. A generation or two after the Ôsaka campaign, there is reason to believe that this number had already fallen significantly.

Although the comparison is far from perfect, it may be instructive to compare the seventeenth-century mobilisation plans with the size of the late Tokugawa army established in 1862, following the opening up of Japan to foreign influences but before the fall of the shogunate in 1868. The mobilisation of the reformed Tokugawa clan army then resulted in an army of 13,625 samurai, of whom more than 8,300 served as infantry. In addition, there were 1,068 *hatamoto* cavalry. A new, modern field artillery had by then been established with 2,845 artillerymen. Finally, there were 1,406 officers. The total was accordingly less than 20,000 samurai, or a sixth of what Caron estimated to have been the size of Iemitsu's army. Naturally, these were selected men, and at least some would, no doubt, have brought able although technically non-combatant servants as well. Furthermore, instead of the old quota regulations, new ones were introduced, levying one samurai per 500 *koku*, three per 1,000 *koku*, and 10 per 3,000 *koku*.[11] Although still an impressive military force, Tokugawa Ieyasu, the victor at Sekigahara, would have found the number of nineteenth-century shogunate soldiers worthy of contempt. Yet, it is doubtful, a century after Ieyasu's death, whether the then shôgun would have been able to field many more combat-ready clan soldiers than his nineteenth-century successor. Greater numbers could have been called up, for sure, but their martial ability would presumably have left much to desire. While the shôgun technically also could muster all the clan armies, the strength of the clans had deteriorated, too. When in 1862 the quotas owed by the *daimyô* were overhauled, they were reduced by at least 50 percent and sometimes by 85 percent. Moreover, the *daimyô* were then permitted the option to pay fines in money or rice instead of supplying soldiers, another indication that able fighting men were unavailable.[12]

10 François Caron and Joost Schouten, *A True Description of the Mighty Kingdoms of Japan and Siam* (London: Robert Boulter, 1671), pp.35–6.

11 Ian Heath, *Armies of the Nineteenth Century Asia*, Vol. 5: *Japan and Korea* (Nottingham: Foundry Books, 2011), p.29.

12 *Ibid.*, p.29.

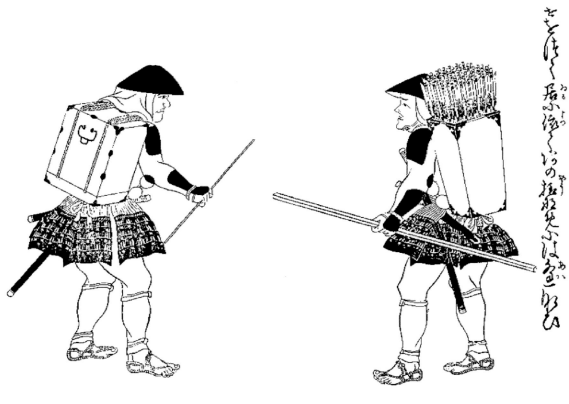

Above: Fig. 27. Samurai infantrymen, on the left an ammunition-bearer with a box with additional supplies of gunpowder and musket balls on his back, on the right an arrow-bearer with a box-like quiver of 100 arrows on his back. The ammunition-bearer also carries what looks like a spare ramrod. Their samurai status is obvious from the two swords, regardless of their apparent support role. (*Zôhyô Monogatari*)

Left: Fig. 28. Samurai infantryman serving in the role of sandal-bearer (*zôri-mochi* or *zôri-tori*) to his lord. Although the name might suggest a menial position, the position of sandal-bearer was an honourable one and he served as a combatant who fought in the close vicinity of his lord. Even so, he is armed and equipped in essentially the same way as other infantrymen. (*Zôhyô Monogatari*)

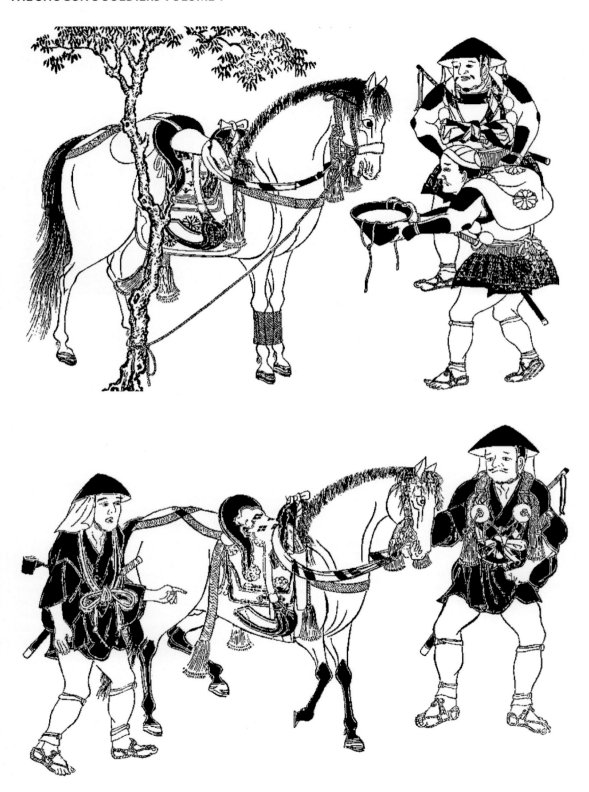

のちと登所しめくたと豆へあふ上方元をでくそれ
船

Above: Fig. 31. Two grooms, one of the *chûgen* class (left). Although armed with a sword, a *chûgen* was only to some extent regarded as a combatant. The other (right) is a samurai, which is shown by the two swords, and may be in a position of command over part of the supply train. Neither wears any armour beyond the war hat (*jingasa*). (*Zôhyô Monogatari*)

Right: Fig. 32. A groom of the samurai class, with a spare bit and bridle slung around his neck and a drinking cup thrust through the sash on his back. (*Zôhyô Monogatari*)

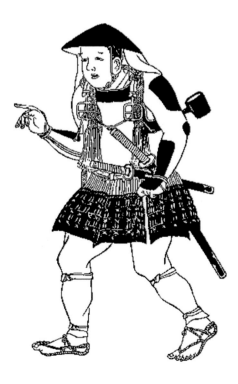

Facing page, top: Fig 29. Two grooms of the samurai class bring fodder or most likely water to their lord's horse, one of them using his war hat (*jingasa*) as a bucket, thereby also exposing the headband (*hachimaki*) tied around and across his head as padding for the war hat. The other man carries a whip thrust through his sash on the back. Having tethered the horse to a tree, they have also secured the horse's front legs in 'temporary trousers' (*karibakama*) to keep it quiet. The saddle is of the standard Japanese type, tied to the saddle girth with a knot clearly visible on the pommel of the saddle. Note the characteristic Japanese open-platform stirrups, the bags of grain and fodder tied directly behind and on the rear side behind the saddle, and the holster for a matchlock pistol attached in front of the saddle. (*Zôhyô Monogatari*)

Facing page, bottom: Fig. 30. Two grooms of the *chûgen* (valet) class, the lowest rank of soldier. Neither wears any armour beyond the war hat (*jingasa*). The man on the left has thrust a drinking cup through the sash on his back and carries a cord or rope around his neck, while the one on the right carries a spare bit and bridle slung around his neck and a whip thrust through his sash on the back. (*Zôhyô Monogatari*)

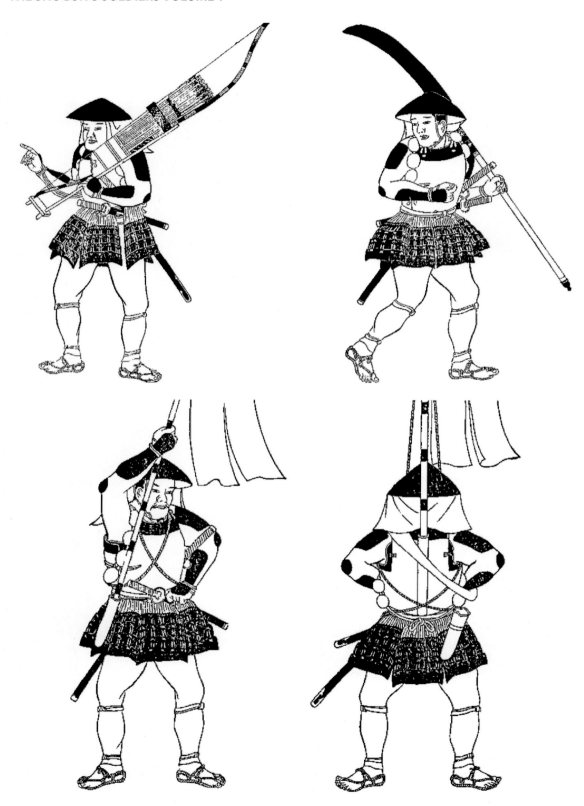

Facing page, top left: Fig 33. Samurai infantryman serving in the role of longbow-bearer to his lord. Although the name might suggest a menial position, the position was an honourable one and he served as a combatant who fought in the close vicinity of his lord. Even so, he is armed and equipped in essentially the same way as other infantrymen. The longbow (*yumi*) and its accompanying quiver of arrows are mounted in a rack for carrying and preservation from wear and tear. Like most other Japanese weapons, the rack had a cover for use when travelling or for storage. (*Zôhyô Monogatari*)

Facing page, top right: Fig. 34. Samurai infantryman carrying a glaive (*naginata*) in a protective scabbard. Since the *naginata* was no longer in general service as a weapon of war but remained the weapon of choice for certain senior samurai who in any case were required to bring it onto the battlefield by shogunate command, it is likely that this samurai carries one of his lord's weapons. Even so, in Edo period paintings the man carrying the *naginata* is usually depicted as part of the supply train. (*Zôhyô Monogatari*)

Facing page, bottom: Fig. 35. Samurai infantry standard bearer, showing two common ways of carrying the standard: in a leather container secured at the right side (left); or in a socket on the back of the cuirass, additionally secured by rope and cord (right). Standards came in several forms, but the depictions show a streamer hung from a cross-piece on a pole, which was a common type. (*Zôhyô Monogatari*)

Right: Fig. 36. A man of the *chûgen* class. Although armed with a sword, a *chûgen* was sometimes regarded as a non-combatant and this man wears no armour beyond the war hat (*jingasa*), which he has put on the ground next to him. Instead of bringing a cooking pot, he has appropriated some other man's war hat to cook his rice. Although an iron war hat would perform well as a cooking pot, his superiors would probably frown on the practice, since it would ruin its appearance. (*Zôhyô Monogatari*)

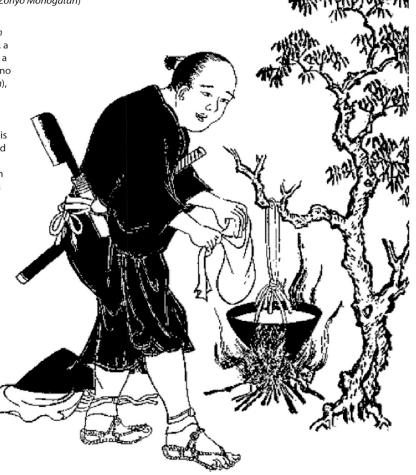

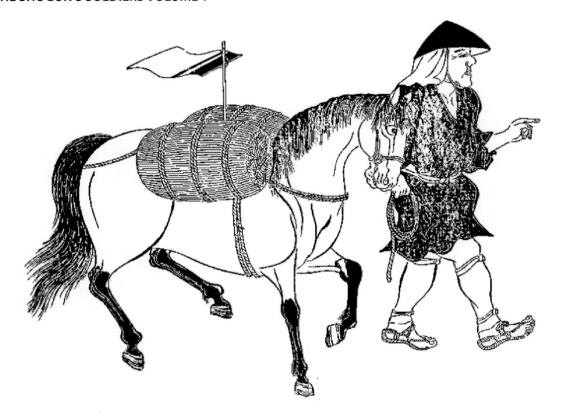

Above:: Fig. 37. A groom of the *chūgen* class, leading a pack horse loaded with two rice bales. A *chūgen* was sometimes regarded as a non-combatant and this soldier does not even seem to carry a sword, nor does he wear any armour beyond the war hat (*jingasa*). A small flag (*jirushi*) is attached to the horse as a means of clan or unit identification. (*Zōhyō Monogatari*)

Units and Unit Structure

The *Gun'yaku* regulations describe the number of men to be provided by each retainer, but they tell us little about the kind of units which were formed by the men raised through this system. Although many, perhaps most, of those called up expected to serve in feudal combat teams, the long period of civil wars had resulted in the understanding that on the battlefield, it was often more effective to fight in a dedicated military unit. Such units were drilled, yet fought in fairly loose formation, just like the feudal combat teams. The units were often temporary in nature. We do not know how, or if, any regular military units endured during the generations of peace that constituted the Edo period.

There was in Japan a theoretical concept of military organisation, based on the Chinese military classics which advocated the organisation of soldiers into squads of five men. Five squads were, in turn, combined into a platoon of 25 men. Four platoons constituted a company of 100 men, while five companies made a battalion of 500 men. Five battalions formed a regiment of 2,500 men. Finally, five regiments formed a division of 12,500 men.[13] Although certainly the upper levels of this structure were pure fiction in a Japanese context (for which reason modern terminology was employed instead of the Japanese

13 Dazai Jun, 'Bubi or Preparation for War', *Transactions of the Asiatic Society of Japan* 32 (1905), pp.24–47, on pp.27–8.

pronunciation of Chinese which Edo period theoreticians used), this form of organisation was upheld as correct and also, apparently, widely believed among educated Japanese at the time. For instance, foreign observers with good knowledge of Japanese government structures, such as François Caron in 1636, reported much the same organisation, as if it truly existed. Caron mentioned squads of five men, platoons of 25 men, sections of 50 men, companies of 100 men, and divisions of 5,000 men (unless this was a printing error for battalions of 500 men).[14] Other contemporary European observers, too, noted the imaginary organisation. In 1649 the German geographer Bernhardus Varenius, apparently based on Dutch informants, described a Japanese military organisation of squads of five men, platoons of 25 men, sections of 50 men, battalions of 250 men, regiments of 1,250, and divisions of 12,500 men.[15] The problem with these descriptions is that above the company of 100 men, none of these units existed.

Dazai Jun, or Dazai Shundai (1680–1747) as he is better known, a Japanese Confucian scholar who wrote a treatise on military preparedness, concluded that Japan had imitated the Chinese system when it established 'five-man groups' (*goningumi*) as a means of enforcing social control by mutual responsibility. He also confirmed that the company of 100 men existed in the shogunate army by noting a native Japanese term for the officer in charge of it, *monogashira* ('headman', captain).[16] We will see that companies of 100 men (known as *hyakuningumi*, 'hundred-men-companies') are known from other Japanese sources, too. However, Dazai also stated that, regrettably, the organisational system that he, based on the Chinese military classics, advocated did not actually exist, except in the companies of 100 men of foot (*ashigaru*). And even in the companies of foot, he noted, there were no platoons or sections, only individual bands of five men each.[17] In short, whatever unit formations had existed during the civil wars rapidly disappeared during the first century of peace, and no new organisation was introduced to replace it.

Not so the organisation of Tokugawa guard units. Although most men raised according to the *Gun'yaku* regulations no doubt served in feudal combat teams, the Edo period Tokugawa clan army also included several named guard units. Most had no specific establishment strength, and they were generally referred to as either *ban* ('guard') or *kumi* ('group', a term that just as well can be translated as section, company, or even gang). Moreover, by the time of the Edo period, most soon lost their martial capability and membership in a unit became a fundamentally honorary position.

Senior among the guard units was the *Ôban* ('great guard'). Originally small in number, it probably consisted of five companies at the time of the battle of Sekigahara. After the battle, there is reason to believe that a sixth

14 Caron and Schouten, *True Description*, p.36.

15 Bernhardus Varenius, *Descriptio Regni Japoniae: Beschreibung des japanischenreiches* (Darmstadt: Wissenschaftliche Buchgesellschaft, 1974), pp.125–6.

16 Dazai , 'Bubi', p.27.

17 *Ibid.*, pp.29–30.

company was added before the unit moved into Edo. In 1623, the number of companies of the Ôban was raised to 12. It is, however, difficult to ascertain any company establishment strength since the Ôban, too, was raised from feudal combat teams. Each company was led by a captain (*ôbangashira*, the latter component of the title meaning 'head'). Under the captain served four lieutenants (*ôbangumigashira*, the latter component meaning approximately 'section head'). The company consisted of 50 guardsmen. However, the captain also brought his 30 personal retainers into the company, and the lieutenants brought their personal followers, too, each according to his income and according to the regulated ratios that governed mobilisation. In addition, all members of the company brought their non-samurai valets, again according to the regulated quotas. As a result, each company would have consisted of more than 100 samurai and a significant number of non-samurai valets, who although primarily serving in a non-combatant capacity would be armed and ready to fight as auxiliary foot soldiers, if required. From 1623 onwards the Ôban can be compared in strength and status to a European guard regiment of horse, since it had not yet lost its military role and was formally supposed to serve on horseback.

Perhaps the second most important guard unit was the *Shoinban* ('sitting room guard'), which formally functioned as the shôgun's bodyguard. Then there was the *Koshôban* ('inner guard') which protected Edo Castle. In 1643, a new guard unit appropriately named the *Shinban* ('new guard') was established. However, the *Shinban* can be said to have symbolised the withdrawal from active military service of the shôgun's soldiers. It was essentially formed to provide honorary positions for men whom third shôgun Iemitsu wished to promote. By this time, most guard positions had turned into honorary positions only. Nobody expected the exalted individuals of these units to actually fight. Yet, they were formally supposed to serve on horseback in times of war.

Below these four guard units of horse was the *kojûningumi* ('small ten-man unit'), which served on foot as the shôgun's escort when he left the castle. Together, all the guard units were referred to as the *Gobankata* or *Gobanshû* ('five guard units').

Yet another infantry guard formation was the escort (*kachigumi*), samurai on foot who headed the procession whenever the shôgun made his way to the Ueno temple area and accordingly lived in this area. Since this unit was older than the Shinban, it was counted among the Gobankata with the others.

With all these units fundamentally playing an honorary role, one may wonder who actually guarded the shôgun and Edo Castle. Such duties were performed by several less easily defined units. These were also the units from which men were seconded to join law enforcement and the fire brigades. All served on foot. Among them we find the *teppôhyakuningumi* ('musketeer hundred-men-companies'), nominally of 100 men each armed with matchlock muskets. Another was the *sakitegumi* ('vanguard unit'), which in times of war was supposed to serve in the vanguard but in the Edo period constituted another group of men who guarded Edo Castle. The *mochigumi* (perhaps best translated as 'support unit') consisted of longbowmen and musketeers who were supposed to constitute the shôgun's real bodyguard

(they were appropriately known as the *mochiyumigumi* and *mochizutsugumi*, respectively, depending on whether they were armed with longbows or muskets). In the Edo period, this unit too was listed among those which guarded Edo Castle.

Finally, a mention should be made of the *tsukaiban* ('messenger corps'), a small group of men, at first 28 in number, who served as messengers. In battle, each wore a *sashimono* (banner) on his back bearing the character *Go*, meaning 'five'.

Edo period military manuals such as the 1649 book *Zôhyô Monogatari* ('Soldier's Story'), which aims to explain how to employ soldiers in the field, including in battlefield drill, give vague but obvious references to units of, respectively, musketeers, spearmen, and archers. The book was allegedly written by Matsudaira Nobuoki (1620–1691), who was the son of Matsudaira Nobutsuna (1596–1662) who had been the shogunate commander at Shimabara in 1638.[18] According to such texts, a regular company of foot was commanded by a captain (*kashira*, literally 'head'). Under the captain served four lieutenants (*kogashira*, 'minor head'), who led the various sections. Some sections consisted of musketeers, while others might be armed with spears. There is every reason to believe that the sections trained in weapons handling and battlefield drill, including in what appears close to European pike drill. Soldiers armed with long spears would line up with about 0.9 m (specifically three *shaku*; one *shaku* equals 30.30 cm) between each man. When facing a cavalry charge, the spearmen would form up in one rank, kneeling and with the spear on the ground next to them. When contact with the enemy cavalry was imminent, they would raise the spears to the height of the breast of the approaching horses, then stand fast, in an ordered rank, no matter what, until the cavalry retreated. At that point, they would pursue, but no longer than about 110 m (one *chô*, that is 109.09 m). This kind of tactics demanded unit drill. Incidentally, one *chô* was advocated by other, somewhat later manuals as the distance when musketeers could begin firing.[19]

On the other hand, the *Zôhyô Monogatari* also advised in favour of mingling archers and musketeers, at the ratio of one archer to two musketeers, so that the former can cover the latter while they reload their weapons. While this description could refer to a distinct, combined unit, it was possibly even more characteristic of the feudal combat team.

The *Zôhyô Monogatari* gives plenty of additional information on how to handle small units of men while on campaign. For instance, the book advises the musketeers on how to carry their food bags so as not to interfere with

18 Matsudaira Nobuoki, *Zôhyô Monogatari* ('Soldier's Story'), Japan National Diet Library Digital Collection. The term *zôhyô*, indicating a samurai of low status, can also be read *zappyô*.

19 The distance for opening fire, together with numerous other observations, in even greater detail than in the earlier *Zôhyô Monogatari*, is described in *Hippu zukai* ('A Soldier's Illustrated Guide'), the military manual of Arisawa Takesada (1682–1739) of the Kaga domain, who in 1707–1708 prepared it as a secret, abbreviated version of the military doctrine of his father Nagasada (1638–1715). In 1716, Kitanoya Heibe (1653–1728) borrowed Takesada's *Hippu zukai* and carefully copied it, and this copy has been preserved into the present.

shooting, how to carry the ramrod when not in use (in a vertical position on one's right side) so that it does not interfere with other soldiers, and when in battle, how first to shoot at the enemy horse, so that the fallen cavalryman can be more easily handled afterwards. The archers are advised to shoot when the musketeers are reloading. However, the *Zôhyô Monogatari* also goes into other practical details, including emergency first aid in various situations ('if you are bitten by a viper, put some gunpowder on the wound and set it on fire') and how to handle horses which were not properly trained ('if you do not tie the horses properly, they will run away, and if you make a noise, they will mistake it for an enemy attack and flee'). It advises against wearing silver or gold ornaments, or a family crest, on one's armour, since they were useless, were likely to be discarded, and might get lost. The author of the book even gives frank advice on how to carry, and not carry, one's sword in a military context ('[when in armour] I often accidentally cut my own horse when I drew it out of the scabbard').

Despite the practical advice of Matsudaira Nobuoki, in the Edo period service in any unit, and in particular the guard units, soon became a question of rank and status instead of martial ability. Over time, all positions within the guard turned into honorary positions, while the lack of mobilisation and non-existence of unit training meant that any other companies turned into empty structures or were abolished altogether. The general decline in fighting ability is also evident from the laws adopted at the time. During the seventeenth century, a number of laws and regulations urged the samurai to practice for war, keep their arms and armament in good condition, and generally retain a martial spirit. The lack of effect of these regulations is shown by the fact that in 1694 it was even found necessary to introduce legislation which compelled the members of the shogunate army to practice the military arts. Although such a command had existed already in Ieyasu's and Hidetada's 1615 *Buke shohatto* ('Law for Military Houses', more on which below),we can assume that military training then, immediately after the Ôsaka campaign, was far more generally taken part in than in 1694, after generations of peace. Simply speaking, most of the shôgun's soldiers had by then abandoned their fighting skills and served as soldiers in name only.

The Law for Military Houses

In 1615, Ieyasu and Hidetada issued the *Buke shohatto* ('Law for Military Houses') which aimed to regulate the warrior class. It is worthwhile to summarise its 13 clauses:

1. The study of literature and the practice of the military arts must be pursued side by side.
2. Drunkenness and wanton revelry must be avoided.
3. Anyone who breaks the laws must not to be given shelter in any domain.
4. *Daimyô*, lesser lords (*shômyô*), and those who hold land under them as retainers must at once expel any soldier in their service who is charged with treason or murder.
5. No sanctuary is to be given to men who plot rebellion or incite

uprisings. Hereafter, residence in a domain shall be limited to men born there.

6. All building work on a castle, even if only by way of repairs, must at once be reported to the shogunate authorities, and all new construction is strictly forbidden.

7. Should it be learned that in a neighbouring domain there are men who plot changes and form parties or factions to carry them out, they must at once be reported.

8. Marriages are not to be contracted without approval from the shogunate authorities.

9. All *daimyô* in attendance at the shôgun's court shall follow the prescribed rules of conduct. They must not bring into the city an escort of more than the number of men allowed for their respective ranks.

10. All costumes and ornaments are to be appropriate to the wearer's rank, and not extravagant in colour or pattern.

11. Commoners are not to ride in palanquins without permission. Exception is made for physicians, astrologers, aged persons, and invalids.

12. The samurai in all domains shall lead a frugal and simple life.

13. All *daimyô* are to choose capable persons to advise them in the government of their domains.[20]

In 1635, Iemitsu amended the *Buke shohatto*. The amended version strictly regulated the *sankin kôtai* system, and also made attendance in Edo mandatory instead of optional. From the very beginning of the Edo period, each feudal lord had had to leave close relatives as hostages in Edo. Henceforth, the shogunate required all feudal lords to live in Edo in alternate years and also to leave their wives and heirs in Edo as hostages while they returned to their provincial fiefs. This was relaxed only for those whose lands were either near or most distant from Edo. This system of control, known as *sankin kôtai* (*sankin* = reporting to one's lord to render service; *kôtai* = rotation), was an efficient way to prevent rebellion. Residences had to be maintained in Edo, and the feudal lord's wives and children had to remain there, when the lord himself left for his home province. This not only required an expensive journey every year, but also the support of two large and very costly residences with many retainers. A feudal lord did not travel alone; for his own dignity and prestige he had to bring a sufficient retinue and live in the style expected of a great lord. This expense cut deeply into the resources of the *daimyô*, most of whom could not have afforded an uprising even if they had the inclination. It has been estimated that the repeated journeys and the upkeep of a costly residence in Edo consumed about 70 to 80 percent of a *daimyô*'s income. It has been calculated that on average, the

20 Based on George Sansom, *A History of Japan* 3 (Folkestone, Kent: Dawson, 1978), pp.7–8; Ryusaku Tsunoda, W. Theodore de Bary, and Donald Keene, *Sources of Japanese Tradition* 1 (New York: Columbia University Press, 1964), pp.326–9.

journey to Edo cost a major *daimyô* from 3,000 to 5,000 *ryô* in gold, while a mid- to low-level *daimyô* had to pay about 1,000 *ryô*. In theory, one *ryô* of gold equalled one *koku* of rice (for further information, see the description of the monetary system, below). Then there was the cost of a residence in Edo, which for a major *daimyô* easily might cost some 35,000 *ryô* in gold.[21]

In addition, the amended version of the *Buke shohatto* ordered all roads, post-horses, ferries, and bridges to be carefully attended to guarantee continued efficient communications within the country, while the construction of ships over a certain tonnage was prohibited to restrict communications with other countries. Besides, it stated that henceforth, 'throughout the country all matters are to be carried out in accordance with the laws of Edo'. Life in the capital accordingly became the norm according to which all should live.

Iemitsu also regulated further the rights and duties of the *hatamoto* (in 1632). He also introduced stricter regulation in a number of other administrative areas. In 1634, Iemitsu mobilised the entire shogunate army, not for war but for a march to Kyôto to impress the *tozama* lords in the west of his military might. The shogunate army reportedly consisted of about 307,000 people.[22] This was the last major show of force by the shogunate army, yet most of the men were raised not by the shôgun but by clans loyal to the Tokugawa house. The visit to Kyôto was a ceremonial event known as *jôraku*, and this was the third time in which Iemitsu participated (as had his predecessors before him). The composition of Iemitsu's powerful army was complex. First, although they were counted as part of the shogunate army, the *daimyô* in western Japan for practical reasons went to Kyôto directly, so they met Iemitsu there. This group included powerful *tozama daimyô* who were not necessarily Iemitsu's friends. It was only the eastern *daimyô* and the shôgun's direct vassals who actually attended Iemitsu's march to Kyôto. Second, for logistical reasons even the eastern *daimyô* travelled in several contingents, the first one under the powerful *tozama daimyô* Date Masamune (1567–1636) who left Edo on 1 June. A group of lesser *daimyô* followed on 10 June. Between 11 and 15 June, a number of *fudai daimyô* headed by the loyal Matsudaira Tadatsugu left Edo. From 16 June onwards, Iemitsu's personal vassals (*hatamoto* and *gokenin*) departed in several contingents, followed by Iemitsu himself who left Edo on 20 June. As a result, although many people (servants as well as soldiers) went to Kyôto, Iemitsu was not necessarily certain of the loyalty of all of them, and with the dispersal of the contingents, he was only in nominal command of the combined army. Even so, the total number of men reported by the official Tokugawa history can be questioned. Each *daimyô* mobilised men according to the aforementioned regulations, each according to his rating in *koku*. Although they were encouraged to show their loyalty by bringing more men than required, most *fudai daimyô* would

21 Herbert Plutschow, *A Reader in Edo Period Travel* (Folkestone, Kent: Global Oriental, 2006), p.225.

22 Sansom, *A History of Japan* 3, 26. Sansom relies on *Tokugawa jikki* ('True Record of the Tokugawa'), the official Tokugawa history which was compiled in the early nineteenth century.

only bring a couple of thousand men, including servants. Besides, we have no information on how well the shogunate logistics system could handle the movement of large numbers of men at this time, nor do we know how the different contingents actually got along when they encountered each other. In short, the march to Kyôto was undeniably a political success, but we know little of what conclusions could be drawn from a military perspective of the last major mobilisation of the shogunate army for two centuries.

We do know, however, that when military contingents from different clans were on the road, separately or together, disciplinary problems might occur. This is clear from instructions issued later, related to the *sankin kôtai* journeys to Edo. As an example, a set of orders issued by the clan army command in the Tosa domain in 1671 read:

1. Strictly obey the laws of the Tokugawa government.
2. It is forbidden to have social intercourse with those from other domains.
3. Even when facing crowded conditions and delays at boat crossings, do not talk to those from other domains.
4. Do not act improperly with shopkeepers, when purchasing items, or with innkeepers.
5. It is forbidden to go to public baths, even if delayed at one place [due to weather or high water levels].
6. Lewd or other inappropriate behaviour, gambling, and sightseeing are prohibited.[23]

Unsurprisingly, the focus is to maintain discipline and follow shogunate laws. The prohibition against social contacts with those from other domains was primarily intended as a safeguard to avoid shogunate suspicions of conspiracy between different clans. However, it seems safe to assume that the prohibition also was intended to decrease the risk of quarrels and fights breaking out between soldiers of different clans. The last two orders both relate to inappropriate behaviour, since public baths in many locations were linked to prostitution.

The marches to Kyôto, of which a total of 14 took place between 1600 and 1637 even though none was greater than the one in 1634, to some extent served as field exercises for the participating shogunate and domain military forces. The same can be said for the repeated mandatory pilgrimage processions to the grave sites of the first Tokugawa shôgun, Ieyasu, a mausoleum to whom eventually was built at the shrine Tôshôgû at Nikkô. The *sankin kôtai* system provided yet other opportunities for the domain militaries to hone their skills in logistics.

Undeniably, these processions gave the shogunate officers and men practical lessons in military logistics. However, these various events could not substitute for real campaigns. They were processions, not military

23 Constantine Nomikos Vaporis, *Tour of Duty: Samurai, Military Service in Edo, and the Culture of Early Modern Japan* (Honolulu, University of Hawai'i Press, 2008), pp.22–3.

manoeuvres in the field. No training was provided in how to move in combat units and there were no combined-arms exercises. There was no formal military combat training in times of peace, beyond that undertaken as individual initiatives. If they trained at all, samurai and soldiers practised the martial arts individually, and not in units. There were also no tactical exercises and manoeuvres. As a result, the military skills of officers and soldiers depended on individual prowess, not unit training.

Military Reasons for the Seclusion Policy

Ever since the third shōgun, Iemitsu, decided to close Japan to foreign trade and travel, historians have wondered about the causes for this decision.[24] The orders to close the country were issued on three occasions, in 1633, 1635, and 1639. Together they show a gradual development of what became a totalitarian policy of isolation. The order of 1635 was the first to state in unambiguous terms that Japanese ships and Japanese subjects henceforth were strictly forbidden to leave the country and make voyages abroad.

Since the purpose of the seclusion orders was stated to be the suppression of Christianity, it is generally argued that a major cause of the policy change was the anti-Christian legislation as it had developed since the death of Ieyasu. Already Ieyasu and Hidetada had issued orders against Christianity, in the years 1611–1614, since they suspected that the introduction of Christianity was a means to introduce a fifth column which in time would facilitate a Spanish or Portuguese invasion of Japan. Some daimyô were known to profit from foreign trade, a few had adopted Christianity, and there was, no doubt, a perception that Portuguese or Spanish support might be forthcoming if any of them decided to challenge the shogunate by military means. However, Ieyasu's anti-Christian orders were not all-encompassing and many punishments were not carried out. Ieyasu was more interested in expanding trade than in executing missionaries. Hidetada gradually implemented the anti-Christian orders in a harsher manner, but he never aimed for seclusion. Besides, by 1625 Christianity had been either eradicated or driven underground and was no longer regarded as a serious threat.

The policy change accordingly took place under Iemitsu, who issued the third and final seclusion order in 1639. This decision was almost certainly influenced by the Shimabara Uprising, which was suppressed in 1638. Many Japanese Christians had taken part in the uprising, and the government military had not performed very well, even though the uprising was suppressed soon enough. Again, the purpose of the seclusion order was stated to be the suppression of Christianity. Even so, contacts were prohibited with other countries as well, except for the closely regulated trade with the Dutch Republic, China, and Korea. The English traders had already voluntarily left Japan, having found the competition with other foreign merchants too stiff.

So what had changed since the reign of Ieyasu? The possibly greatest change was that the shogunate, despite is apparent power, had grown

24 See, for example, Sansom, *History of Japan* 3, p.36, which explains the process in considerable detail but also describes the decision as 'surprising'.

significantly weaker in the one resource which its rulers knew was vital for remaining in power: its military capacity.

Ieyasu and Hidetada would not have worried about the availability of experienced fighting men. The combat experience and strength of the Tokugawa clan army had been proven at Sekigahara in 1600 and Ôsaka in 1615. However, Iemitsu must have realised that since then, a new generation had grown up which lacked military training, and yet worse, due to the soft life in Edo seemingly lacked military skills altogether. In 1634, Iemitsu had mobilised the shogunate army for a march to Kyôto to impress the *tozama* lords in the west of the military might of the shogunate army. Official reports had it that the army had been great in numbers and all had gone well. But had it? Apparently, and this needs to be emphasised, the only contemporary sources known to us are the official reports. It remains possible that the inexperienced samurai called up by Iemitsu had found the preparations for the peacetime expedition a process not quite as smooth as Iemitsu would have desired. If so, there is every reason to expect the shogunate to have treated information on any failings in military preparedness as a state secret.

Whatever actually happened on this occasion, which was the last major mobilisation of the Tokugawa army for 200 years, there is a strong sequential link between the march to Kyôto in 1634 and significant changes in both domestic and foreign policy in 1635. In domestic policy, Iemitsu introduced stricter domestic controls, including the *sankin kôtai* system, which aimed to control and impoverish the *daimyô* and to pre-empt any remaining or future domestic threat. In foreign policy, Iemitsu closed the borders and set in force the policy of isolation.

François Caron of the Dutch East India Company wrote (in 1641) that he some years earlier had informed Iemitsu about the geography of the world. The Dutch in Japan had maps and perhaps a globe, and in the 1630s, the Japanese leaders were interested in taking advantage of what could be learnt from foreign visitors. However, Iemitsu's reaction may have surprised Caron. Iemitsu, 'after investigating the size of the world, the multitude of its countries and the smallness of Japan … was greatly surprised and heartily wished that his land had never been visited by any Christian.'[25]

In fact, Iemitsu was right to be concerned. The Dutch had told him about their struggle with Spain and the ongoing Thirty Years' War in Europe. The Japanese already knew of the powerful Spanish army and navy, and how it had been used to establish a global colonial empire. What might be Spain's next target, after the war in Europe had ended? Or, perhaps worse, if the northern Europeans came out on top, then a European power militarily stronger than Spain might look towards the east. The news from China was worrying, too, and followed a similar pattern. The mighty Ming China was in turmoil, and to the north, in 1629 the Manchu ruler Hung Taiji (1592–1643) already raided the outskirts of the capital Peking. In 1636, Hung Taiji declared himself emperor, and in 1637 he subjugated Korea. This could not be good news for Japan, since during Hideyoshi's invasion of Korea, even

25 Sansom, *History of Japan* 3, p.43.

the Ming Chinese army had been too powerful for the Japanese invaders to handle. Now a yet more warlike northern enemy threatened to move south, just like the Mongols a few centuries earlier, and they had attempted to invade Japan twice. Within a few years, Manchu armies would indeed seize Peking and the rest of China. This was the context in which Iemitsu learnt of the size of the world and the smallness of Japan.

Iemitsu must also have realised that if even Hideyoshi's large, battle-hardened Japanese army ultimately had failed in its only foreign war, the prospects of his own inexperienced and poorly trained army were far worse (Matsudaira Nobuoki's comments in the *Zôhyô Monogatari* come to mind on how, when in full armour, he often accidentally cut his own horse when drawing his sword). In short, Iemitsu realised that any foreign involvement in the affairs of Japan could only mean trouble. Either the foreigners would invade and defeat the shogunate forces, or foreign soldiers might ally with one or more of the *tozama* lords in an uprising against the Tokugawa. When a Ming loyalist, Huang Tsung-hsi, in about 1646 went to Japan to seek assistance against the Manchus, he was turned down. Huang noted the shogunate's fear of Europeans and a Christian fifth column, but he interpreted the main reason for the seclusion then enforced as Iemitsu's unwillingness to jeopardise internal security by involving Japan in any foreign adventure.

There was also, no doubt, an element of trade policy in the decision to enforce isolation. Through the seclusion policy, the shogunate guaranteed itself control and accordingly a monopoly of the profits from foreign trade and left that source of wealth and potential unrest out of reach of the feudal lords. Although the volume of trade was too small to have a major impact of the shogunate's economy, at least the seclusion policy ensured that these revenues were denied to potential rivals among the *daimyô*, who henceforth were not allowed to conduct legal foreign trade.

To conclude, all evidence suggests that the seclusion policy was the Tokugawa response to its own military weakness and lack of effective military force, and a means to ensure both internal and external peace for as long as possible.[26]

26 The military weakness of the Tokugawa at this time has been disputed, indeed contradicted. See, for example, Matthew E. Keith, *The Logistics of Power: Tokugawa Response to the Shimabara Rebellion and Power Projection in Seventeenth-Century Japan* (dissertation, Ohio State University, 2006). Keith argues that the logistics system employed to deploy a large army to defeat the Shimabara Uprising proves the superior military strength of the shogunate and its capacity for power projection (*ibid.*, p.28). He also argues that the mobilisation and deployment of this army against the Shimabara insurgents was presumably the result of a deliberate shogunate decision 'to ensure control of the damage inflicted [by the uprising] on Tokugawa authority' (*ibid.*, p.57). However, a logistics system, regardless of level of excellence, will only prove its utility as long as those who control its components, in this case the *daimyô*, choose to play along. The key issue was whether the shogunate could take the support of the truly powerful *daimyô* for granted at all times, and such an assumption can only be made if we examine events with the benefit of hindsight. Iemitsu could not have known that the great lords would fail to rebel against the shogunate for more than 200 years. If Iemitsu's spirit had returned from the dead

The State of the Shogunate Army at the Turn of the Century

By the end of the seventeenth century, many samurai realised that the shogunate army had lost a significant share of its military capability. The aforementioned Dazai Shundai, the Confucian scholar who in addition to his main work in the field of political economy also wrote a treatise on how a country should prepare itself for war, was one of them. The title of his treatise, *Bubi*, simply means 'Preparation for War'. Dazai 's treatise was first published in 1729, as part of major work on political economy. Like all Japanese scholars at the time, Dazai wrote in a kind of literary Chinese rather than his native Japanese. He also mainly drew on Chinese sources. Besides, he was keen to mix in references to ancient Chinese history, and the military practices of ancient China. However, unlike most other Confucian scholars, Dazai never hesitated also to describe his own country, and its past and present military practices. For instance, Dazai briefly describes some of the battle formations used by the Japanese, and explains the use of flags and drums to maintain formation.[27]

Dazai concludes that the Japanese samurai of his time know nothing of military organisation or formations and when large bodies of men have to be moved, they invariably end up as mere disordered rabble. This, he argues, was a major reason for the ultimate failure of the Japanese sixteenth-century invasion of Korea. Dazai later complains that a samurai only knows how to fight a single enemy, and that nobody has any knowledge of tactics. The samurai had learnt the art of handling longbows, horses, and guns, but they had neglected the training of soldiers, he concludes.[28]

Dazai finds slightly more favour with the Japanese infantry (*ashigaru*), who certainly had been useful at the time of the civil wars and might be expected to be so again (Figs 38–39). However, he dismisses the lowest rank of soldier, the *chûgen*, as mere onlookers. In a way he was right; the *chûgen* of medieval Japan formed a class of combined servants, foot warriors, and onlookers. However, by the late seventeenth century, the *chûgen* were more valets than soldiers.[29]

after two centuries, he would probably have been pleased that his domestic and foreign policies had served the shogunate so well for so long in preventing rebellion. As for Iemitsu's motives, there are no contemporary shogunate policy documents with regard to the Shimabara decision and, for obvious reasons, no documentation on what he would have thought two centuries after his death. The historian must exercise caution when attempting to explain the motives of individuals based not on their documented decisions but on the outcome of events. Keith is likely correct in assessing Iemitsu's reaction to the uprising as a threat to Tokugawa authority. However, we have already noted that the army which mobilised and defeated the Shimabara insurgents was shogunate in name only. The suppression of the uprising is accordingly of little help in assessing the shogunate's military strength against a real internal or external challenge, nor did such a challenge emerge before the fall of the shogunate centuries later.

27 Dazai , 'Bubi', p.30.

28 *Ibid.*, pp.30, 33–4.

29 *Ibid.*, p.30.

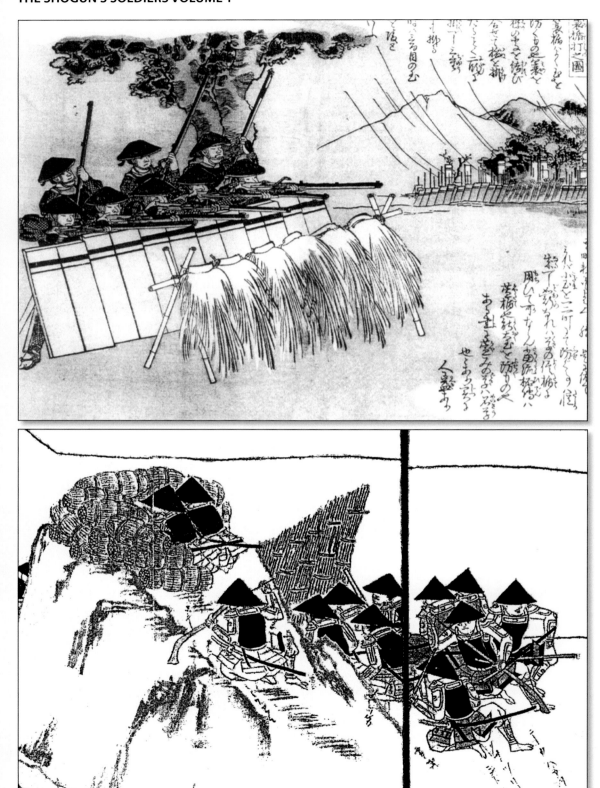

It is also clear that Dazai knew something about cavalry warfare. Twice he points out that horses, not trained for war, upon seeing men in armour or hearing the sounds of conch shells (used as trumpets) or guns are prone to panic. He also comments on the number of horses in Japan, which he finds insufficient for cavalry purposes. Moreover, he claims, Japan had lost the tradition of cavalry fighting.[30]

Dazai was an expert in political economy. This shows in his keen understanding that manufacture, especially of war materials, and a sufficient food supply are factors at least as important as the fielding of a proper army.[31]

Having described the dilapidated state of Japan's then military, Dazai argues for emulating China and its Manchu rulers in military science. He finds favour with the practice of great hunts as military exercises, commonly employed by the Mongols and the Manchus. Another old Chinese custom he wishes to introduce is the review of the preparedness of soldiers, weapons, and military equipment. In Japan, he (rightly) complains, some samurai had pawned their armour and weapons.[32]

Finally, Dazai radically proposes that since the spoiled city samurai (whose 'minds, bodies, and customs' were just the same as the effeminate court nobles and their female attendants) are of no use for war ('but one man in several thousands of their number is likely to have any military value'), farmers should instead again be recruited into the army or at least as a militia, formed according to the Chinese model.[33] History eventually proved Dazai right, but only at the very end of the Edo period.

Facing page, top: Fig. 38. Musketeers firing from the protection of a line of free-standing mantlets (*tate*). (Utagawa Kuniyoshi, 1855)

Facing page, bottom: Fig. 39. Musketeers firing from the protection of gabions. The two swords show their samurai status.

30 *Ibid.*, pp.36–7, 39, 42.
31 *Ibid.*, pp.45, 47.
32 *Ibid.*, pp.32, 36.
33 *Ibid.*, pp.40–41, 44.

**Left: Battle standard of Tokugawa Ieyasu, first shôgun. Gold ball over gold curtain.
Right: Banner of Tokugawa Ieyasu, first shôgun (white)**

(Source: *Hata umajirushi ezu* ('Illustrated Banners and Battle Standards'), late seventeenth century.
Brigham Young University Library, Tom Perry Special Collections (call no. 895.61 H28).)

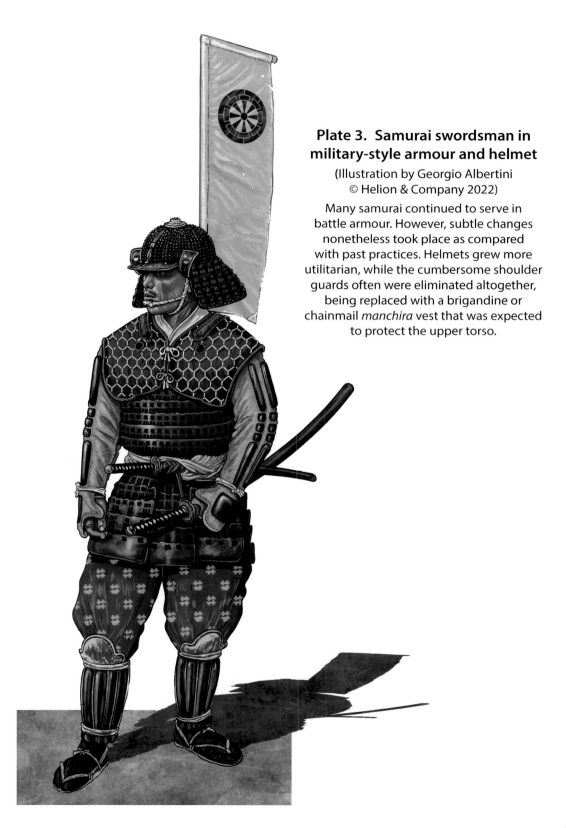

Plate 3. Samurai swordsman in military-style armour and helmet

(Illustration by Georgio Albertini
© Helion & Company 2022)

Many samurai continued to serve in battle armour. However, subtle changes nonetheless took place as compared with past practices. Helmets grew more utilitarian, while the cumbersome shoulder guards often were eliminated altogether, being replaced with a brigandine or chainmail *manchira* vest that was expected to protect the upper torso.

Plate 4. Samurai spearman in civilian dress, chainmail armour, and fireman's helmet

(Illustration by Georgio Albertini © Helion & Company 2022)

Over time, most samurai dispensed with the full set of battle armour. Often, they could not afford it. Instead, lower-ranking samurai acquired only those pieces of armour which they could afford and found useful, such as a set of gloves and armoured sleeves, a simple, often non-metallic helmet such as the fireman's helmet illustrated here, and perhaps some protection for the torso, in this case consisting of chainmail.

Dress was largely civilian, and this spearman has prepared for battle by tying up his wide sleeves with a cloth band. Warriors preparing for combat customarily tied up their wide sleeves with a cloth band or cord (*tasuki*), commonly twisting this cord to form loops through which the arms were passed, and then tying the ends together. The cord then formed an 'x' across the back between the shoulders, keeping the sleeves out of harm's way.

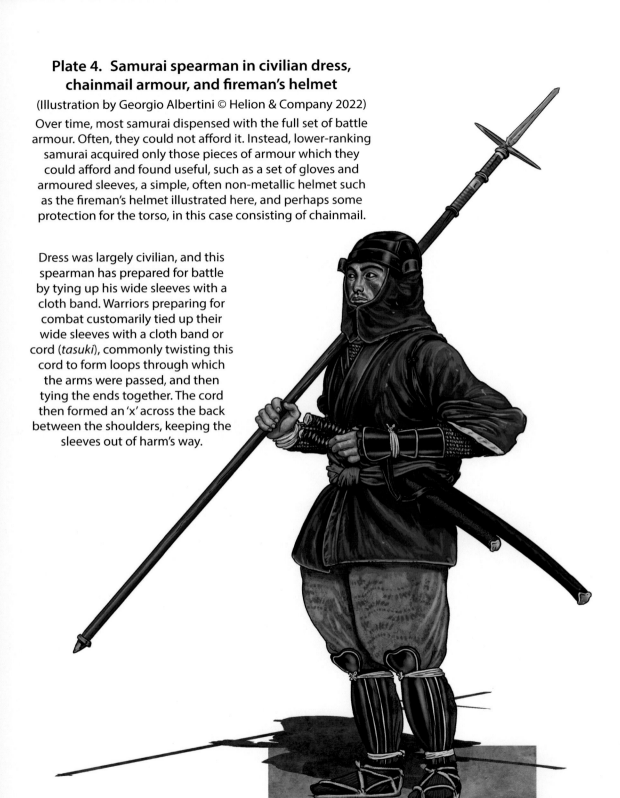

2

Edo's Inhabitants

Life in Edo

The location and type of housing available to a samurai depended on his *koku*-rating. Low-ranking samurai generally had to live communally in barracks divided into apartments not much different from the commoners' tenement houses of downtown Edo. Most barracks were built in residential areas near the castle, although some low-ranking samurai instead lived in similarly sized rows of apartments on the upper floor of the castle gateways.

A low-ranking samurai, if he had any duties at all, might begin the day standing guard at one of the castle gates. A senior samurai with official duties would likely begin the working day with ceremonial attendance on his lord. Either way, these samurai were not seen very often by the lower classes of Edo, unlike they left their residential areas in pursuit of leisure activities.

For the ordinary townsman, a shopkeeper in the Shitamachi, or 'downtown' district of Edo, the day began with the sixth hour, or the Hour of the Hare, around 6:00 a.m., when he opened his shop. The street front was the most important part of the shop. Wide open in the daytime, it was shuttered at night. Thus the new work day was always heralded by the clatter of shutters being slid back along their channels and pushed into the box-like covers that concealed them during the day.

The shopkeeper also hung out his *noren* above the shop entrance. The *noren* was an indigo-dyed cloth, usually bearing the name of the shop or its stock-in-trade, which helped to keep out the dust and heat of the streets and served as the symbol of an independent business establishment. It generally reached halfway to the ground, although some shops kept longer *noren*, reaching all the way down.

The checkpoint on the shopkeeper's gated street was also opened at sunrise. The gate had been shut at sunset to prevent the intrusion of burglars or other undesirables. No respectable townsman left his street at night, unless he had urgent reasons and special permission.

The opening of the gate meant that business could commence. Soon the peddlers appeared, their loud cries announcing the availability and general excellence of *asari* clams and dark-shelled clams (*shijimi*), soybean curd (*tôfu*), and fermented bean paste (*nattô*). Other loud voices were heard as

well, especially those of the wives of the shopkeepers. They were invariably around the well, washing and preparing food. It was time for people to begin breakfast.

Merchants and traders had to get up early. Young employees rose before sunrise to clean the shop, and only afterwards could they have breakfast. The menu consisted of *miso* (bean paste) soup, pickles and rice. The Edokko was happy. He knew that in the provinces, no commoner could eat rice every morning. After breakfast, with the shop safely open and in the capable hands of his young workers, the master of the establishment went to have his morning bath. By then the older, married employees, who lived in nearby tenement houses, had also arrived for work. There was plenty to do. The goods had to be arranged on the shelves, or displayed on the streets.

After breakfast, the sons and many of the daughters of the shopkeepers went to school (*terakoya*). They all had to bring books, which they spent the morning copying. In Edo, most schools were privately owned and quite small.

It was suddenly very quiet in the tenement houses. The husbands had gone to work and the wives were doing needlework, or other household chores. Among other duties, the wife was responsible for the three most important possessions of the Edokko, said to be the kimono, the *futon* (mattress), and the *nabe* or *kama* (the cooking pan and the handleless cooking pot for rice, respectively).

A kimono was expensive, so in most families clothes often had to be repaired. Washing was difficult. Once a year, the wife undid the seams and washed the kimono, after which she stitched it together again.

If the Edokko had both quilt and mattress (*futon*), he considered himself quite rich. He knew that some had no mattress at all, and slept on the hard wooden floor. The cotton wool used in bedding was very expensive. Even though the mattress was heavy, bulky, and easily flammable, the Edokko brought it with him when escaping a fire. A mattress was too expensive to abandon.

The *nabe* and *kama* were also expensive for the average Edokko, as iron was very costly. The cheaper ones were ceramic. An iron pan or pot was commonly used for several generations, repaired when necessary by an *ikakeya*, a smith who specialised in such items.

At the midday mealtime, the tenement houses again became active and noisy, as the husbands came home to eat (Fig. 40). The wives were again busy at the well, cooking and gossiping.

The streets were always full of people: street peddlers, women selling flowers, young girls on their way to *shamisen* music lessons, entertainers of various kinds, hairdressers, salesmen, delivery men, geisha, and everything else in between (Fig. 41). The shopkeeper was happy; he had a vast number of potential customers to accost, inviting them to enter his shop.

In the evening, as husbands returned home after a day of work, the tenements were again a bustle of activity. Everyone went to wash hands and face at the communal well. Soon it was sunset, and Edo closed, together with the checkpoints on the gated streets. People remained at home, separated from each other by the closed gates. Only criminals and those on urgent business, such as doctors, remained on the streets.

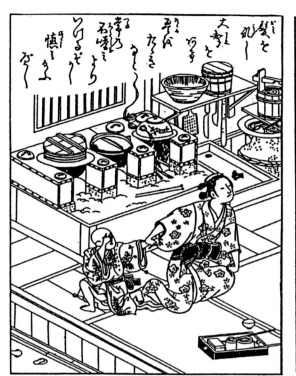

Above; Fig. 40. An Edo kitchen, showing the various kitchen implements, including the *kama* (the handleless cooking pot for rice) and *nabe* (cooking pan) on the cooking oven (*kamado*), to the left and centre, respectively. Behind the oven there is a tub of water.

Below: Fig. 41. Basket peddler, mid nineteenth century. Although a staged photograph, it illustrates daily working class dress earlier in the Edo period as well. (Photo: Felice Beato)

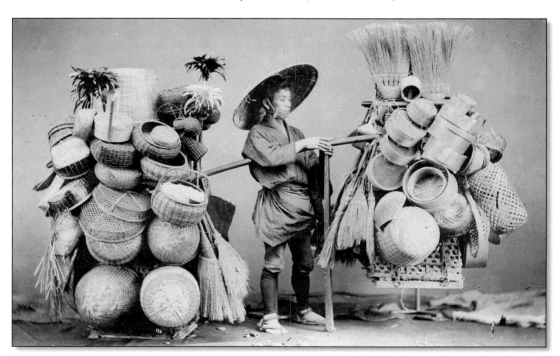

The shopkeeper was already in bed. His landlord, the wealthy merchant, however, was nowhere to be seen. He had presumably again decided to stay overnight in the licensed quarter of Yoshiwara. So did, no doubt, quite a few samurai, as long as their daily duties were light or nonexistent. At Yoshiwara, too, the gate was closed, but the establishments inside thrived whether it was day or night.

Most visitors to Edo were fascinated by the amazing crowds of the city. The early visitor Engelbert Kaempfer described street life in Edo upon his first visit to the city in 1691:[1]

> We kept to the great middle street, which runs Northward across the whole city, tho' somewhat irregularly. We pass'd over several stately bridges, laid over small rivers and muddy ditches, which run on our left towards the castle, and on our right towards the sea, as do also several streets, all which turn off from the great one … The throng of people along this chief and middle street, which is about 50 paces broad … is incredible, and we met, as we rode along, many numerous trains of Princes of the Empire and great men at court, and Ladies richly apparell'd, carried in chairs and palankins. Among other people we met a company of firemen on foot, being about one hundred in number, walking much in the same military order as ours do in Europe: they were clad in brown leather-coats to defend them against the fire, and some carried long pikes, others fire-hooks upon their shoulders: their Captain rode in the middle. On both sides of the streets are multitudes of well-furnish'd shops of merchants and tradesmen, drapers, silk merchants, druggists, idol sellers, booksellers, glass blowers, apothecaries and others. A black cloth hanging down covers one half of the shop. They stood out a little way into the street, and curious patterns of the things sold therein, lay expos'd to people's sight. We took notice, that there was scarce any body here had curiosity enough to come out of his house, in order to see us go by, as they had done in other places, probably because such a small retinue as ours, had nothing remarkable or uncommon to amuse the inhabitants of so populous a city, the residence of a powerful Monarch, where they have daily opportunities to see others far more pompous and magnificent.

The streets of Edo were indeed crowded. People shopped, or visited business acquaintances, friends, or relatives. Some were on their way to shrines or temples. Messengers carried money and letters, porters carried goods on their backs, or on poles borne by one man or several. Numerous people were constantly eating or drinking at the innumerable stalls and shops of the city. A shopkeeper could grow rich in Edo.

In 1822 the Dutch warehouse-master Johannes Frederik van Overmeer Fisscher (1800–1848) also visited Edo. He gives an impression of the city similar to Kaempfer's more than 130 years before:

> The streets were so thronged with people that at times we could scarcely see anything of the buildings; and although our escort very unceremoniously drove

1 Kaempfer, *History* 2, p.520.

them back, it did not prevent our bearers from being inconveniently crowded. We passed along wide streets, paved on both sides with stone, and, as in other towns, lined by uniformly built houses. We saw also very large edifices and shops, the latter protected by awnings. In front of these, and of every place where goods were exhibited for sale, stand a number of lads, who clamorously recommend the wares to draw the attention of passengers. Here, as in England, great account is made of signs and inscriptions over their shops; and although there are no carriages to increase the tumult, I can compare the bustle of Edo to nothing but that of London.[2]

In the two accounts, so separated in time, not much seems to have changed.

For the ordinary townsman, Edo was indeed a very crowded and busy place to live. In the mid eighteenth century, the total population of Edo was between 1.3 and 1.4 million inhabitants. By 1721 the shôgun, the great lords, and people in their service accounted for 500,00–700,000 of this total population (of these possibly as many as a quarter were servants). Religious orders accounted for 50,000–60,000, and ordinary townspeople for the remaining 600,000, or about half of the total population. The latter figure also included some 60,000 shopkeepers and tradesmen who lived within the grounds of temples and shrines; the 10,000 inhabitants of the Yoshiwara licensed quarter; and some 25,000 outcasts who lived in separate quarters within the city.

Of these various groups, the first – people in the service of the shôgun and the great lords, as well as the families and entourages of the lords – occupied about 61 percent of the land within the boundaries of the city. Another three percent or so of the land was reserved for other government or lordly use. Shrines and temples took up a further 15 percent. This left only about 21 percent to the commoners (Table 4). We can estimate the population density within the commoners' quarters to be 33,000–34,000 people per square kilometre, higher than that recorded between the two World Wars.[3] If vagrants and street entertainers, as well as traders who operated from temple grounds, are added to this estimate, the figure might well have been slightly higher, perhaps 37,000 per square kilometre.[4] Moreover, Edo was a city of one-storey buildings. Few houses had second floors, and no residence had more than two floors.

2 Jan F. van Overmeer Fisscher, *Bijdrage tot de Kennis van het Japansche Rijk* (Amsterdam: J. Müller & Comp., 1833).

3 Waley and others suggest 67,000 to 69,000 people per square kilometre, but this figure appears to be exaggerated. For instance, Paul Waley, *Tokyo: City of Stories* (New York and Tôkyô: Weatherhill, 1991).

4 This may be compared to the modern population density of the cities of Hong Kong and Macao, 25,400 and 25,500 per square kilometre, respectively. Statistics from 1983 (Hong Kong) and 1991 (Macao). In comparison, the most densely populated part of modern Tôkyô, Nakano Ward, has 'only' a population density of 19,437 per square kilometre. Statistics from 1993. Recent years have seen a decrease in the population of Tôkyô, but population density after the Edo period never reached the levels of Edo.

The less populated and more spacious residential districts of the warrior class had an estimated population density of at most about 14,000 per square kilometre.[5] As the number of servants in the service of the feudal lords remains uncertain, this figure might have been even lower, perhaps 10,000 per square kilometre.

Even the precincts of urban temples and shrines had a population density of at least 5,000 per square kilometre.[6] If one assumes that the traders who did business on the grounds of temples and shrines also lived there (many of them did), the population density might have reached a level as high as 10,000–11,000 per square kilometre. The grounds of temples and shrines were hardly empty. Many people lived on temple land, and most of them were not in holy orders.

Table 4. Land Use in Edo After 1818. Source: Tôkyô-to (Tôkyô Metropolitan Government). *Tôkyô no toshi keikaku hyakunen* ('One Hundred Years of Planning in Tôkyô Metropolis'. Tôkyô: Tôkyô Metropolitan Government, 1989), p.4.

	Hectares	Percent
Edo Castle	131	1.7
Lords' upper residences	796	10.2
Lords' middle residences	340	4.4
Lords' lower residences	1,630	20.9
Samurai residences	1,878	24.1
Commoners' residences	1,626	20.9
Government use	199	2.6
Additional lords' use	5	0.1
Buddhist temples	1,112	14.3
Shintô shrines	70	0.9
Confucian temple	5	0.1
TOTAL	7,792	100

In Edo, life was strict. The political authorities imposed rigorous economic and social controls on all commoners. Each resident was registered, either as a householder (*iemochi*), a householder's caretaker (*yamori* or *iemori*), or a tenant (*tanagari* in Edo; *shakuya* in the Ôsaka-Kyôto area). As mentioned above, major street intersections had gates that closed at sunset and opened at sunrise, to maintain security and control the movement of people. Order was also imposed by other means. For instance, the caretaker of a section of rented stores and tenements was not only responsible for looking after the properties

5 Comparable to that of modern Tôkyô's Shinagawa Ward (14,452 per square kilometre). Statistics from 1993.

6 About the same as that of many of the distant suburbs or satellite cities of modern Tôkyô, for instance Machida and Kamakura (4,890 and 4,430 inhabitants per square kilometre, respectively). Statistics from 1993.

owned by his master, but also to supervise the conduct of the tenants. As a small cog in the vast security apparatus of Edo, the caretaker of rented stores or tenements was therefore a very powerful man. But the system worked both ways. If a tenant misbehaved in any way, not only he but also the caretaker was punished. The punishment could, in serious cases, be as severe as jail or death. Every caretaker had to report the state of affairs in his community to the local police office every morning, even if nothing of interest had occurred.

High-ranking members of the samurai class were not seen every day. Apart from attending to his landholdings, if he had any, the samurai concerned himself mainly with the administration of the domain to which he was attached, or to the central administration at Edo (either with the governing of Edo itself or of the country as a whole). Lower samurai had simple duties such as standing guard at the castle gates, while higher-ranking ones might be councillors to great lords or to the shôgun himself. In either case, compulsory ceremonial attendance on his lord was a part of his usual duties. As most of these duties were performed inside the castle or *daimyô*'s residences, these samurai were not seen very often by the lower classes of Edo, unless the samurai in question travelled frequently on official business or perhaps served as a magistrate.

Likewise, the great lords were seen on their annual journeys to or from the shôgun's capital, but gawking by commoners was not encouraged, as the samurai at the head of the lord's procession invariably shouted 'Down! Down!' (*Shita ni, shita ni!*) and all commoners had to prostrate themselves until the lord and his retinue had passed.

Below the great lord in feudal rank stood the aforementioned *hatamoto* and *gokenin*. As noted, after 1635 the *hatamoto* numbered slightly more than 5,200, of whom only about 250 had stipends of 3,000 *koku* or more. This number remained fairly constant, as the number of *hatamoto* in 1722 totalled 5,205. The *gokenin* numbered between 17,000–20,000. It was not unusual for *gokenin* to fall into impoverishment and lose their warrior status. By 1722, the number of *gokenin* was 17,399. By the end of the seventeenth century, nearly 90 percent of the total number of *hatamoto* and *gokenin* were living on fixed stipends. As the stipends proved insufficient, many impoverished samurai had to work at trades, such as making nails, umbrellas, or wooden clogs (*geta*). Others accepted clerical positions. Many adopted commoners against cash payment, thus conferring samurai status on them.

All samurai depended on their *koku* rating, not only to determine their income but also to be allowed land to build a residence. The lowest grade of samurai generally had to live communally in 'long-houses' divided into apartments not much different from the commoners' tenement houses of downtown Edo. Alternatively, a similarly sized row of apartments might be found on the upper floor of one of the castle gateways. There were also some samurai who had no official income in *koku*. These were the masterless samurai, or *rônin* ('wave-men', a poetic expression indicating that these men were as free – and sometimes as turbulent – as the waves of the sea). The *rônin* had either abandoned his allegiance to a lord, temporarily or permanently, or else his master had been deprived of his post and all his samurai, in effect, fired. In the early history of Edo, the latter reason was the most common. During the first

half of the seventeenth century, no less than 90 feudal lords were deposed by the shogunate, and more than 240,000 samurai were forced to become *rônin*.

As their name indicates, the masterless samurai were among the freest men of Japan. Many of them were also among the poorest. *Rônin* retained the rank of samurai, but they had to earn a living as best they could. A few became intellectuals, such as writers, scholars, or teachers. These often made great contributions to the cultural life of Edo and the other cities of Japan. Some became stewards of higher-ranking samurai, especially among the *hatamoto* of Edo. Others preferred to become martial arts teachers, or to hire themselves out as professional debt-collectors or bodyguards for rich merchants or gangsters. The more marginal *rônin* seldom settled down, and had to live wherever they could, for instance in temples or hijacked hovels, whenever they were out of a job.

In the early years of the shogunate, many *rônin* posed a clear and present danger to the shogunate. In the years following the battle of Sekigahara, the shogunate confiscated numerous fiefs and moved many *daimyô* from their hereditary lands to new locations. Each confiscation resulted in the expulsion of numerous soldiers who by this act were deprived of both master and livelihood. Some have estimated the dispossessed soldiers to have reached as high a number as 500,000.[7] Although many managed to take service with a new master, others did not. Already hostile to the shogunate, tens of thousands of *rônin* fought on the Toyotomi side in the 1614–1615 Ôsaka campaign. Others joined the insurgents at Shimabara in Kyûshûin 1637–1638. Having failed to overthrow the shogunate by force, yet other disgruntled *rônin* conspired to do so by coup d'état. Most serious was the aforementioned Keian Incident in 1651, but there were others.

As the income of all samurai was fixed and undividable, it was impossible for a lower-ranking samurai to enable both his eldest son and his younger sons to enjoy the same standard of living as himself. The younger sons were therefore obliged to seek adoption into another family, become *rônin*, or find employment in the city, thereby losing their status as samurai. Although the samurai status was inherited by all sons, the rice stipend could never be divided. Many younger sons therefore had to give up their samurai status voluntarily to make a living as merchants.

The samurai were supposed to enjoy a way of life quite different from the life of the townspeople, the merchants and craftsmen. In theory the lowest social class, the merchants in many ways dominated life in downtown Edo because of their wealth. Yet there were as many disparities in rank and status among the merchants as there were among members of the warrior class. The life and fortunes of the wealthier merchants will be treated in a separate section; here we will touch only on the lower end of the economic ladder – the street peddlers. Many newcomers to Edo took up peddling, as this required hardly any capital investment. The easiest and cheapest business was dealing in clams, as these were caught in the estuaries of Edo. Edo clams were said to be very delicious as they fed on rice or other grains spilled from

7 Sansom, *History of Japan* 3, p.32.

the warehouses along the rivers. Peddlers (*botefuri*) carried whatever they were selling in baskets suspended on a pole over their shoulder and went from place to place, calling out what they had to sell. Many of them eventually set up shops, and a few turned these businesses into great merchant houses. Most, however, had to be content selling vegetables, bean curd, soy sauce, sweets, incense sticks, straw sandals, or flowering plants.

There were numerous types of craftsmen in Edo, or for that matter, in any city or large town, and again, there were many gradations of status and wealth within this class. A limited few attained high rank. These high-ranking craftsmen included swordsmiths, sword-sharpeners (in fact mainly involved in polishing swords), scabbard-workers, lacquerers, armourers, bowyers and shaft-makers (who made the handles for spears and other pole-arms), painters (such as those of the well-known Kano and Tosa families), certain potters, and workers in fine materials such as goldsmiths, silversmiths and wood-carvers who worked expensive cypress wood.

These craftsmen, especially the ones who made swords and other kinds of arms and armour, were well paid and well housed, since these crafts were essential to the warrior class. Often employed by high-ranking samurai, perhaps even the shôgun or a *daimyô*, they accordingly received their pay in the form of a rice stipend, in the same way as the samurai. This allowance was often generous, and such men often enjoyed a comfortable existence. Even clothiers and confectioners could enjoy such benefits if they directly served the shôgun and his court. At times, certain such individuals were also honoured by being awarded privileges normally associated with the samurai class. Outstanding craftsmen might be allowed the right to use a family name, and a few, for instance the swordsmiths, were awarded the right to carry the two swords of the samurai. High-ranking craftsmen were also permitted to sign their work.

The vast majority of Edo craftsmen, what might be called the middle class of craftsmen, were involved in construction work. Frequent fires meant that this line of business was highly profitable and of considerable importance. Craftsmen connected with the construction trade were known as the 'five crafts' of carpenter, plasterer, stonemason, sawyer, and roofer.

Carpenters formed the single biggest group. The carpenter was in charge of the entire construction operation, functioning as a building contractor. He supervised the work of the other craftsmen involved, and personally saw to the timber framing of the walls and roof. Carpenters, unlike most other craftsmen, were for these reasons allowed to put their name on the houses they built. In 1698 the chief carpenter of Kyôto, Nakai Mondo, was even given a stipend of 500 *koku* and allowed to wear a sword.

The masters of the other four crafts were perhaps not as highly regarded as carpenters, and were under the carpenter's supervision, but had nearly equal status. Plasterers made solid walls, and covered all walls for fire-resistant buildings such as storehouses. Stonemasons first laid the foundation upon which the building was to be erected, and then busied themselves with the carving of stone lanterns, basins, or statues to decorate the garden. Stonemasons also made gravestones and other votive statuary such as the *komainu*, the lion-dogs guarding the entrance of many Shintô shrines. The sawyer cut the timbers that

Fig. 42. Two mat-makers at work. The one to the left is adding the lining to a mat.

the carpenter needed. The roofer was a shingler, tiler, or, in the early days of Edo, thatcher (and was supposed to have an especially shrill voice, to enable him to shout at other craftsmen when on the roof). Tilers not only worked on the roof, they also made the tiles.

Lower-ranking craftsmen were also necessary for the construction trade. Paperers were responsible for covering the light latticework of the sliding screens with translucent paper, which admitted some light while preventing draughts and keeping out neighbours' prying eyes. Mat-makers (Fig. 42) were also essential craftsmen. They made the thick *tatami* mats of bound straw covered with special woven rushes and laid them over the plank floors in the houses or tenements of everyone who could afford them, Important, too, though much lower in status, were the manual day labourers (*hiyatoi*) and the porters.

Many professions in Edo were licensed. The Edo day labourers' registry (*hiyatoiza*) was established in 1665. Among the occupations that were required to register there were the general labourers known as 'hook men' (*tobi*), rice polishers (*kometsuki*), porters and palanquin carriers, and common day labourers. Every worker had to pay a monthly fee (*fudayakusen*) of 24 copper *mon* (for the value of money, see below). The fee was later decreased to 22 *mon* in 1695 and 20 *mon* in 1707, then raised again to 30 *mon* in 1718. Wages of porters and other transportation workers had been rising, and by 1747 their fee rose to 46 *mon*. From 1679, another group of labourers known as 'levermen' (*teko*), as well as deliverymen (*mochikomi*), and draymen (*bariki*) also had to register. Many other professions, including prostitutes, hairdressers, and beggars, were also licensed.

The licenses (*hiyatoi fuda*) issued to day labourers were wooden tags that could be worn on the person, measuring roughly 15×8×3 cm, usually with a hole at the top so that the tag could be slung on a cord. In 1698, and presumably in most other years, Edo labourers were ordered to hang their licences at their waists while working. The registry was never very efficient, however. A common way to circumvent the regulations was for small groups of three to five day-labourers to live together and change jobs frequently, all working on the same license. The registry was closed in 1797.

There were many other types of lower-ranking craftsmen, many of whom plied their trade from small tenement houses. These included groups such as coopers, tobacco-cutters, and (of less importance in Edo than in other parts of Japan) spinners and weavers. Rice polishers (who removed the husks from the rice) had an important task when it came to supplying Edo with food. They, however, generally worked out of larger rice shops.

Apart from the somewhat nebulous but clearly perceived difference in rank, craftsmen were commonly divided into two groups: those to whom the customer would come, that is, those who had their own workshops, and

those who had to go to the place where the work was to be done, such as the carpenters. This division, although commonplace, did not really have any special significance. A craftsman who ran his own business spent most of his time working to orders from his clients. If he had any free time, he made articles for his stock, to be sold whenever he found a purchaser. Such a craftsman in most cases never struck it rich. Instead he kept his small workshop which he passed upon retirement to his eldest son or an adopted heir. To determine a fair price for his goods was difficult; collecting payment more so. Bills were generally paid only twice a year.

In the castle towns, of which Edo was the most important, prices were strictly controlled. Especially in the latter half of the Edo period, many samurai were impoverished by falling rice prices, so often it was not easy – and always a delicate business – for a craftsman to collect payment for goods delivered to a samurai family. Furthermore, not all craftsmen could count on being paid in hard cash. An itinerant craftsman would be supplied with raw materials, room, and board, and this formed a major part of his payment. Alternatively, a high-ranking samurai might choose to pay part or all of the price in commodities, such as clothing or foodstuffs.

The only group of craftsmen who could, with some luck, expect to strike it rich were those connected with the always very profitable construction trade. As the population in Edo and the other cities and towns tended to increase, new buildings were always needed. Frequent fires and earthquakes also necessitated the rebuilding of large parts of the city. In such times, even a young craftsman just out of apprenticeship would quickly be taken on at a good wage. Other commercial opportunities in times of disaster included selling wood at highly inflated prices. In the early days of Edo, a few wealthy timber merchants regularly cornered the market. For these reasons, construction workers, already organised in gangs (*kumi*) of sometimes 200 or 300 workers, easily found connections with organised crime.[8]

In Edo and other towns, craftsmen of the same craft were encouraged, and at times even apparently required, to live in the same neighbourhood. This not only assisted the customer in finding a craftsman of the desired vocation, but also served as a means for the authorities to ensure control. The craftsmen were also organised into professional associations (*nakama*), which supervised the standards of the members and acted as benevolent societies. The 'five crafts' of carpenter, plasterer, stonemason, sawyer, and roofer had such associations, as did the blacksmiths. Some associations had protective Shintô deities. Blacksmiths and swordsmiths were especially helped by Inari, the rice god whose messenger is the fox. The reason for this may have been a popular legend, and a Nô play derived from it, in which the god Inari helps the swordsmith Sanjô Kokaji Munechika (938–1014) with a particularly difficult job, resulting in the famous sword named Kogitsunemaru ('Little Fox'). Professional associations usually sponsored an annual festival or meeting, which helped maintain a feeling of group solidarity, and the leading

8 Even today many gangster groups have the word -*gumi* ('gang') suffixed to their name. As we have seen, *kumi* also signified a military unit, here often translated as 'section' or 'company'.

members of the association – the more affluent elders – were held in high esteem by the lowly rank and file of the membership.

Although the shogunate never ceased to proclaim the virtues of a commoner being satisfied with his lot, no matter how poor he was or how hard he had to work, the Edo period did bring a gradual change in attitude among the commoners, if not among the officials and the samurai. Instead of only or mainly working for individual clients, an increasing number of craftsmen who made things for sale (as opposed to service workers such as carpenters) turned to working full time for rich merchants, who acted as middlemen between the craftsman and his customer. These middlemen owned warehouses and were more interested in low prices and large quantities than old-fashioned quality goods.

Naturally, quality suffered. One way to avoid losing customers was therefore to advertise and create fashions and fads. A fad did not have to be concerned with quality. What a product lacked in quality could be made up for in a beautiful wrapping. Because of this, the merchants never hesitated to bring in cheap unskilled labour. A reduction in quality hardly mattered as long as the price was competitive. This strategy became increasingly tempting as new and cheap labour rushed into Edo from the provinces. As transportation improved it also became possible to manufacture goods in remote areas of the country. By the end of the Edo period Japan had in this way developed its own brand of industrialisation. Though it was an industrialisation without mechanisation, it nevertheless laid a solid foundation for the 'modernisation' of Japan even before the shogunate had fallen.

Daily Dress, Arms, and Armament

The Kimono

For members of the warrior class as well as others in old Japan, clothes were not, most of the time, intended as uniforms. However, the clothes one wore, as well as the material from which they were made, undoubtedly reflected social rank. Clothing was strictly regulated, and regulations were at times severely enforced. Farmers, for instance, and sometimes other commoners too, were not allowed to wear clothes of silk but had to make do with hemp or cotton.

Hemp was in any case extensively used for outer clothing, including the *hakama* or skirt-trousers of the samurai, especially in the early Edo period. Cotton grew increasingly common, imported from China and Korea since the late twelfth century and in larger volume since the fifteenth century. Domestic cultivation of cotton began in the late sixteenth century around the city of Ôsaka. During the first half of the Edo period, cotton production rose rapidly, and a commercial cotton industry was firmly established in the mid eighteenth century. Soon afterwards cotton replaced hemp as the raw material for clothing almost everywhere in Japan.

Silk cloth was the most lavish material available for clothing. It was often highly decorative, with imaginative patterns derived from the use of different coloured threads worked into the cloth at the time of weaving, and various textures and damask effects. Designs were often embroidered on the fabric to

produce brocade. While patterned weaving was produced in various regions of Japan, embroidery was a town industry. There the cloth could also be dyed in beautiful patterns, either by a process whereby colours were painted on to the fabric or by tie-dyeing. Tie-dyeing was a method in which small areas of the cloth were drawn up into bunches before the whole cloth was immersed in the dye, producing a beautiful pattern in which small areas were left in the original colour when the bunches were undone. The most celebrated area for dyeing and embroidery was Nishijin, the traditional weavers' district north-west of Kyôto. Nishijin had been settled in ancient times by Chinese immigrants who brought with them silk cocoons and the techniques of spinning and weaving. Nishijin weavers had long worked for the Imperial court, and in the Edo period they also found opportunities working for the shôgun.

In Edo period Japan, fashions in colour and cloth changed with bewildering rapidity. Edo celebrities vied with each other in the creation of new fads. Each Edokko who had the means sported clothes, paraphernalia, and hairstyle in imitation of the fashion leaders. Rapid changes in fashion brought opportunities, but also bankruptcies, among participating merchants. The short-lived English trading post at Hirado, for instance, found out the hard way in the early years of the period how short-lived cloth fashions were in Edo.

Of imported cloth, silk was naturally most popular. In the early years of the period, some silk was imported from Bantam (Java), Cochin China, and Siam, but the bulk of imported silk always came from China. Before their subsequent expulsion, the Portuguese were fortunate enough to supply large quantities of high-priced Chinese silk from their enclave at Macao. Chinese merchants based at Hirado and Nagasaki also profited from the silk trade, and eagerly assumed, or rather resumed, the trade later abandoned by the Portuguese.

A major share of the weaving of cloth, especially of hemp and cotton but also the plainer varieties of silk, was done by farm women. The material was produced in standard rolls, measuring about 60×18 m. Each roll was sufficient to make one kimono (literally, 'a thing to be worn'), the basic type of clothing in Japan, worn by both men and women. The novelist Saikaku reports that expensive silk cost between three-quarters and one *ryô* of gold per kimono, or half *hiki*. A *hiki* when measuring cloth equalled two *tan*, and a *tan* was sufficient for one adult kimono[9] (for the value of money, see below).

The kimono was, and is, a long gown with expansive sleeves set at right angles to the body. The kimono was designed to lap left side over right, crossed over the chest, and was secured at the waist with a sash (*obi*). The kimono was made to fit the wearer, but only approximately. As it did not have pockets, buttons, or other fastenings and was held together only by the sash, an exact fit was deemed unnecessary. Besides, the stitching of a kimono was more like tacking. The washing of a kimono (Fig. 43) involved taking the entire dress apart, washing and starching the pieces separately, on frames, and then reassembling the garment, with appropriate changes to distribute wear and tear. Parts from another kimono could also be substituted, a process that saved material and at the same time produced new, interesting patterns.

9 Nowadays less material is used; a roll of cloth is 34 cm wide and 10.6m long.

Above: Fig. 43. Washing and starching the kimono

Below: Fig. 44. The formal dress (*kami-shimo*) of a samurai retainer. However, this particular man is a commoner, a high-ranking member of the city administration known as 'neighbourhood chief' or 'community head' (*machi-nanushi*).

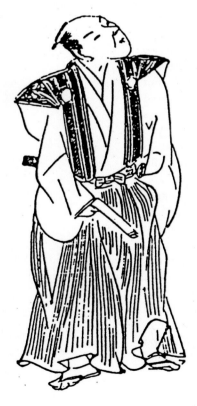

Samurai Dress

The samurai always wore formal dress when on duty or on ceremonial occasions. This attire was known as the *kamishimo* ('upper and lower') and consisted of a jacket or shoulder-dress (*kataginu*) with stiffened shoulder pieces somewhat akin to wings, decorated with his family crest (*mon*), and trousers (*hakama*) shaped like a divided skirt or culottes (Figs 44–46). The trousers were open at the sides, and held in place by two sets of ties on the front and rear, both fastening round the waist, which left a deep vent at each hip. The family crest was monochrome and invariably either round or square.

Higher-ranking warriors sometimes had to wear a variant of these skirt-trousers called *nagabakama*. Such trousers were very long, trailing on the floor behind the samurai, and completely enclosing the feet at all times. The wearer in fact had to walk on the lower parts of the trousers rather than on the floor. Naturally, the wearing of such trousers required special skill, as any change of direction required sharp movements of the feet to bring up the trailing portion behind the wearer. Although it was possible to move fast, and even to run, in such a garment, its main function was to indicate rank, and to ensure that visitors to the shôgun were sufficiently restrained in case they had a sudden urge to attack him. The entire set of ceremonial clothes was then known as *nagakamishimo*.

Above: Fig. 45. Samurai in *kamishimo*, late Edo period. Seen from the rear, he wears *geta* as footwear. (Raimund von Stillfried)

Right: Fig. 46. Samurai in *kamishimo*, late Edo period. A member of the 1860 Japanese diplomatic mission to the United States. (Mathew B. Brady)

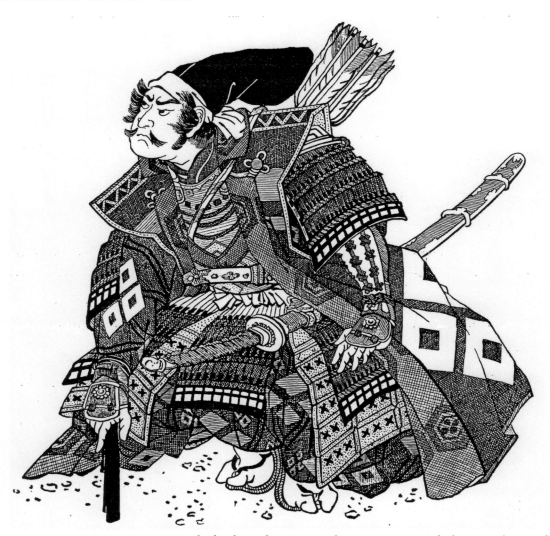

Fig. 47. Edo period illustration of the mediaeval warlord Sasaki Takatsuna, dressed in a highly embellished *jinbaori* and armour in the style of the seventeenth century

Beneath the *kamishimo*, an ordinary samurai-style kimono (*monpuku*) was worn. It, too, was decorated with the samurai's family crest. The kimono came with a sash, behind which the straps of the shoulder wings were inserted. Underneath, a white undergarment (*kosode*) was worn. The undergarment always showed at the neck. The samurai also always wore his two swords, thrust through and fastened to his sash. Indoors, the longer sword was usually removed, but the shorter one was always retained.

On his feet, the samurai wore *tabi*, black or white cotton (or sometimes silk) socks with a padded sole and a division between the big toe and the others to allow for the thong of the footwear. Fine leather could also be used, at least early in the period. In early times, white *tabi* were most common. From the days of the third shôgun, Iemitsu (1604–51, r. 1623–51), or some say, the eighth shôgun, Yoshimune (1684–1751, r. 1716–45), men often used black (or indigo) *tabi*, while women wore white. This fashion was said to have originated with the shôgun himself, who at one time had dyed his *tabi* black (or indigo) for a hunt. The size of the *tabi* was measured in units of copper coins (*mon*).

Above: Fig. 48. Highly embellished *jinbaori*, seventeenth century, seen from the front and behind. (Metropolitan Museum of Art)

Below: Fig. 49. Regular style of *jinbaori*, seventeenth century, as seen from behind. (Musée Guimet, Paris. Photo: Ash Crow)

Outdoors, instead of the formal jacket with shoulder wings the samurai wore a three-quarter length, slightly padded kimono-shaped coat known as *haori*. The *haori* was not closed over the chest but worn open or merely tied together at the level of the chest. When used with armour, the *haori* generally lacked sleeves and was known as a *jinbaori* or 'war coat' (Figs 47–49). As this coat was always lifted up at the rear by the samurai's sword, it had a distinct shape, easily recognisable from a distance. Many types of *haori* had a split back (sometimes known as *bussakibaori*), to enable the sword to protrude at the rear. Fraudulent commoners at times deceived their inferiors by attaching a long stick through their sash, so that it appeared as if their legitimate short sword was in fact the long sword of the samurai. In this way, they ensured better treatment. Needless to say, it was not advisable to attempt to fool a real samurai in this way.

On his head, the samurai often wore what became known as a 'horseman's war hat' (*bajôjingasa*) as protection against the sun or rain (Fig. 50). This was essentially a 'war hat' (*jingasa*), like those worn by infantrymen (Fig. 51), but of better quality and frequently made of lacquered wood or even wicker instead of iron (Figs 52–53). Moreover, its

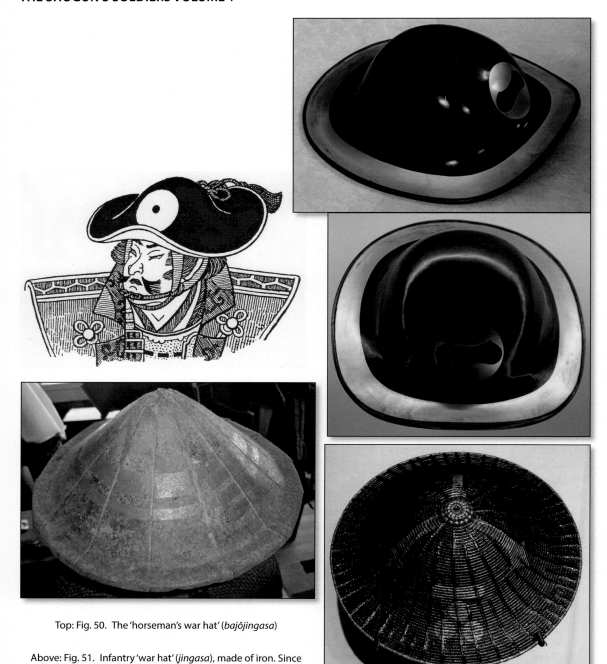

Top: Fig. 50. The 'horseman's war hat' (*bajôjingasa*)

Above: Fig. 51. Infantry 'war hat' (*jingasa*), made of iron. Since Edo period infantry equipment was until recently not considered valuable, these items often linger, rusty and uncared for, in the basements of antique shops and museums. In the Edo period, many war hats were made of leather instead of metal. (Photo: Samuraiantiqueworld)

Top and centre: Fig. 52. A 'horseman's war hat' (*bajôjingasa*), as seen from the side and above. (Musée Saint-Remi, Reims. Photo: G. Garitan)

Above: Fig. 53. Edo period 'horseman's war hat' (*bajôjingasa*), with the crest of the Mori clan of Chôshû. Made of lacquered wicker. (The Ann and Gabriel Barbier-Mueller Museum, Dallas. Photo: Daderot)

rim was upturned, reportedly because this style was more aerodynamic and accordingly better adapted to horseback riding. The type was also known as a Takeda Shingen *jingasa* since it was associated with the sixteenth-century warlord of this name. When not attending a formal occasion, lower-ranking warriors wore a sort of knee breeches, drawn in at the knee, most often accompanied by leggings. Higher-ranking samurai generally preferred the *hakama* trousers (Fig. 54).

Fig. 54. A group of samurai. The leader wears formal dress, but the others (those with two swords) wear trousers or breeches. In the background, a collection of water buckets, stored in readiness for fire.

The colours samurai chose for their clothing were generally very restrained. Blue, grey, dark green, light yellow, and brown were common, either plain or with inconspicuous patterns or stripes. Even the family crests were generally very discreetly applied.

The *kamishimo* was the formal dress of a retainer. The shôgun himself, and the great lords when at home or on leisure, instead wore luxurious kimono. A very few ceremonies, however, were considered sufficiently important or exalted that even the shôgun, and definitely the feudal lords, instead wore the costume of the Imperial court. This always came with a hat that indicated the wearer's rank. This ceremonial court dress has remained virtually unchanged from the Heian period (794–1185) until today.

Fig. 55. Samurai in daily dress having tea, mid nineteenth century. The photograph may be staged, since they each carry only one sword, but the clothes are typical of daily dress earlier in the Edo period as well. The two men to the left wear the 'horseman's war hat' (bajôjingasa) while the man in the middle also is dressed in a coat (haori). The maid wears geta as footwear. (Photo: Felice Beato)

A samurai, when off duty, often wore only the kimono. This style was considered informal, and known as *kinagashi*-style. Instead of a *haori*, a similar type of short coat (*dôbuku*) was from the end of the sixteenth century worn informally by upper-class men. The *dôbuku* was actually a garment older than the *haori*, and is generally regarded as the origin of the *haori*. However, it later came back into fashion in its original shape. Cut like a half-length kimono and without the padding of the *haori*, it was also known as a *sansaibaori*. However, soon both samurai and townsmen wore informal coats of this style (Fig. 55).

Arms

The primary weapon of the samurai was the sword. He carried two swords, one long and one short. The long sword was known as a *katana*, if carried edge upwards, thrust through the sash, or *tachi*, if carried edge downwards, hung from the sash. In times of peace, and often at war, the swords were carried through the sash. To qualify as a *katana*, the blade length had to be at least two *shaku*, or 60.6 cm (Fig. 56). Those samurai who could afford

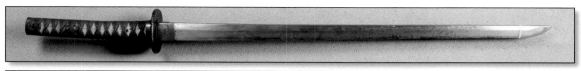

Above: Fig. 56. *Katana* without scabbard, Edo period. Total length 94.7 cm, blade length 68.0 cm. (Army Museum, Stockholm; from the collection of Gösta H. Benckert)

Left: Fig. 57. Edo period leather hanger (*koshiate*) which enables the carrying of a *katana* in *tachi* style without the appropriate sword fittings. (Photo: Samuraiantiqueworld)

it acquired two sets of sword fittings, so that the blade could be carried in either *katana* or *tachi* style. However it was easier, and cheaper to purchase, a leather hanger (*koshiate*) which enabled the carrying of a *katana* in *tachi* style without the appropriate sword fittings (Fig. 57).

Commoners might, under certain circumstances, carry the short sword, the *wakizashi* (Fig. 58). However, it was only the samurai who had the right to carry both, which indeed served as an identifier of the status of samurai, a member of the warrior class. Together, the set of two swords, *katana* and *wakizashi*, were known as *daishô* ('great and small') (Fig. 59). Some would carry a dagger (*tantô*) with a small shield guard of a type similar to that on the sword as well (Fig. 60). Samurai ladies would instead carry a different type of dagger (*kaiken*) which lacked the shield guard.

The second most common weapon, and still the most widely used weapon of war, was the spear (*yari*), which existed in several lengths and varieties, some very long and others less so. Most were around 2.5–3.6 m long (Figs 61–62). Some infantrymen used long spears (*nagaeyari*) which were 5.4 m or more in length, that is, sufficiently long to qualify as pikes. The Tokugawa used spears with a length of three *ken* (5.4 m). During the final decades of the civil wars, units of *ashigaru* spearmen with these long swords operated in unison, not that different from European pike units. This was a new style of fighting, since previously all spear fighters had trained as individuals. However, senior samurai did not train in unit combat and continued to train as individuals, both on foot and on horseback. On horseback, the spear was used with both hands, the warrior swinging it from side to side like he would a sword. The spearhead might be cross-bladed (that is, have a sharpened crossbar), which was used in various fighting styles, including as a hook against horsemen.

Another polearm was the *naginata*, a glaive (Fig. 63–64). In the Edo period, the *naginata* was primarily used by samurai ladies (Fig. 65). However, samurai rated at 1,100 *koku* or more were required to bring a *naginata* onto the battlefield, if for no better reason than to maintain their dignity.

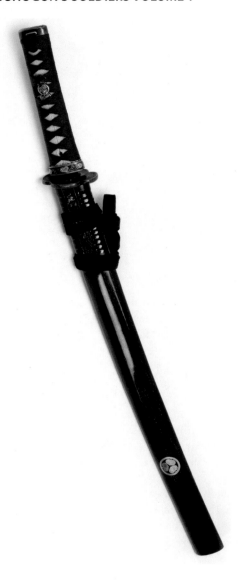

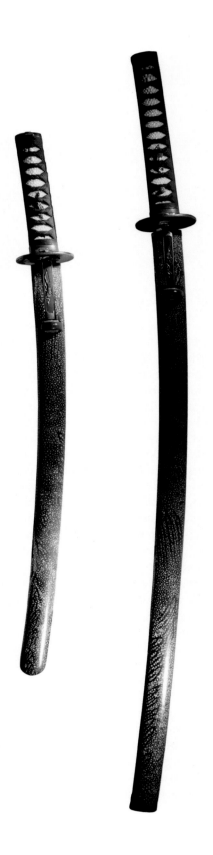

Above left: Fig. 58. *Wakizashi*, Edo period. Scabbard and fittings with the Tokugawa crest, three *aoi* leaves inside a circle. Commonly translated as the triple hollyhock, the *aoi* or triple-heartvine leaf crest symbolised the Tokugawa family and *bakufu* government. Total length 66.0 cm, blade length 45.5 cm. (Private collection; author's photo)

Above right: Fig. 59. Set of two swords (*daishô*). (Bern Historical Museum. Photo: Rama)

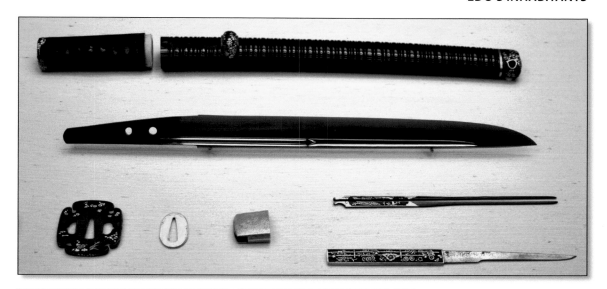

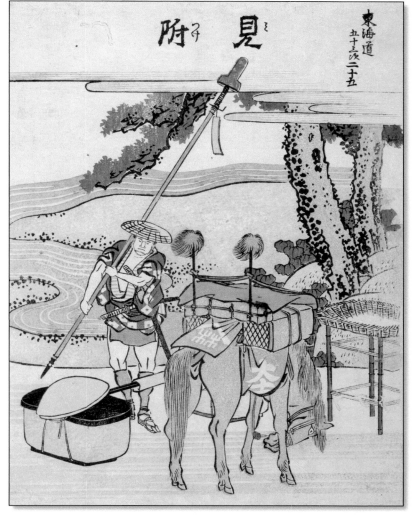

Above: Fig. 60. Stripped-down dagger (*tantô*), Edo period, showing how the weapon was essentially a sword in miniature. As with a sword, its scabbard included a utility knife ('small sword', *kogatana*, often referred to as a *kozuka* which was the term for its decorative handle) and a utility tool (*kôgai*) primarily for hair-styling although it also had other uses. (British Museum, London. Photo: brianburk9)

Left: Fig. 61. Travelling samurai with spear (*yari*), with the cross-bladed spearhead in a protective scabbard (*saya*). (Attributed to Katsushika Hokusai, *c*.1806–1808)

Far left: Fig. 62. Spear (*yari*), Edo period. (Museu Militar, Lisbon. Author's photo)

Left: Fig. 63 *Naginata*, Edo period. (Photo: Rama)

Facing page: Fig. 65. Samurai lady with *naginata*, in a woodblock print depicting Riku, wife of Ôishi Yoshio, in a fictitious scene from the first play written about the Forty-Seven *Rônin* Incident. Although this particular fight never happened, many samurai ladies were trained to use the *naginata* to defend themselves. (Utagawa Kuniyoshi, 1848)

Fig. 64. Below: Stripped *naginata* with scabbard, showing how the weapon essentially was a sword affixed to a pole. Overall length 207 cm, of which the unusually short blade accounts for a mere 32.5 cm. This particular blade is a pre-Edo period sword, signed *Kunimitsu*, which at some point during the Edo period was remade as a *naginata* blade together with other bits and pieces. The guard, too, is an old sword guard (*tsuba*), signed by another craftsman, Mitsuei Chiku. (Private collection; author's photo)

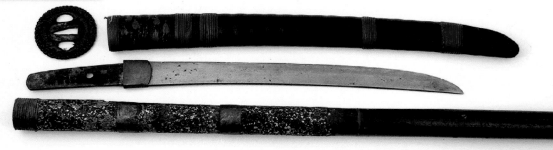

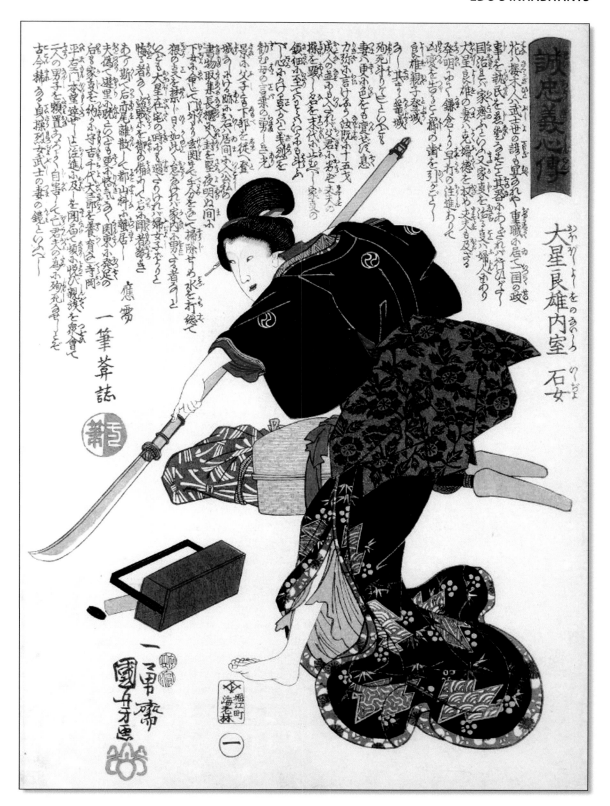

The longbow (*yumi*) was traditionally associated with the samurai class. Made of lengths of bamboo and wood glued together, the weapon remained in fairly common use, and as we have seen, was still used on the battlefield (Fig. 66). The Japanese longbow was held vertically, but unlike most other bows, the arrow was discharged not from the central point between the two ends but from a position one-third of the length up the rod. When not in use, the bowstring was carried in woven bowstring holder (*tsurumaki*) (Fig. 67). The longbow and its accompanying quiver of arrows were mounted in a rack for carrying and preservation from wear and tear when not in use (Fig. 68). A large feudal combat team included an arrow-bearer who would carry an additional 100 arrows in a box-like quiver on his back.

Far more common than the longbow was the matchlock musket (*teppô*). Muskets were typically 1–1.5 m long and weighed from 2–4 kg. Calibres varied widely but were seldom greater than 18 mm. The most common calibres ranged from 9–15 mm, and most muskets fired balls around 11.6 mm in diameter (Figs 69–71). The stock was very short, and the musket was held in the hands when fired, not rested on the shoulder. Ramrods were of wood, and in case they broke, spares were always carried into battle. Musket balls were carried in a dedicated ammunition box attached to the sash, next to the gunpowder flask which was attached in the same manner. From the seventeenth century onwards many musketeers kept preloaded matchlock cartridges (*hayagô*) in the box, to speed up the firing process (Fig. 72). The matchlock mechanism was improved, too. Most importantly, a pivoting pan cover was introduced, which when kept shut covered the priming powder. When ready to fire, the pan cover was swung aside so that the match could ignite the powder (Fig. 73). In heavy rain a lacquered box seems to have been used to keep the slow match and firing mechanism dry (Fig. 74). Musketeers were also taught methods of firing at night, when the target could not be seen. To avoid firing too high or low, they used premeasured strings fixed to the musket (Fig. 75).

Matchlock pistols were used, too. Edo period woodblock prints show them carried in special hip holsters, attached to the sash around the waist together with a cartridge box (Fig. 76). Alternatively, the holster was attached in front of the saddle. The gunpowder was carried in a flask. On horseback, some samurai instead used what can best be described as a matchlock carbine (Figs 77a and 77b). Longer than the pistol, it functioned in essentially the same way. Again, calibres varied widely. Pistols and carbines, around 45–59 cm in length, typically had a weight of around 1 kg and typically had calibres ranging from 8–10mm (Fig. 78). Balls for pistols and carbines were even smaller than those used in muskets, being around 7.9–8.5 mm in diameter. However there were larger carbines, too, approaching the musket in length and calibre (Figs 79a and 79b). Much smaller matchlock pistols were also made, with a length ranging from 24–35 cm (Figs 80–81).

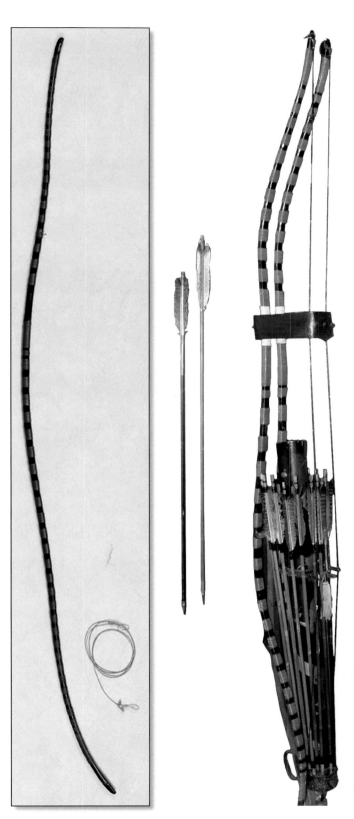

Far left: Fig. 66. Longbow (*yumi*), Edo period. (Army Museum, Stockholm; from the collection of Gösta H. Benckert)

Left: Fig. 68. Two longbows (*yumi*) mounted in a rack with its accompanying quiver of arrows, Edo period. (Photo: Rama)

Below: Fig. 67. Edo-period woven bowstring holder (*tsurumaki*). (Photo: Samuraiantiqueworld)

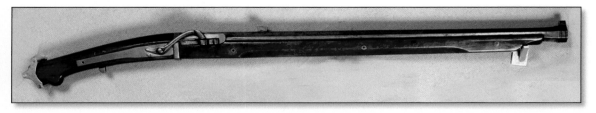

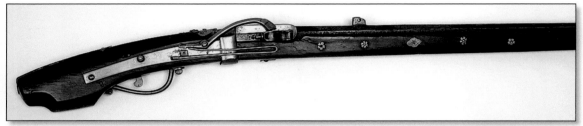

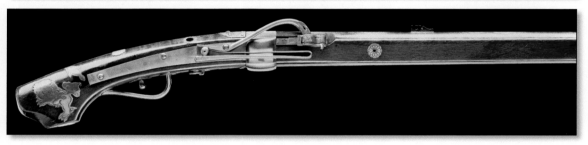

Top: Fig. 69. Matchlock musket (*teppô*), Edo period. With a total length of 108.2 cm, a barrel length of 76.1 cm, a calibre of 15.9 mm, and a weight of 5.33 kg, this regular-sized musket belongs to those which are somewhat heavier than the average. (Army Museum, Stockholm; from the collection of Gösta H. Benckert)

Centre: Fig. 70. Matchlock musket (*teppô*), with additional focus on the firing mechanism, Edo period. The musket's total length of 114.0 cm, barrel length of 86.0 cm, calibre of 15.0 mm, and weight of 3.30 kg makes this a more representative sample of the muskets used in Japan. (Private collection; author's photo)

Bottom: Fig. 71 A more embellished matchlock musket (*teppô*), late Edo period, with a total length of 134.9 cm, barrel length of 103.3 cm, and weight 3.86 kg. (Royal Armoury, Stockholm; photo: Erik Lernestål)

Right: Fig. 72. Reenactment of a samurai musketeer loading his musket, with the slow-match (*hinawa*) wound around his left hand. A pre-loaded matchlock cartridge (*hayagô*) is taken out of the cartridge box. (Photo: Yoshida Fujitani)

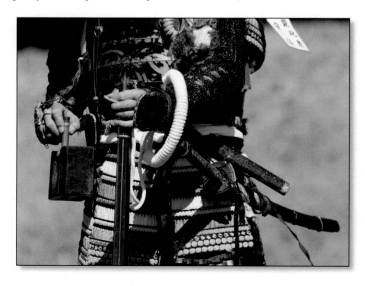

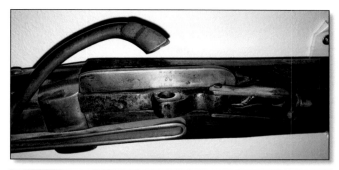

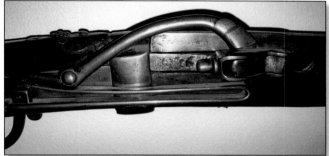

Left: Figs 73a and 73b. Close-up of the pivoting pan cover of the matchlock musket, in open and closed position. When kept shut, the pan cover shielded the priming powder. (Private collection; author's photo)

Below left: Fig. 74. Musketeers in heavy rain, wearing straw raincoats (*mino*) against the rain and displaying the use of lacquered boxes to keep the firing mechanism dry. (Utagawa Kuniyoshi, 1855)

Below right: Fig. 75. Musketeers firing at night, with the help of pre-measured strings to avoid firing too high or low. The two swords show their samurai status. (Utagawa Kuniyoshi, 1855)

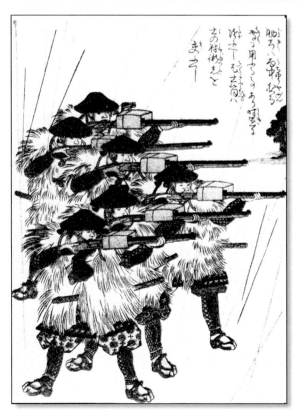

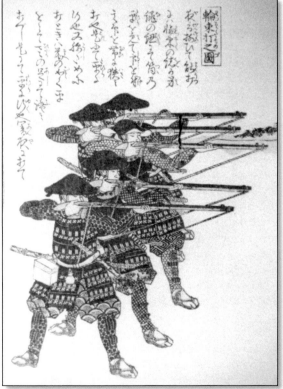

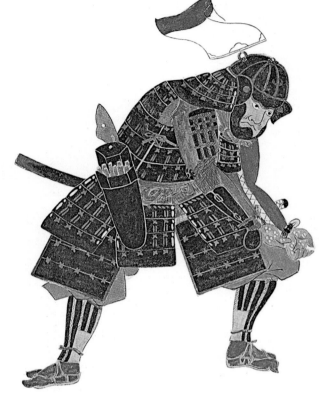

Right: Fig. 76. Samurai in full armour, with a matchlock pistol in a hip holster and cartridge box, as depicted in the late Edo-period book *Yoroi chakuyô no shidai*. Instead of a banner (*sashimono*) on a pole attached to the back of the cuirass, he identifies himself with a helmet flag (*kasa-jirushi*) attached to a ring at the back of his helmet.

Below: Figs 77a and 77b. Matchlock carbine, Edo period, as seen from both sides. The barrel is signed Sesshûjû Inoue Kanemon. Total length 55.2 cm, barrel length 30.1 cm, and calibre 1.3 cm. (Author's photos)

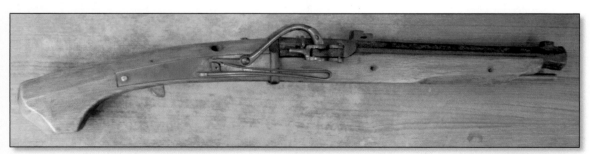

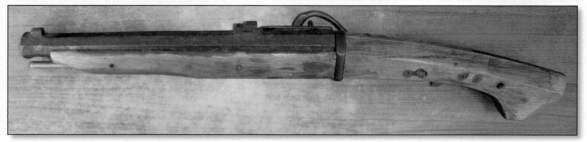

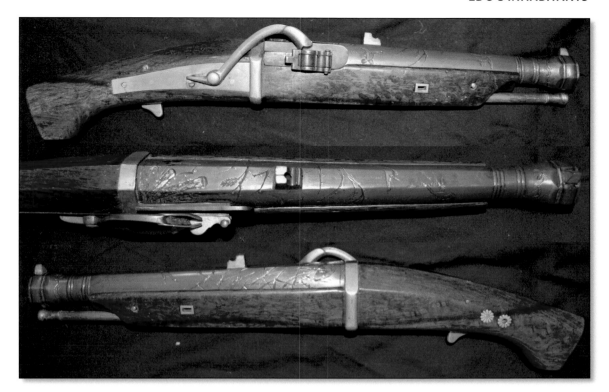

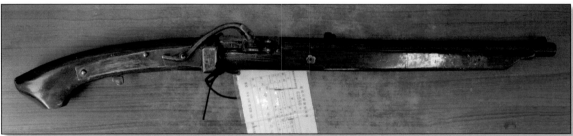

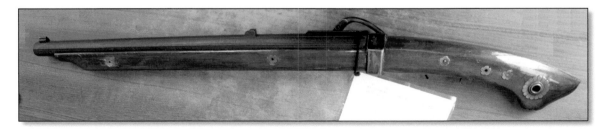

Top: Fig. 78. Matchlock pistol with bronze barrel, deeply engraved with gold and silver inlays of flying birds and plants, Edo period. As usual, the ramrod is made of wood, although in this highly embellished item it comes with a brass tip. Total length 43.18 cm. (Photo: Worldantiques)

Centre and bottom: Figs 79a and 79b. Matchlock carbine, Edo period, as seen from both sides. The barrel is signed Fukuda Hikoemon Naomasa. Total length 70.2 cm, barrel length 45.3 cm, and calibre 1.4 cm. (Author's photo)

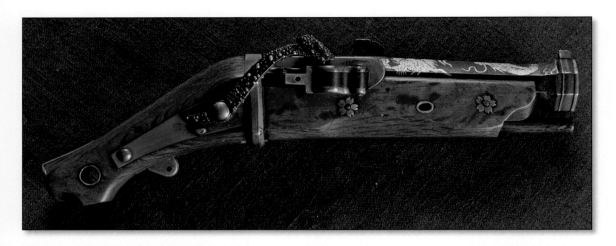

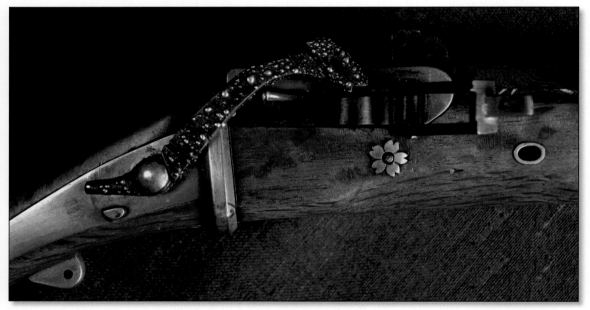

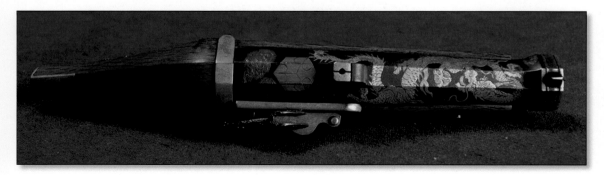

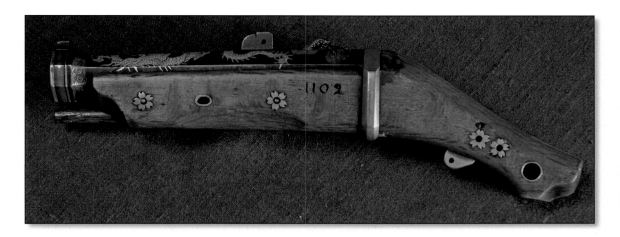

Figs 80a–80e.Matchlock pistol with blued steel barrel, engraved with primarily gold and some silver inlays in the shape of a dragon motif. Eighteenth century. Total length 24.5 cm, barrel length 14.4 cm, calibre 8.9 mm, and weight 0.69 kg. (Army Museum, Stockholm)

Fig. 81. Matchlock pistol with steel barrel, the customary ramrod of wood, but an atypical grip. Edo period. Total length 34.9 cm. (Photo: Worldantiques)

There were also heavier guns. Some of them were used as wall guns, but others were used in the field, held in a similar manner to the regular muskets or, if very heavy, with the gunner kneeling and the stock rested on the ground. Heavier guns were around 1 m long and generally had a weight ranging from 6.5–16.6 kg, or occasionally more, if they were intended to be used from a gun carriage as artillery which was a common practice, too. Heavier guns had calibres up to 25 mm, or sometimes more, and fired balls with a diameter commonly ranging from 18.4–28.2 mm or more (Fig. 82). Heavier muskets could also be used to launch fire arrows (*bôbiya*). Such a musket would be referred to as a fire arrow launch tube (*hiyazutsu*). Launch tubes for fire arrows had been used in Japan for centuries. What distinguished the new type of musket-launched fire arrow which came into use in the sixteenth century was that it was designed as a rocket, with large fins and a tip which hid an explosive warhead with which the operator hoped to set something on fire (Fig. 83). Fire arrows, when used, seem to have been launched in barrages, since they were difficult to aim properly and the trajectory was difficult to estimate.

Although each musketeer would carry a minimum supply of ammunition, we have seen that a large feudal combat team, and no doubt any musketeer unit, included an ammunition-bearer who would carry additional supplies of gunpowder and musket balls in a sturdy box on his back.

Cannons, primarily of designs of Chinese origin, were cast in two locations in Japan, Nagahama and Sakai, which both were located in western Japan. Many were breech-loaders in the Chinese manner, which meant

that the chamber, detached from the barrel, was loaded separately and then inserted into the cannon before firing. Although the Japanese learnt how to construct breech-loaders from China, the design was known to be of European origin and accordingly referred to as 'Frankish' guns (*furanki*). Most were not very heavy. In 1600 Ieyasu ordered five 8-pounders and ten 6-pounders (approximate calibres expressed in European terms) from Nagahama. More useful were the cannons imported from Europe. Although quantities were not large, the Dutch supplied some cannons and mortars to the shogunate. In 1650, a Dutch gunner spent nine months in Edo for the purpose of instructing the Japanese in the casting of large cannons.[10] By then, however, the shogunate had just about lost interest in its artillery arm. Yet, interest dropped further still. When the Swedish physician and botanist Carl Peter Thunberg visited Japan in 1775–1776, he noted that the coastal defence artillery in Nagasaki was test-fired only once every seven years, and that the gun crews had only 'slight knowledge' of how to handle them.[11]

In 1607, the shogunate began to centralise and regulate gun production. The four senior gunsmiths at Nagahama were raised to samurai status, and regulations were issued that enabled the shogunate to take control of the industry under a new Commissioner of Guns (*teppô bugyô*). Henceforth, firearms and gunpowder were to be produced in Nagahama only. Any provincial gunsmiths would have to relocate there. Moreover, all sales of firearms would have to be approved by the shogunate before delivery. The shogunate only approved sales to itself, and a problem soon arose when it was found that the gunsmiths could not make a living based on the few shogunate orders. As a result, in 1609 it was decreed that the gunsmiths at Nagahama would be salaried by the shogunate, regardless of whether any guns were ordered or not. Over the years, the shogunate purchased increasingly few guns. Orders were in no way sufficient to sustain the army's need, assuming that this was the intention. As we have seen, by then the shogunate army had already declined in martial ability, and there was no longer any interest in sustaining a major force of musketeers.[12]

At first, the new regulations did not apply to Sakai, which continued to produce firearms. Sakai was an anomaly in feudal Japan, since it until the late sixteenth century was the country's closest analogy to a free city. The port city profited from both its seaborne trade and its capacity to function as one of Japan's principal sources of armaments. However, its self-government by a council of wealthy merchants had ended already in 1569, although the city remained immune from the political upheavals for some time. In the early

10 Charles R. Boxer, *Jan Compagnie in Japan, 1600–1850* (The Hague: Nijhoff, 1950), p.113.

11 Carl Peter Thunberg, *Resa uti Europa, Africa, Asia, förrättad åren 1770–1779*, Vol. 4 (Uppsala: Johan Edman, 1788–93), p.14.

12 Noel Perrin, *Giving Up the Gun: Japan's Reversion to the Sword, 1543–1879* (Boulder: Shambhala, 1980), pp.47–58, 62–3. Perrin's work is useful for presenting some aspects of the story of Japanese firearms to English-language readers. There is no evidence whatsoever that Japan ever 'gave up' the gun, nor that the shogunate successfully introduced a comprehensive gun control regime beyond the attempt to establish a monopoly of gunsmiths.

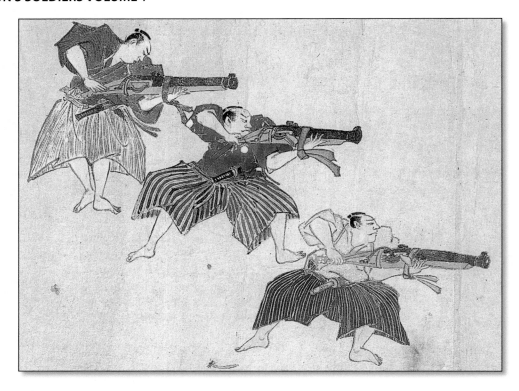

Above: Fig. 82. Three samurai practicing with heavy matchlock muskets. Already from the outset, muskets came in a large variety of sizes and calibres. They have tied their left arms to the musket barrels to handle the strong recoil of large-calibre muskets.
(Iwasaki Nagakata, *c.* 1820s; Gyôda Museum)

Below: Fig. 83. Two samurai with heavy muskets prepare to launch fire-arrows (*bôbiya*). Edo period woodblock. They wear breastplates of the same type as firemen so as to protect themselves from flames and sparks.

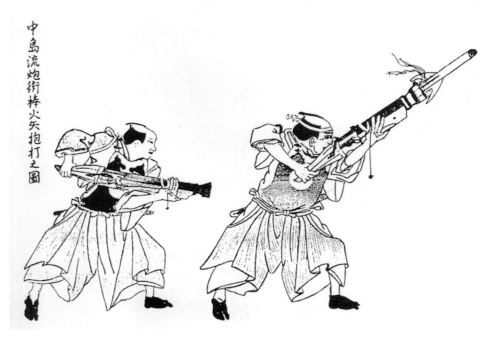

1620s, the Sakai gunsmiths produced an average of 290 muskets a year. In the 1660s this number had grown into some 2,500 a year. However, thereafter orders diminished substantially, and after 1668 the shogunate no longer ordered any muskets from Sakai. After 1696 there were no longer any orders, from anybody. In the eighteenth century, the number of gunsmiths in Sakai shrank to about 15.[13] By then, the former independence of Sakai had long ago become an anomaly of history, and so had most of Japan's military gun production facilities.

Although the production of military muskets decreased, some criminal gangs retained firearms and were not shy to use them. In addition, matchlock muskets for hunting purposes remained very common in rural areas throughout the Edo period. Farmers continued to make extensive use of them to scare off or kill animals that damaged their crops.[14]

Armour

A full set of body armour traditionally consisted of several pieces, chief among them the helmet (*kabuto*) with neck guard (*shikoro*), the cuirass (*dô*), which in the sixteenth century might be shot-proof and short, usually lamellar tassets (*kusazuri*) attached to the cuirass to protect hips and thighs.[15] When on the march, the tassets could be folded up and tied around the cuirass so as not to impede movement.[16] To this was added several additional pieces, first the shin guards (*suneate*), which commonly consisted of vertical metal plates linked together by chainmail on a cloth backing. At the top of each shin guard was commonly attached a round knee pad (*tateage*) with metal plates between layers of quilted cloth (Fig. 84). This type of protection, brigandine armour made of metal or hard leather plates quilted between layers of fabric in a pattern known as 'turtle shell' (*kikkô*), was already common and became increasingly more so in the Edo period, since it was lightweight and could be used under regular clothing. Above the shin guards were often worn thigh guards (*haidate*) in the form of a divided apron with the lower parts covered with lamellar armour. Archer's gloves (*yugake*) and armoured sleeves (*kote*), the latter reinforced with vertical metal plates linked together by chainmail, protected the arms in much the same way as the shin guards protected the shins (Figs 85–86). The sleeves might or not be attached to the armpit guards (*wakibiki*), which consisted of pads of cloth and occasionally chainmail. The latter were necessary, since samurai were trained to aim their weapons at the opponent's armpits, since these could not be as strongly protected as the rest of the body, yet were susceptible to fatal wounds.

13 *Ibid.*, pp.64–5.

14 David L. Howell, 'The Social Life of Firearms in Tokugawa Japan', *Japanese Studies* 29: 1 (2009), pp.65–80.

15 Modern works often suggest that if the tassets were detachable, they were known as *gessan*, not *kusazuri*. This term for tassets seems to have come into use only in the late eighteenth century. Sakakibara Kôzan, *The Manufacture of Armour and Helmets in Sixteenth Century Japan (Chûkokatchû seisakuben)* (London: The Holland Press, 1963), pp.104, 107.

16 *Ibid.*, p.108.

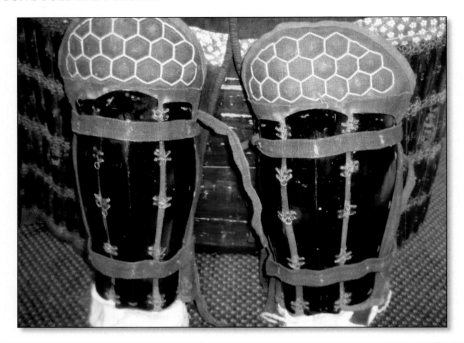

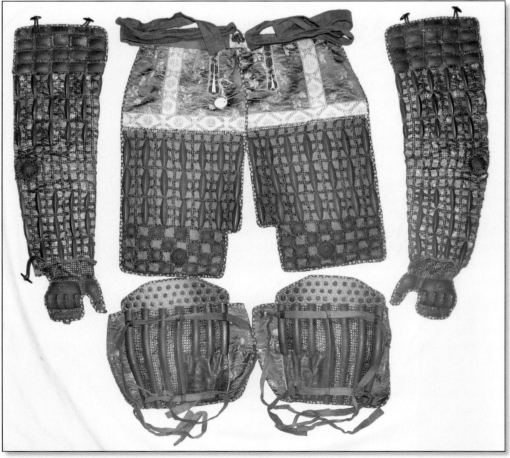

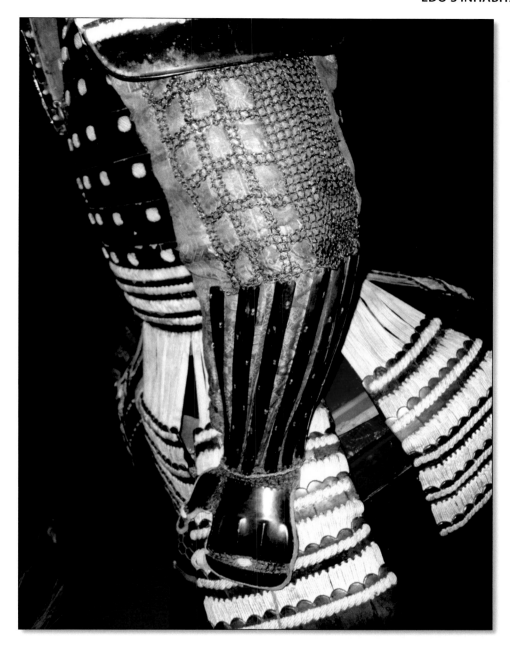

Facing page, top: Fig. 84. Armoured shin guards (*suneate*) made from vertical iron plates on a cloth backing, with round knee pads (*tateage*) with hexagon-shaped metal plates between layers of quilted cloth, Edo period. (Photo: Samuraantiqueworld)

Facing page, bottom: Fig. 85. Armoured shin guards (*suneate*), thigh guards (*haidate*) in the form of a divided apron, and armoured sleeves (*kote*) in a matching set, made of metal plates and chainmail attached to a cloth backing, Edo period. (Photo: Samuraiantiqueworld)

Above: Fig. 86. Armoured sleeves (*kote*) of iron plates linked by chainmail attached to a cloth backing, Edo period. (Photo: Samuraiantiqueworld)

Fig. 87. As additional protection, many wore a chainmail or brigandine sleeveless vest (*manjû no wa*) made with flaps that passed under the arms and over the shoulders to tie on the chest. (*Tanki Yôryaku Hikôben*, 1735)

As additional protection when not in full armour or as a replacement for the armpit guard (*wakibiki*), some wore a tight-fitting chainmail or brigandine sleeveless jacket or vest (*manjû no wa*) made with flaps that passed under the arms and over the shoulders to tie on the chest (Fig. 87). Some varieties of this item had an armoured collar as well (Fig. 88). Above the cuirass, the samurai in full armour would usually wear shoulder guards (*sode*). However, these were inconvenient and sometimes discarded under field conditions. By the Edo period, some samurai began to wear a larger version of the *manjû no wa* vest, known as *manchira*, above, not below, the cuirass (Fig. 89). If so, the shoulder guards could safely be omitted. Generally speaking, chainmail and brigandine armour grew increasingly popular in the Edo period, since such armour allowed easier movement than did the old (and sometimes partially shot-proof) suits of armour. The samurai would protect the base of the throat with a throat guard (*nodowa*) and the face with a face mask ('face and cheek', *menpô*). In the last quarter of the sixteenth century it had become fashionable to wear face masks with moustaches of horsehair, and this practice continued into the Edo period (Fig. 90). However, many expert armourers argued that moustaches of real hair impeded visibility in combat.[17] In the Edo period, many face masks were also fitted with a throat defence (*yodarekake*), so often the *nodowa* was discarded (Figs 91–92). Under the helmet, the samurai would wear a headcloth (*hachimaki*) as padding.

Finally, in war the samurai would carry a typically rectangular banner (*sashimono*) on a pole attached to the back of the cuirass. The banner was marked with a unit identifier, commonly the crest (*mon*) of his lord, which served to give the unit a uniform appearance, even if the men wore different types of armour.

17 *Ibid.*, p.71.

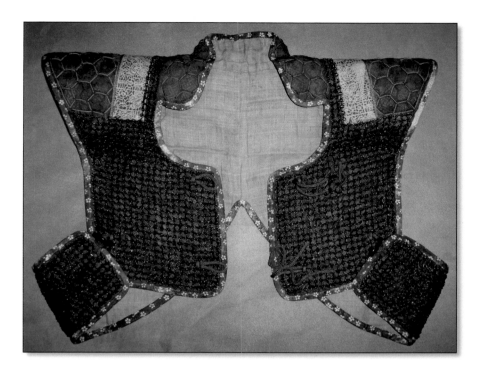

Above: Fig. 88. A *manjû no wa* vest with armoured collar, made of chainmail and small hexagon-shaped armour plates sewn to fabric. (Photo: Samuraiantiqueworld)

Below: Fig. 89. The armoured vest known as *kikkô manchira*, in this case made of small hexagon-shaped armour plates between layers of fabric. Edo period. (Photo: Samuraiantiqueworld)

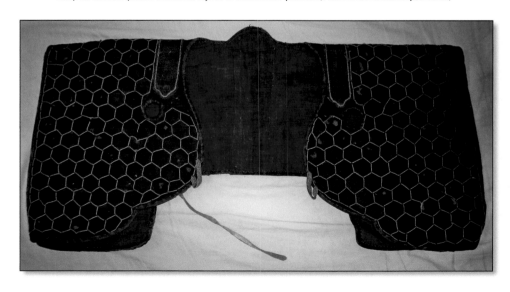

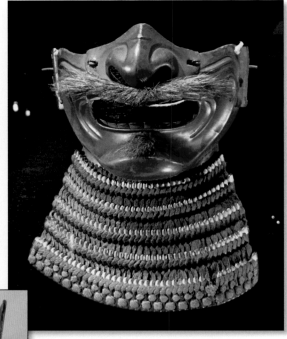

Right: Fig. 90. Face mask (*menpô*) with moustache and goatee of horse hair as well as throat defence (*yodarekake*). Late Edo period. (Museum of Far Eastern Antiquities, Stockholm. Author's photo)

Below: Fig. 91. Face mask (*menpô*) with throat defence (*yodarekake*), eighteenth century. (Army Museum, Stockholm; from the collection of Gösta H. Benckert)

Below right: Fig. 92. Face mask (*menpô*) with throat defence (*yodarekake*), eighteenth century. (Army Museum, Stockholm; from the collection of Gösta H. Benckert)

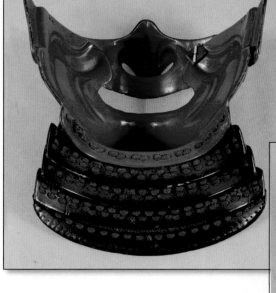

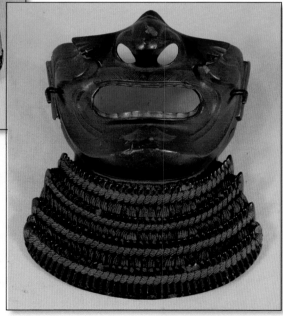

Under certain conditions, including at night and in strong winds, a shoulder flag (*sode-jirushi*) or helmet flag (*kasa-jirushi*) was used instead.

Under the armour, the samurai wore a loincloth (*fundoshi*), and a short kimono (*shitagi*; 'under-clothing'; other terms were *yoroishita* and *gusokushita*, 'armour under[wear]') tied with a sash (*obi*), commonly made of cotton, and short trousers of the *hakama* type (known as *kobakama*), but narrower, which reached below the knees but not all the way to the feet (Figs 93–94). The kimono might have cords at the wrists, so that they could be tied tight for ease of movement. Likewise, the trousers had cords at the hem so that they could be tied under the knees. The samurai would wear gaiters (*kyahan*) wrapped around the calves and the lower edge of the trousers and held in place by cords at the top and bottom (Fig. 95). On his feet he wore divided socks (*tabi*) and straw sandals (*waraji*). Since the latter frequently broke, a samurai would make sure to keep a servant at hand with a spare pair, or alternatively carry a replacement himself on his person.

For a description of how to put on a suit of full armour, see Figs 96–117.[18] In the Edo period it became increasingly common to wear a regular *hakama* even when putting on armour. The *hakama* was then pulled up so as to enable increased mobility (Fig. 118). The suit of armour was stored in a portable armour box. When on campaign, it could be stored in a box carried on the back of a soldier. The box would then have padded shoulder straps.

At the time of the civil wars, foot soldiers (*ashigaru*) were issued less complete versions of the full armour of the samurai, usually only consisting of a basic cuirass with its attached tassets to protect hips and thighs, simple armoured sleeves, and a war hat (*jingasa*) shaped like a peasant's straw hat but made from metal or hard leather and often worn with a cloth hanging down from the rim to the shoulders to provide additional protection, including against the sun. This armour was easier to put on than a full suit of armour (Fig. 119). They usually did not receive thigh or shin guards but instead wore dark-coloured trousers or breeches (*momohiki*), tied beneath the knees, of the same type which many urban manual labourers used (Fig. 120). These items were provided by their lords, which often gave the men a uniformed appearance.

The Tokugawa clan army used these types of armour in the civil wars including the early seventeenth-century Sekigahara and Ôsaka campaigns. However, major changes in military dress took place soon afterwards. This was, no doubt, the result of two developments. First, the extended period of peace meant that full armour no longer was needed, since the army was not called up to fight. Second, despite the decreasing number of firearms purchased by the clan armies, firearms remained in the inventories, and there must have been an understanding that armour, in particular the types commonly issued to foot soldiers, provided little or no protection against a musket ball. What seems to have happened was a development which mirrored the one in Europe, where soldiers at the same time gradually

18 Based on the book *Tanki Yôryaku Hikôben* by Murai Masahiro (1693–1759) from 1735, published (in five volumes) in Edo, Kyôto and other locations by Suharaya Sasuke, Katsumura Jiuemon, and others in an edition by Kinkadô in 1837.

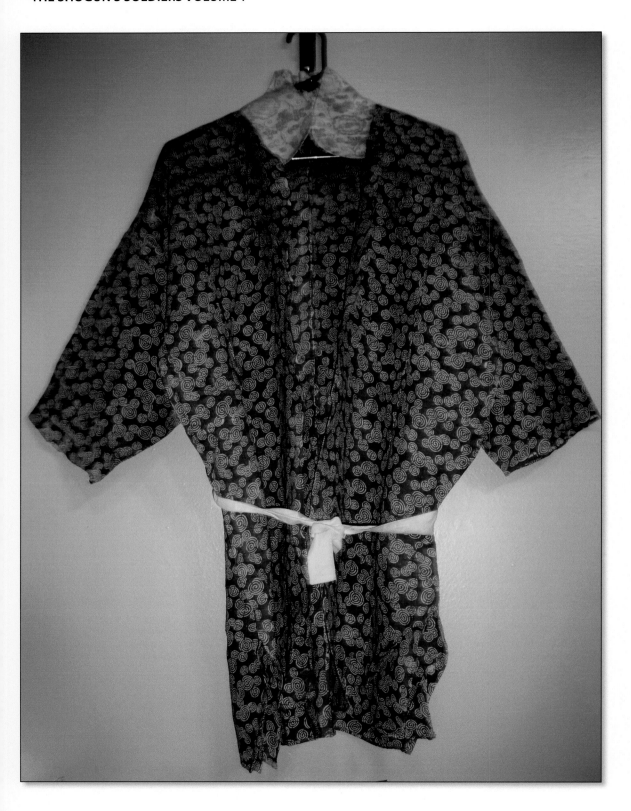

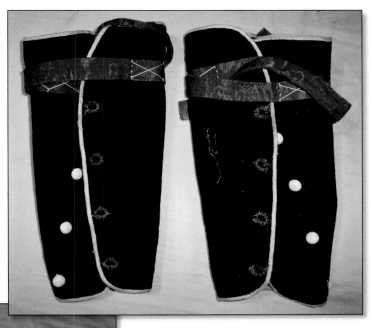

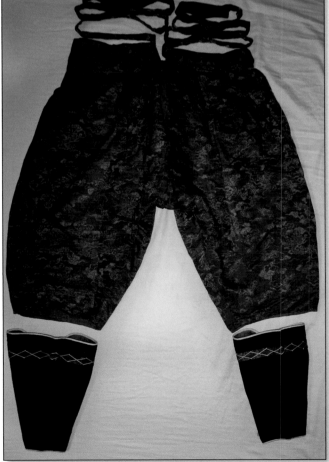

Facing page: Fig. 93. Short kimono (*shitagi*) to be worn under armour. Edo period. (Photo: Samuraiantiqueworld)

Left: Fig. 94. Short trousers (*kobakama*) to be worn under armour, together with the corresponding gaiters (*kyahan*). Edo period. (Photo: Samuraiantiqueworld)

Above: Fig. 95. Close-up of gaiters (*kyahan*), Edo period. (Photo: Samuraiantiqueworld)

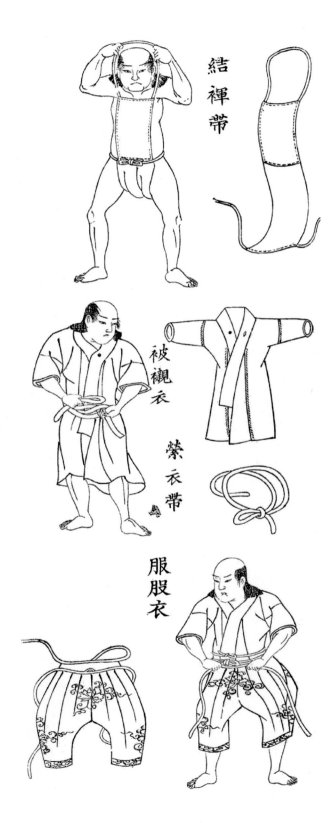

Fig. 96. The first step in putting on full armour was to loosen one's elaborate queue or topknot (*chonmage*), since it was not comfortable when wearing a helmet. However, closest to the skin was, unsurprisingly, the loincloth (*fundoshi*). (*Tanki Yôryaku Hikôben*, 1735)

Fig. 97. Next the samurai put on a short kimono (*shitagi*, *yoroishita*, or *gusokushita*), which was fastened with a sash (*obi*), commonly made of cotton and wound twice or thrice around the waist and tied at the back. The sash not only tied the kimono but also provided some support to the cuirass, thus reducing the weight upon the shoulders. (*Tanki Yôryaku Hikôben*, 1735)

Fig. 98. He would then put on his short trousers (*kobakama*), which had cords at the hem so that they could be tied under the knees. (*Tanki Yôryaku Hikôben*, 1735)

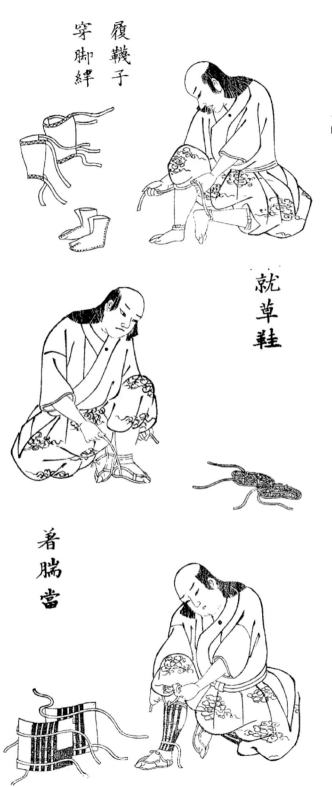

履鞜子
穿脚絆

Fig. 99. The samurai then put on his gaiters (*kyahan*), wrapped around the calves and the lower edge of the trousers and held in place by cords at the top and bottom. On the feet, he put on the customary divided socks (*tabi*). (*Tanki Yôryaku Hikôben*, 1735)

就草鞋

Fig. 100. The next step was to put on straw sandals (*waraji*), tied in one of several ways but preferably with an extra tie across the instep, since this helped to keep the sandals in place when marching across difficult ground. (*Tanki Yôryaku Hikôben*, 1735)

著臑當

Fig. 101. Then he put on the shin guards (*suneate*). (*Tanki Yôryaku Hikôben*, 1735)

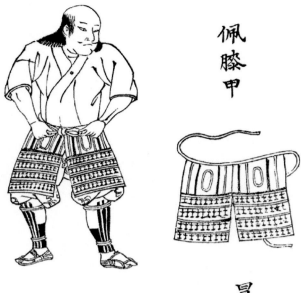

Fig.102. Above the shin guards, the samurai put on thigh guards (*haidate*) in the form of a divided apron with the lower parts covered with lamellar armour; the entire set was tied in front with a cord around the waist. (*Tanki Yôryaku Hikôben*, 1735)

Fig. 103. Next, the samurai would don archer's gloves (*yugake*). (*Tanki Yôryaku Hikôben*, 1735)

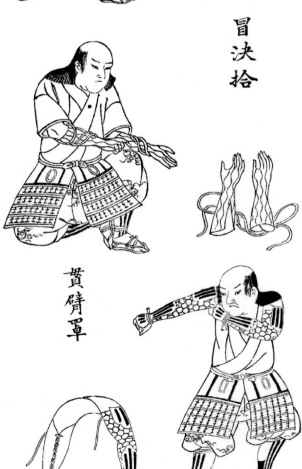

Fig. 104. Then he would put on the armoured sleeves (*kote*). Most included plate half-gauntlets to protect the back of the hand. Some types of armoured sleeves could be attached to the cuirass, but more common in the Edo period was a type (*aigote*) in which the two sleeves were attached to each other, and then tied with a cord across the chest. This type could also be used without cuirass. (*Tanki Yôryaku Hikôben*, 1735)

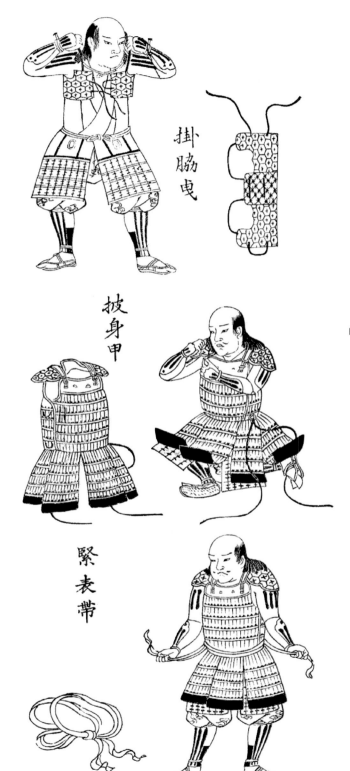

Fig. 105. The next step was to put on the armpit guards (*wakibiki*). In the Edo period, these often formed part of a sleeveless jacket of chainmail or brigandine which also provided some additional protection to the chest and upper back. (*Tanki Yôryaku Hikôben*, 1735)

Fig. 106. The samurai then put on the cuirass (*dô*) and tassets (*kusazuri*), which were attached to the cuirass to protect hips and thighs. Most Edo period cuirasses consisted of distinct but attached breast- and backplates, which opened at the side (*dômaru*). The cuirass depicted here, unlike the shot-proof ones of the sixteenth century, consists of overlapping metal lamellae, laced together in horizontal rows. A revival of an older style of armour which was repeatedly condemned by contemporary experts as unsuitable for modern warfare, its popularity for aesthetic reasons nonetheless grew during the long peace of the Edo period. (*Tanki Yôryaku Hikôben*, 1735)

Fig. 107. A second sash (*uwa-obi*) was wound twice or thrice around the waist and tied in front as a means of supporting the cuirass and keeping the tassets in position. (*Tanki Yôryaku Hikôben*, 1735)

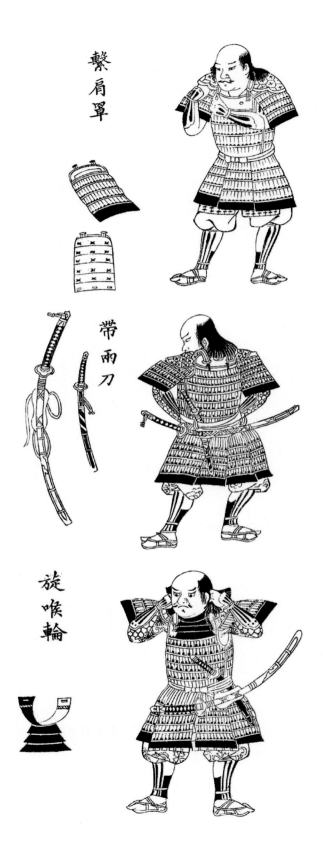

Fig. 108. Next, the samurai put on shoulder guards (*sode*). Originally large and worn over the armoured small wings (*kohire*) attached to the shoulder straps (*watagami*) of the cuirass, shoulder guards began to be worn as depicted already in the late sixteenth century. In the Edo period, shoulder guards were often dispensed with altogether. In the illustration, a shoulder guard is depicted as seen from both the outside and inside, displaying its lamellar structure. (*Tanki Yôryaku Hikôben*, 1735)

Fig. 109. The next step was to don the two swords. In this style, the long sword was tied to a looped leather hanger (*koshiate*) which enable the carrying of a regular *katana* in *tachi* style, that is, with the edge downwards but without the fittings of a *tachi*. Since the function of the sword remained the same, the introduction of this manner of carrying the *katana* saved the expense of buying two separate sets of mountings for the same sword. (*Tanki Yôryaku Hikôben*, 1735)

Fig. 110. The samurai then donned a throat guard (*nodowa*). (*Tanki Yôryaku Hikôben*, 1735)

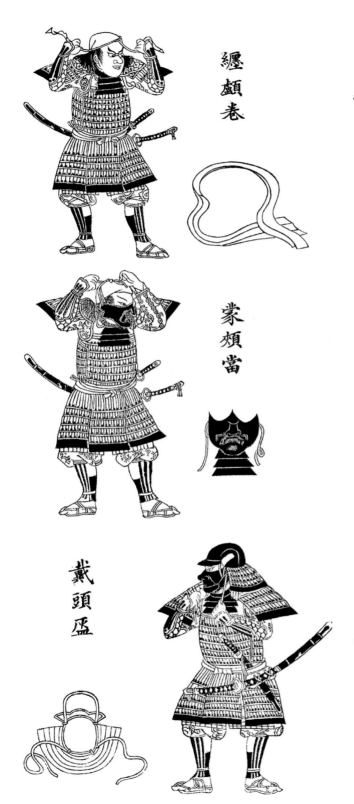

繩顱巻

Fig. 111. Next, he tied the headband (*hachimaki*) around his head to soak up sweat and provide some additional padding for the helmet. (*Tanki Yôryaku Hikôben*, 1735)

蒙頰當

Fig. 112. He then donned a face mask (*menpô*). At this time, many face masks were fitted with a throat defence (*yodarekake*), so often the *nodawa* was discarded. Face masks came in many different varieties, some of which included fierce-looking moustaches and depicted the face of an old man or demon. (*Tanki Yôryaku Hikôben*, 1735)

戴頭盔

Fig. 113. The next step was to put on the helmet (*kabuto*), of traditional type with a lamellar neck guard (*shikoro*). The helmet, the bowl of which had a quilted silk lining, is also depicted from underneath. (*Tanki Yôryaku Hikôben*, 1735)

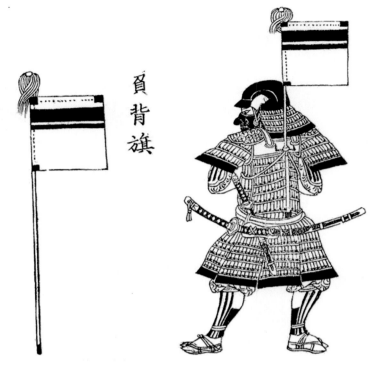

Fig. 114. Many samurai would carry a banner (*sashimono*) on their back as a means of identification. Typically bearing the crest (*mon*) of the clan for which he was fighting or the unit in which he served, the banner rested in a socket on the back of the cuirass at waist level and was secured by a hinged bridge-piece ending in a ring between the shoulder-blades. (*Tanki Yôryaku Hikôben*, 1735)

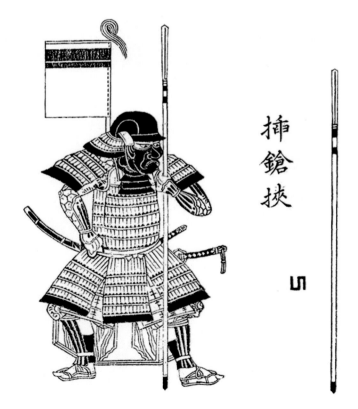

Fig. 115. Samurai in full armour, armed with spear (*yari*) and prepared for battle. (*Tanki Yôryaku Hikôben*, 1735)

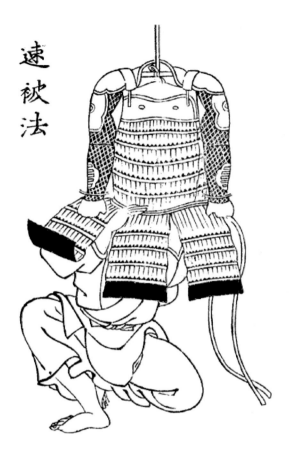

速秘法

Fig. 116. The most important pieces of the suit of armour could be attached to the cuirass in advance and hung up, so that the owner, when in a hurry, could put it all on at once by kneeling down and then rising up into the suit of armour from below. (*Tanki Yôryaku Hikôben*, 1735)

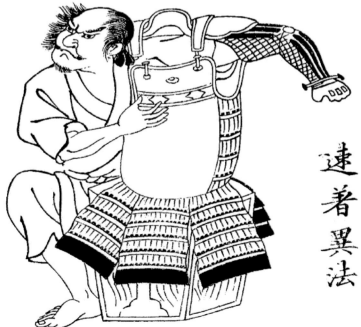

速著異法

Fig. 117. Another option to don a suit of armour with its pieces attached in advance was to stand it on the armour box, and then ease into it sideways through the cuirass's opening at the side. (*Tanki Yôryaku Hikôben*, 1735)

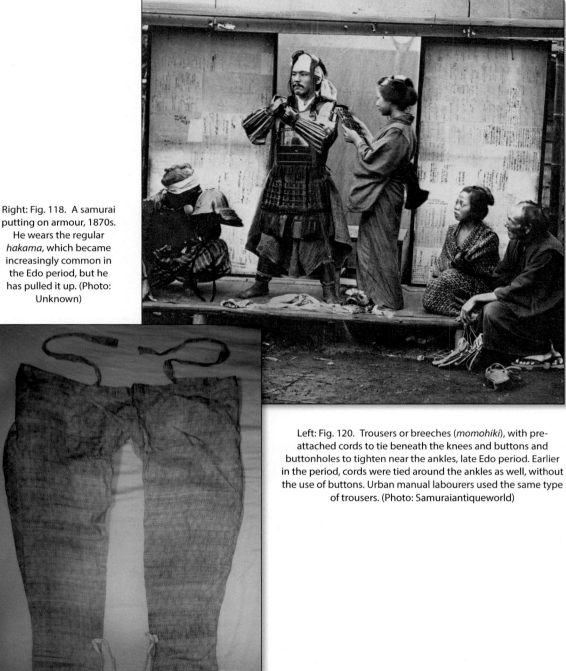

Right: Fig. 118. A samurai putting on armour, 1870s. He wears the regular *hakama*, which became increasingly common in the Edo period, but he has pulled it up. (Photo: Unknown)

Left: Fig. 120. Trousers or breeches (*momohiki*), with pre-attached cords to tie beneath the knees and buttons and buttonholes to tighten near the ankles, late Edo period. Earlier in the period, cords were tied around the ankles as well, without the use of buttons. Urban manual labourers used the same type of trousers. (Photo: Samuraiantiqueworld)

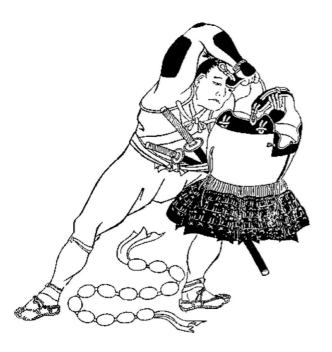

Fig. 119. Having already put on the armoured sleeves (*kote*) with attached plate half-gauntlets to protect the back of the hand, and tied them with a cord across his chest, this samurai infantryman is easing into the cuirass sideways through its opening at the side. If putting on a full suit of armour, he would not have worn his swords already at this time, since the second sash (*uwa-obi*), through which the swords were thrust, would be tied afterwards as a means of supporting the cuirass and keeping the tassets in position. However, all depictions of infantrymen in the *Zôhyô Monogatari* shows the *uwa-obi* not above but under the tassets. Among seventeenth-century samurai of low rank, this may have been a reflection of how they carried their swords with the edge upwards when in civilian dress. Most would not have owned the mountings to hang the sword in *tachi* style. The secondary illustrations depict his war hat (*jingasa*), cuirass, and some gear, including the cloth tube of provisions in which each section contained a day's ration of rice and a float for crossing water. (*Zôhyô Monogatari*)

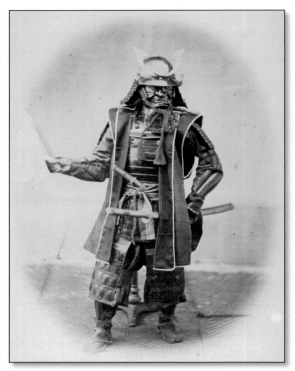

Fig. 121. Kubota Sentarô, a shogunate general, 1863. (Photo: Felice Beato)

discarded their armour. In Japan, the trend was further augmented by the fact that the country remained at peace.

Daimyô and senior samurai continued to procure and wear full armour when the country was at peace, for ceremonial use among those who could afford it or, in some cases, perhaps as heirlooms, stored in a storehouse and gradually forgotten by those who lacked the means to acquire a completely new set (Fig. 121). In fact, those who could afford it tended to procure increasingly expensive sets of personal armour, sometimes in what can only be referred to as retro styles, that were so exquisitely decorated that in reality they would have served less well under battlefield conditions than the types of armour that had been perfected in the sixteenth century. This revival was exemplified and to some extent initiated by the publication of the multi-volume work on classical armour *Honchô Gunkikô* ('General History of Military Discipline'), written between 1709 and 1722 by the Confucian scholar, antiquarian, and statesman Arai Hakuseki (1657–1725).[19] Later in the century, the armour expert Sakakibara Kôzan (1734–1798) grumbled that while Arai's work was 'an excellent guide for later generations in the collection of the arms and accoutrements of antiquity', the book appeared a century after the age of civil wars when knowledge of military matters had almost faded from knowledge. As a result, 'the *Gunkikô* misled people into forgetting them entirely … [since the book evoked among samurai] the spirit of the curio-collector … trivial details insisted upon, and the wildest statements made.' For instance, unlike the shot-proof cuirasses of the past, the expensive peacetime cuirasses tended to be embossed or use an excessive amount of lacing, either of which caught the points of enemy weapons instead of allowing them to glance off. Moreover, the lacing tended to become very heavy when soaked with water, dried only slowly, and might then freeze in winter. In addition, Sakakibara sardonically noted, on campaign the lacing tended to become infested with lice.[20] The revival of retro fashions was obvious in the manufacture of helmets as well. For instance, the wings or turnback (*fukigaeshi*, 'blown backwards') of the traditional helmet was originally formed by the front edge of the upper row or rows of lamellae of the neck guard. However, it will be shown that in the Edo period many helmets were manufactured for use with a hood instead of a neck guard. For this reason, the turnback was often attached directly to the helmet (Fig. 122). Moreover, for practical purposes the size of

19 Arai Hakuseki, *The Armour Book in Honchô-Gunkiko* (London: The Holland Press, 1964).

20 Sakakibara, *Manufacture of Armour and Helmets*, pp.19, 20, 93. Sakakibara's work was first published in 1800.

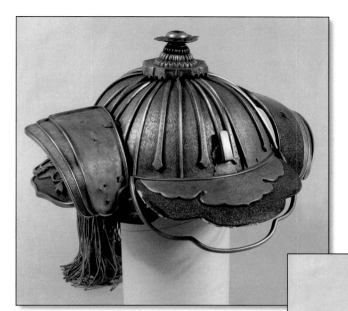

Figs 122a–c. A ridged helmet (*sujibachi kabuto*), eighteenth century, made in the retro style then fashionable. A ridged helmet consisted of multiple plates riveted together in a manner in which the rivets were countersunk leaving the flanged edges of the plates prominent. In some helmets (not this one), the overlap of the plates effectively doubled the thickness of the helmet. The wings or turnback (*fukigaeshi*) was originally formed by the front edge of the upper row or rows of the neck guard; however, in the Edo period many helmets were manufactured for use with a hood instead of a neck guard, for which reason the turnback was attached directly to the helmet. (Army Museum, Stockholm; from the collection of Gösta H. Benckert)

the turnback had been reduced in the sixteenth century. Experts of military armour such as Sakakibara Kôzan deemed the reduced size more suitable for combat conditions. However, the large turnback, too, enjoyed a revival in the Edo period, even when attached directly to the helmet (Figs 123–124).[21]

However, a low-ranking samurai rarely had the financial means to purchase a full set of armour. At about the time of the introduction of the shogunate, the Tokugawa elevated all foot soldiers to samurai status, turning many of them into *gokenin*. As a result, henceforth they had to provide their own equipment, each according to his means. The same development with regard to armour accordingly took place among them as well as among other low-ranking samurai. While it is likely that old military cuirasses, war hats, and the like were retained in the shogunate armouries, to be issued to the *chûgen* (valets), if they were ever called up for war, we know little of the procedures and plans for such an event, and in any case, the former *ashigaru* were no longer eligible. Moreover, since the wars were over, a low-ranking samurai would not perceive a real need for armour. As a result, lower-ranking samurai acquired only those pieces of armour which they could afford and found useful, such as perhaps a set of gloves and armoured sleeves, a simple, often non-metallic helmet, and perhaps some protection for the torso.

The gradual simplification, indeed elimination of armour was not only the result of changing military practices. It was also the result of a lack of practise. Dazai Shundai noted that '[t]he officers of these times never once in a lifetime don their armour at all; they would not therefore know how to wear it, should necessity arise. They do not know how to move when clad in armour.'[22]

As a result most samurai, even those on active duty, reduced the quantity and types of armour which they used. For a while, foot soldiers on active duty retained the kind of simple armour – cuirass, tassets, and war hat – which they or their ancestors had worn during the final decades of the civil wars. Officers adopted this simplified style, too, although they might still wear a better-quality cuirass. The short trousers of the *kobakama* type might then be worn either tied up below the knee (*tattsukebakama*) as in the old style, or open at the bottom (*nobakama*), which was more comfortable in hot weather. When anticipating combat, both men and officers might add whatever pieces of armour that they found convenient or affordable, typically a set of gloves and armoured sleeves and shin guards. Most warriors needed no more, since any fighting for which they might be called up usually was akin to police action rather than battlefield operations. Some items of armour were reduced in size. For instance, the armoured sleeves (*kote*) were sometime exchanged for the shorter half-sleeves (*hankote*) (Fig. 125). For daily dress, officers commonly replaced the old cumbersome helmet with a 'horseman's war hat' (*bajôjingasa*).

The armour used by law enforcement officers and firefighters developed in a somewhat different direction than that of other samurai. This was unsurprising, since these two professions, unlike most samurai, faced a continued need for protective armour in the carrying out of their duties.

21 *Ibid.*, pp.56, 60.

22 Dazai , 'Bubi', p.36.

Right: Fig. 123. Riveted or knobbed helmet (*hoshibachi kabuto*) with the crest of the Matsudaira clan, eighteenth century. This helmet, too, is in retro style. The protruding rivets or knobs are positioned on the centre line of each plate rather than along the rear edge, which characterised older helmets since from a manufacturing perspective this was the more utilitarian position. However, the turnback (*fukigaeshi*) is of the reduced size that became common in the sixteenth century and which experts of military armour such as Sakakibara Kôzan deemed more suitable for combat conditions. On the other hand, the turnback is overlaid with leather, which again was in imitation of earlier styles. (The Ann and Gabriel Barbier-Mueller Museum, Dallas. Photo: Daderot)

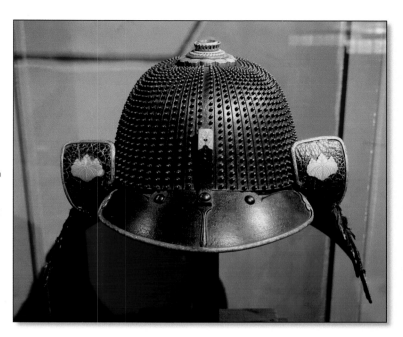

Below: Fig. 124. Riveted or knobbed helmet (*hoshibachi kabuto*), signed Myôchin Shikibu Ki (no) Munesuke and dated 1693. Munesuke was a well-known master armourer who worked in Aoyama and Kanda, Edo. Probably for this reason, the bowl's protruding rivets or knobs are positioned along the rear edge of each plate, in the utilitarian style which characterised sixteenth-century helmets. However, at some later point new embellished items were added to the bowl, including a large separate turnback (*fukigaeshi*) in imitation of earlier styles. It was common to modify a high-quality helmet bowl according to changes in fashion. (The Ann and Gabriel Barbier-Mueller Museum, Dallas. Photo: Daderot)

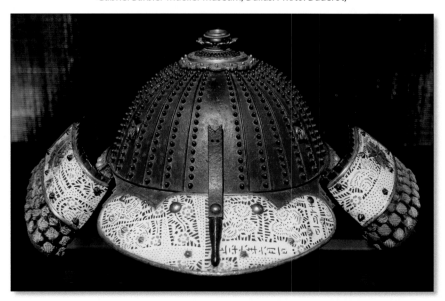

Moreover, over time the types of armour preferred by these two groups increasingly came to influence the choice of armour among other samurai, too, with the possible exception of those great lords who could afford the traditional armour.

Perhaps the most characteristic development was the general introduction of 'folding armour' (*tatami gusoku*), and as part of this trend, the increased use of chainmail (*kusari*). Neither innovation was, strictly speaking, new but both these types of armour grew significantly more common in the Edo period. Introduced in the sixteenth century, folding armour typically consisted of a cuirass of rectangular or hexagonal plates, linked together by chainmail (Figs 126–127). In effect, the principles already in use for shin guards and armoured sleeves were henceforth applied to the entire suit of armour. Even the helmet with its neck guard could be manufactured in this way (Figs 128a and 128b). The advantages were that the entire set easily could be folded away for storage or transportation when not in use, which was good for those who lived in cramped quarters; it could easily be worn under one's usual clothes, which did not draw as much attention on the street as a man in full battlefield armour; and due to its light weight was more comfortable to wear. Moreover, folding armour remained adequate as protection when dealing with unruly, unarmed townsmen or common criminals, which made it very suitable for law enforcement. Folding armour was also attributed to the assassins in later years known as *ninja* or *shinobi* (Fig. 129). In its most lightweight form, folding armour consisted merely of an armoured coat (*tatami katabira*) (Figs 130–132). To this might be added a hooded half-helmet of metal or leather (*hanburi* or *hachigane*) (Figs 133–134). Then again, the samurai might use an entire folding helmet (*tatami kabuto*), which consisted of a collapsible skullcap and neck guard

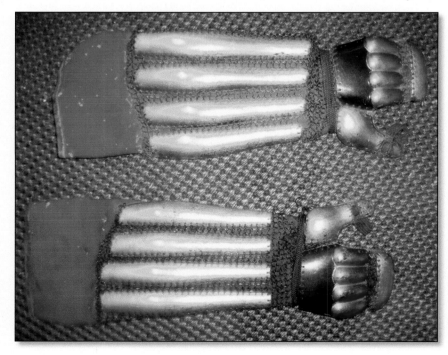

Fig. 125. Half-sleeves (*hankote*) of iron plates linked by chainmail attached to a cloth backing. Edo period. (Photo: Samuraiantiqueworld)

made of iron plates linked together by chainmail (Fig. 135). Alternatively, the neck guard might consist of brigandine. There was also the collapsible 'paper lantern helmet' (*chôchin kabuto*) which commonly had a folding brigandine neck guard (Fig. 136). In style, the folding helmet was similar to the helmet with hood (*kaji kabuto*) used by firemen (Fig. 137).

Chainmail armour, which had existed in Japan for centuries, formed an important component of folding armour. However, in the Edo period chainmail came into its own. Soon entire suits of armour (*kusari gusoku*) were made of chainmail. The main reason for its growing popularity was that chainmail armour was lightweight, easily portable, and performed well also when worn under ordinary clothing. For this reason, chainmail was particularly favoured by police officers, and in extension, everybody else who had reason not to display a full set of military paraphernalia openly. Chainmail coats (*kusari katabira*) with chainmail sleeves (*kusarigote*), which might or not be detachable, were in relatively common use. Many were used with chainmail hoods (*kusari zukin*). Soon, all parts of the armour were made from chainmail, including even the throat guard and face mask (Figs 138–150). Such an outfit, worn under regular clothing, was, for instance, used by the famous 47 Akô *rônin* who in celebrated raid carried out in 1703, known as the Forty-Seven *Rônin* Incident or Akô Incident, took revenge for the death of their lord. Their clothes and other gear including chainmail armour, regular shin guards, armoured sleeves with half-gauntlets, and half-helmets (*hanburi* or *hachigane*) or fireman's helmets (*kaji kabuto*), were preserved in Sengakuji Temple in Edo, which is also the location of their tombs (Figs 151–152). Although most chainmail links in Japan were only butted or turned together (that is, the ends touched but were not fastened to each other), the use of riveted links was known and sometimes described as copied from chainmail introduced by Europeans (*nanban*) in the sixteenth century.

Neither folding nor chainmail armour were shot-proof, but they were less bulky than traditional armour and, as we have seen, most pieces could be worn under regular clothing. This was another advantage, in particular for police officers in civilian dress and their opponents, that is, those who did not wish to be easily spotted.

As noted, many of the 47 Akô *rônin* wore light metal or leather half-helmets (*hanburi*, 'half-head', or *hachigane*) for their protection. As with the other new developments in Edo period armour, the half-helmet, too, had existed in the past, even though it certainly grew more prevalent in the Edo period. Most half-helmets covered the forehead only, which not only made them lightweight but also enabled the retention of the samurai queue while wearing the helmet. Generally made from a series of retractable, hinged plates, some half-helmets were attached to chainmail hoods and/or were covered with leather, with a strap on each side to fasten the helmet under the chin. An even more simple form of head protection was the forehead guard, which fundamentally consisted of a headcloth (*hachimaki*) reinforced across the forehead.

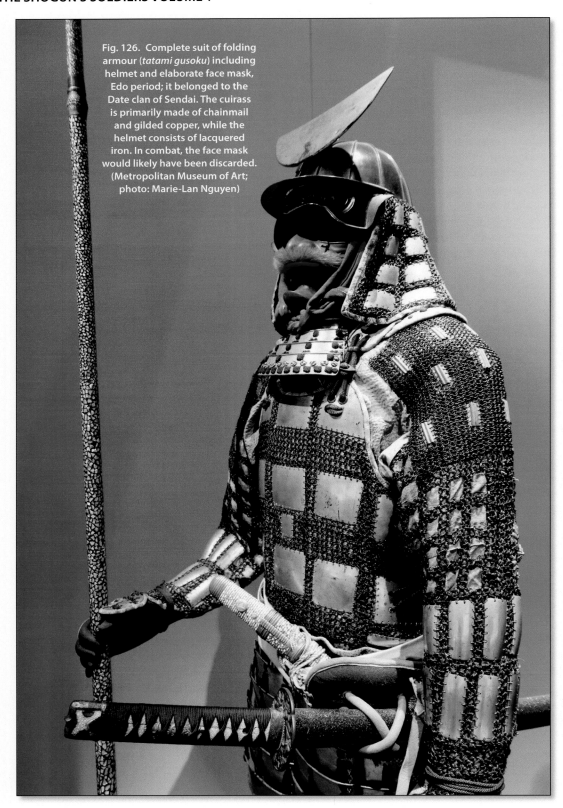

Fig. 126. Complete suit of folding armour (*tatami gusoku*) including helmet and elaborate face mask, Edo period; it belonged to the Date clan of Sendai. The cuirass is primarily made of chainmail and gilded copper, while the helmet consists of lacquered iron. In combat, the face mask would likely have been discarded. (Metropolitan Museum of Art; photo: Marie-Lan Nguyen)

Left: Fig. 127. Cuirass of folding armour (*tatamidô*) made of brigandine, probably Edo period. (Photo: Samuraiantiqueworld)

Left: Fig. 128a. Cuirass with tassets and hooded helmet of folding armour, Edo period. Although folding, the cuirass was probably not intended to be worn under the owner's civilian clothes but the material was likely chosen for easy transportation. (Photo: Samuraiantiqueworld)

Below: Fig. 128b. Close-up of the folding helmet, shaped like a hood (*tatami zukin*), Edo period. (Photo: Samuraiantiqueworld)

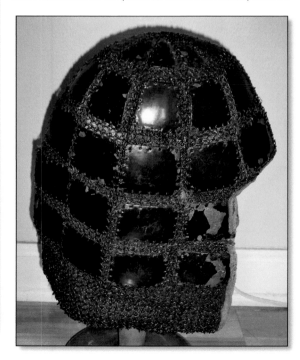

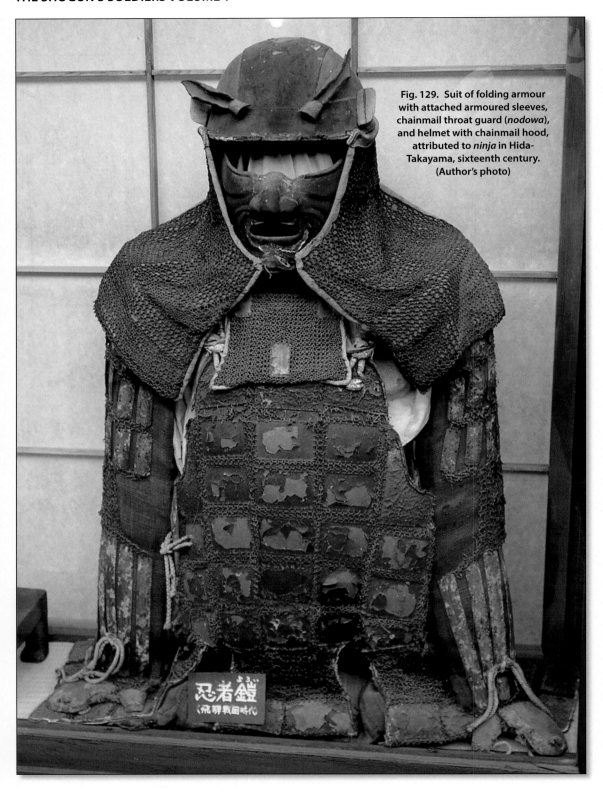

Fig. 129. Suit of folding armour with attached armoured sleeves, chainmail throat guard (*nodowa*), and helmet with chainmail hood, attributed to *ninja* in Hida-Takayama, sixteenth century. (Author's photo)

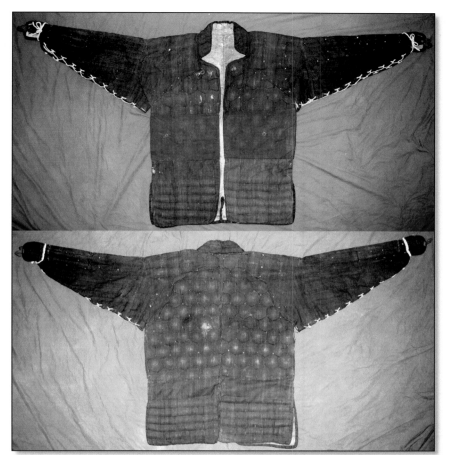

Left: Fig. 130. Front and back views of a brigandine coat (*kikkô katabira*) with attached armoured sleeves with half-gauntlets of the same material. Edo period. Made of brigandine, with metal plates hidden between layers of fabric. (Photo: Worldantiques)

Below: Fig. 131. Brigandine coat (*kikkô katabira*) with attached armoured sleeves, Edo period. Made of brigandine, with hexagon-shaped leather (*nerigawa*) plates hidden between layers of fabric. (Photo: Samuraiantiqueworld)

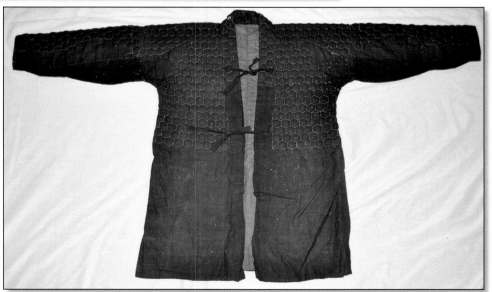

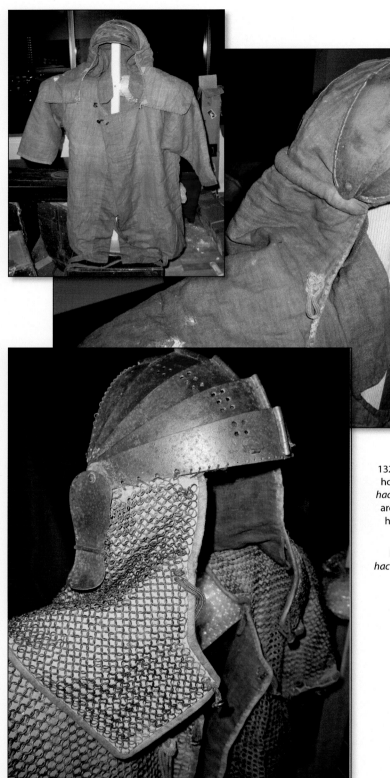

Top left, and above: Figs 132a and 132b. Brigandine coat (*kikkô katabira*) with hooded half-helmet of leather (*hanburi* or *hachigane*), Edo period. Both coat and hood are made of brigandine, with metal plates hidden between layers of fabric. (Photo: Samuraiantiqueworld)

Left: Fig. 133. Half-helmet (*hanburi* or *hachigane*) with chainmail hood, Edo period. (Photo: Samuraiantiqueworld)

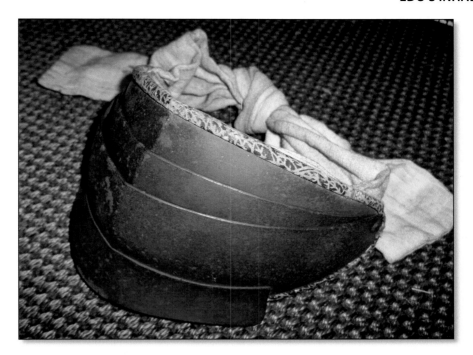

Above: Fig. 134. Half-helmet (*hanburi* or *hachigane*), Edo period. (Photo: Samuraiantiqueworld)

Below: 135. Helmet of the skull cap type with chainmail neck guard (*kusari shikoro*), as seen from behind, Edo period. (Photo: Samuraiantiqueworld)

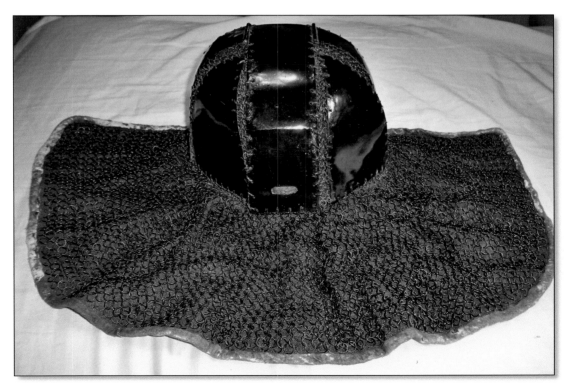

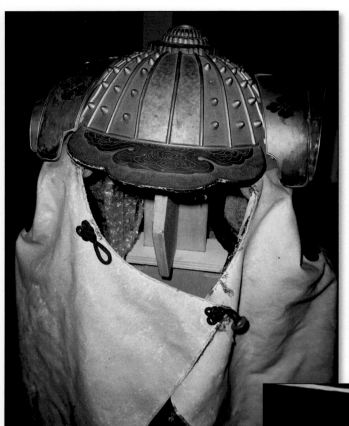

Left: Fig. 137. Fireman's helmet with hood (*kaji kabuto*). (Photo: Samuraiantiqueworld)

Below: Fig. 136. Collapsible 'paper lantern helmet' (*chôchin kabuto*) with folding brigandine neck guard, probably Edo period. Named after the collapsible paper lantern (*chôchin*), it could be collapsed for easy transportation. (Photo: Samuraiantiqueworld)

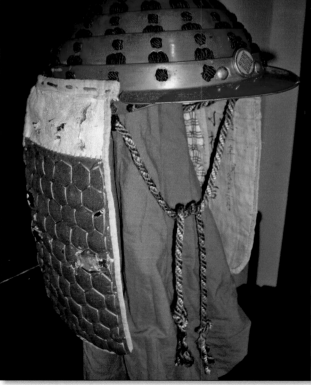

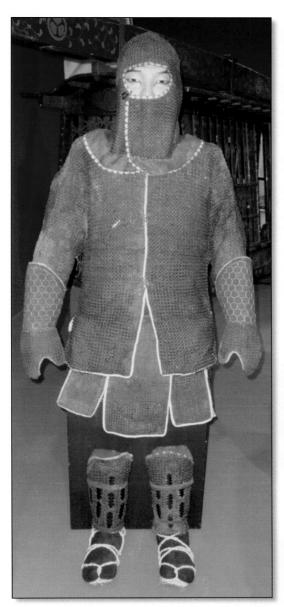

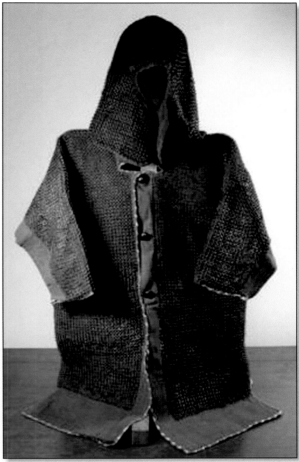

Above: Fig. 139. Chainmail coat with sleeves (*kusarigatabira*) and hood (*kusari zukin*), Edo period. (Author's photo)

Above: Fig. 138. Complete suit of chainmail armour (*kusari gusoku*), consisting of coat with sleeves, gloves, thigh guards, shin guards with knee pads, and hood, Edo period. When worn under civilian dress, the thigh guards would be discarded. (Photo: Samuraiantiqueworld)

Right: Fig. 140. Chainmail coat (*kusarigatabira*) and hood (*kusari zukin*), Edo period. (Photo: Samuraiantiqueworld)

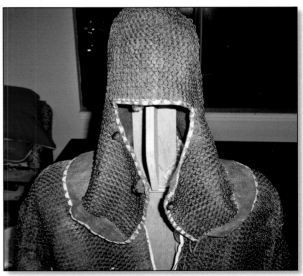

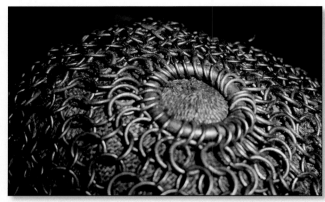

Top: Fig. 141. Top of the chainmail hood (*kusari zukin*), Edo period. (Photo: Samuraiantiqueworld)

Centre: Fig. 142. Chainmail coat with gilded copper plates (*karuta katabira*), probably Edo period. (Photo: Samuraiantiqueworld)

Bottom: Fig. 143. Chainmail hood (*kusari zukin*), Edo period. (Photo: Samuraiantiqueworld)

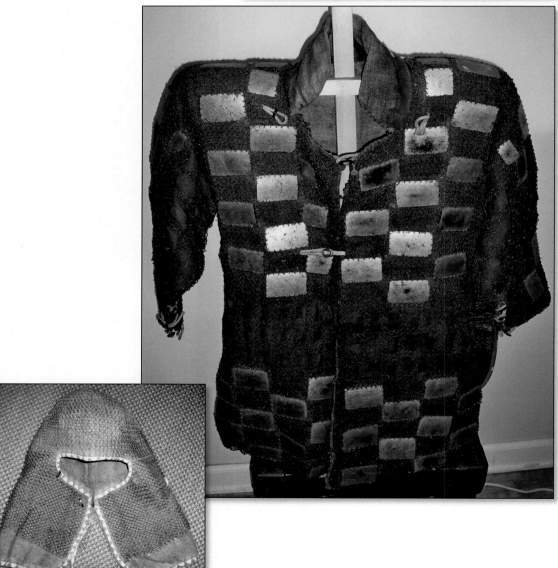

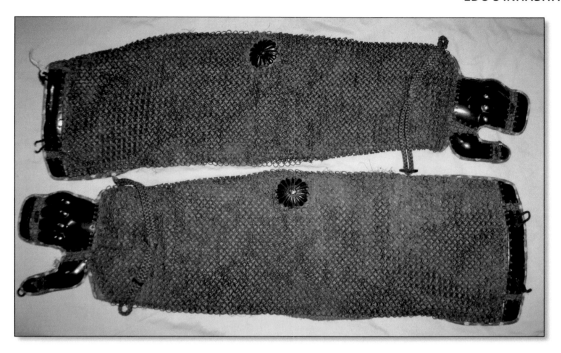

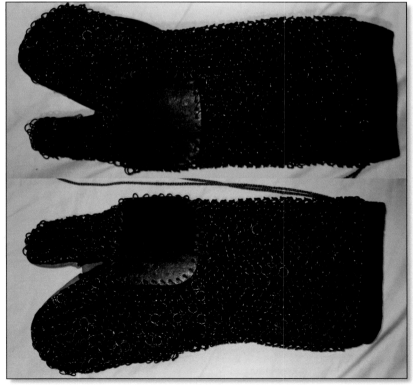

Above: Fig. 144. Detachable armoured sleeves (*kusarigote*), consisting of chainmail on fabric, with plate half-gauntlets to protect the back of the hand and thumb, probably Edo period. (Photo: Samuraiantiqueworld)

Left: Fig. 145. Chainmail half-sleeves with gauntlets (*kusari hankote*), Edo period. (Photo: Samuraiantiqueworld)

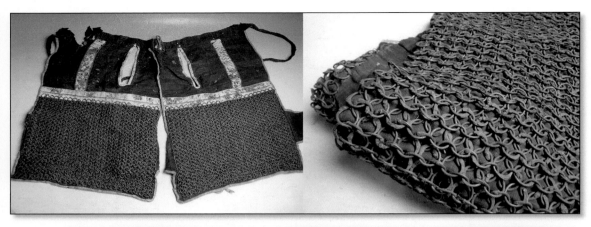

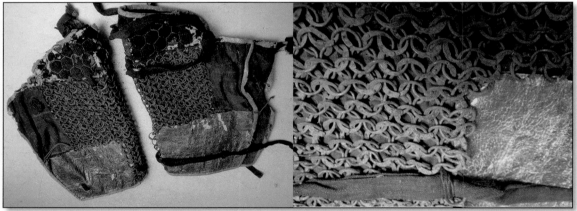

Top: Fig. 146. Chainmail thigh guards (*kusari haidate*), Edo period. Notice the use of riveted links. (Photo: Samuraiantiqueworld)

Centre: Fig. 147. Chainmail shin guards (*kusari suneate*), Edo period. Notice the use of riveted links. (Photo: Samuraiantiqueworld)

Right: Fig. 148. Chainmail socks (*kusari tabi*), Edo period. (Photo: Samuraiantiqueworld)

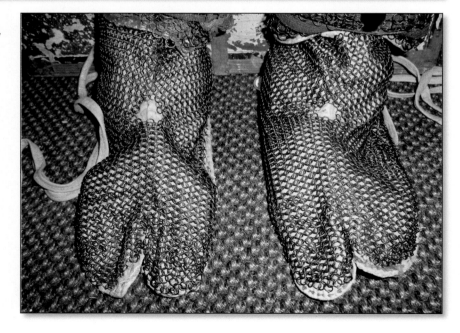

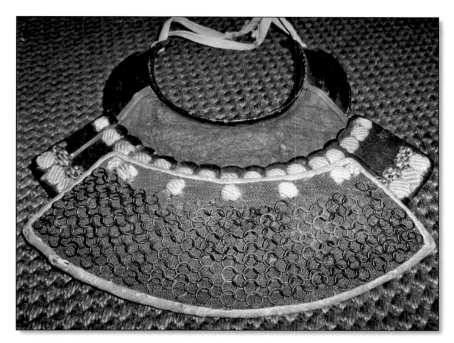

Left: Fig. 149. Throat guard (*kusari nodowa*), Edo period. (Photo: Samuraiantiqueworld)

Below: Fig. 150. Chainmail face mask (*kusari menpô*), in reality with only the throat defence (*yodarekake*) made of chainmail, Edo period. (Photo: Samuraiantiqueworld)

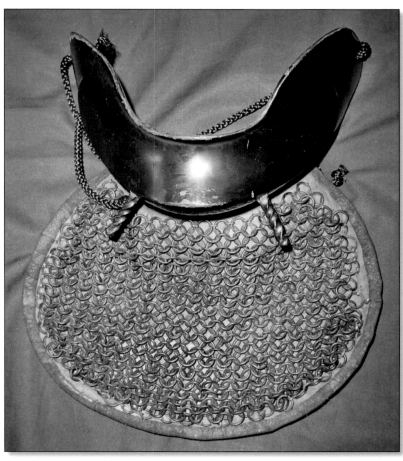

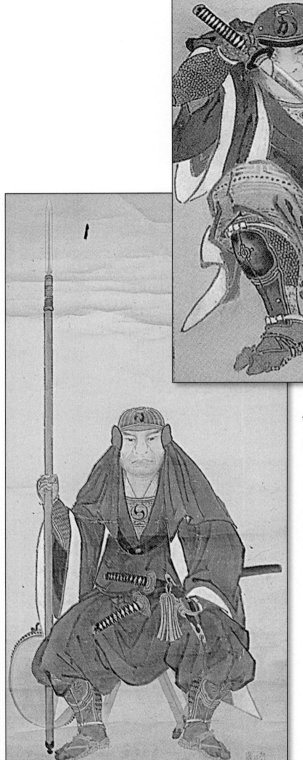

Above: Fig. 151. Okuda Sadaemon Yukitaka, one of the men from the Forty-Seven Rônin Incident, as painted by Nagayasu Yoshinobu (1788–1868). Like his chief Ôishi (left), he has a hooded fireman's helmet while his cuirass, armoured sleeves, and shin guards are worn under his regular clothing.

Left: Fig. 152. Ôishi Yoshio, from the Forty-Seven Rônin Incident, as painted by Nagayasu Yoshinobu (1788–1868). With a hooded fireman's helmet and cuirass, armoured sleeves, and shin guards hidden under his regular clothing, this depiction probably gives a fair picture of what fighting samurai looked like during the long period of peace.

Some of the Akô *rônin* wore a variant of the fireman's helmet instead of a regular helmet or a half-helmet. This was the result of yet another development in Edo period armour. Many samurai eager for a career of physical action served as firemen, a duty which was held in high regard and certainly was seen as more honourable than service as a police officer. For this reason, the fireman's hooded helmet (*kaji kabuto*) became a common addition to the Edo period samurai's set of armour. With a skullcap commonly of leather, it had a fire neck guard (*hikeshi shikoro*) customarily made of woollen felt (*rasha*, a word of Portuguese origin) and a long hood which for senior samurai and *daimyô* would reach around one metre in length, both of which served as protection against sparks. Reinforced with chainmail, such a helmet would bring significant protection to the head. Common firemen did not always wear the helmet but had to make do with a fireman's hood (*hikeshi zukin*) of similar shape but without skullcap and metal protection. It is telling of the efficiency of this particular item that its basic shape remained in general service for civil defence purposes well into the twentieth century. In addition to the fireman's helmet, many samurai on firefighting service wore a cotton and silk breastplate (*muneate*), which at least late in the period commonly was non-metallic, under a protective fireman's coat (*kajibaori*) made of thick woollen cloth lined with silk. The coat was tied together with a special belt (*ishi-obi*). The purpose of the outfit was to protect against sparks from the fire.

Horse Armour

With the general deterioration of the army that took place in the early Edo period followed, paradoxically, the reintroduction of horse armour. Although horse armour had existed in ancient times, before the emergence of the samurai class, samurai cavalry had never used horse armour (*bagai*) in battle. However, the peaceful conditions of the last years of the sixteenth century and, even more so, the Edo period enabled those who could afford it to dress their horses in increasingly extravagant gear and tack (*bagu*). Both bardings (a horse's body armour) and the chanfron (armour plate to protect the horse's head) were reintroduced. Since no further wars took place, neither is believed ever to have been used in battle. An Edo period chanfron (*bamen*) was in all essentials a mask portraying the head of a dragon, monkey, or mythical beast such as the *kirin* (the unicorn of Chinese legend). Oddly enough, quite a few chanfrons instead depicted the head of a horse. Although a few were made of steel, most were made of paper or leather and had little protective value (Figs 153–154).

Bardings were lightweight, consisting of small square scales of leather moulded, lacquered, and sewn on cloth. The crupper, which covered the quarters, was rectangular, with an attached, likewise rectangular tail guard. Triangular pieces covered the neck and the horse's chest, although the latter seems sometimes to have been protected by an additional rectangular piece. The flanchards were large, oval, and hung from the saddle. Flanchards were frequently carried also without bardings and then for decorative purposes only (Figs 155–156). A horseman might display his family crest (*mon*) on the bardings as a further means to show off his importance.

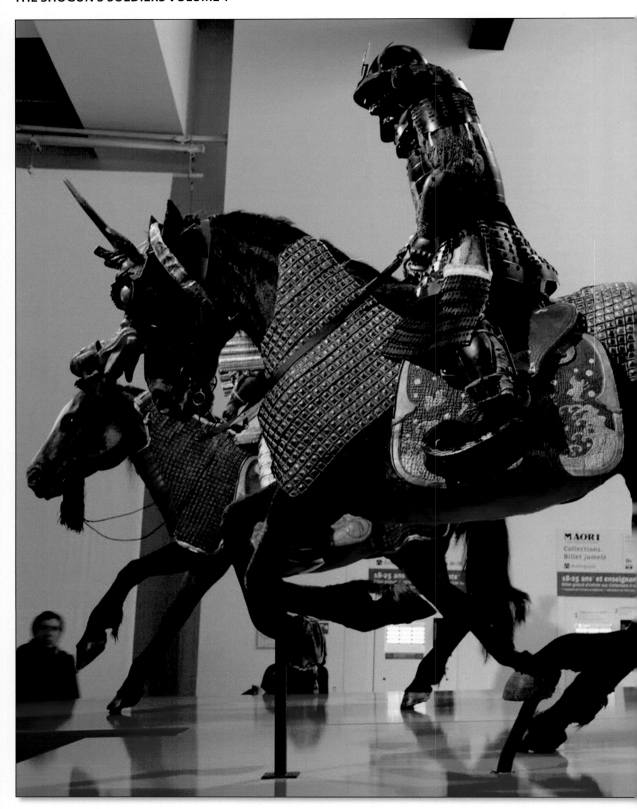

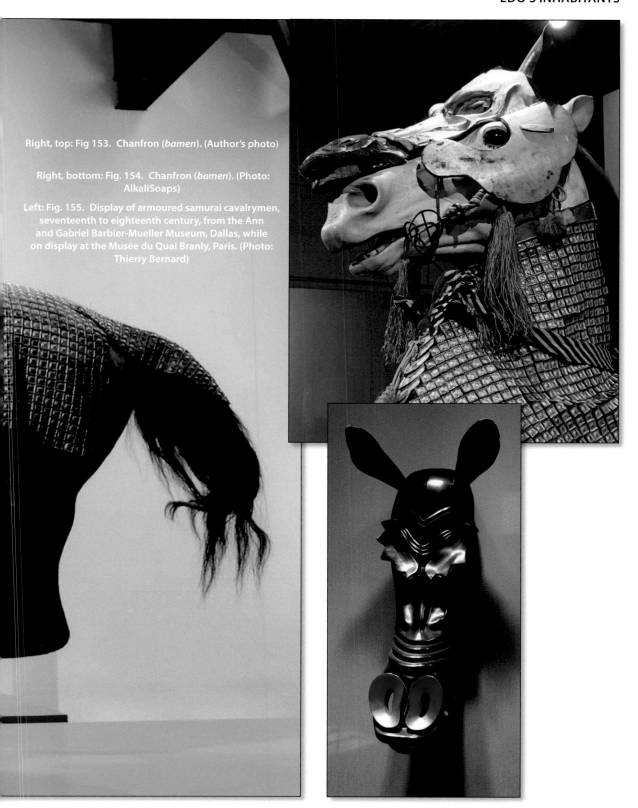

Right, top: Fig 153. Chanfron (*bamen*). (Author's photo)

Right, bottom: Fig. 154. Chanfron (*bamen*). (Photo: AlkaliSoaps)

Left: Fig. 155. Display of armoured samurai cavalrymen, seventeenth to eighteenth century, from the Ann and Gabriel Barbier-Mueller Museum, Dallas, while on display at the Musée du Quai Branly, Paris. (Photo: Thierry Bernard)

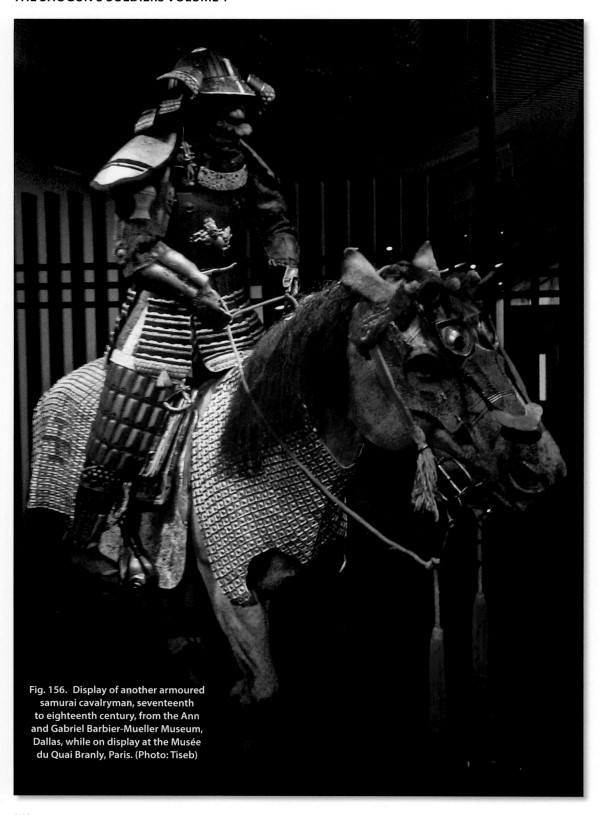

Fig. 156. Display of another armoured samurai cavalryman, seventeenth to eighteenth century, from the Ann and Gabriel Barbier-Mueller Museum, Dallas, while on display at the Musée du Quai Branly, Paris. (Photo: Tiseb)

Female Dress

Women's dress consisted basically of the kimono. There were, however, numerous small details that depended on current fashion. In addition to choice of cloth, colours, and patterns, there were also fashions in the styles of sleeves and sashes. High-ranking courtesans were considered to be fashion leaders. Each generally required a complete new wardrobe each season, paid for by her patrons. The coming of each new season accordingly caused great expectations, and the new styles were soon eagerly copied and followed by the pillars of the community, the steady, married upper-class ladies.

From the mid Edo period, the *furisode* (long-sleeve) style of kimono became fashionable among the young daughters of wealthy families (Fig. 157). These kimono were more costly, as they had wide flowing sleeves that, when the arm was extended, hung down further than those of an ordinary kimono, from then onwards known as the *tomesode* (abbreviated sleeve) style.

Fig. 157. Young woman, mid nineteenth century. Although a staged photograph, it illustrates daily dress earlier in the Edo period as well. (Photo: Felice Beato)

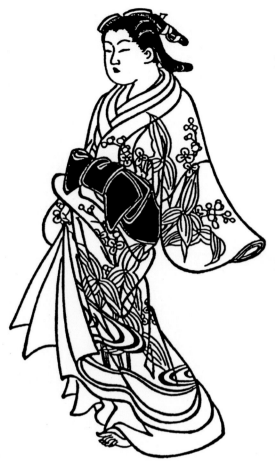

Fig. 158. Woman with the *obi* tied in front, signifying married status

More important than the kimono itself was arguably the long sash (*obi*). Before the Edo period, the sash was rather narrow, about 7.5–10 cm wide. This frugality was dispensed with early in the Edo period (around the mid seventeenth century). Broad *obi* became fashionable, with women's *obi* measuring approximately 20–30 cm in width and two metres or more in length. Even this width was not considered sufficient, however, as a broader *obi* was more expensive and therefore a better display of the owner's wealth. Saikaku mentions *obi* of imported satin as long as 3.6 m and as wide as 60 cm, but this may – at his time – have been a literary exaggeration. From the mid eighteenth century, however, fashion caught up with Saikaku's satire. By then, more than three, sometimes even four metres, was the standard length (this length remains common today), and soon, although not for long, the *obi* also grew to the astonishing width of one metre.

The *obi* was generally made of silk, if the wearer could afford it. Twill, satin, figured satin, and gold and silver brocade were most popular. From the mid seventeenth century, it also became customary for young girls and unmarried women to tie their *obi* at the back. Married women (and courtesans, who were regarded as married because of their profession and who had enacted a mock wedding upon their initiation) customarily tied the *obi* in front (Fig. 158). There were numerous styles for tying the *obi*, and many of them had ritual significance.

Until the seventeenth century, noblewomen used to wear a ceremonial full-length robe (*uchikake*) over the kimono. In the early Edo period, however, this robe developed into what was regarded as formal bridal attire for anyone who could afford it. On matrimonial occasions, white silk was used. This was the colour of mourning, and signified the daughter hence no longer belonged to the family into which she was born.

In cold weather, women wore several kimonos on top of each other. Another option, especially among commoners, was to instead wear a kind of short coat on top of the kimono. This, however, seems to have been regarded as rather low-class and was definitely out of fashion.

Among city- and town-dwellers, women's dress was otherwise essentially the same for the different social classes. Only material and cost told the difference between rich and poor, high and low. Unlike the men, whose mode of dress was heavily determined by rank and social status, women's dress remained the same in the house of the merchant and the mansion of the samurai.

Commoners' Dress

A commoner's dress, although subject to the previously mentioned sumptuary edicts, depended on his position in society and his wealth. Merchants, and especially the wealthy ones, did not differ that much from the samurai in their choice of clothing. However, the *kamishimo* was never worn, and the *hakama* trousers only seldom. The two swords were of course also off-limits.

Urban manual labourers wore a somewhat different dress, consisting of dark-coloured trousers or breeches (*momohiki*), usually with a straight-sleeved, hip- or knee-length coat or jacket (known as a *happi* or, if padded for winter use, *hanten*). In some cases, for instance when used by servants of wealthy families or palanquin carriers, the *happi* had a family crest or guild mark embroidered on the back.[23] These coats were usually dyed indigo or brown, and if of slightly better quality, perhaps edged with red. They were invariably made of coarse unlined cotton, and usually worn with a narrow sash (*hiraguke*).

Farmers wore hemp or cotton clothes of types that varied from region to region. A kimono might be used by both sexes, especially at home or (for the men) with the skirts tucked into their narrow sash to allow freedom of movement during hard, physical work. Work clothes otherwise and more commonly consisted of a short jacket worn with tight breeches not unlike those used in the cities. Women in some regions wore wide trousers, drawn in round the ankles, but usually both sexes wore breeches. Women everywhere often used a simple kimono, generally with an apron, that served to protect the kimono. Both men and women wore sashes about 12–13 cm wide.

In hot weather, the workman commonly stripped to his loincloth. If he did not go this far, he could at least free the upper half of his body from clothing and tuck it into his sash, or remove his jacket entirely and work stripped to the waist. In either case, this leads us to the question of undergarments.

Undergarments

The basic male undergarment was the loincloth (*fundoshi*), a strip of cloth slightly less than two metres long, usually made of white but sometimes of red cotton, passing between the legs and fastened round the waist. Regional variation in style existed, but the colour always remained white or red. Red was believed to scare away demons. Whatever the colour, the loincloth was usually made of only one strip of cloth. The upper classes also wore loincloths but preferred them of silk rather than cotton. There was also a variant loincloth requiring slightly less than one metre of material. This cheaper variant, said to be devised by the lord of Etchû Province (now Toyama Prefecture), was known as the *Etchû fundoshi*.

Men's underwear (*shimekomi*) could also include what looked like a girdle or belly-band wrapped around the abdomen. In addition to this, upper-class males also wore the previously mentioned kimono-like undergarment known as *kosode*.

23 Today, unlike in Edo, family crests are very commonly seen on the back of *happi*.

Undergarments used by women consisted of a short skirt, sometimes made of brightly coloured red *crêpe de chine*, so that it could be easily discerned beneath the simple, usually white under-kimono. The latter was a long undergarment called *nagajuban* or *hadajuban*, shaped similarly to the ordinary kimono. Women wore no loincloth.[24]

Footwear

On the feet, *geta* (wooden clogs) or *zôri* (straw sandals) were used as everyday footwear by all classes during the entire period and well into the 1930s (Fig. 159). The samurai favoured a *zôri*-like footwear known as *ashinaka*, originally designed for combat. Although the design of these types of footwear was simple, the fashion-conscious could show off by their choice of the thongs or cloth-straps (*hanao*) used to secure the foot in the *geta* or *zôri*. Beautiful colours were required, and the fashion frequently changed.

Geta were naturally suitable for use on muddy streets, and many were designed with high pegs to facilitate walking in mud or a thin covering of snow. In case of rain, a kind of high clogs similar to *geta* but with attached toe covers were worn. These were known as *ashida*.

When making long journeys on foot, however, *geta* were uncomfortable and *zôri* both too expensive and uncomfortable. Both types of footwear were only secured by the single thong between the big toe and the rest of the toes. Rough straw sandals (*waraji*) tied around the feet were therefore used on longer trips. Even horses used similar straw sandals, and both types were for sale in many booths along the main highways. They did not last long, especially when wet, and the Swedish physician and naturalist Thunberg points out that there were always numerous broken and discarded straw sandals along the roads and highways.[25] The British horticulturist Robert Fortune made the same observation in 1860.[26]

The *geta* were made for walking in mud, dirt, and dust. Few areas in Edo were firm and dry; if dry, they were dusty and usually also dirty. Although *geta* are uncomfortable for walking on the paved roads and concrete of today, they were eminently suitable for use on the kind of surfaces that constituted the streets and back alleys of Edo.[27]

The Japanese always left their footwear at the entrance to a house. Indoors, they went either barefoot or wore only the *tabi*, the split-toed socks. The shock of seeing someone enter while still wearing sandals was considerable;

24 This habit endured beyond the Edo period, not changing until 1932. In that year, a great fire took place at the Shirokiya department store in Nihonbashi, and shop girls wearing kimono trapped by the fire refused to jump to safety out of fear of exposing themselves. They all perished in the flames. After this incident, the department stores changed salesgirls' dress to Western clothes, and Japanese women began to wear drawers under their kimono.

25 Thunberg, *Resa* 3, pp.362–3.

26 Robert Fortune, *Yedo and Peking: A Narrative of a Journey to the Capitals of Japan and China* (London: John Murray, 1863), p.135.

27 Footwear almost identical to the *geta*, known as pattens, remained common in Europe well past the Middle Ages, disappearing only with the introduction of cobblestone streets.

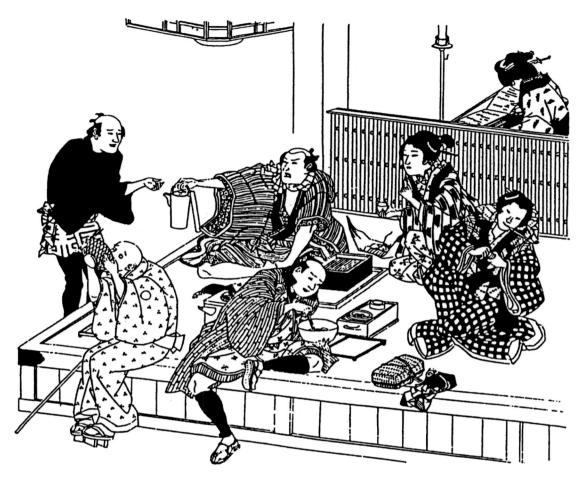

Fig. 159. A *soba* noodle restaurant. The two men in front wear wooden clogs (*geta*) and straw sandals (*zôri*), respectively. Both are busily gobbling noodle soup.

this only happened in violent situations such as war, acts of robbery, or when officials made an arrest. On any other occasion it was very rude to enter a house with sandals. Incidentally, it was also a very serious insult to strike somebody with a straw sandal or clog. Here, too, the reason was the Buddhist concept of the foot being the lowest and therefore the most unclean part of the body.

Coiffures and Headgear

A mirror stand was one of the most common of the generally very few pieces of furniture in Edo. The mirror was not so much used to see one's dress as it was to observe one's hair arrangement. Hairstyle was as important as dress, if not more so, in determining the standing and social class of an individual.

The samurai shaved his beard and the whole front and crown of his head. The hair at the back and sides he gathered together into a queue or topknot. This queue was well oiled, then doubled over, and finally tied with a paper strip so as to form a sort of tuft on the bald top. The queue was finally trimmed off very neatly into a cleanly cut end (Fig. 160). This remarkable hairstyle (*chonmage*) had its origin far away, in the nomadic warrior's life in Inner Asia.

Originally, the hairstyle was used as a challenge to enemy warriors ('Come and get it, if you can!'), and the construction of helmets – with a hole through which the queue had originally been displayed – indicate that this Central Asian custom had been retained in Japan well into the Middle Ages. Even in the comparatively peaceful Edo period, the samurai still had vague memories of this violent custom. It was considered important not to have one's hair out of place, and it was regarded as particularly embarrassing to have the hair undone or cut in a sword-fight. The worst was if the whole queue was cut off. This shame was regarded as identical to losing one's head, which indeed in the distant past had been the usual prerequisite for cutting off a queue. Another consequence of this ancient belief was that the queue of hair at times was cut off as a sacrifice to the gods. This act of prayer was common only in the direst of circumstances, for instance when a ship's crew was utterly lost at sea.

Fig. 160. How to dress one's hair. 1. Back of head before the hair is tied up. 2. The hair is gathered into a queue. 3. The queue has been oiled, doubled over, tied, and neatly trimmed; the completed hair-style.

A samurai who was severely ill left the crown of his head unshaven, with the hair growing until it could merely be tied up in a simple topknot. A respectable man never appeared so in public. However, *rōnin* down on their luck and careless about appearance apparently did. Prisoners and captives, too, did not shave their hair. Neither did people in mourning, but they usually kept out of public view during the period of mourning. An informal variety of the normal hairstyle did exist. This style was basically the same

as the formal one, but the crown of one's head was not shaved. Instead the queue was simply tied in the regular fashion on the top of the head.

It was not an easy task to arrange a proper hairstyle. Most people commissioned the help of a professional hairdresser (*kamiyui*). This vocational group enjoyed a brisk trade. The upper classes had the hairdresser make home visits, while the lower classes went to special hairdressers' shops. The hair was fixed in place by a thick sort of grease. It took time to rearrange the hairstyle, so it was customary to wash the hair only every 10 days or so. The elaborate hairstyle of an eighteenth-century (or later) courtesan took even longer to arrange, so they washed their hair only once a month, on the twenty-seventh day. They did, of course, perfume the hair every day.

The number of hair-dressing shops grew fast in the early Edo period, and to regulate this the shogunate decreed in 1658 that only one hairdresser was to be licensed to operate in each neighbourhood of Edo. Under this system there were 808 licensed hairdressers, and the common phrase 'the 808 neighbourhoods of Edo' derives from this number.

Hairdressers also provided their customers diversion in the form of board games (*Go* and *Shôgi*, see below) and books. They thus became local centres for relaxation. There were also female hairdressers who only served men. Most or all of them provided diversions in other forms, of more importance than their hairdressing skills.

At the end of the eighteenth century, hairdressers were temporarily banned in a futile attempt by the shogunate to reduce the sumptuousness and expenditures of the townspeople. This ban was ineffective, but the shogunate saw fit to ban female hairdressers again; this time in a vain attempt to improve the morals of the Edokko. Female professionals of many kinds were forbidden to practice by the sumptuary edicts issued between 1841 and 1843, as the shogunate wished to contain prostitution to the licensed pleasure quarters.

Not only the hairdressers were concerned with the hair of the Edokko. If natural hair was scanty or nonexistent, there were specialised shops that sold wigs. Most of these were located just outside Yoshiwara, as the courtesans sometimes shamed an errant patron by cutting off part of his hair.

Buddhist monks always shaved their heads and all facial hair. As this by the Edo period had become a sign of withdrawal from the world, it was not uncommon for gentlemen and intellectuals of leisure to do likewise, particularly when they retired from active life. Masseurs also shaved their hair, just like the monks.

Women arranged their hair in an elaborate way, compared by many contemporary foreign observers to the making of a turban. The hair was held together with a large number of long hairpins, most of them with two prongs and made of fine tortoiseshell, ivory, horn, wood, or metal, including at times even gold and silver, as well as other ornaments such as tortoiseshell combs or bars. The use of gold and silver among wealthy commoners became fashionable by the end of the seventeenth century, even though this was prohibited at times by sumptuary edicts.

To cover the head, various types of hats were used. These were usually made of spliced bamboo and cloth, or straw. Townsmen did not often use hats,

as they were considered somewhat rustic and more suited for pilgrimages and long journeys. Many commoners instead tied a rectangular cotton towel (*tenugui*, in the Edo period also known as *tanagui*) around the head. These were frequently dyed in bright colours, and often printed with the crests of famous Kabuki actors. In this way, they served as advertisements for this or that actor, as well as indicating that the owner was a man who kept up with the times and contemporary fashion.

Other Items of Clothing

Japanese clothes never had pockets. Women could carry small objects in their sleeves, and high-ranking men with similarly wide sleeves could do likewise. However, most men had to devise other means of carrying essentials such as purses, tobacco pouches, seal or medicine cases, pipe cases, or small, portable writing kits (*yatate*). Usually they were suspended from the sash, and were thus collectively referred to as *sagemono* ('hanging objects').

One ubiquitous accessory was the *netsuke*, a toggle for conveniently attaching and reattaching 'hanging objects' to one's sash. The *netsuke* was used to secure the cord from which the object in question was suspended to the sash itself. The *netsuke* was commonly a piece of finely sculptured ivory or wood, often in the shape of a human, animal, deity, or some mythological creature. Almost any subject could be used by the *netsuke* carver, and pornographic motifs were quite popular among the Edokko; however, these were regarded primarily as curiosities and not generally worn.

The novelist Ihara Saikaku advised against keeping one's purse as a 'hanging object'. He wrote: 'In this world we cannot afford to be careless. When travelling, keep the money in your waistband out of sight.'[28] More valuable articles were indeed usually kept in the capacious bosom of the kimono or hidden inside the sash. In the bosom of the kimono was also kept, at least among the upper classes and the more wealthy or refined commoners, a number of neat squares of clean white paper, used as pocket handkerchiefs. After being used, they were frequently hidden in the sleeve until they could be quietly disposed of.

The wide sleeves of the kimono frequently interfered with manual work. Workers – and warriors preparing for combat – therefore always tied up their wide sleeves with a cloth band or cord (*tasuki*). Most common was to twist this cord to form loops through which the arms were passed, and then tie the ends together. The cord then formed an 'x' across the back between the shoulders, keeping the sleeves out of harm's way.[29]

In case of bad weather, various articles of clothing were added to one's apparel. In cold or rough weather, farmers and workers wore leggings and coverings for the forearms, the latter with a flap to cover the back of the

28　Ihara Saikaku, *Five Women Who Loved Love* (Tôkyô: Charles E. Tuttle, 1956), p.176. Saikaku followed up this laudable advice with two other items of useful information: 'Do not display your knife to a drunkard, and don't show your daughter to a monk.'

29　In modern Japan, *tasuki* retain a ceremonial function. During festivals *tasuki* may be worn with traditional dress.

hands. In the snowy parts of northern and eastern Japan, it was also common to use snow boots of straw, but such footwear was rarely seen in Edo itself.

Rain or snow was kept out by the use of a cloak or cape (*mino*), in snowy regions fitted with a hood, made of lengths of straw sewn together. A conical straw hat or a hood was worn to protect the head. Straw hats were also used as protection against the sun in summer. There were a large number of regional variations on these items. Straw hats were inexpensive. Saikaku reports that a secondhand straw hat could be had for a mere 14 copper *mon* at an auction (for the value of money, see below).

Other raingear included the European cape (*kappa*), introduced in the sixteenth century by the Portuguese (who called it *capa*). The cape was made of wool, paper treated with paulownia seed oil, or cotton. The latter was most common in Edo. The German physician Kaempfer describes such a cape as 'a large cloak, against rainy weather. This is made of double varnish'd oil'd paper, and withal so very large and wide, that it covers and shelters at once man, horse, and baggage.'[30] Umbrellas (*karakasa*) were also very common, made of oiled paper stretched over a bamboo-rib framework.

A special mention must also be made of the fan. Both men and women used these items extensively during all seasons, although chiefly in hot weather, when no one left home without one, either in hand or tucked into the kimono sash. The fan had numerous functions beside its obvious use in fanning oneself. It was, for instance, used to cover one's mouth while using a toothpick, or as a tray when delivering a gift. Many people therefore carried a fan only out of politeness. It was, however, considered very impolite to fan oneself in the presence of a superior.

The ordinary fan was made of thick paper by special craftsmen. Some were cheap, while others were expensive and beautifully decorated. A merchant often used the cheaper variety, and when he needed to make a note on some business matter he wished to remember, he simply wrote it down on his fan as a memorandum. A merchant, like any other Edokko, always carried his fan about, and constantly opened it, looked at it, and shut it. There was accordingly no better location for a quick memo.

Fans were of two main types, the folding variety (*ôgi* or *sensu*), or round and flat (*uchiwa*). Both were effective in directing cooling currents of air to whatever part of the body that most required it. A stiff, rigid variant of the *uchiwa* was the war fan. This was used by officers to give signals or directions, but also as a final means of defence. Some folding fans, too, were reinforced with metal and could be used as weapons.

Seasonal and Rental Clothes

As Japan has four distinct seasons, it became first customary – and then virtually compulsory – to change clothes at the officially designated days when the seasons changed. This custom was known as *koromogae* (seasonal changing of clothes).[31]

30 Kaempfer, *History* 2, p.400.

31 The custom of *koromogae* remains strong in modern-day Japan.

In Edo, the date for changing from the padded clothes for winter wear to the spring ones that had only one lining (*awase*) was the first day of the Fourth Month. Spring clothes were worn until the fifth day of the Fifth Month. Then the unlined clothes for summer wear were unpacked, and the spring clothes were put away and stored neatly in anticipation of the next change of season, naturally with measures taken to protect them from mildew, moths, and other insects. On the first day of the Ninth Month, the Edokko changed again, this time from the unlined clothes of summer to the clothing with only one lining. Already on the ninth day of the Ninth Month, they discarded these in favour of padded winter clothes.

Winter clothes relied on silk or cotton floss as lining. As heating opportunities were minimal and not very effective in Edo, the winter clothing had to be the main protection against cold weather. Usually several layers of kimono and other clothing were worn, in futile attempts to keep out the cold. In summer, light clothes – typically of cotton – were worn. The *yukata* was a kimono made of light material, commonly worn in summer. It was originally designed to be used after taking a bath, to absorb the body's moisture.

Clothes, and in particular fine clothing suitable for ceremonies and visits to high officials and high-ranking courtesans, could be easily rented from shops specialising in this trade. These shops customarily marked the inside of their clothes in certain ways, for instance with a particular number, so the knowledgeable could still recognise a man who appeared in rented outfit, for instance in the licensed quarter, where clothes were frequently removed.

The Environment, the Seasons, and the Calendar

To fully understand both military and non-military institutions and ways of life in Edo period Japan, one must first gain an understanding of the environment in which they developed, including climate conditions, the calendars in common use, and the timekeeping system.

Japan has four distinct seasons. Edo followed a lunar calendar (see below), so there is a disparity of approximately one month with the Western solar calendar now used in Japan.

Spring in Edo began on the fifth day of the Second Month of the year, today equivalent to March. Winter clothes, however, continued to be worn until the very end of the Third Month, or early May. Today, the pleasant spring season lasts through May. The weather grows mild, and blossoming cherry trees mark the gradual passage of spring from south to north. Spring and autumn are the most comfortable seasons.

Summer begins in June (in Edo, the official date was the fifth day of the Fifth Month) and lasts through September. Summers are hot, sustained by winds from the Pacific, which also cause clouds on the Pacific coast. This makes the summers not only hot but also very humid and unpleasant. Edo, and all Japan except Hokkaidô, from the middle of June until the middle of July feel the northern limits of the monsoons, producing a short but frequently torrential rainy season (*tsuyu* or *baiu*).

From late July to mid September, Edo was commonly assailed by typhoons coming up from the Pacific. These unroofed houses, tore trees out of the ground, and wrecked ships.[32] The heavy and violent rains of the typhoon season were a curse, causing frequent and massive floods in Edo. Records indicate that through the more than 300 years of the Edo period and the subsequent Meiji period, the Sumida River flooded on an average of once every three years. When a major flood occurred, the levees of the river were breached. Such a disaster affected most of Edo, but in particular the Asakusa area and Yoshiwara.

Autumn begins hesitantly in late September, or more commonly early October, after the typhoons have subsided, and lasts through November. In Edo, the official starting date was the first day of the Ninth Month, or the very beginning of October according to the current calendar. Autumn is, like spring, a comfortable season. The heat of summer gives way to days cool and crisp.

Winter, finally, begins in December and lasts through February. The weather is fresh, dry, and cold, because of the winds from Siberia. Mount Fuji can frequently be seen, especially in silhouette against the sunset. Skies are clearest around the (present) New Year holiday. By then, snow-capped Mount Fuji was a common sight, although of course never towering quite as high above Edo as the volcano is depicted in many old woodblock prints. In Edo, winter clothes were worn already from the ninth day of the Ninth Month, despite the fact that winter was not considered to begin until the Tenth Month.

Although the cold winds of winter pick up moisture from the Japan Sea before reaching Japan, most of this moisture is deposited as heavy snowfall in more northerly and mountainous areas long before the winds reach the Pacific seaboard, where the weather is generally bright but cold. There is little snow. What little does come, generally comes late, around February.

In 1860 the American medical missionary Dr James C. Hepburn (1815–1911) made a number of weather observations in Kanagawa, near Edo (Tables 5 and 6).[33]

Table 5. Temperature (F)

	Average at Sunrise	At 2:00 p.m.	Highest	Lowest
January	30	47	59	18
February	32	47	58	19
March	40	51	69	30
April	49	64	76	36
May	58	69	80	44
June	67	76	87	54
July	75	82	92	63

32 Nowadays the rains are necessary for the metropolitan water supply.

33 Fortune, *Yedo*, p.266.

August	75	87	92	69
September	72	80	89	62
October	57	70	84	50
November	45	58	68	36
December	38	50	71	22

Table 6. Precipitation

	Clear Days	Cloudy Days	Rainy Days	Rain (inches)	Snowy Days	Snow (inches)
January	19	9	3
February	14	12	2	0.5	1	2
March	9	4	18	6.5	3	1.5
April	16	5	9	3.25
May	18	..	13	16.5
June	10	7	13	18.75
July	17	1	13	8.25
August	21	4	6	1.0625
September	14	4	12	2.25
October	15	6	10	7.5
November	18	7	5	5
December	19	5	7	3.5	1	1

The Calendar

In any agrarian society, life is regulated by the seasons. This was also true of Japan, which for this purpose used an ancient solar calendar of Chinese origin. This calendar, however, was used almost exclusively by farmers. According to this calendar, the year was divided into 24 fortnightly periods, most of them named after the season or the prevalent weather.

However, in Edo and the other great cities the need arose for a more detailed breakdown of time to sustain the city's increasingly artificial life. As the Gregorian calendar was introduced in Japan only in 1873, after the Meiji Restoration, old Japan instead relied on the Chinese lunar calendar, the *Hsüan-ming li* or, in Japanese, *Senmyôreki*, adopted as official calendar in 862 and revised (under different names) in 1685, 1755, 1798, and more substantially, in 1843. The lunar and the solar calendar worked fairly well together. The calculation of the calendar, however, was no mean feat and was in the hands of experts, who relied on privileged knowledge of Chinese calendar science.

The calendar was a complex work. Not only did it include the number of days proper to the months, the dates of the vernal and autumnal equinoxes and the summer and winter solstices, sunrise and sunset times, and predicted dates of solar or lunar eclipses, it also detailed predicted fortunes for each day of the year, lucky and unlucky directions relative to each day, and much other useful information.

The Chinese lunar calendar is based on the waxing and waning of the moon. The year was divided into a total of 12 'small' (*shô no tsuki*) and 'great' (*dai no tsuki*) months, of 29 and 30 days, respectively. This produced too few (only 354) days to make up an entire solar year. For this purpose, an additional thirteenth intercalary month (leap-month, or *urûzuki*) was inserted every two or three years to keep the year in step with the seasons. All lunar months except the first, which in the Edo period was usually known as Shôgatsu, were, and are, identified by number, although semi-poetical names were also used. The intercalary month was numbered by a modification of the name of the preceding month, with a special sign to show that it was additional. As mentioned earlier, dates on the lunar calendar lag about a month behind those on the solar calendar. The sexagenary cycle (see below) could in theory also be used for naming the months. This, however, was very unusual.

As in most agricultural societies, spring – renewal and rebirth – marked the beginning of the year. The traditional beginning of spring was New Year's Day according to the ancient solar calendar. The new year in Edo, too, began on this date, at a date usually corresponding to a day in February or early March in the modern calendar.[34]

The month naturally also had to be divided into days. The days were numbered from one to 30 within the month. Each month in the lunar calendar began with the dark night of the new moon, that is, on the first night when the moon is invisible. The moon was at the full in the middle of the month (around the fifteenth). This date was accordingly the time for moon viewing, originally of religious significance but in Edo more of an occasion for entertainment. The Eighth Month brought the most celebrated moon of the year. Even the mere mention of the moon in a poem is sufficient to indicate this month. The first and the fifteenth day of each month were considered holy days because of their relationship with the moon. They were also regarded as days of rest. No craftsman worked on these days, and even the whores refused to meet customers, as the blunt Swedish naturalist and physician Carl Peter Thunberg pointed out.[35] Hairdressers, however, instead closed on the seventeenth day, in memory of Tokugawa Ieyasu's death, as this vocational group had a particular devotion for him.

Although Buddhism had a concept of a period of seven days, used in connection with the services for the deceased, the week as such was not used as a measure of time. Instead the month was divided into three periods of 10 days each, called *shun*, and referred to as the upper, middle, and lower. To some extent, this system is still in use. A shop, for instance, will close not on a particular day each week, but instead on days of the month ending with the same number, for instance the fourth, fourteenth, and twenty-fourth – one day in each 10-day period.

There were also a large number of *ennichi*, festival days that were held to have a special connection (*en*) with certain Shintô or Buddhist deities. Divine

34 December, so named by the ancient Romans, means 'the tenth month', which shows that they, too, made the straightforward connection between spring and the new year.

35 Thunberg, *Resa* 3, p.98.

favour or special merit was gained by participating in religious services on these days. The eighteenth day of the month was, for instance, the festival day of Kannon, the Buddhist bodhisattva of mercy, while the twenty-fourth day was the festival day of Jizô, the Buddhist protector of children, travellers, and others exposed to particular dangers. These festival days had already lost much of their religious significance before the Edo period; but they retained and indeed increased their significance as times for periodic markets, fairs, and other occasions drawing vast crowds of people looking for entertainment.

Years and Year Periods

Years were – unlike the highly developed monthly calendar – counted in a rather inefficient way, its basic form inherited from China and adopted in Japan in 645. There was no recognised 'beginning' of time, so each year had to be identified by a year period name (*nengô*, in English sometimes translated as 'era'), followed by its number in the year period to which it belonged.

Originally, and also at present, each year period corresponded to the reign of an emperor. The year period name was changed by order of the Imperial court within a year or two of the death of an emperor. In addition, a new year period was usually proclaimed at two points in each sexagenary cycle (see below): the first year, regarded as especially auspicious, and the fifty-eighth year, regarded as so inauspicious that only a new year period might dilute the bad luck summoned by it.

Under the Tokugawa shogunate, however, the year periods had no precise connotation, and were not connected to Imperial reigns. The shogunate tended to order the Imperial court (still nominally responsible for this) to change year period names when things were not going well, in the hope that bad luck would be dispelled and better times would follow. A year period could therefore begin, and end, at any time (Table 7). To identify the exact year, it was necessary to memorise all the year periods, as well as their relationship to each other. Many people did not, accordingly, know how to identify a given year, unless they were highly educated, or in case of very old dates, even accomplished scholars with years of diligent study. The year period system was of little utility for ordinary purposes. When a particular event was referred to, the average Edokko had only a vague sense of whether or not it had happened recently, that is, within the present year period or perhaps the immediately preceding one. If not, he probably considered the event to have taken place a very long time ago indeed.

The Sexagenary Cycle

Premodern Japan also relied on another, more complex method of designating units of time. This formula – the sexagenary cycle – was commonly used to count years as well as other units of time. Two sets of terms for the purposes of enumeration are employed. This system, known as the 'ten celestial stems and twelve terrestrial branches' (*jikkan jûnishi*), also came from China. As the name implies, one set contains 10 terms, while the other contains 12 terms. When both series are used together, they form a greater cycle of 60 combinations (from which the name of the cycle is derived).

Table 7. Japanese Year Period Names from the Edo Period to the Present

(Note. The first date is the traditional one. The date in parenthesis, if any, is corrected to the solar calendar and therefore more exact.)

Keichô	1596–1615	Hôei	1704–11	Kyôwa	1801–4	Taishô	1912–26
Genna	1615–24	Shôtoku	1711–16	Bunka	1804–18	Shôwa	1926–89
Kan'ei	1624–44 (1624–45)	Kyôhô	1716–36	Bunsei	1818–30 (1818–31)	Heisei	1989–2019
Shôhô	1644–8 (1645–8)	Genbun	1736–41	Tenpô	1830–44 (1831–45)	Reiwa	2019–
Keian	1648–52	Kanpô	1741–4	Kôka	1844–8 (1845–48)		
Jôô	1652–5	Enkyô	1744–8	Kaei	1848–54 (1848–55)		
Meireki	1655–8	Kan'en	1748–51	Ansei	1854–60 (1855–60)		
Manji	1658–61	Hôreki	1751–64	Man'en	1860–1		
Kanbun	1661–73	Meiwa	1764–72	Bunkyû	1861–4		
Enpô	1673–81	An'ei	1772–81	Genji	1864–5		
Tenna	1681–4	Tenmei	1781–9	Keiô	1865–8		
Jôkyô	1684–8	Kansei	1789–1801	Meiji	1868–1912		
Genroku	1688–1704						

Table 8. The Sexagenary Cycle

1	Wood Rat (yang)	16	Earth Hare (yin)	31	Wood Horse (yang)	46	Earth Cock (yin)
2	Wood Ox (yin)	17	Metal Dragon (yang)	32	Wood Sheep (yin)	47	Metal Dog (yang)
3	Fire Tiger (yang)	18	Metal Snake (yin)	33	Fire Monkey (yang)	48	Metal Boar (yin)
4	Fire Hare (yin)	19	Water Horse (yang)	34	Fire Cock (yin)	49	Water Rat (yang)
5	Earth Dragon (yang)	20	Water Sheep (yin)	35	Earth Dog (yang)	50	Water Ox (yin)
6	Earth Snake (yin)	21	Wood Monkey (yang)	36	Earth Boar (yin)	51	Wood Tiger (yang)
7	Metal Horse (yang)	22	Wood Cock (yin)	37	Metal Rat (yang)	52	Wood Hare (yin)
8	Metal Sheep (yin)	23	Fire Dog (yang)	38	Metal Ox (yin)	53	Fire Dragon (yang)
9	Water Monkey (yang)	24	Fire Boar (yin)	39	Water Tiger (yang)	54	Fire Snake (yin)
10	Water Cock (yin)	25	Earth Rat (yang)	40	Water Hare (yin)	55	Earth Horse (yang)
11	Wood Dog (yang)	26	Earth Ox (yin)	41	Wood Dragon (yang)	56	Earth Sheep (yin)
12	Wood Boar (yin)	27	Metal Tiger (yang)	42	Wood Snake (yin)	57	Metal Monkey (yang)
13	Fire Rat (yang)	28	Metal Hare (yin)	43	Fire Horse (yang)	58	Metal Cock (yin)
14	Fire Ox (yin)	29	Water Dragon (yang)	44	Fire Sheep (yin)	59	Water Dog (yang)
15	Earth Tiger (yang)	30	Water Snake (yin)	45	Earth Monkey (yang)	60	Water Boar (yin)

The first combination is thus formed by the first celestial stem and the first terrestrial branch; the second combination by the second stem and the second branch, and so on until the eleventh combination, which consists of the first stem and the eleventh branch; the twelfth combination is the second stem and the twelfth branch; the thirteenth combination is made of the third stem and the first branch, and so on. The 10 celestial stems were thus repeated six times and the 12 terrestrial branches five times to create a cycle of 60. This cycle was then repeated *ad infinitum*. In Japanese writing, the combination was always written with only two characters, one from each of the two sets of terms.

It eventually became customary to refer to the 12 branches using 12 horary animal signs or zodiacal symbols: rat, ox, tiger, hare, dragon, snake, horse, sheep, monkey, cock, dog, and boar. Each of the 10 stems was then identified as either *yang* (the male and positive aspect in ancient Chinese cosmology, but for this purpose in Japan referred to as 'elder brother') or *yin* (the female and negative aspect, here referred to as 'younger brother'). These yang–yin pairs, five in number, were then connected with each of the five phases or elements – wood, fire, earth, metal, and water. There was thus a yang version and a yin version of each of the elements, each with a slightly different name. These 10 names for the 10 stems were then combined with the 12 animal names of the 12 branches to form new names for each of the two-symbol combinations of the cycle.

This complex procedure resulted in a cycle of 60 combinations which in translation read as in Table 8.

The sexagenary system was commonly used for counting years. As a cycle of 60 years is made up of five cycles (identified by elements) of 12 years (identified by animals), the association of a year with a specific animal and a specific element soon arose. The first year of Genroku (1688), for instance, was the year of the Earth Dragon, while the year 12 years later was the year of the Metal Dragon. Both years were thus Dragon years.

The sexagenary system as it was applied in astrology was further complicated, so the outline here should not be considered as a complete description of the system. This outline may, however, represent what presumably was the general level of knowledge among the people of Edo. For further information, they would consult an astrologer or a fortune-teller. He would – for a fee – be more than willing to give further information.

The sexagenary cycle was the foundation for much of the astrology in vogue in old Japan. Many of these beliefs survive to this day. In the Edo period, it was, for instance, believed that a woman born in the year of the Fire Horse (the forty-third year of the sexagenary cycle) would devour her husband. It might therefore be difficult for such young women to find husbands. Indeed, there was a good chance that a baby girl unfortunate enough to be born in such a year would be the victim of infanticide. A prudent family therefore postponed a marriage to a date which ensured that the first child would be born in an auspicious year, rather than in an inauspicious one.[36]

36 The last year of the Fire Horse was 1966. The birth rate plummeted that year, as Japanese parents delayed having a child rather than face the risk of giving birth to a girl.

The cycle of the 12 terrestrial branches (or rather their associated animal names) were also at times used to label months, as 12 months made up one year. These names were also used to label divisions of the day, starting at midnight. A day and night were thus divided into 12 periods or 'hours' (see below). Points on the compass could also be identified in this way, with the points 30 degrees apart, the rat being considered north, the hare east, and so on. This was important to determine lucky and unlucky directions. There was, indeed, almost no field in which the sexagenary signs did not have some influence. For purposes of astrology, the sexagenary system was also used for counting days.

One well-known day according to the sexagenary cycle was *kôshin*, which designates any day that occurs on the conjunction of *kô* (Chinese: *keng*), the seventh of the 10 celestial stems, and *shin* (Chinese: *shen*), the ninth of the 12 terrestrial branches. This combination represents the fifty-seventh day in the complete cycle of 60 days. A Chinese tradition of Taoist origin informed the Edokko that on the night of a *kôshin* day (that is, the preceding night as the Japanese counted a day from sunset to sunset) 'three worms' (*sanshi*) believed to exist within the human body escape during a person's sleep to report his or her bad deeds to Heaven. Such a report would naturally result in a shortening of one's life (the Edokko misbehaved frequently and knew it). To avoid the consequences of one's deeds, the Taoists – and the Japanese – followed the custom of staying up all night, keeping awake by playing music and games, so that the worms were unable to escape. This ancient custom, known as *kôshin machi* (*kôshin* 'vigil'), became widespread during the Edo period.[37]

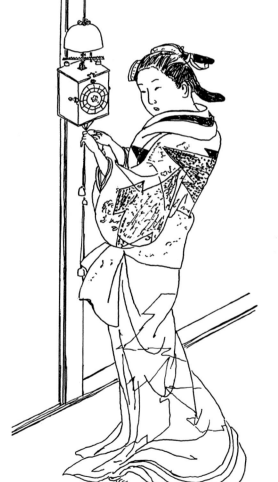

Fig. 161. A young woman adjusting a wall clock

Timekeeping – Hours

The timekeeping system in Edo was based on the Chinese system, adopted in Japan as early as in 628, which was also the year the first water clock was constructed in Japan.

The Japanese – unlike the Chinese – used an ancient system by which day and night were each divided into six equal parts (*koku* or *toki*). Since the length of day and night fluctuated according to the season, so did the length of these periods. Only at the time of the two annual equinoxes was each time period equal in length (two modern hours); at all other times the periods differed. This in summer, one daytime *koku* was roughly two hours and 36 minutes by modern reckoning, while in winter, it was only about one hour and 48 minutes.

37 The tradition of vigil survives in some areas in modern Japan, though usually it does not last all night.

Clocks imported by the Portuguese and Dutch needed a special mechanism to compensate for the varying length of the hours. Strictly speaking, the length of the hours should have varied from day to day, but such extreme accuracy was dispensed with. The variations were commonly regulated only four times in the year, calculated on three month averages (Fig. 161).

Members of the warrior class (as well as commoners on ceremonial or formal occasions) often referred to the hours by using the 12 animal signs of the sexagenary system. The hours were more commonly designated by numbers, however. Midnight, sunrise, noon, and sunset occurred in the middle of their respective hours, not at the beginning. The ninth hour period started before midnight, the numbers decreasing from then so that the eighth hour began at 1:00 a.m. and so on until the fourth hour before noon, when the series again started from nine (Table 9).

Table 9. The Timekeeping System of Edo

11:00 p.m.–1:00 a.m.	9th hour of dawn	Hour of the Rat (midnight)
1:00 a.m.–3:00 a.m.	8th hour of dawn	Hour of the Ox
3:00 a.m.–5:00 a.m.	7th hour of dawn	Hour of the Tiger
5:00 a.m.–7:00 a.m.	6th hour of sunrise	Hour of the Hare (sunrise)
7:00 a.m.–9:00 a.m.	5th hour of morning	Hour of the Dragon
9:00 a.m.–11:00 a.m.	4th hour of morning	Hour of the Snake
11:00 a.m.–1:00 p.m.	9th hour of midday	Hour of the Horse (noon)
1:00 p.m.–3:00 p.m.	8th hour of midday	Hour of the Sheep
3:00 p.m.–5:00 p.m.	7th hour of midday	Hour of the Monkey
5:00 p.m.–7:00 p.m.	6th hour of nightfall	Hour of the Cock (sunset)
7:00 p.m.–9:00 p.m.	5th hour of night	Hour of the Dog
9:00 p.m.–11:00 p.m.	4th hour of night	Hour of the Boar

Note. For this chart to be valid, sunrise occurs at 6:00 a. m. and sunset at 6:00 p.m.

Although the Japanese system may seem unnecessarily complicated, it is in fact no more so than the common English system of hours before and after noon, a.m. and p.m. Familiarity was the main thing, and the actual length of an hour in modern minutes was not as important as the fact that everybody knew exactly how long the hour was.

To further break down the unit of time, some also divided each of the 12 hours into three. Others divided only the night-time hours into three. These

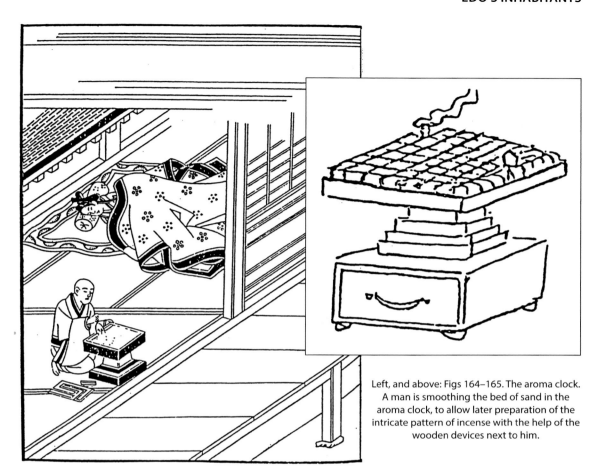

Left, and above: Figs 164–165. The aroma clock. A man is smoothing the bed of sand in the aroma clock, to allow later preparation of the intricate pattern of incense with the help of the wooden devices next to him.

Right, Figs. 162–163. The Japanese clock

subdivisions did not fulfil any particularly useful purpose, however, and were not much used.

Beginning in the Edo period, the hours of the day were announced by the sound of temple bells. There were a total of nine bells in Edo, the most famous being the one at the temple Sensôji in Asakusa.[38] For each bell, a manager and a bell-striker were hired. Their salaries were shared by the warrior class, the temples and shrines, and wealthy commoners, as all could hear the bell and benefited from it.

The Edokko also used clocks. Some were imported from Europe, modified as described above. Specially trained craftsmen also built Japanese clocks (*wadokei* or *yaguradokei*) after the European model (Figs 162–163). Another common type of clock was the aroma clock. Such a clock measured time by how fast a string of incense burned along an intricate pattern, made on a bed of sand with a special wooden device (Figs 164–165).

One of the directors of the Dutch factory in Nagasaki, G. F. Meijlan (fl. 1829–33), described the appearance of a Japanese clock, presumably more elaborate than average as it was intended as a gift to the shôgun.

The clock is contained in a frame three feet high by five feet long, and presents a fair landscape at noontide. Plum and cherry trees in full blossom, with other plants, adorn the foreground. The background consists of a hill, from which falls a cascade, skilfully imitated in glass, that forms a softly-flowing river, first winding round rocks placed here and there, then running across the middle of the landscape till lost in a wood of fir-trees. A golden sun hangs aloft in the sky, and, turning upon a pivot, indicates the striking of the hours. On the frame below the twelve hours of day and night are marked, where a slowly-creeping tortoise serves as a hand. A bird, perched upon the branch of a plum-tree, by its song and the clapping of its wings announces the moment when an hour expires, and as the song ceases a bell is heard to strike the hour, during which operation a mouse comes out of a grotto and runs over the hill … Every separate part was nicely executed; but the bird was too large for the tree, and the sun for the sky, while the mouse scaled the mountain in a moment of time.[39]

The Japanese liked novelties, and this clock was elaborate but by no means exceptional as a mechanical toy.

The Edo Period Economy and Monetary System

The shogunate government and military system with its emphasis on clan armies emerged from the economic conditions of sixteenth-century Japan, which were grounded on the agricultural capacity of the country and based on rice production. Yet, the monetary economy was well established in

38 The oldest bell remaining today is in Nihonbashi Ishichô.

39 G. F. Meijlan, *Japan: Voorgesteld in Schetzen over de Zeden en Gebruiken van dat Rijk, bijzonder over de Ingezetenen der Stad Nagasakij* (Amsterdam: M. Westermann & Zoon, 1830).

Edo period Japan, and it was said that 'the true Edokko never keeps a coin overnight'.

The Edo Period Economy

The foundation of the economy was rice. Each member of the warrior class, from the senior officials in Edo to lesser officers and foot soldiers, received an income according to his status in the form of a stipend from his lord. Whether he served directly under the shôgun or under a lesser feudal lord did not really matter. This income, however, was generally calculated in rice instead of cash. Likewise, land was not usually measured by area but by the amount of rice it could produce.

Rice was measured in a unit known as *koku*, equivalent to 180.39 litres. One *koku* was an amount sufficient to feed one person for one year. Records indicate that the annual national production of rice at the beginning of the seventeenth century was about 25 million *koku*. The entire amount was distributed by the shôgun to his retainers and lords, and redistributed further downwards in the hierarchy. High-ranking individuals received control of areas of land equivalent to their income, while lesser ones received rice only (with time, however, many low-ranking samurai found their *koku* ratings transformed into cash payments).

The price, or buying power, of a *koku* fluctuated. In theory, one *koku* of rice equalled one *ryô* of gold. After 1723, however, the rice price tended steadily downward, from a peak of 70 to 80 *monme* of silver per *koku* to as little as 22 *monme* by 1730–31 (for an explanation of these monetary instruments, see below). This fall in value was little short of a disaster for the warrior class, as their incomes diminished accordingly.

Although the economy was based on rice, money in the form of coins was in very widespread use. Copper currency, and sometimes also gold and silver coinage, seem first to have been minted in Japan by the end of the seventh century and continued to be issued until 958.[40] In 987, however, the use of such coins had been prohibited. After this early period, copper coins had been imported from China, Korea, Annam, and other countries. Toyotomi Hideyoshi had coins minted in 1587 (gold, silver, and copper) and in 1592 (silver only).

Mints for various types of coins were also set up by Tokugawa Ieyasu from 1594 onwards. The work process was mainly manual. One such mint was established in 1601 at Fushimi, just south of Kyôto, for the minting of gold and silver coins. Another gold mint was set up in Edo in 1601 at the eastern foot of Tokiwabashi Bridge, a few hundred metres west of Nihonbashi (the site of today's Bank of Japan). In 1612 a mint for casting silver coins was relocated from Suruga Province (now Shizuoka Prefecture) to the Ginza district of Edo (the name means 'silver mint'), where it operated until 1800. Tokugawa copper mints were first established in 1636, one of them in Edo, and coins from them were declared the official copper currency. In 1670 the

40 Japanese coins from the end of the seventh century AD have been found in Nara. The earliest finds before this site was excavated date from 708.

use of older and imported coinages was proscribed. However, Chinese coins appear to have remained in limited use even 100 years later (see below).

The shogunate strove to consolidate control over all mints in the hands of the central government in Edo. From the 1770s onwards, most copper coins were minted in Edo. In 1800, because of several incidents of corruption, silver and gold mints were relocated from other cities to Edo. During the seventeenth century mints were run as hereditary business monopolies under the supervision of the shogunate. Afterwards, they were placed directly under the Finance Commissioners (*kanjô bugyô*).

The monetary system of Edo period Japan was quite complicated. Like so many other aspects of civilisation in Japan, the fundamentals of the monetary system were imported from China. In the Edo period there were three main types of metal cash, namely, gold (*kinka*), silver (*ginka*), and copper (*senka*), sometimes supplemented by iron. The exchange rate was not fixed, remaining variable throughout the Edo period. For this purpose, money-changers existed, and their trade was very profitable.

The theoretical basis of shogunal monetary policy was as simple as it was unrealistic: The shôgun and the great lords were supposed to pay a salary or award to upper-level samurai (such as the Edo *hatamoto*) in gold, to lower-level samurai (in Edo, the *gokenin*) in silver, and to commoners in copper. In real life, things were never as simple as that. The wealth of the merchant class meant this theoretical system could not really be maintained.

As in many other countries, the central government made frequent attempts to improve the economy by either debasing or improving the content of the coinage. Coinage was debased in 1695 and improved in 1714. A new but similar currency was introduced in 1718. After this, however, currency debasement continued as an important means of economic policy, causing widespread inflation.

In addition, the coinage was not uniform over the entire country. Whilst gold was the basis of the currency in Edo, Ôsaka and Kyôto relied on silver. The country thus had in effect two different economies. In eastern Japan, prices were usually expressed in *ryô*, *bu*, or *shu* of gold, while in western Japan they were expressed in *monme* and *fun*, both weights of silver. Note that all these terms were related to old units of weight; but while the gold units were no longer treated as actual units of weight, the silver units remained so until the very end of the period. Copper was in general use, even though it, too, was sometimes replaced by iron or brass.

To supply this monetary economy, there were numerous mines all over Japan. The most famous gold mine was located at Aikawa on the island of Sado, off present-day Niigata Prefecture in northern Japan, and was directly overseen by a high shogunal official. This mine was so important that this official was equal in rank and status to the Edo town magistrate. There were also several gold mines in the Izu Peninsula, and in other locations as well. Silver mines were located on Sado, as well as on the island of Tsushima, in Ômori in Iwami Province (now Shimane Prefecture), Ikumo in Tajima Province (now Hyôgo Prefecture) and elsewhere.

Gold Coinage

The basic unit of counting gold was the *ryô*. Until the late sixteenth century, the *ryô* had been a mere unit of weight, used to weigh gold, silver, medicine, and incense; afterwards the *ryô* was instead treated as a unit of currency. The *ryô* was divided into smaller units of similar origin. For this purpose, one *ryô* equalled four *bu*, which equalled 16 *shu*. All gold coinage was counted as coins and not weighed for purposes of determining value (Table 10).

Above left: Fig. 166. The gold *koban*

Above right: Fig. 167. The gold *ôban*, mainly reserved for ceremonial purpose

Table 10. Edo-Period Gold Coinage

The basic unit of counting gold was the *ryô*. The *ryô* was divided into smaller units. For this purpose, one *ryô* = four *bu* = sixteen *shu*. All gold coinage was counted as coins, not weighed to determine value.

Coin	Value	Year
ôban	nominally 10 *ryô*, but fluctuating	1601–
goryôban	five *ryô*	1837–
koban	one *ryô*	1601–
nibukin	half-*ryô*	1818–
ichibukin	quarter-*ryô*	1601–
nishukin	eighth-*ryô*	1697–
isshukin	sixteenth-*ryô*	1824–

The most common gold coin was the oval *koban* (Fig. 166). It was worth one *ryô*. The *koban* was a thin plate of gold–silver alloy, the exact percentages of which were kept secret, but initially included 84.29 percent gold. The coin measured about 71×38 mm, but its size gradually decreased through the Edo period because of the shogunate's debasement policy. Initially, the coin's usual weight was 4.76 *monme*, or slightly less than 18 g (one *monme* equalled 3.750 g).

One hundred *koban* were known as a 'bundle' and 1,000 *koban* were known as a 'box' (*hako*).

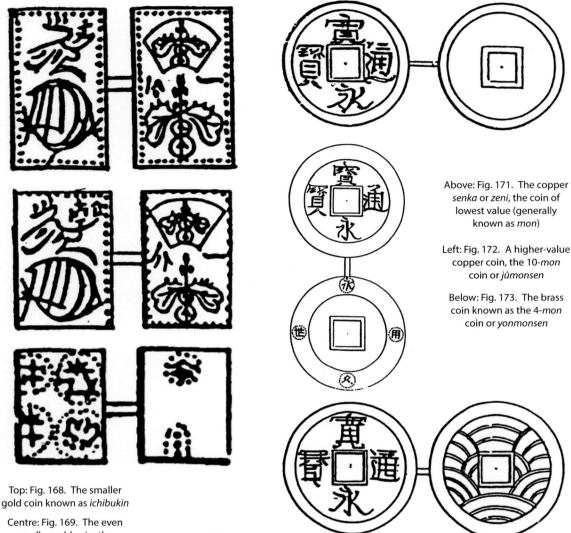

Top: Fig. 168. The smaller gold coin known as *ichibukin*

Centre: Fig. 169. The even smaller gold coin, the *nishukin*

Bottom: Fig. 170. The smallest gold coin, the *isshukin*

Above: Fig. 171. The copper *senka* or *zeni*, the coin of lowest value (generally known as *mon*)

Left: Fig. 172. A higher-value copper coin, the 10-*mon* coin or *jûmonsen*

Below: Fig. 173. The brass coin known as the 4-*mon* coin or *yonmonsen*

There was also an even larger gold coin, the *ôban* (Fig. 167). The *ôban*, too, was oval, and large enough to cover the palm of an adult hand, ranging in size up to 100×150 mm. This coin weighed about 44 *monme*, or 165 g. It contained about two-thirds gold and one-third silver, as well as some copper. Under Toyotomi Hideyoshi, who first minted the *ôban* in 1588, it was 74 percent pure, but the first Tokugawa *ôban* was 68 percent pure; moreover, as the *ôban* was several times recalled and reissued, the gold content decreased regularly. In theory, the *ôban* was worth 10 *ryô*. Its original value was regarded as only seven and a half *ryô*, however, as the purity was lower than the first *koban*. Yet the rate later rose to 25 or more as the smaller *koban* became increasingly debased in quality and purity. The *ôban* was not in common commercial use, as it was reserved for ceremonial purposes, used as offerings, gifts, or awards. This coin was also known as *ôgon* (gold).

Smaller gold coins were also produced from time to time. The first of these was the *ichibukin* ('one *bu* of gold'), a small rectangular coin worth one-fourth of a *ryô* (Fig. 168). This coin measured 18×10 mm. These were the only gold coins ordinary people might encounter. Even the *koban* was generally used only in transactions between samurai or large merchant houses. The *ichibukin* was later followed by other small gold coins, also rectangular in shape. These were the *nishukin* ('two *shu* of gold', Fig. 169), *nibukin* ('two *bu* of gold'), and *isshukin* ('one *shu* of gold', Fig. 170), valued at one-eighth of a *ryô*, half a *ryô*, and a sixteenth of a *ryô*, respectively.

The *goryôban* was yet another elliptical gold coin, which appeared quite late in the period in yet another attempt to improve the economy. As the name implies, it was valued at five *ryô*.

Base Metal Coinage

The monetary unit of lowest value was the *senka* or *zeni* (coin of base or non-precious metal). This was in the form of a circular coin made of copper, iron, or brass about 23–25 mm in diameter (Fig. 171). A characteristic feature of this coin was that it had a six millimetre-square hole in the centre, following the style of Chinese coins since the third century BC. The coin weighed two to three grammes.

These coins were first made in Japan in 1636. Before that time vast amounts of imported copper coins, minted principally in China but also in Korea and Annam, had been in common use. Chinese coins had become legal tender in Japan in 1226. Both China and Korea had attempted to halt the outflow of coins from their countries, but the demand in Japan had been so great that the trade had been impossible to halt. As late as the 1770s the Swedish physician Thunberg noticed that Chinese copper coins, known as Canton *zeni*, remained in current use at least in Nagasaki, the location of the Chinese trading post. According to Thunberg, Japanese coins were made of 'red copper' while the Chinese ones were 'yellow copper', by which Thunberg possibly meant brass.

Copper coins were generally known as *mon* or *sen*. Commodity prices were commonly quoted in *mon* throughout the country, whenever expressed in copper coins. The buying power of a *mon* was limited, being enough for such things as a cup of tea and a rest at a street stall. For bigger purchases, it was common to string together a great number of copper coins with a strand of hemp through the central holes to make a 'string of cash' (*zenisashi*). Such strings existed in two sizes (*shaku*), the smaller with a nominal value of 100 *mon*, while the bigger one, known as *kan*, or *kanmon*, had a nominal value of 1,000 *mon*. The 'strings of cash' made up of Chinese coins customarily included this amount of coins, but when the shogunate introduced the Japanese *mon* in 1636, it also decreed that 96 of the new Japanese coins were equivalent to 100 of the old Chinese ones. In most districts, therefore, the 'strings of cash' held 96 (*kurokusen* or *kurokushaku*) and 960 coins, respectively (Table 11).

As inflation caught up with the prices expressed in *mon*, it became necessary to introduce higher value copper coins. The first of these was the 10-*mon* coin (Fig. 172), which was minted only from the Fourth Month of 1708 to the First Month of the following year. It was made of copper and though bigger had the same shape as the one-*mon* coin. It weighed 9.4 grammes, and the diameter

was 28mm. It did not prove popular, because its real value was regarded as inferior. Its weight was only one third of the nominal value. The one-*mon* coin therefore remained in considerably more widespread use. In 1768, another attempt was made to introduce a new *mon* coin: a four-*mon* coin made of brass, as usual circular and with a square hole in the centre (Fig. 173). Finally, an oval brass coin worth 100 *mon* was also circulated. Despite these new coins, the ancient Chinese practice of using 'strings of cash' remained more popular. In the first half of the Edo period, the 'thousand-string' was equivalent in value to the small gold coin known as *ichibukin*.

Table 11. Edo Period Base Metal Coinage

All base metal coinage was counted as coins, not weighed for purposes of determining value. A unit of a thousand mon was known as *kan*, or *kanmon*. Ten *mon* was also referred to as *hiki*.

Coin	No. per one *ryô* gold	Year
ichimonsen (1 *mon*)	4,000 (or, 3,840)	1636–
yonmonsen or *shimonsen* (4 *mon*)	1,000	1768–
jûmonsen (10 *mon*)	400	1708–
hyakumonsen (100 *mon*)	40	1835–

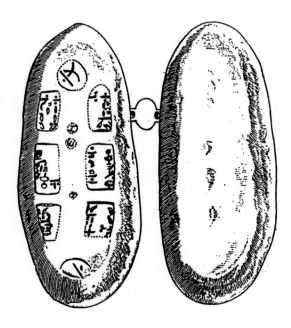

Fig. 174. The largest silver coin, the *chôgin*

Silver Coinage

Silver coins were a currency valued by weight. The basic unit of silver weight was the *monme* (1 *monme* = 3.750 g). Ten thousand *monme* of silver was called a 'box' (*hako*). When weighing silver, one *kanme* equalled 1,000 *monme*, which equalled 10,000 *fun*, which in turn equalled 100,000 *rin*. In the last half-century of the Edo period, a *rin* of silver more or less equalled one *mon* of copper.

The largest silver coin, and the only early silver coin that even attempted to keep a uniform value, was the *chôgin* (Fig. 174). This was a silver bar, either elliptical or of irregular, elongated shape, measuring about 91×30 mm. The *chôgin* weighed about 43 *monme*, or a little over 161 g. This coin often had quite a rough finish (Table 12).

A smaller silver coin was the *mameitagin* (Fig. 175). It was also often referred to as *kodamagin*, or *kotsubu* ('little drops'). This was hardly more than a rounded lump of silver, of indefinite weight and irregular dimensions, with a mark stamped on it to testify to the purity of the metal.

Table 12. Edo Period Early Silver Coinage

Silver coins were valued by weight. The basic unit was the *monme* (1 monme = 3.750 g). One *kanme* = 1,000 monme = 10,000 *fun* = 100,000 *rin*.

Coin	Value	Year
chôgin	43 *monme*	1601–
mameitagin	Weight only	1601–

Fig. 176. The rectangular silver coin of fixed weight known as *5-monme-gin*

Originally these two coins were sliced whenever necessary, as they were measured by weight only. This practice was prohibited in the 1620s. *chôgin* and *mameitagin* were often wrapped in paper stamped either with a government seal or that of a large merchant house, before being placed in circulation. The stamp guaranteed the value of the contents.

For exchange rate between the gold and silver currencies, see Table 14.

At various times, smaller denominations of silver coins of fixed weight also appeared (Table 13). Although of fixed weight, such later silver coinage did not cause an end to the practice of counting the older types of silver coinage by weight only. A few new coins were introduced, however, that had fixed values related to the gold *ryô*.

The *isshugin* and *nishugin* coins were small and of rectangular shape. The *ichibugin* and the *gomonmegin* (Fig. 176) were also of rectangular shape, but slightly bigger. As these coins were of relatively high value, but of a common shape and size, they were frequently hidden in special compartments in one's travelling gear, to fool any would-be thief. Even so-called 'money [hiding] swords' (*zenigatana*), short swords of the size approved for merchants, have been preserved. Next to the sword blade inside the scabbard, the scabbard hid a long pull-out compartment for rectangular coins. The compartment remained invisible to the casual observer even if the blade was drawn from the scabbard. Other devices of the same nature were also undoubtedly used.

For large payments, silver coins were made up into packets of convenient weight. Packets of 100 or 500 *monme* were common. If gold was being used,

gold *koban* were stacked in packs of 25, 50, or 100, then covered with strong paper and stamped, either with a government seal or that of a large merchant house. As these stamps guaranteed the contents, normal practice was to use the packs without opening them. Even larger sums were stored and transported in special strong-boxes made of wood. These were made to hold a fixed amount. Most common were 1,000-*ryô* boxes.

The ordinary Edokko never, of course, carried such large amounts of money. He (or she) instead carried his hard-earned coppers or few pieces of silver in a draw-purse, kept in the bosom of his kimono. The sash prevented the purse from falling out, and this location was reasonably safe from pickpockets. Gold, however, even in small amounts, was usually not carried in a draw-purse. It was more common to store the gold coins in a flat case similar to a modern wallet.

How was the purchasing power of the money used in Edo? We will go into this question in most chapters, as a surprising amount of information is preserved on costs of living and average incomes. To give the reader an idea of the wide range of prices in Edo, however, let us give a few examples. A samurai's expensive heirloom sword (the blade only, without scabbard and mountings) could cost anything between 600 and 1,000 gold *ryô*. A more ordinary sword cost 80 to 100 *ryô*. On the other hand, the seventeenth-century writer Saikaku reports that a scribe writing new year's greeting letters to be sent from a shrine earned only one copper *mon* per letter, and could not expect to write more than approximately 200 letters per day. Incomes thus differed considerably.

In the 1800s, the writer Jippensha Ikku (1765–1831) reported that a simple object such as a ladder could cost 200, or even 600 copper *mon*. At the same time, he noted that the cost to repair a hole in the ceiling was 300 *mon*. Copper had depreciated during the years between Saikaku and Jippensha. But even with inflation, the gap between luxury and poverty had not changed. In Jippensha's time, famous actors enjoyed annual incomes of more than 1,000 gold *ryô*.

Table 13. Edo Period Later Silver Coinage

Later silver coinage had fixed values related to the gold *ryô*.

Coin	Number per one *ryô* gold	Year
gomonmegin	12	1705–
nishugin	8	1772–
isshugin	16	1829–
ichibugin	4	1837–

Paper Currency

Unlike China, where paper currency issued by the central government was in common use, the shogunate did not issue paper money, except in the last year of its existence. Paper money had, however, been known (as *kaezeni*) and in limited use in Japan from the thirteenth century, although none of these early notes have survived.

In the Edo period, commercial firms were the first to issue paper currency. Already from 1600 or thereabouts, merchants of Yamada in Ise Province (now Mie Prefecture) had begun the practice of issuing deposit receipts for silver in lieu of change. These receipts (*Yamada-hagaki*) are considered to have been the first paper currency in the Edo period, as it was backed by the credit of several leading merchants.

Some of the domains under the rule of the great feudal lords also issued paper currency (*hansatsu*). A possible explanation for the introduction of provincial paper currency is the fact that when the shogunate assumed the sole right to mint coins, it did not mint in sufficient quantities to counteract the drain of specie to foreign countries through Nagasaki. The result was a shortage of coins in the provinces. Some great lords accordingly printed notes expressed in gold, silver, or copper values to use in fulfilling their local obligations. The first to do so was the Fukui domain in Echizen Province (now Fukui Prefecture), in 1661. These were long strips of paper, stamped with official seals.

But it is also reasonable to attribute the introduction of provincial paper currency to the increasing debt of many feudal lords. Domain paper notes were prohibited between 1701 and 1730, but after that date they again appeared, although in restricted use. Most common were the so-called rice notes, offered as a lien on the next year's land tax in rice as a security for large-scale borrowing. At the end of the Edo period, as many as 244 domains had their own currency. Moreover, towns, villages, shrines, temples, and as we have already seen, commercial firms also issued their own paper money.

The presumed cause of the prohibition of paper notes is telling. In 1701, the famous Forty-Seven *Rônin* Incident began when Asano Naganori (1665–1701), lord of the Akô domain in Harima Province (now Hyôgo Prefecture), was provoked by an insult into drawing his sword inside Edo Castle, wounding the shôgun's master of ceremonies, Kira Yoshinaka (1641–1703). This was strictly against the law, and besides, Kira was a friend of a powerful favourite of the shôgun, Yanagisawa Yoshiyasu (1658–1714). Asano was dispossessed of his domain and condemned to take his own life. After his death, 47 of his loyal retainers, now *rônin*, led by Ôishi Kuranosuke Yoshio (1659–1703), better known as Kuranosuke, swore to avenge his death. This was accomplished in January 1703, even though the *rônin*, too, were sentenced to commit suicide, as such vendettas were against the law. The affair attracted considerable interest all over Japan and resulted in numerous plays, stories, and nowadays also films.

From the point of view of the shogunate, however, the affair brought not only security worries but also financial problems. The lord of Akô had not only been condemned to take his life, his estates had also been confiscated by the government. The shogunate was – as all governments everywhere – in constant need of more money. However, one of the retainers of the lord travelled with great speed from Edo to the home castle of the lord, where senior retainer Ôishi Yoshio was in charge of the treasury. Ôishi at once counted the gold in the treasury and found that it represented only 60 percent of the notes issued. He knew that when the official messenger from the shôgun arrived, he was bound to hand over everything to the shogunate.

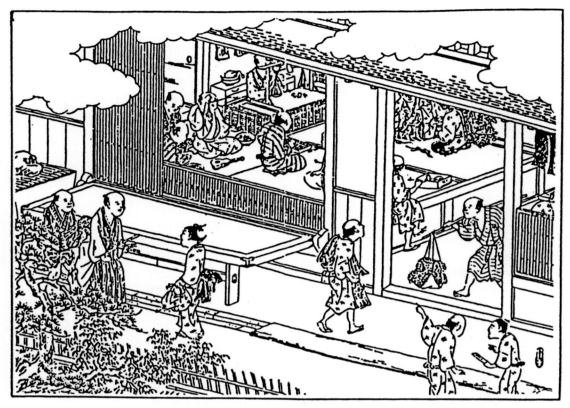

Fig. 177. The office of an
Ôsaka money-changer

Instead he chose to redeem the paper money at a rate of 60 percent of the note issue. He thus enabled the holders of the Akô notes to at least rescue something of what the late lord had owed them. The shogunate was naturally not amused when the official messenger found the treasury empty. Paper money was accordingly prohibited for several decades.

Local paper money was, of course, not always reliable even if the lord remained alive and in control of his finances. Although convertibility was guaranteed at time of issue, devaluation, inflation, and plain bad luck could easily hamper the holder of the note. Unfortunately, there was little a commoner could do if a great lord chose to pay in his own paper money. At times, even wealthy merchants suffered losses when a lord refused to honour his financial obligations. Other merchants suffered far worse – in some cases imprisonment on trumped-up charges – when the lord was unable to repay his debts.

The use of bills of exchange among merchants was also very common, and the economy was well developed in this respect, in fact so well developed that the shogunate often lost money by being unable to fully understand the many ingenious ways in which money could be transferred between different cities without physically moving it as cash. For the shogunate – as well as for the samurai in the street – it always seemed that the money-changers got the better deal whenever currency transactions took place.

Currency Exchange Rates and Money-changers

The shogunate made great efforts to stabilise the mutual exchange values of coins made from the various metals in use. Such efforts had been made already by Oda Nobunaga, who set the first exchange rates in 1569. At first, rates of exchange fluctuated wildly. In 1604, the rates for base metal coinage could differ as much as one to four *kanmon* per gold *ryô*. In 1609, a more stable situation had been attained. Despite this, the exchange rates changed constantly throughout the Edo period (Table 14).

In 1609, the exchange rate was fixed at one *ryô* of gold to 50 *monme* of silver to four strings of coppers. Soon afterwards, however, the value of silver declined to 60 *monme*. This gold to silver ratio remained more or less constant until the very end of the Edo period, when silver declined further until one *ryô* of gold equalled 100 *monme* of silver. This drop in value was caused by the international world parity of gold and silver, put in effect by the treaties of commerce with the Western countries. Prior to these treaties, world exchange rates did not directly affect the economy of Japan.

Copper, too, tended to decline in relation to gold. In the last quarter of the eighteenth century, copper slipped to six strings of coppers to one *ryô* of gold, and at the end of the Edo period, after the artificial Japanese economy had been exposed to the harsh realities of international trade, it fell further to 10 strings of coppers per gold *ryô*.

Table 14. Edo Period Exchange Rates for Gold, Silver, and Base Metals

Year	Gold coinage	Silver coinage	Base Metal Coinage
1609	1 *ryô* =	50 *monme* =	4 *kanmon* (4,000 mon)
c. 1625	1 *ryô* =	60 *monme* =	4 *kanmon*
1705	1 *ryô* =	60 *monme* =	4 *kanmon*
c. 1800	1 *ryô* =	60 *monme* =	6 *kanmon*
1842	1 *ryô* =	60 *monme* =	6½ *kanmon*
c. 1860	1 *ryô* =	100 *monme* =	10 *kanmon*

Note 1. One *kanmon* was nominally 1,000 *mon*, but after 1636 the *kanmon* in fact consisted of only 960 *mon*.

Note 2. The exchange rate fluctuation from 1858 was caused by the international world parity of gold and silver, put in effect by the treaties of commerce with the Western countries.

Throughout the Edo period, there were also short-term fluctuations in the exchange rates. Local fluctuations also affected trade to a significant degree. In 1840, for instance, the rate was reported to be 63.6 *monme* of silver per *ryô* of gold, and one silver *monme* per 110 copper *mon*. The gold *ryô*, however, was set at 6,980 *mon*. Upon close inspection, these two rates do not coincide. In addition, as the markets in western Japan were based on silver, while the markets in eastern Japan relied on gold, there was always profitable opportunities and a ready market for money-changers (*ryôgaeshô*, Fig. 177). Many grew very wealthy.

Another factor which favoured the money-changers was that different coinage metals were used on different levels of trade. Most retail trade in the cities and towns (and in the villages whenever coins were used instead of goods) was transacted in coppers. Wholesalers and large shopkeepers had to change their coppers into gold or silver for various purposes, such as settling debts and buying stock. Alternatively, a wholesaler might find it necessary to exchange his gold or silver into coppers when he sent men out to buy goods from local craftsmen or farmers. In addition, transfer of money between Edo and Ôsaka necessitated an exchange between gold and silver.

The money-changers naturally extracted a commission for their work. In the Genroku period (1688–1704), the rate of commission for gold-silver exchange was 10 coppers for each *ryô* of gold, that is, 0.25 percent.

The money-changers existed in a hierarchy of three basic levels of prestige and importance. The top money-changers were really wealthy merchants, such as the members of the 'ten-man company' (*jûningumi*), 10 Ôsaka-based merchant houses that from the 1660s onwards acted as financial agents to the shogunate. In this role, they both acted as bankers to and exercised the role of superintendents over all other money-changers. These leading members of the trade had great prestige and power, and were responsible for seeing that the lower-level money-changers conformed to the accepted customs of their profession. These leading families also acquired the right to wear the swords of the warrior class. From 1691, two (later three) members of the Mitsui family (see below) were added to these official agents, in competition with the older 'ten-man company'. Beginning in 1709, several of the former went bankrupt, but top-level money-changing remained in a few hands only.

The middle-level money-changers consisted of regular money-changing businesses, advertised by a sign of a large wooden representation of a copper coin hanging outside the office. In many ways, these establishments were similar to the banks of today. Dealing especially on the level of inter-city trade, they also issued documents for the transfer of money, accepted deposits, and advanced loans. No interest was given on deposited money, but certificates were issued that could be used for financial transactions. Loans were generally restricted to those who already had money on deposit, and also depended upon the good character and sound reputation of the borrower. To avoid the shipping of huge quantities of silver and gold between Ôsaka and Edo, the use of letters of credits and other financial instruments rapidly developed among the great merchant houses.

The lowest level of money-changers consisted of small dealers, often known as 'copper-shops'. They dealt mainly with the exchange of coppers and small amounts of silver, and these shops were indeed at the same time often retailers of other commodities, for instance oil or the popular alcoholic drink *sake*.

The shogunate did not yield all control of the national economy to the money-changers. In particular, the scales and weights used to ascertain the value of coins were strictly controlled. These had to be inspected by officials responsible for weights and measures. In addition, the approved pairs of scales were made by only two families, and the weights were manufactured by the same family that controlled the mints.

Despite all the security measures, counterfeiting was not unusual. This malpractice, beginning long before the Edo period, grew especially rampant when the coinage policy changed. During only a few years after 1695, there were over 500 convictions for this offence. The widespread use of counterfeit money, or 'bad coin' (*akusen*), was forbidden by Oda Nobunaga as early as 1569, and the shogunate had to repeat this ban frequently.

Income and Expenses

The true Edokko was, in the words of the novelist Saikaku, a gullible fellow, without any forethought and thus liable to make bad bargains. Ôsaka merchants often said that the Edokko were like children, who did not understand how to use money. Maybe they were right, as Edo was a free-spending city.

Most current academic work contains remarkably little (and often inconsistent) information on the daily income and expenses of an ordinary family in Edo. As an example, let us look at the budget of a construction worker in the 1820s, with a family consisting of a wife and one child. They live in a small rented apartment. In Edo, rent was paid at the end of each month.

Of the 354 days in an Edo period year, there were about 294 working days. Carpenters and other construction workers did not work on public or local holidays, the first and the fifteenth days of each month, and rainy days. This makes for a total of approximately 60 days without work. The worker's average daily wage was about 5.4 *mon,* including his allowance for rice (1.2 mon per day). His annual income was thus 1,587 *mon.*[41] Expenses claimed almost all his income, or 1,514 *mon,* divided as in Table 15.

Table 15. Expenses Divided by Type

1. Salt, soy sauce, oil, charcoal	700 *mon*	46.20 %
2. Rice	354 *mon*	23.40 %
3. Apartment rent	120 *mon*	7.90 %
4. Tools, furniture	120 *mon*	7.90 %
5. Clothing	120 *mon*	7.90 %
6. Ceremonies (funeral, marriage, birth, etc.)	100 *mon*	6.60 %
Total	1,514 *mon*	100 %

Source: *Bunsei nenkan manroku,* cited in Edo-Tôkyô Museum, Tôkyô.

A townsman of this type did not generally pay any taxes. This left 73 *mon* for savings or entertainment. He hardly had money to spare, after necessary expenses were paid. To follow the local fashions, enjoy in cultural pursuits, or to visit expensive entertainment quarters were clearly out of the question for the average townsman. This must be remembered whenever considering what 'typical' life in Edo was.

41 *Bunsei nenkan manroku,* cited in Edo-Tôkyô Museum, Tôkyô.

However, this summary of the wages and expenses of a townsman, although quoted in most current works on the Edo period economy, is inconsistent with what is known from other sources. Polished rice, for instance, was not cheap. Although the price in the country for raw rice may have been as low as five to six *mon* per *shô* (1.8039 litres), the same rice, polished, often sold for about 100 *mon* per *shô* in Edo. At times, the price was even higher, such as during the 1786–87 famine, when a mere three tenths of a *shô* cost 100 *mon*.

In the 1820s, the city price of rice was actually around 33 *mon* for a daily ration (half a litre). Even in the 1830s, when the price was low, a daily ration of rice cost about 25 *mon*. Besides, in the early nineteenth century, a bowl of buckwheat noodles in a restaurant is said to have cost about 16 *mon*, an often quoted figure that appears reasonable although perhaps of dubious accuracy.[42] By the mid nineteenth century octopus, squid, or shellfish sushi typically cost eight *mon*, while sushi with egg cost twice as much. High-grade sushi sold for 16 *mon*.

The Edo novelist Jippensha Ikku also mentions numerous prices and costs of daily living in his novels, published from 1802 to 1809, and these costs are almost invariably higher than those mentioned above. Even though it is true that his prices, enumerated in copper *mon*, are higher than in previous centuries because of copper depreciation, this can hardly explain all discrepancies. Let us therefore regard the example above as possibly true when it comes to the relative proportion of the various expenses of a working class family, but likely incorrect in the actual numbers.

According to Jippensha, clothes were a considerable expense. Cloth for an ordinary kimono cost anything from 1,500 to 2,200 *mon*. A dirt-cheap secondhand kimono cost 300 *mon*, while an ordinary but well-used secondhand one cost 1,000 *mon*. Even to rent (admittedly rather fine) clothes cost 900 *mon* per day. City sandals (*zôri*) cost 48 *mon* per pair, while cheap straw sandals (*waraji*) for use while travelling cost 14 to 16 *mon* per pair.

Luckily, other sources are also available for incomes in Edo and other cities. The seventeenth-century novelist Saikaku mentions that a maid received pay of 32 *monme* every six months, which equals slightly more than one *ryô*. By then, a wet-nurse was offered 85 *monme* for a year, in addition to a new kimono four times a year. The cash salary alone was equal to more than 1.4 *ryô*. These salaries (roughly 70–110 *monme* per year) remained more or less unchanged until the end of the Edo period. In addition to salary, tips were also often paid, ranging in value from of a couple of percent to as much as 24 percent of the salary. A century after Saikaku, in the eighteenth century, the annual salary of a shop clerk or maid in domestic service was about three to four *ryô*, or 12,000–16,000 *mon*.

Valets, especially those employed by samurai families, were often paid higher wages if they cut a fine figure in public. According to records from

42 This price is often quoted because of the recorded name of a certain type of buckwheat noodles (*nihachi soba*). However, this name instead appears to be derived from the type of noodles used in this particular dish. See the section on food and drink in Chapter 4.

1829, the tallest ones (of a stature admittedly very rare indeed in Edo!) could earn as much as 3,600 *monme* (60 *ryô*) a year, while short valets enjoyed less than a quarter of this. Not all samurai could afford a valet; some *gokenin* earned less than the average valet.

We also know something about the employees of the really big merchant families. The Shirokiya dry goods store in Edo maintained an annual salary (*kyûkin*) schedule that in 1769 varied from four *ryô* for starter employees to 10 *ryô* for branch managers.

The merchant house of Kônoike also kept detailed employee records, which give an idea of both the ordinary career and the income of employed merchants in the eighteenth century. It was common to begin work for the firm as an apprentice at age 12. An apprentice was unsalaried, but at the age of 18 (after undergoing the *genpuku* or coming-of-age ceremony) was promoted to the rank of clerk, and received a salary that commenced at about 50 to 60 *monme* of silver every two months. That was the equivalent to 3,300 to 4,000 *mon,* or an annual salary of 19,800 to 24,000 *mon.*

At Kônoike, a clerk spent some 20 years at this level, until at the age of 38 he rose to the rank of manager-in-training. After an additional two or three years, he was usually promoted to the rank of manager (*bantô*). After two or three more years (at the age of 42 or 43) he was either authorised to form a branch house as branch house manager, or remained as a resident manager. From attaining the lowest managerial rank (manager-in-training), the annual salary rose from 300 or 400 *monme* up to as much as three *kanme* (3,000 *monme*) of silver, depending on rank. A range equivalent to between 20,000 and 200,000 *mon* annually. In addition to these annual incomes, there were special payments or bonuses. At least since 1719, an annual bonus payment (*moyaigin*) of 200 *monme* (about 13,330 *mon*) was awarded to employees working for the house, put aside and earmarked (but not actually paid) in the Eleventh Month of each year. The bonus was only paid when the employee left the house to set up an independent business or branch shop, and only if the discharge was honourable.

The average clerk therefore had an actual annual income of about 560 *monme* of silver, which at the time equalled 37,330 *mon* or slightly less than 10 *ryô* of gold. This can be compared to the income of a farmer, which by the end of the Edo period varied from six or seven *ryô* per year, in addition to clothing and food. Wealthy farmers had incomes that could be as high as 30 *ryô* per year. Most low-level samurai earned far less, sometimes as little as four *ryô*. This was the equivalent of what a trainee shop clerk or maid in domestic service made – and clerks and maids did not have to provide their own arms and armour as part of the deal. In comparison, the *chûgen* (valet) made even less than the low-level samurai, commonly only about two *ryô* per year, but they also received room, board, weapons, and other necessary gear.

As an additional benefit, merchants and craftsmen customarily gave their employees money for visiting home each summer and new year holiday. Every two or three years, the Kônoike house also paid a special bonus known as *nazukegin* to employees who had been with the house since their youth. Payment began at the age of 21 or 22. Employees who had been hired at an older age were eligible to receive special allowances from their eighth or

ninth year of employment. The special bonus was not paid to the employee, however, until the time of his retirement or gaining the right to open a branch shop.[43]

Domestic servants and labourers usually had to pay a 3–10 percent commission on their wages to a labour broker (*hitooki* or 'people-placer'). According to Saikaku (who may have exaggerated the plight of the employee), this commission was hurriedly exacted from the advance wages (*maegane*) paid to the servant. At least in the nineteenth century, however, the employer commonly appears to have paid one-third of the commission payment. In any case, as a servant's or labourer's term of employment usually lasted only six months, the commission could be costly if he frequently had to find new employment.

The law required that a servant seeking employment find a guarantor (*ukenin*) who ensured that the servant adhered to the employment contract. The guarantor could be a friend or relative, but for the majority of the migrants who had come to find work in Edo, a professional labour broker acted as guarantor. A servant's contract was therefore generally accompanied by a promissory note (*tegata*) from the guarantor, who was held liable for repayment of wages in the event that the servant absconded. Some labour brokers also provided hostels where the jobseeker could stay while waiting for employment. The broker then charged rent as well as commission. The rent in such a hostel in Ôsaka during the Genroku period (1688–1704) was one *shô* (1.8039 litres) of rice per day.

Casual and day labourers also made a living, somehow. According to Saikaku, one could polish pots and pans for five *mon* per large pot or two *mon* for smaller ones, wash rice for four *mon* per bushel, and, if one had a carpenter's plane, shave down chopping boards (*manaita*) for three *mon* each. Others, who had their own rakes, bins, and bamboo brooms, cleaned the gutters for one *mon* per one *ken* (1.8 m) of waste removed. For five *fun*, that is, half a *monme*, someone would prune a tree, and graft on branches for one *fun* each. A part-time carpenter charged six *fun* per hour.

Saikaku realised that day labourers did not have easy lives. According to him, their daily income of from 37 to (in exceptional days) 50 *mon* had to support a family of perhaps four of five. Edo regulations from 1657 further indicate the cost for hiring day labourers en masse from a labour broker. The average daily wage per labourer was then about 57–89 *mon*, depending on whether he supplied his own tools or not, but on the other hand, the labour broker would pocket a good share of this. However, these regulations seem to have been frequently ignored, and higher wages were paid when there was a demand for labour.

For poor people with low or nonexistent wages, another means to raise cash was to go to a pawnbroker (*shichiya*) with clothes and other objects. Pawnshops were numerous; there were said to be 2,731 of them in Edo

43 In the Meiji period, at least by 1876, the Edo period bonuses had developed into the modern bonus system (*bônasu*, from the English word) still commonplace in Japan. This bonus consists of two annual lump sum payments, which most Japanese employees receive apart from regular salaries in the summer and at the year's end.

alone. Pledges were according to government decree commonly accepted for a maximum of eight months. Pawnbrokers especially liked to receive clothing. Bedding, umbrellas, and other articles were also accepted, but the pawnbroker charged twice or three times as much interest on them as he did on clothes. The interest rate was calculated per month, which was regarded as the minimum term, and the basic rate of interest for clothing was generally from 3.6–8 percent. The higher rate (8 percent, or 151.8 percent per year) was charged for lower amounts, that is, cheaper articles. Poor people generally had to pawn items quite often, and thus were charged the higher rates. It was not uncommon for a really poor worker to pawn his clothes and bedding in the morning, and then to redeem his belongings the very same evening. This process was repeated day after day. Only his daily wage could then sustain the eternal pawn transaction. The great winner was, of course, the pawnbroker. Saikaku gives some curious indications on how much money was received when pawning household goods. For example, an old umbrella, a cotton gin and a tea kettle yielded a value of one *monme* of silver, or roughly 67 copper *mon.*

On more substantial loans, handled by moneylenders rather than pawnbrokers and received by respectable merchants rather than the urban poor, the interest was around 18–20 percent per annum.[44] Saikaku reports an old woman who extorted interest from her own son at the rate of 15 percent, on money she had accidentally mislaid while staying in his house! Usury was not uncommon, however, and interest of 100 percent was hardly unknown. Curiously, the blind and shaven-pated masseurs who plied their trade along the streets of Edo also operated a thriving trade as moneylenders. They lent small sums of money at an interest rate of 20 percent per month (which equals a stunning 791.6 percent a year).[45]

Investors also put money into the businesses of particularly trustworthy merchants. A reasonable yield, mentioned by Saikaku, was 0.6 percent per month, or roughly 7.4 percent per year. Such an investment could provide a handsome living, if the amount was large enough.

The shogunate naturally exacted taxes. Members of the warrior class were exempt, which made good sense as the vast majority lived on their stipends only. For some curious reason, townsmen were also not usually taxed. While farmers and the majority of craftsmen had to make a contribution either in the form of goods or services or as cash payments, other groups were only taxed under certain circumstances.

Property owners in the towns and cities had to pay a property tax of one *monme* per mat (a common unit for measuring a house's size, roughly 90×180 cm). In addition, a special tax was assessed according to the width of the property facing the street. Properties with a frontage of less than 15 *ken*

44 Thunberg, *Resa* 3, p.97.

45 The closest similarity today is not found in Japan; so-called pay day lenders in many US cities offer small loans at an interest rate of 15–25 percent a month, with an average annual percentage rate of 569 percent. *The Economist*, 5 June 1999, p.58.

(1 *ken* = 1.8 m), or about 27 m, appears to have been exempt from this impost, and these were in the majority.[46]

Other taxes came in two different kinds. Direct taxes (*unjôkin*) were levied on articles of commerce and upon fixed capital, such as water-wheels, ferries, wharves, and undertakings such as licensed brothels. In addition, there were also nominally voluntary payments (*myôgakin*), paid whenever a privilege of any kind was granted. Today the latter would be called an administrative or service charge. Something akin to patent rights were available to inventors of certain devices or processes, but this too demanded a payment.

The Merchant Houses and Samurai Salaries

The merchants, in theory the lowest social class, became increasingly powerful in the Edo period. For most samurai, this became increasingly obvious over time, since it was merchants who handled all practical arrangements with regard to the payment of samurai salaries. For low-ranking samurai, the process soon became painfully obvious, since it was the same merchants who also handled their pay day loans, without which they could not sustain their families. However, the main reason for the rise of the merchant class was its assumption of control over trade, vital to the economic life of the country. In this context, samurai pay day loans formed a minor part of merchant activities. Merchants frequently organised in monopolistic professional trade associations (*kabunakama*). This promoted cooperation and, likewise, profits.

Although at first opposed by the shogunate, trade associations became an integral part of business life in Edo. Every trader, and especially the smaller ones, were affected. Monopolies were frequently formed, and the shogunate awarded exclusive privileges to recognised dealers in many staple commodities in exchange for contributions (*myôgakin*) or outright bribes. This increased the power of the great merchant houses at the expense of all other classes, including the warrior class. By the end of the Edo period, growing economic confusion and the excessive power of the trade associations caused the shogunate at times to dissolve or proscribe them.

Edo had many kinds of merchants. The most profitable houses generally dealt in rice, salt, oil, lumber, or fertiliser, or several of these commodities. As the monetary economy developed, the rice merchants – already important, as the economy was based on rice – ventured into large-scale banking, and grew increasingly powerful. The amount of trade handled by big merchant houses expanded rapidly. It was not unusual to deal in goods valued at hundreds of thousands of *monme* of silver.

Nonetheless, the economy of Edo period Japan remained founded upon rice. Each year, shogunal officials inspected the tax rice owed by farmers. The rice was then transported, usually by ship, to Edo. After a farmers' representative from the district of origin of the rice had received his receipt,

46 Farmers also had to pay tax on their rice land, but at a severely slashed rate – as is the case in modern Japan.

the rice was stored in the vast Edo granaries. There it remained until it was time to distribute salaries.

The samurai received his salary three times a year, in spring, summer, and winter (paid out in the Second, Fifth, and Tenth Months, respectively), normally in the proportions of a quarter in spring, a quarter in summer, and the remaining half in winter. Part of the income was sometimes paid in cash instead of rice, at a rate that did not necessarily have anything to do with the true market value of the rice. In the early Edo period, the chosen rate was at times actually higher than the market value, but in the later years it was usually lower.

Samurai were divided according to their rank, and different days were allotted to the delivery of rice to different ranks. For samurai of the same rank, a sort of lottery determined the order in which they were paid. At first, each samurai personally collected his rice, waiting his turn in one of the tea shops near the rice granaries. Soon, however, it became increasingly common to send a member of the merchant class instead. These specialised rice merchants (*kurayado*), who often began as owners of the nearby tea shops, acquired the right to present warrants from the samurai and thus collect the rice. This rice was sometimes delivered to the samurai, but more often it was sold and the samurai compensated in cash. All, except the most low-ranking samurai, were provided with more rice than they could consume, so in any case they had to sell the surplus to acquire cash for any other necessities.

In the later years of the Edo period, the rice price frequently fell, while samurai salaries remained fixed. As the samurai then had to borrow money from the same rice brokers (*fudasashi*) in advance of the actual delivery and sale of the rice merely to muddle through until the next pay day, the rice merchants as compensation charged high interest rates and demanded the interest be secured by rice to be received from future crops. Like the very poor, who had to pawn their bedding and clothing every morning, the samurai often had to borrow on their future rice allowances merely to make ends meet until the allotment date when the allowance was received. By then, however, they would find the entire allowance was already owed to the broker. The interest rate of the rice brokers was at first 15 percent, although it was later reduced by government decree to 12 percent. This was still a substantial amount for the lower samurai.

As the rice brokers profited both from interest on loans and from the commission for their services in collecting and selling the rice, it was natural that they soon grew into banking houses.

The rice received as income by the great feudal lords was handled in a similar way. The great lords, too, needed hard cash instead of rice. These lords, too, soon found themselves in debt to the major rice merchants. A broker who handled rice sent for sale by one or several great lords could cash in on huge volume of sale, as well as on lending advance money to the lords. The latter, too, naturally had to pay high interest. The loans were secured by rice futures and other products that the feudal lords had to sell.

Although the samurai regarded the merchants as unnecessary and parasitic middlemen – which was certainly true – they soon found themselves depending on these very merchants to survive in the money economy that

rapidly developed in the highly artificial conditions of Edo period Japan. The rice crop was harvested only once a year and usually in distant provinces. The samurai, however, lived in the towns and cities. There prices were high, as little was produced and virtually all goods had to be brought in from the provinces. The samurai – whether high or low – could maintain the lifestyle required by the shogunal system only with cash advanced by the merchants.

Most of the major rice merchants also dealt in rice from other sources than the warrior class. There was usually a certain amount of private rice, often hidden from the tax-collecting authorities. This rice, however, was mainly sold to merchants in Ôsaka, as there were fewer samurai there and accordingly less control. Among the wealthiest merchants were those designated to act as agents for the shôgun or other members of the samurai class. It was, for instance, common to employ a merchant as broker not only for disposing of rice but in all other trade transactions as well. A merchant fortunate enough to be in this position would naturally profit immensely.

The Mitsui Family

Edo was never as important as Ôsaka as a production centre. Most of the major merchant houses in Edo originated in Ôsaka or elsewhere in western Japan. No description of the life and times of the wealthy merchant houses in Edo is complete without mentioning the Mitsui family. Although the wealth of the Mitsui family began with a sake, soy, and pawnbroking business in the town of Matsusaka, near Ise in Ise province, their fortunes were to be closely intertwined with the development of Edo. Moreover, the family was of samurai origin – hence the family name. Its history illustrates how many samurai families remade themselves into merchants in the Edo period. An early Mitsui, Takahisa, had been a relative of the warrior house of Sasaki in the province of Ômi and commanded his own castle. A later Mitsui, Takayasu, enjoyed the honorary title lord of Echigo (Echigo no Kami). When confronted by the powerful warlord Oda Nobunaga, however, he realised the fortunes of war were not likely to be in his favour, and immediately fled to the town of Matsusaka.

The eldest son of Takayasu was Sokubei Takatoshi (died 1633; most members of the family had several personal names, used at different times). He was no more warlike than his father, so he gave up his samurai status and instead started a soy sauce and sake-brewing business. People began to call his business 'Lord Echigo's Sake Shop' (Echigo-dono no sakaya), because of his father's former rank. Despite this, business was slow. Sokubei Takatoshi had married Shuhô (1590–1676), the daughter of a merchant, and she soon proved to have more business sense than her husband. On market days, she cajoled farmers and pilgrims on their way to the Ise shrine to buy more sake than they could really afford. Consequently they had to borrow money for the return journey, leaving part of their valuables as security. This led to a successful pawnbroking and money-lending business. She also sold, among other things, bean paste (miso).

When their eldest son, Saburôzaemon Toshitsugu (1608–1673) was around 17 years old, in about 1625, he was sent to Edo. Young Toshitsugu began his career by working for some Edo relations who had a drapery

businesses. In 1627, at the age of 19, he opened his own small drapery shop. The shop took the name Echigoya ('The Echigo Shop' or 'Echigo House'). Most merchant houses added -ya ('house') to their commercial name, so this was a suitable name. Toshitsugu was scarcely more successful than his father, but the shop proved useful as a foundation for what was to come.

The eighth and youngest son of Sokubei Takatoshi was Hachirôbei Takatoshi (1622–1694). In 1635, when he was 13 years old, his mother – the father having died prematurely – sent him as an apprentice to his elder brother Saburôzaemon Toshitsugu in Edo. Hachirôbei Takatoshi was so able that the brothers opened a second shop of the same name in the same neighbourhood. Eventually Saburôzaemon Toshitsugu left for Kyôto, where he organised a cloth-procurement scheme and set up yet another shop. Hachirôbei Takatoshi remained in Edo, in charge of the two shops there.

Around 1649, when Hachirôbei Takatoshi was 27, his remaining elder brother in Matsusaka died, and Hachirôbei was forced to return home to take care of his mother's family business. He soon found himself married to Nakagawa Jusan (1636–1696), the 14-year-old daughter of another wealthy Matsusaka merchant and money-changer. The couple was in due time blessed with 11 sons, of whom six were eventually considered sufficiently qualified to continue the business concerns of the house of Mitsu (the couple was also burdened with five daughters, but they were successfully married off. The Mitsui by then had no problems providing sufficient dowries).

As everybody expected Saburôzaemon Toshitsugu, who had remained in Kyôto, to inherit the family fortune, Hachirôbei Takatoshi decided to create an independent business to pass on to his own heir. He accordingly built his own residence in 1652, and set up a money-changer's business, financed by extensive savings from his time in Edo. He soon made great profits, especially from lending money to feudal lords, including the lord of Kii Province (now Wakayama Prefecture), head of one of the three Tokugawa branch families. Other merchants, and farmers who needed a cash advance to pay taxes, could also count on loans from the new business. As most of these loans (all except a few that went to other merchants) were secured by rice, Hachirôbei Takatoshi also added rice-brokering to his growing business concern.

In 1667, Hachirôbei Takatoshi sent his eldest son, the 14-year-old Takahira (1653–1738), to learn the trade in his father's footsteps at Saburôzaemon Toshitsugu's shop in Edo. In 1668 and 1672, respectively, his next two sons followed. Takahira also turned out to be an able merchant. He changed his name to Hachirôemon Takahira in 1670.

In 1673, Saburôzaemon Toshitsugu died. Hachirôbei Takatoshi, then 51 years old, reached two important decisions: he would no longer rely mainly on lending money to the great lords, and would instead devote his business to commoners through his shops. According to the filial records of the Mitsui, his octogenarian mother Shuhô agreed to the plan, and Hachirôbei Takatoshi then moved to Kyôto, where as new head of the Mitsui family he took over the retail store and the procurement of cloth to be sent to Edo. Then, leaving his son Hachirôemon Takahira in charge in Kyôto, later in the same year he took his second son with him to Edo where he opened a small retail shop in a good location close to where the other, by then defunct, family

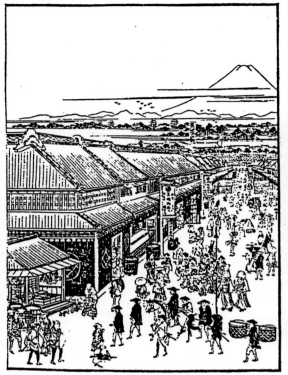

Fig. 178. The Echigoya in Surugachô; the crowded Edo streets.

shops had been located. They called the business Echigoya, after the earlier shops. It was a rented property with a mere 2.7 metre frontage, virtually the minimum available in Edo. By this time, Edo already had 20 or 30 drapery shops. All or most were located on the same street, Honchô Dôri. The size and importance of a shop was reckoned by the width of its frontage. The largest reached some 36 metres.

However, the new Echigoya, despite its minimal size, began with a capital of 100,000 *monme* of silver, a significant amount. It also had considerable family support. At first, the Edo shop employed five or six senior employees and three junior employees. By comparison, the main Kyôto shop had only four senior men and the same number of junior employees. Business went well. Within a year of Hachirôbei Takatoshi's arrival in Edo, he opened a new shop in the same street, with six times the frontage of the old one. He employed some 15 clerks, five apprentices, and several servants at both stores.

As competition was stiff, Hachirôbei Takatoshi had to find something new to attract customers. All other businesses in Edo operated on similar lines. They did not, for instance, rely on cash sales. Instead the customers had to settle their accounts twice a year, at the end of the Sixth and Twelfth Months. This locked up capital for a considerable period, but on the other hand was a good excuse to keep prices high. Most customers belonged to the warrior class, and were expected to be unconcerned with the pricing of goods they bought.

Hachirôbei Takatoshi changed all this. He slashed prices by 10 to 20 percent. To afford this, he began to accept cash sales only and relied on

fixed prices. His famous first signboard, still preserved by the Mitsui family, announced 'cash sales, no fancy prices' (*genkin kakene nashi*). This outrageous behaviour won him many customers, but caused great consternation among his more traditional competitors. In 1683, the shop indeed had to move into a different neighbourhood (Surugachô) to avoid harassment. Echigoya advertised its goods freely, including on rainy days lending its customers oiled paper umbrellas emblazoned with the Mitsui mark, and by providing handsome contributions to playwrights, poets, and writers as a public relations campaign. The store also did not look down on the sale of even small quantities of cotton or silk cloth to poorer customers. Business accordingly thrived. To sell in small quantities was also an innovation, as the other shops did not cut up a kimono-sized roll of cloth, even if a customer required only a small piece. Echigoya's policy became sales at low profit but high volume.

The new location was also a good one. Surugachô was considered among the most attractive commercial locations in Edo. It was so named because on clear days the neighbourhood had a view of Mount Fuji (Fig. 178) so good that it was said to resemble the view from Suruga province (other explanations of the name have also been advanced). As a sign for his business, Hachirôbei Takatoshi chose the three horizontal strokes for *mitsu* ('three'), and the four boards forming the rectangular curb of a well (*i*). Together, these symbols thus made up a rebus of the family name Mitsui.

In 1683, a money-changing office was also added to one of the Edo shops, and yet another Edo shop was opened, this time for the sale of cotton textiles. The Mitsui family also introduced other business innovations. The sales staff, for instance, was specialised, with each man – the sales staff was composed solely of men – in charge of a different product. Employees were required to work only for a specified number of hours, and were given regular rest periods during the course of each day. Dormitories were provided for the staff. Echigoya trained its employees in manners, speech, and personal appearance. An efficient system of bookkeeping was also introduced (it was indeed so efficient that eventually, in 1707, the Mitsui family was appointed as the shogunate's accounting office). Productivity was encouraged by granting bonuses amounting to one percent of profits. The firm also became noted for its readiness to quickly make up materials into garments while the customer was waiting.

As a result of its numerous innovations and efficient public relations campaign, Echigoya soon became a famous sightseeing spot in Edo. The contemporary writer Saikaku, in his work *Nippon eitaigura* (The Japanese Family Storehouse, 1688), had the following to say about Echigoya:

> At Surugachô, a man named Mitsui opened a shop of nine *ken* by forty *ken* [roughly 16×73 m], adopting the cash-payment, fixed-price system. There are forty-odd clerks, each engaged in a different category of business. For example, one is handling brocade, two men are selling silks from Hino and Gunnai, one is in smooth silk, one in textured silk. One sells *hakama* [skirt-trousers], and another woollens. Thus divided, they sell velvet by one-inch squares, brocade large enough to make a tweezer case, or red satin enough to cover a spear insignia. When ceremonial costumes are required in a hurry, the shop lets the servants (of the customer) wait and has the regalia made up immediately by several dozens

of their own tailors … To look at the shop owner, he appears no different from others, with his eyes, nose, and limbs in the usual arrangement; but he is clever at his business. This is an example of a really big merchant.[47]

The staff of the dry goods stores were divided into at least 16 different ranks, from the apprentices and shop boys at the bottom to the foremen, administrators, representatives, and managers at the top. The seniority system was used as the basis for promotion, but after around 1735 those promoted to higher rank than group foreman were selected on the basis of their performance as well as their age. Lower ranks continued to be promoted strictly according to seniority.

Around 1686, well after the death of his aged mother, Hachirôbei Takatoshi moved the family residence from Matsusaka to Kyôto. A new money-changing office was included in the new building. In 1687, Mitsui became one of the official drapers (*gofukushi*) to the shogunate, with offices for this purpose in both Edo and Kyôto. The family also expanded the Kyôto side of the business. The procurement office already established in the Nishijin district, the centre for weaving of high-class silk, was considerably expanded. By about 1720, its original staff of 17 had grown into more than 130. In the early 1700s, the family also began to import silk from China through Nagasaki.

By the mid 1680s the management of the Edo shops had been delegated to Hachirôbei Takatoshi's eldest son, Hachirôemon Takahira. He proved no less competent than his father, and the fame and wealth of the Echigoya possibly reached their zenith under his management. Indeed, some of the innovations credited to Hachirôbei Takatoshi may well have been introduced by his son, although filial piety in the Mitsui family did not make an issue of it.

In 1689, the house of Mitsui was made official purveyor of apparel, ornaments, and personal accessories to the shôgun. This was the highest rank available to commoners, so the Mitsui were awarded a good residence with a frontage of about 11m. In the same year, the Edo money-changing and money-lending business became one of the 30 or so 'principal money exchanges' of Edo. This group enjoyed supervisory powers over all others involved in the trade. This promotion also enabled the Mitsui family to handle money for the government, attest to the accuracy of wrapped coinage, and much else.

The aforementioned Confucian scholar, historian, and statesman Arai Hakuseki, a contemporary, wrote in a collection of essays that 'Echigoya of Surugachô has two stores in Edo and an authorised exchange house for the shogunate. One of the stores deals in dry goods (silk) and the other sells cotton. It is said that the two stores have combined daily sales amounting to 1,000 *ryô*, or 360,000 *ryô* a year, on a cash basis.'[48]

The Mitsui already had a money exchange in Kyôto. In 1691, the Mitsui also opened a business – as usual drapery and money-changing – in Ôsaka.

47 Saikaku, *The Japanese Family Storehouse* (1688). Based on the translation by John G. Roberts, *Mitsui: Three Centuries of Japanese Business* (New York: Weatherhill, 2nd ed. 1989).

48 Arai Hakuseki, *Shinsho*. Based on the translation by Roberts, *Mitsui*.

In this year, the shogunate appointed two members of the Mitsui family as 'chartered merchants' (*goyô shônin*) or regular purveyors and fiscal agents to the shogunate, in Ôsaka. From then onwards, the family profited from the transfer of shogunal funds from Ôsaka to Edo, and from then on banking became their main business. As Mitsui had offices in both cities, transfers could be easily arranged, with no need to actually move any cash. Instead, when shogunal funds to be transferred to Edo were received in Ôsaka, the Mitsui lent out the money against promissory notes to other Ôsaka merchants who had debtors in Edo. These notes were then taken there and presented to the debtors, who as the money transfer system enjoyed official protection had to redeem them, thus settling their debts. Such money orders were also useful for many other purposes, and the Mitsui profited greatly from thus disposing of the former need to physically move funds between the cities. During the period of transfer, the Mitsui could also use the funds to produce regular interest. The shogunal treasury allowed at first 60 days, later increased to 150 days, during which the money could be held and used by the Mitsui without their paying interest to the shogunate. The merchant house had finally become a truly nationwide organisation, no longer restricted to a single field of business.

Just before his death in 1694, Hachirôbei Takatoshi laid down a set of house laws to be observed by his six sons engaged in the Mitsui business. He also ensured that the family fortune would not be split up in an imprudent way. He pointed out that risky transactions, such as loans to great lords, were to be avoided. After all, the Mitsui by then was firmly backed by the shogunate. House laws were not unusual in warrior families, and it was undoubtedly the memories of their past that encouraged the Mitsui to formulate their own as merchants. Takatoshi had indeed begun establishing house rules already in 1673–76. These house rules and procedures were followed by his descendants and are preserved to this day. The house rules were revised in 1722 and again in 1728.

By 1700, Echigoya was Japan's largest store. Already in 1705, the Mitsui enterprises under Hachirôemon Takahira had become so diversified that a family council had to be established to manage the dry goods stores in Kyôto, Edo, and Ôsaka. In 1709 or 1710, the family transformed this council into a Kyôto-based coordinating body or board of directors, the Ômotokata, for all their enterprises. In 1719 a family banking council was also set up to oversee the operation of the money-changing firms in the three cities.

Echigoya did not decline either in wealth or importance. In the 1800s the director of the Dutch factory in Nagasaki, Hendrik Doeff (1777–1835; director 1803–1817), visited Edo. He had the following to say about Echigoya:

> There is a silk-mercer here, named Itsigoya, who has shops in all the great towns throughout the empire. If you buy anything of him here and take it away to another town, say to Nagasaki, and no longer like it, you may return it, if undamaged, to his shop there, and receive back the whole sum paid for it at Yedo. He sent us five or six large chests out of which to choose. The wealth of this man is astonishing, as appears by what follows. During my stay at Yedo there occurred a tremendous fire, that laid everything, our residence included, in ashes, over an area of about

three leagues by one and a half. Itsigoya lost on this occasion, besides his shop, a warehouse containing upward of a hundred thousand pound's weight of spun silk, which fell altogether upon himself, the Japanese knowing nothing of insurances. Notwithstanding this, he sent *forty* of his servants to our assistance during the fire, who were of great use to us. The second day after the conflagration he was already rebuilding his premises, paying every carpenter at the rate of about ten shillings (English) a day.[49]

Today the house of Mitsui remains influential in many fields. The drapery business, too, endures, in the form of the Mitsukoshi department store chain, which in 1904 made the transition from traditional dry goods establishment to modern department store (*Mitsu* being, as before, the first element of the family name, while *koshi* is the Japanese reading of the character used for writing *echi* in Echigo, the original commercial name of the merchant house). The main Mitsukoshi store today stands very close to the site of the original Echigoya. It is interesting to note, however, that what began in old Edo as a discount store, is today a conservative department store that prefers to profit from high prices rather than quick sales. Hachirôbei Takatoshi may not have approved.

Other Famous Merchant Houses

Mitsukoshi is not the only old, established department store in Tôkyô to have developed out of an Edo kimono shop (*gofukuya*). Among other famous Edo shops was Shirokiya ('White Tree House'), founded in 1662 by Ômura Hikotarô (1636–1689), the descendant of a lumber merchant from Ômi province. Shirokiya was highly successful in the Edo period, mainly because ingenious ploys to attract customers. These included the provision of seats (and meals) for those watching the famous processions of the Sannô and Kanda festivals, and the arrival of the diplomatic missions from Korea and the Ryûkyû Islands, all of which passed close by the shop.[50] A third large shop was Daimaru, the Edo branch of an Ôsaka firm.[51]

Most great merchant house had their origins in and around Ôsaka. Also, in similarity to the Mitsui, they all seem to have originated in the warrior class. Probably none of these great merchant houses were as important to daily life in Edo as the Mitsui, but all had at least some operations in the shôgun's capital. Examples include the Sumitomo and the Kônoike, which will be briefly described for comparison with the Mitsui.

The house of Sumitomo was established by Sumitomo Masatomo (1585–1652), the second son of Masatsura, who in turn was the son of the lord of Maruoka Castle, Sumitomo Masatoshi. Masatomo was said to have served as a samurai under Shibata Katsuie (*c.* 1522–83), a famous retainer of Oda Nobunaga, but this is an unlikely claim as the latter committed suicide long

49 Hendrik Doeff, *Herinneringen uit Japan* (Haarlem: Bohm, 1833). Translation based on Philipp Franz von Siebold et al., *Manners and Customs of the Japanese* (London: John Murray and New York: Harper & Brothers, 1841), pp.87–88.

50 Nowadays, however, the shop name remains only in Honolulu, Hawai'i.

51 This shop closed after the Edo period but has since re-established itself in Tôkyô.

before Masatomo was born. In any case, becoming (or being born) a *rônin* due to his superior's suicide, Masatomo moved with his mother to Kyôto and opened a pharmacy and a printing shop. The husband of Masatomo's elder sister, Soga Riemon, had learned modern copper and silver mining and smelting techniques from European traders at the port of Sakai in 1591, and he used this knowledge to advance the family business. Soon mining was the main trade of the Sumitomo. Riemon's eldest son Tomomochi (1607–1662) followed in his father's footsteps and was therefore adopted by Masatomo as his own son-in-law and designated heir.

Tomomochi, the second head of the house, moved the business from Kyôto to Ôsaka in 1623 or 1624. He also engaged in copper exports to foreign merchants, a trade that grew in size and importance. The house of Sumitomo entered banking in 1662, when a younger brother of the third-generation house head expanded the family business by opening a money-changing office in Ôsaka. Mining remained the main activity, however – the house operated several mines – and especially so after the excavation of the Besshi copper mine in Iyo province (now Ehime Prefecture) on Shikoku in 1690.

In 1746, the house established a rice brokerage in Asakusa, Edo, and began to make loans to the shogunate samurai, the *hatamoto* and *gokenin*. The house also had a money-changing business at their Nakabashi store in Edo, established in 1805 under the name of the founder of the store, Izumiya Kichijirô. This was, however, apparently not the first Sumitomo money-changing office in Edo. Sumitomo also became a chartered merchant (*goyô shônin*) to the three senior branches of the Tokugawa family, as well as the official purveyor of copper to the shogunate.

The house of Kônoike was another great Edo period merchant house. Yamanaka Shinroku (1570–1650), from Kônoike village in Settsu province (now Hyôgo Prefecture), founder of the Kônoike House, was the eldest son of the famous warrior Yamanaka Shikanosuke Yukimori (1545–78), and therefore (although a *rônin*) a samurai by birth. Nonetheless, he relinquished his status and set up shop as a sake brewer in his native village in 1600. By around 1604, Yamanaka Shinroku was shipping sake to Edo. In 1619, his house branched out to Ôsaka where he opened a brewery and also engaged in shipping tax rice from several western lords to Ôsaka, as well as other commodities to Edo. The house entered the banking business in 1628. By 1630, the house was a major shipper as well as brewer. Shinroku, too, became a rice broker for several great lords. Part of this rice was used for the production of sake. Not surprisingly, the house was by 1637 also busy lending money to the very same lords.

Kônoike Zen'emon (1608–93) was the eighth son – and successor – of Shinroku, and he reinforced the banking business of the house by establishing an office in Ôsaka in 1656. Soon the firm was agent for more than 20 great lords, as well as financial agent of the shogunate in Ôsaka. The firm's activities eventually also included foreign trade with the outside world through Nagasaki. The Kônoike joined the 'ten-man company' of Ôsaka bankers at the foundation of this group in 1662, and became one of the official bankers (*goyô ryôgae*) of the shogunate. By around 1696, the main business consisted of loans to the great lords. The number of lords who relied

on the Kônoike again grew, from 32 to 110. The latter number included well over 30 percent of the lordly houses of Japan. From 1705, the third head of the house, Munetoshi, purchased farmland in Wakae-gun in Kawachi Province (now Ôsaka Prefecture) and reclaimed new land along the Yamato river. The new line of business – real estate – turned into yet another success. Eventually, after the Meiji Restoration, the firm formed the first Western-style company in Japan, a banking house. The Kônoike family remains in Ôsaka, active especially in banking, real estate, and insurance.[52]

Despite the impressive success stories of the Mitsui, the Sumitomo, and the Kônoike, it is difficult to measure the incredible wealth garnered by the really successful merchants. After all, a successful merchant generally reinvested his profits rather than squandering them, and in the process preferably hid as much as possible from the government's tax and bribe collectors. To determine the real wealth of such a merchant, let us investigate the estate confiscated from a wealthy merchant who for various reasons lost his fortune after falling out of favour with the shogunate. This man was Yodoya Saburôemon Tatsugorô (*c.* 1687–1717), the teenage fifth-generation head of the wealthy Yodoya house.

Yodoya's ancestor Okamoto Tsuneyasu had moved to Ôsaka around 1619 and opened a lumber business under the name of Yodoya. He and his heirs amassed a vast fortune as silk importers and as rice agents for great lords. The last heir inherited the lot while still young and never learnt caution. By 1705, young Yodoya Saburôemon Tatsugorô had in two years managed to spend no less than 166,600 *ryô* of gold. We may assume that he had had a jolly good time. Unfortunately, before young Yodoya could waste the rest, he was banished from Ôsaka and found his entire remaining estate confiscated by the authorities.

There are several accounts of Yodoya's property at the time of confiscation. They are not easily reconcilable. According to one, an incomplete(!) list of the property confiscated from Yodoya included 50 pairs of gold screens, three jewelled toy ships, 373 mats, 13,266 pounds of 'liquid gold' (presumably mercury), 273 large precious stones and innumerable small stones, two chests of gold, 3,000 gold ôban (each worth about nine *ryô*), 120,000 *ryô* worth of other gold coins, seven million pounds of silver, 150 boats, 730 warehouses, 17 treasure houses, 160 granaries, 92 houses and shops, 367 acres of cypress forest, and an annual rice stipend of no less than 55 tons. Another, presumably more imaginative account mentions the same number of gold screens and an innumerable number of precious stones, but lists 480 mats, and then goes on to detail 21 solid gold hens, with 10 chicks; 14 solid gold macaws; 15 solid gold sparrows; 51 solid gold-and-silver doves; 150 pounds of mercury; more than 700 swords; over 17,000 rolls of velvet, silk, and brocade; 96 crystal sliding doors; a solid gold *Go* board seven and a half centimetres thick, three and a half million *ryô* in gold coin; 14 million *ryô*

52 The banking business that Kônoike Zen'emon established in Ôsaka in 1656 is regarded as the oldest of three forerunners of Sanwa Bank which until a merger in 2002 was the second-largest bank in Japan.

in silver; 550,000 copper coins; about 750 Chinese paintings; 540 mansions, houses, and warehouses; and 250 farms and fields.

Yodoya was wealthy, but to the Edokko, his confiscated estate was not surprisingly large. In 1686, 19 years before Yodoya's downfall, an ironic but surprisingly similar inventory of a wealthy but imaginary merchant was published by Saikaku. This inventory, intended as a parody, is not that far from what constituted the possessions of young Yodoya:

> To Gengobei were turned over all the keys to the family possessions, three hundred and eighty-three of them … In [the storage cellar] were great trays of money, six hundred and fifty of them, each marked 'eighty-two pounds of silver.' All the coins were covered with mould and seemed to have been hidden away for so long that one could almost hear them groaning to be let out of confinement.
>
> In the northeast[53] corner of the cellar stood seven large jars, full of newly-minted coins that spilled out through the cover and lay about like sand littering the floor. Outside in a separate storehouse there was a mountain of fine clothes which had originally come from China, and a piece of aloewood as large as the beam on which a cauldron is hung over a fire. There were one thousand two hundred and thirty-five flawless coral beads, weighing from one and a half to one hundred and thirty *monme* each; sharkskin for sword handles; celadon porcelain in unlimited quantities; fine teacups from the Asuka River region, piled about carelessly because it made no difference how many got broken; some salted Mermaids;[54] a small bucket made of agate; a rice pounder from the Taoist paradise of Han-tan in China; a kitchen-knife box from Old Urashima;[55] a scarf from Benzaiten, Goddess of Beauty [and Money]; a razor made for the long-headed Fukurokuju, God of Luck; the spear of Tamon, Guardian of Heaven; a winnow from the God of Plenty large enough to winnow five thousand bushels of rice; and so many other things that one could not remember them all.[56]

The Merchant's Life

A merchant's life was not necessarily an easy one. Yes, he could strike it rich. But except in very unusual cases, this required much hard work and little leisure time. The vast majority of merchants, it must be remembered, were not the likes of Mitsui, Sumitomo, and Kônoike.

They all had things in common, of course. Most important was marketing. To ensure that their goods caught on in the ever faddish world of Edo, shops resorted to a variety of advertising techniques. It was common to employ hawkers on the street promoting certain goods. Theatres distributed prints of famous actors for publicity, and several acclaimed Kabuki actors promoted lines of dress.

53　The north-east was regarded as the unlucky direction, which suggests even more wealth in the other corners.

54　Salamanders.

55　The submarine palace of a goddess.

56　Saikaku, *Five Women*, pp.225–29.

Fig. 179. Merchants working with the abacus and a pair of scales, respectively. The thick ledger of accounts is on the floor beside them.

The Edo merchant knew that even a small shop could enjoy a brisk business, if properly promoted. As an example, let us look at a small workshop involved in one of the many popular fads of Edo, for instance a *hanao* maker. The *hanao*, it will be remembered, were the thongs of the sandals and *geta* commonly used in Edo. The colours of these were to a very large extent subject to the whims of fashion. Young ladies would seek out the fashionable shops where these articles were sold, and spend their money on these and other small items. The trader and wholesaler of *hanao* did not need to operate out of a large shop. Despite this, he would have had two or three workmen and five or six apprentices. His shop might sell about 1,000 pairs of *hanao* a day, for which five or six bales of jute rope were needed each month, used as padding seamed into the *hanao*. Thus it was a profitable business without a great deal of overhead or fixed capital, at least as long as the vendor made sure his goods came in the right colours.

Essential pieces of equipment for all merchants big or small were the ledger and the *soroban*, or abacus (Fig. 179). All transactions a business carried out were recorded in the ledger. Frequently quite thick, a new book was started each new year. The ledger was handled only by the owner and manager, as it contained information about the turnover and earnings. The abacus was quite an advanced tool, consisting of a bead frame about 40×10 cm, on which not only addition and subtraction, but also multiplication and division could be easily carried out. Other, more advanced functions could also be performed, such as the extraction of square roots, but these functions were naturally not much, if ever, used by merchants. The Edo abacus had 27 rows of beads, while in most other places it had only 23. As an abacus enabled the experienced user to perform calculations with great speed and accuracy, it was a vital tool for all merchants.[57] Moreover, apparently it was quite common for the merchant to use his abacus to strike the head of an erring or lazy apprentice, and it may even have been used as a weapon of defence in case of assault.

We have already described career possibilities in the great merchant houses; let us now look at a smaller but still prosperous house, the Isedana. The early career of a clerk at the Isedana dry goods shop, while still an irresponsible young shop boy, will be described below in the chapter on

57 Tests have been held in which a user of the abacus was tested in speed and accuracy against a user of an electronic calculator. The abacus users often emerged as victors. Unfortunately, it takes time to master the abacus, while anyone of at least minimal education can master the electronic calculator. As a result, the abacus quickly fell out of favour, even though it is sometimes still seen in use in Japan.

children. But a shop boy eventually grew older and took up serious work. At the Isedana shop in Edo, all clerks were recruited from distant Ise. A new clerk had to work for eight years until he was granted his first vacation, six months back in his home town of Ise. Afterwards, he might be promoted to salesman (*hanbai-in*). A second vacation was granted after another six years.

If the employee had real talent, he might finally be promoted to head clerk at around the age of 36 or 37 (Japanese reckoning). A few years later, he might be allowed to leave his post to establish a branch shop. Finally, at around the age of 46 or 47, his master might give him the approval to get married. By then, only a few years remained until he expected to die. A male heir had to be produced as soon as possible.

Among the hard-working lower classes, consumed by back-breaking manual labour, there was usually little chance of retirement, even though an old relative might well have been kept at home. Among the prosperous merchants, a life of leisure was at times attainable, unless illness brought an end to such hopes. Judging by the Mitsui house rules, the retirement age was around 55 – an age before which some employees would already have died from natural causes. The house rules make it clear that this age limit was considered proper as old people 'become slow and obtuse as they grow older.'[58]

Working hours were apparently rather short in Edo, as compared to contemporary Europe. Not much is known about the working hours of the merchant class. However, the working hours of carpenters (and by extension other manual workers) in Ôsaka in 1794 are detailed in an edict that has been preserved:

The workers must arrive between the sixth hour and a half (that is, sunrise) to the fifth hour, and after waiting a bit until all have been assembled, they should begin work before the fifth hour.

At the fourth hour, the earlier short break.

At midday, a lunch break.

At the eighth hour, the later short break.

At the sixth hour, return home.

Concerning the above: the lunch break is to be no more than four-tenths of an hour, and each of the short breaks is to be no more than three-tenths of an hour; no more than one hour of breaks per day, and four hours total of work.[59]

58 Roberts, *Mitsui*.

59 Endô Motoo, *Shokunin no rekishi* (Tôkyô: Shibundô, 1958), p.109. Translated in Gary P. Leupp, *Servants, Shophands, and Laborers in the Cities of Tokugawa Japan* (Princeton: Princeton University Press, 1992), p.146.

As noted above, the time between sunrise and sunset was divided into six equal hours, and the length of the hours depended on the season. The fifth hour, when work began, therefore corresponded to anywhere from about 6:30 a.m. to around 8:00 a.m. The four hours of total work varied according to the season from around seven to over 10 modern hours. However, as the peak employment season corresponded to the months from May to July – when the working hours were longest – we may assume that most labourers (and their supervisors) worked long hours. After all, daily wages were fixed without regard to the variable length of the day. On the other hand, during these months, the midday break (as well as the shorter breaks) were also correspondingly longer. Besides, in the edict referred to above the shogunate allowed for 'one hour and six-tenths' break time during the period from the eighth day of the Fourth Month to the first day of the Eighth Month. The total length of the three breaks must thus have reached around four modern hours in the season when the days were longest and most tiring. This made sense, as the workers then could rest by day and work longer in the evening cool.

What did the Edokko see as the proper way to riches? Ihara Saikaku, the son of an Ôsaka merchant, prescribed the following 'millionaire's medicine' (chôjagan), which the aspiring merchant is to take regularly at morning and at night:[60]

Early rising	5 ryô (10 %)
Devotion to the family business	20 ryô (40 %)
Working at night	8 ryô (16 %)
Thrift	10 ryô (20 %)
Care of one's health	7 ryô (14 %)
Daily total	50 ryô

The ryô was here used as a unit for measuring medicine.

Furthermore, Saikaku declares, the following will prevent the beneficent operation of any merchant house:

1. Expensive food and women; silk kimonos every day
2. Private palanquins for wives; music or card lessons for marriageable daughters
3. Drum lessons for sons of the house
4. *Kemari* (soccer), miniature archery, incense-appreciation, poetry contests
5. Renovations to the house; addiction to the tea ceremony
6. Cherry blossom viewing, boat trips, daily baths
7. Spending nights on the town, gambling parties, playing indoor games
8. Lessons, for townsmen, in sword-drawing and duelling
9. Temple visits, and preoccupation with the next world

60 Saikaku, *The Japanese Family Storehouse* (1688).

10. Becoming involved in the troubles of others, and standing surety
11. Litigation over reclaimed land; participation in mining projects
12. Sake with the evening meal, excessive pipe-smoking, unnecessary trips to Kyôto
13. Sponsoring charity *sumô* wrestling; excessive contributions to temples
14. Carving small articles during working hours; collecting gold sword fittings
15. Familiarity with actors and pleasure quarters
16. Borrowing money at more than eight percent per month
17. All these are more deadly than cantharides or arsenic.

In other words, Saikaku admonishes us, work hard and do not waste time or money on irrelevant pursuits. Irrelevant pursuits here clearly include all the Edokko's favourite preoccupations.

Not all merchants followed Saikaku's sensible advice. Wealthy merchants often bought samurai status for themselves or their sons. It became regarded as acceptable among the increasingly impoverished samurai to adopt a townsman in return for a cash payment. There was a recognised scale of payment for such transactions. The lowest rank of samurai, the *ashigaru*, could charge around 20 ryô of gold, while higher ranks demanded 1,000 *ryô* or more.

The Housewife

A woman was supposed to devote herself solely to the 'three obediences' (*sanjû*): obedience to her parents when a child; to her husband when married; and to her male children in old age.

In ancient times, Japanese women had frequently been leaders in their own right, and women remained in a very strong position in samurai society prior to the introduction from China and Korea of the Neo-Confucian philosophy of Chu Hsi (1130–1200; known in Japan as Shushi). This philosophy, however, demanded a woman's enjoyment be confined to her domestic duties, and (for the less lofty commoners) in gossiping with her neighbours at the well or in the public bath.

Unless very elevated in status, the average Edo housewife had many duties. Most important – after the raising of children – was perhaps cleaning and washing. All washing was done at the communal well or water pump (Fig. 180). The women of Edo always crowded around the well, washing clothes, rice and vegetables, and preparing fish and other food. In this respect, the wives of low-ranking samurai were no different from those of common townsmen, although the two social groups lived in separate residential areas and hence had no reason to mingle with one another. The women used the daily gathering at the well as a good source of news and gossip. There was even a special term for this kind of well-side meeting, *idobata kaigi*.

The relations between men and their wives depended completely on the social class of the couple. The husband was free to observe whatever moral standards he preferred, while the wife was bound to strict fidelity. Marriage was technically a business deal, which the families of the young man and woman were not to undertake without the greatest consideration. After

Fig. 180. Washing at the communal well. The women are either bare-foot or wear wooden clogs (*geta*). They have tied up their kimono sleeves with a cloth band or cord (*tasuki*) so as not to soil their clothes while working.

marriage, the husband could divorce his wife without any complication. The wife did not have this right.

The humbler the social class of the couple, one may assume, the better treatment the husband would give his wife. In the lower classes, a husband had to depend on his wife, as the daily living he earned was not sufficient to feed an entire family. Among the samurai, the wife of a lower-ranking man would also be closer to her husband than a wife of a high-ranking man. The wife of a great lord was always chosen out of political expediency, and when the lord was away from Edo on his annual trip, the wife had to remain behind as hostage. The higher the rank of the husband, the more probable that he would have one or more concubines. The shōgun was expected to have a very large number. They lived in what was basically a harem within the walls of Edo Castle.

To preserve the social order, samurai were not allowed to marry a mistress or raise a concubine to the level of a formal wife. Edicts to this effect were frequent, and we may safely assume that there was a distinct lack of feeling between husband and wife in many higher-ranking samurai families. As the husband in such a family had both the right, the money, and the time to engage in extramarital romantic pursuits, he hardly refrained from doing so. One could employ a servant girl explicitly as a concubine (*mekake*). Around 1700, the cost to do so was up to 100 *ryô* of gold per year.

Although the wife might, in fact, have had considerable influence over her husband, especially in poorer families, she would have exercised this influence discreetly and never in public. The head of the family, that is, the oldest male, was considered supreme. He did not suffer being spoken against by his own family, at least not in public. If so, it was a grave matter of losing face, not only for him but for the entire family.

The normal marriage, at least among all townsmen who were not completely destitute, and definitely among all samurai, was the result of what can only be called business negotiations between two sponsors, who served as go-betweens. The young man, and most certainly the young woman, would

not have been consulted, except in a minimal way. Neither were supposed to contradict the head of the family, even if asked for an opinion. The practice of *miai*, a formal meeting of prospective marriage partners, begun in the Edo period, as urban commoners copied the behaviour of their social superiors. The *yuinô*, or ceremonial exchange of engagement gifts between families, also became important at this time. So did elaborate wedding ceremonies. In the country, an informal relationship could still develop into a recognised marriage, but this was definitely not the done thing in the towns. It could, presumably, still take place, but then only among the lowest classes. Among affluent merchants, financial and business considerations reigned supreme in the choice of a husband or wife.

To attract a sufficiently well-to-do bride or bridegroom was not always an easy task. One of the many possible causes of financial ruin in Edo was said to have been when a family with a bachelor son spent too much money on his training in social graces and on extensions and redecorations of the house, in the futile hope of attracting a bride with a greater dowry than could otherwise have been hoped for.

When a marriage partner had been found and the monetary details were settled, everything was ready for the wedding ceremony. The bride would bring with her a dowry as well as bedding and clothing. This was carried in one or several oblong, legless wooden chests (*nagamochi*), slung from a long pole carried by two bearers in the bridal procession. Saikaku thus describes the dowry of the maidservant Osen:

> Her dowry consisted of twenty-three items, including a second-grade chest with a natural finish, a wicker hamper for her trousseau, a folding pasteboard box, two castoff gowns from her mistress, quilted bedclothes, a mosquito net with red lining, and a scarf of classic colours. With all of these, more than a pound of silver was sent to the [bridegroom's] house.[61]

As for cash, the dowry in an average townsman's family might typically consist of two *ryô* of gold. This was at least the amount described in the popular Kabuki play 'The Love Suicides at Sonezaki' (*Sonezaki shinjû*, written in 1703 and based on a real event) by the acclaimed samurai dramatist Chikamatsu Monzaemon (1653–1724).

The daughter of a well-to-do merchant naturally had a more valuable dowry. Saikaku mentions the price of 5,000 *monme*, or more than 80 *ryô*, as a suitable dowry for her. He also wrote that in the case of wealthy merchant worth a million *monme*, or almost 17,000 *ryô*, the daughter would get a dowry of 30,000 *monme*, or 500 *ryô*, in addition to a bridal trousseau worth roughly 20,000 *monme*, or more than 330 *ryô*. Formerly, Saikaku points out, it was not unusual to spend 40,000 *monme*, or almost 700 *ryô*, on the trousseau and allot 10,000 *monme*, or almost 170 *ryô*, for the dowry, but in his time, people preferred hard cash.

61 Saikaku, *Five Women*, p.103.

To ensure that the wife fully understood her duties to her husband, she was apparently often given an illustrated handbook in love-making techniques. It not only improved the family relationship if the husband spent his nights at home, it also benefited the family economy.

The wedding itself was organised by the two sponsors. The essential rite of the marriage ceremony was the ritual exchange between the bride and bridegroom of three cups of sake, each one to be drunk in three sips (*sansankudo*, 'three cups nine sips'). This ritual, still in use today, was codified in its final form as early as the fourteenth century. The origin of the custom presumably goes back much farther, however, in particular among the warrior and noble classes. The exchange of sake was followed by a few prayers, after which the ceremony was concluded. The bride now belonged to her new family.

The young bride in any family that was not destitute did not have an enviable task in front of her. Most of the workload that had previously been the responsibility of her mother-in-law at once passed to her. If a vast number of contemporary accounts are to be believed, most mother-in-laws immediately embarked upon a life of leisure, harassing the young bride to do all household chores. In addition, the new bride had to become a kind of personal maid to the mother-in-law, taking care of her every whim. She must also, of course, not neglect her husband in any possible way. If he was not sufficiently pleased, he could divorce her with a few strokes of his writing brush.

This life continued at least until the bride managed to give birth to a son. Then she would be slightly better off, as she had thereby fulfilled the most important obligation of a wife. Eventually, she too would reach the day when her young son grew up and brought home a bride, whom she in her turn could terrorise.

Japanese women generally had to work hard. In many rural areas, though presumably not in fashionable Edo, the women had to work harder than their husbands. They often had to carry great burdens, and in many areas, especially in western Japan and around Kyôto, Japanese women – like those in many of today's developing countries – used to carry heavy loads on their heads.

The most important duty was to continue the family line. If no son was produced, the family had to resort to other means. If at least a daughter was born, an unassertive and properly submissive son-in-law was usually taken into the family as an adopted child (*yoshi*). Such a son-in-law frequently began his career as an apprentice or workman, and was almost invariably of lower rank or came from a less wealthy family. The position of adopted son-in-law was a joke in many places. There was a saying, 'Do not become an adopted son as long as you have an income of at least some rice bran', that is, any means of support, however minimal.

In the towns, it was possible for a younger son or an apprentice to be allowed to set up a branch of the main business, and take his wife with him. A wife in the town had to work hard, perhaps even as hard as in the country; the Japanese, however, regarded life in the town as more civilised, and many young country women apparently relished the idea of marrying some family connection who had moved to the town.

Edo women were of course not completely submissive. Some forms of entertainment were available to women, too. Women could, and did, go on pilgrimages, both to local shrines and temples, and to the great national ones at Ise. Another attraction for women, especially from the 1680s, was the theatre. In the great towns of Edo, Kyôto, and Ôsaka, women formed a large part of the theatre audience. By then, the overt representation of violence and eroticism of the early theatre had been adapted to a mixed audience.

The husband did not have any legal difficulty in divorcing his wife. No real reason was required, although he was technically supposed to divorce on one of seven legally acceptable grounds. These included childlessness, loose behaviour, disease, and the explanation that the wife was out of harmony with the customs of the husband's family. He merely had to write a letter, in more or less set form, saying he gave her leave to go, and certified that she was free to form any other connection. Such a letter, handed to the wife or her parents, filled only three and a half lines of writing, so the term 'three lines and a half' (*mikudarihan*) become the popular word for a divorce document.

In samurai families, the divorce procedure was slightly more elaborate, but there, too, women enjoyed little protection.

Pregnancy did not prevent divorce, even though in some regions the former husband had to take responsibility for the child as long as the former wife reported the pregnancy within three months of the divorce. In any case, the husband was technically obliged to return the dowry, clothing, and other objects that the wife had brought into the marriage. Usually, it seems, not much remained. As long as the dowry was subject to dispute, the divorced wife could usually count on the support of her father or the head of her former family. Any children remained with the father, never with the divorced mother.

A wife had no similar right to leave her husband. It was, of course, possible to merely run away, but this was hardly an attractive solution in the highly regulated Japanese society. There was one other course of action, if the woman was lucky enough to be of the samurai or noble classes and living in certain regions, including Edo. There were a few temples, of which Tôkeiji in Kamakura, near Edo, was the best-known, that gave sanctuary to wives who wanted to divorce their husbands. This temple had been founded by Mino no Tsubone, one of the twelfth-century shôgun Minamoto no Yoritomo's ladies-in-waiting, and the custom of giving such sanctuary was established, with Imperial approval, as early as in 1285 by the widow of the shogunal regent Hôjô Tokimune (1251–84).

A wife of sufficiently high social class who wished to divorce her husband first had to take refuge in this temple. The temple authorities then opened negotiations through an intermediary with the husband to persuade him to release his wife. Most husbands apparently gave up the struggle at this point. If the husband refused, the wife remained in the temple for a period of three years, later reduced to two years by the Abbess Yôdô, daughter of Emperor Go-Daigo (1288–1339, r. 1318–39). After this, she was free to leave, and her marriage was dissolved by the government official in charge of temples and shrines. It was therefore futile for the husband to struggle, as long as the woman gained entry to the temple. This temple was therefore also known as

Enkiridera, the 'divorce-temple'. Another temple with this function was the Mantokuji, in present-day Gunma Prefecture.

In the extreme case that an angry husband pursued his wife to the gate of the temple, the wife had only to throw in one of her sandals to qualify for assistance. Although for practical reasons, the temple could only offer protection to women who could reach it, which in practice meant the inhabitants of the nearby region, the temple did provide a safe and legal way out of marriage.

Most of the temple records have been destroyed, but it seems that in 1866, four women were living out the period of sanctuary in Tôkeiji, and 40 others were given a divorce by their husbands. At its busiest time, the temple was known to give sanctuary to from 70 to 80 women a year. It has been estimated that Tôkeiji alone harboured 2,000 wives in the century and a half prior to the 1873 divorce laws.

As elsewhere in the world, pregnancy could be either a blessing or a curse to the expectant mother. In a poor country family, a baby girl might be smothered after birth. In Edo and the towns, it was more common to practice abortion. This, however, was not only prohibited but also a considerable danger to the mother.

As mentioned earlier, there was also a superstition that women born in the forty-third year of the traditional sexagenary cycle, the Fire Horse (*hinoe uma*), would grow up to have a wild disposition, bully their husbands, and frequently also eventually kill them. The reason was that this year marked the coincidence of fire with fire in the lunar calendar – the Horse itself also representing fire. As such women did not easily find husbands, there was a tendency for pregnancy and childbirth to be avoided during such a year. Few parents wanted to risk giving birth to a daughter.[62]

If the pregnancy for whatever reason was allowed to proceed, it was customary, on the day of the dog (according to the zodiacal cycle) in the fifth month of pregnancy, to invite the woman's relatives to the formal announcement of her state, and tie a wide strip of cloth called the *iwata obi* around the waist of the prospective mother. This custom (known as *obi iwai*, 'sash celebration', *chakutai*, 'sash-fastening', or *harami obi*, 'pregnancy sash') was taken care of by the midwife who was to attend at the birth and was believed to ensure a safe and light delivery. The cloth, which was then worn by the woman up to the moment of birth, was believed to ensure a light delivery by keeping the child small. Different regions had different customs for this procedure. Sometimes one of the husband's loincloths was used. Alternatively one could acquire an auspicious length of cloth from a shrine whose deity was believed to assist in childbirth. The prospective mother might also receive a suitable strip of cloth from her parents. The day of the dog was chosen as dogs were believed to enjoy a remarkably painless delivery.

During the period of pregnancy, a number of precautions were taken. Food containing vinegar, spices, or excessive fat was avoided. The midwife made regular calls to inspect the process, and in wealthy families, she was

62 The most recent *hinoe uma* was in 1966, and the birth rate, expectedly, saw a marked drop.

often made to live in the house during the last month of pregnancy. Prayers were offered to the appropriate deities and temples. In ancient times, it had been customary to erect a special building and confine the woman there during the time of pregnancy and giving birth, as the blood associated with childbirth was believed to defile the house in which it took place. This practice still persisted in the higher social classes, resources permitting. Common townsmen, however, had neither the space nor the money for such a procedure, so the birth would have to take place at home, usually in the sleeping quarters. A first child, however, was customarily delivered in the home of the mother's parents.

A papier-mâché dog (*inu hariko*) was used as a talisman for safe childbirth, following an ancient tradition and the same superstition concerning dogs referred to above. This colourfully painted dog was included in a bride's trousseau, and also put on display during the Girls' Festival (see below).

Women in Japan traditionally gave birth in the squatting position, and this might still have been common in the country. By the Edo period, a special bed with support for the back had been introduced and this was commonly used in the cities (Fig. 181). Most of the mystery of former times associated with childbirth seems to have had disappeared. The community rituals, however, remained, even when the mystery had gone and the reason for the rituals were no longer fully understood.

Formerly, the umbilical cord had been cut with a bamboo knife. This had been modernised, too, and a steel knife was used by the Edo midwife. Then the child was washed in warm water, dressed, and shown to the mother and

Fig. 181. To the left, a woman has just been delivered of a child in the special bed with support for the back devised for the purpose. To the right, relatives and friends congratulate her on the new arrival.

her family. The placenta was put in a flat earthenware container, in effect a flat dish covered with another of the same kind. This container was subsequently deposited under the house, where it was positioned in an auspicious direction to ensure good luck: often at the front entrance, inside the door if a boy and outside if a girl, as the latter was destined to leave the family upon marriage.

After delivery, it was common to serve the woman particularly nutritious food, such as rice boiled with beans (*daizu meshi*). The baby, however, was served seaweed and liquorice, mixed into a laxative syrup that was thought to cleanse the newborn of any impurities left in it from the womb.

Confucian thought demanded that siblings be classed into elder and younger. This usually proved no problem. The question only arose when dealing with twin births. In such a case, it was reasoned that the child born first was the younger and the later child, no matter how many hours later, was the elder. It was – and is – believed that the later one was conceived first (the child was after all deeper inside the mother) and was therefore the first seed of the father.

The impurity produced by childbirth according to Shintô beliefs was usually deemed to disappear after 21 days, and each seven-day period marked a stage in this process. It was not considered safe to take the infant out of the house before the seventh day. The mother, too, remained at home, and might not leave her bed until the twenty-first day. Only on the 'seventh night' (*shichiya*) after the birth were the relatives of the parents invited, in a celebration organised by the midwife. This was also the time when the child received his or her name.[63]

If the mother died during childbirth, the child was put to a foster mother or wet-nurse. This was also common practice for a very busy mother, such as the wife of a merchant who had to assist her husband in his business. Wealthy families also sometimes sent their offspring to live as foster children (*satogo*) with farming families in the country. Many children, including those as elevated as the sons of the shôgun, developed strong loyalties to the foster mother, and also strong ties with foster brothers and sisters.

In the lower social classes, the mother would usually breastfeed her child for several years, as it was commonly believed that she would not conceive again until after the child was weaned.

Most families, whether wealthy or poor, regarded a certain Shintô deity as their special protector. The newly born child's first presentation to the god or 'shrine-going' (*miyamairi*) was an important occasion attended by the family's relatives and again usually organised by the midwife. If the birth had taken place in a separate building, this first visit also marked an end to the period of confinement. The ceremony often took place on the thirty-first day for a boy, and on the thirty-third day for a girl, although there appear to have been many local variations. For instance, it seems to have been considered auspicious to delay the ceremony for another two days, a delay that eventually turned into a widespread practice. The child was then considered to be officially part of the community. It was also often the first time the child would wear real clothes.

63 The *shichiya* celebration remains an important part of childbirth in modern Japan.

The Children

A young baby spent most of its time being carried on its mother's back. An infant was held in place by a broad band that was passed under its arms and over the mother's shoulders, and after crossing the mother's chest, one end was passed under the mother's arm and the child's buttocks and tied at the side to the other end. The baby spent all day in this position, except when released for feeding. If for some reason the mother herself did not carry the baby, then another female would, usually an elder sister of the baby. It was not unusual to see a girl who was only a few years older than the infant carrying her young sister all day, whether at work or at play. The baby was never left alone. At night it slept in its mother's bed. When older, the child would in most families still sleep in the same room as his or her parents (Fig. 182).

The child's age was not regarded as depending on the actual birthday. A newborn baby was considered to be one year old – the period of gestation counting as one year – until the end of the Twelfth Month of its year of birth, at which point he or she turned two. Accordingly, a child born on the last day of the year was counted as two years old the next day. For a newborn, age in days was counted in the same fashion, the day of birth counting as the first day.

Young children did not wear much clothing. In the warm seasons they commonly ran about naked or almost naked. At most, a small gown was worn. From the end of the Edo period, small identification tags for children, giving the child's name, address, and age, were also sometimes hung on the child. These were made of metal (generally copper), wood, or cloth, the latter sometimes in the shape of a doll to amuse the child.

Fig. 182. Young woman watching a sleeping child, mid nineteenth century. Although a staged photograph, it illustrates daily dress and furniture earlier in the Edo period as well. (Photo: Felice Beato)

Most early European visitors remarked that children were always well treated and never struck or abused. One sixteenth-century writer even remarked that the Japanese 'chastice their children with wordes onlye, and the'admonishe theire children when they are five yeares oulde, as yf the'weare oulde men.'[64] Arnoldus Montanus continued: 'The Japanners breed up their children not only mildly, but very prudently, for if they should cry whole nights they endeavour to silence them by fairness, without the least snapping or using bad language to them.'[65]

Especially in upper-class families, boys and girls were already from an early age expected to follow different standards. Upper-class girls were taught never to lose control over mind or body, while boys were permitted more lax habits, in particular when young. This was shown even in how the children were allowed to sleep. Boys might sleep with outspread arms and legs, in a position described in Japanese as named after the writing character *dai* ('big'). A girl, on the other hand, had to curve herself into a more modest and dignified sleeping position, named after the character *kinoji* ('spirit of control').

In the life of a child, there were various festivals to look forward to in addition to the private celebrations already described. On the fifteenth day of the Eleventh Month, the festival called 'seven-five-three' (*shichigosan*) took place among the upper classes. This festival became popular in the eighteenth century. Ordinary commoners, however, did not take up this practice until well after the end of the Edo period. This festival, although slightly changed, was of ancient origin, connected with the belief that children (and adults) of certain ages were particularly prone to bad luck and therefore in need of divine protection. These particular ages were not the same for men and women, so the children taking part in this shrine festival differed in age according to sex. Boys were three or five years old, while girls were three or seven. The name of the festival was derived from the age of the participating children.

The youngest participants were children of both sexes in their third year, For them, it was the day when they no longer were considered babies. No more running naked; a kimono bound at the waist with an attached narrow girdle was used from now on. Formerly, this had been an important hair-cutting ceremony (*kamisogi*). The celebration was still accompanied by a change in the way the child's hair was arranged. Boys traditionally had their hair shaved off, but from the late seventeenth to the early eighteenth centuries, it became common to let children's hair grow long, worn loose. The hair was then gathered in a typical forelock. Many still shaved off the hair, however, or cropped it very short.

Five-year-old boys also took part in this festival. Facing a lucky direction and standing on a *Go* board (a thick platform about 45 cm square, used in the game of *Go*), he was dressed for the first time in adult clothes, his first

64 *The Firste Booke of Relations of Moderne States* (Harleian MS. 6249, 16th century). Quoted in Laurence Oliphant, *Narrative of the Earl of Elgin's Mission to China and Japan in the Years 1857, '58, '59* (Edinburgh and London: William Blackwood and Sons, 1859), 2nd vol., p.205.

65 Arnoldus Montanus, *Atlas Japannensis* (tr. John Ogilby, London, 1670), p.314. Quoted in Ronald P. Dore, *Education in Tokugawa Japan* (New York: Routledge and Kegan Paul, 1965), p.52 n.1.

hakama, the left leg being put in first. His old kimono with the attached girdle was discarded. This 'trouser-wearing' ceremony (*hakamagi*) was followed by a visit to the shrine. The seven-year-old girls taking part in this festival went through a similar ceremony. The girls, too, replaced the kimono with an attached girdle with an adult-style kimono, which required a separate sash. This 'sash-tying' ceremony was known as *obi-toki*.[66]

For low-ranking samurai and commoners in Edo, these were the most important ceremonies related to childhood – if they took place at all – and no particular ceremonies usually initiated older children into adulthood. Among the court nobles and higher-ranking samurai, however, boys went through an additional coming-of-age ceremony, *genpuku* ('war clothes'), sometime between the ages of 10 and 16. Among the samurai, it generally took place at age 15. In earlier times the ceremony had been performed when a boy reached a certain height, equivalent to about 136 cm. This ceremony was also the time when a boy received his adult name, superseding his child name. The ceremony consisted of shaving off the forelock and arranging the hair to allow the wearing of a court head-dress (*eboshi*), which the young court noble hence assumed. Adult clothing, including the two swords of the samurai, was also worn from this time onwards. An auspicious day was chosen for this ceremony, which otherwise could take place at any time.

Daughters of court nobles also went through an adulthood ceremony, usually upon reaching the age of puberty. From this time on they blackened their teeth (*nesshi*) and shaved or plucked their eyebrows (*okimayu*), which were then instead painted in a curved, very high position on the forehead with bright black dye (*haizumi*) made from soot. The daughters of samurai furthermore had their hair arranged in adult style.

Women of the lower classes also practiced tooth-blackening. They, however, waited until either marriage or first becoming pregnant. After delivery of a child, these women, too, shaved the eyebrows and drew artificial ones. In the Yoshiwara pleasure quarter, an elaborate tooth-blackening ceremony took place before a young woman's debut as courtesan. This ceremony, and many others in the pleasure quarter, was in mock imitation of the life of the upper classes.

Many merchant families, too, had some sort of initiation ceremony for their sons upon the threshold of adulthood, although this was not regarded as vital. The ceremony usually took place at the age of 18 or 19. The forelock was shaved off, in the same style as among the samurai. In addition, ceremonial dress was worn for the first time.

There were other public festivals mainly aimed at children, although the adults were by no means prohibited from taking part. A family with a daughter would celebrate the Girls' Festival (*momo no sekku,* originally called *jômi* or

66 In modern Japan, three-year-old girls, five-year-old boys, and seven-year-old girls take part in the ceremony. Dressed up in their best clothes, usually but not necessarily kimono, they are taken to shrines to pray for a good future. It only became customary to dress children in elaborate kimono in the late nineteenth century, as a marketing and sales promotion ploy by the kimono industry.

joki) or Doll Festival (*hina matsuri*) on the third day of the Third Month.[67] This festival was originally part of the life of the nobility of the Heian period (794–1185), with the purpose of exorcising one's impurities and transferring them to paper images. It was then customary to throw these paper images into a river (a ceremony known as *nagashibina*) and pray for good fortune. This soon developed into a custom called *hina asobi* ('doll play'), in which the children of the Kyôto nobility played with paper *hina* dolls which were set adrift on a river instead of being simply thrown into it. Other ancient customs may also have contributed to the later Doll Festival, which developed from the early Edo period among the upper classes. In the nineteenth century, the custom also took root among the general population of Japan.

By then, the custom had changed into the display of a set of about 15 small dolls called *hina ningyô* on a tiered stand of shelves covered with a bright red cloth. These dolls, if a complete set, represented the emperor, empress, and their retinue of attendants, court ladies, and musicians, all exquisitely dressed and attired. The display was positioned in the most favoured position in the house, the alcove known as the *tokonoma* (see below). Various paraphernalia were also included in the set, such as musical instruments, lamps, chests of drawers, and the like. A model palace to house the dolls might be part of the set. In the Edo period, the display could be either very elaborate, or it might consist of merely a few paper dolls. In spring, a flourishing trade was done in these dolls. Manufacturers also made certain that there were periodic changes in design, so that the demand for new dolls would never by satisfied.[68]

In Edo, the room in which the dolls were displayed was also decorated with plum blossoms. The *hina matsuri* doll set was often not displayed alone, but together with white sake made blended from sake and rice malt (*shirozake*), lozenge-shaped rice cakes (*hishimochi*), and peach blossoms. Female relatives would visit to celebrate and view the display.

On the fifth day of the Fifth Month, the Boys' Festival (*tango no sekku*) was celebrated, a festival particularly important for the samurai class. Presents were given and received. Boys celebrated the festival by fighting with wooden swords and by slapping the ground with plaited iris leaves. For the latter reason, the festival was also known as the 'Iris Festival' (*shôbu no sekku*). The iris is a flower of the early summer, so it was right in season. The Boys' Festival was also considered to mark the first day of summer. In the residences of great lords sets of weapons, armour, and helmets were put on display, together with banners and an honorary guard of retainers. Officials wore special clothing including the long *nagabakama*. The commoners in Edo and other towns, impressed by the ways of their superiors and stirred by shrewd salesmen, bought displays of model helmets, armour, and weapons, which were put on sale in anticipation of the festival. Saikaku reports that a miniature display bow could cost as much as two gold *ryô*, or half a year's income for a servant. Another feature of the

67 The Doll Festival currently occurs on 3 March.

68 At present, an entire set can cost upwards of 200,000–300,000 yen, so the value is substantial. The set is usually on display for about two weeks, after which the dolls are carefully put away until next year.

festival was *kashiwa mochi*, rice dumplings wrapped in oak leaves. Another was *chimaki*, dumplings wrapped in iris leaves.

From the middle of the Edo period, a wealthy household with a son under the age of eight might erect on a tall bamboo pole a banner or a small streamer shaped as a windsock at a modern airfield, made of cloth or paper in the shape of a carp (*koinobori*). The carp, symbolising the surmounting of obstacles because of its vigour in ascending rapids, was chosen because of an ancient Chinese legend about a carp that swam upstream and was eventually transformed into a dragon. The flying of carp streamers was not as common in Edo as one might believe, however. The custom remained an upper-class habit until about the time of the Sino–Japanese War (1894–1895), long after Edo had become Tôkyô.[69]

There were of course many other festivals that the children of Edo could look forward to. There were also numerous games to be played and toys for their diversion. Games frequently played were of types common to children all over the world, such as blind man's buff and hide-and-seek. More typically Japanese games such as paper folding (*origami*) were also natural favourites. These will be described in a later chapter. There were also innumerable types of toys in Edo period Japan, and early European visitors were often amazed to see the variety and ingenuity displayed in the making of them. Toys were also usually inexpensive. Toy glaives (*naginata*), for instance, sold for only one copper *mon* each.

One may safely assume that being a child in Edo was not such a bad thing. However, life was not only play and games. Young girls were frequently sent to work as live-in maidservants. When young they received no salary, as compensation was regarded as being largely in the form of training, room, and board. Among craftsmen, the eldest son was naturally expected to learn his father's craft and ultimately take over his workshop, whenever the father died or chose to retire (life expectancy in Edo was only around 50 years). Other young boys were taken in as apprentices (*detchi*, or *deshi*) or as simple shop boys (*kozô*) at age 10 to 12 (Japanese reckoning). Such boys might be the younger sons of other townsmen or maybe country boys from a large family, naturally also younger sons. The boy had by then often attended three or four years of elementary schooling.

In households of merchants or craftsmen, apprentices generally served on 10-year contracts (although many left before the term was completed, and the contractual apprenticeship term had by the end of the period been reduced to six or seven years). Other young men became indentured workers or servants (*hôkônin*), who lived in the household and generally worked on six-month or one-year contracts. In either case, the apprentice lived in his master's household and in most ways had to treat his master as his own father. The master, of course, would in some ways regard his apprentices as his children. This was not only out of affection. Confucian doctrine clearly

69 This festival is still celebrated today in the form of the official public holiday known as Children's
 Day (*kodomo no hi*). It takes place on 5 May (the fifth day of the fifth month), when multicoloured
 carp streamers and banners fly from rooftops and flag poles.

stated that a master was to have the same relationship with his apprentices and workmen as with his own children. This concept was also a fundamental part of the generally recognised legal system in Edo period Japan. A master was legally responsible for the actions of his apprentices and workmen.

An apprentice expected to eventually set up a shop of his own. The period of training was normally seven or eight years (although as previously mentioned, 10-year contracts were common in the early Edo period), after which he was expected to continue work for his master out of gratitude for a further six or 12 months (possibly even five years in the early Edo period). Thereafter, two possibilities remained. Either the master arranged for the former apprentice's status as an independent craftsman to be recognised by employers, and maybe gave him a share of his customers as a foundation for a new business, or the former apprentice simply continued to work in his master's workshop as a journeyman.

The training of an apprentice was not limited to the actual techniques required for his craft. The lore of the craft and its specialised vocabulary – at times almost a secret language reserved for members of the trade – were also to be taught. This was of great importance, as such knowledge enabled the craftsman to prove to other professionals that he really was one of them. It also served to preserve and hide professional knowledge from the public. The specialised vocabulary was at times almost impossible for any outsider to understand. Among shipbuilders, for instance, the word *aka* was used as shipbuilders' jargon for 'water'. This word, according to linguists, traces back to a Sanskrit root related to *aqua*, Latin for water, common to many European languages.[70]

The merchant houses used a similar apprentice system, but the time required to advance in rank was generally longer. An employee was promoted to head clerk after serving for 10 to 15 years, and (in larger businesses) to the rank of group foreman after an additional two or three years. Few were promoted higher.

In the prominent dry goods shop Isedana, which flourished in Edo from the early 1680s, all male employees were recruited from the province of Ise at age 13 (Japanese reckoning). They were first appointed as shop boys (*kodomoshi*). Their tasks included sweeping the shop floor, watering down the dust at the doorway, polishing the tobacco trays offered to customers, and running errands. They were also gradually taught how to use the abacus, scales and measures, and the other tools of a merchant's trade.

After three years, each youngster underwent an examination in the use of these tools. If successful, he was assigned a more active part in dealing with the customers. Four years later he might be appointed 'shop boy head' (*kodomogashira*) with the responsibility of supervising the younger boys. The following year, when the boy had reached an age of around 19 or 20, and after undergoing the *genpuku* ceremony, he became a regular clerk (*wakaishû* or *tedai*). Only then was he allowed to handle important matters such as expenditures and receipts.

70 'The Craft That Wouldn't Go Away', *The East* 8: 9 (October 1972), pp.10–11.

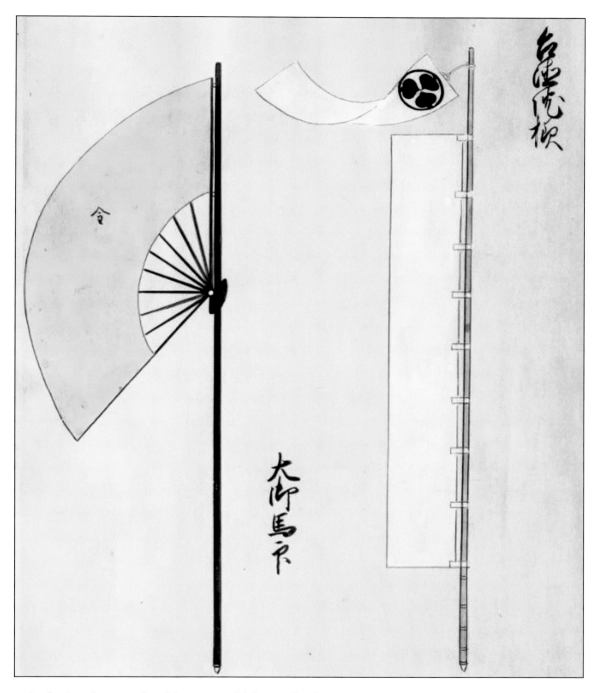

Left: Battle standard (open gold fan) of Tokugawa Hidetada, Ieyasu's eldest son and second shôgun
Right: Banner of Tokugawa Hidetada, Ieyasu's eldest son and and second shôgun. White banner and white pendant with black *aoi* crest.

(Source: *Hata umajirushi ezu* ('Illustrated Banners and Battle Standards'), late seventeenth century. Brigham Young University Library, Tom Perry Special Collections (call no. 895.61 H28).)

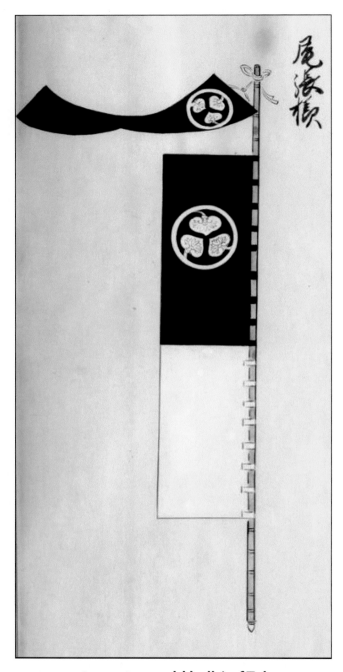

Left: Battle standard (black feather ornament over two gold balls) of Tokugawa Hidetada, Ieyasu's eldest son and second shôgun
Right: Banner of Tokugawa Yoshinao (1601–1650), Ieyasu's son and founder of the Owari branch of the Tokugawa clan. White and black banner with white *aoi* crest; black pendant with white *aoi* crest.

(Source: *Hata umajirushi ezu* ('Illustrated Banners and Battle Standards'), late seventeenth century. Brigham Young University Library, Tom Perry Special Collections (call no. 895.61 H28).)

228

Plate 5. Samurai archer in civilian dress, chainmail armour and fireman's helmet

(Illustration by Georgio Albertini © Helion & Company 2022)

This archer is armed with a military-style war bow, but the rest of his gear mirrors that of many other lower-ranking samurai. He wears civilian dress, with the wide sleeves tied up with a cloth band. His fireman's helmet comes with a retractable forehead guard, a type which provided less protection but was lightweight and comfortable to wear.

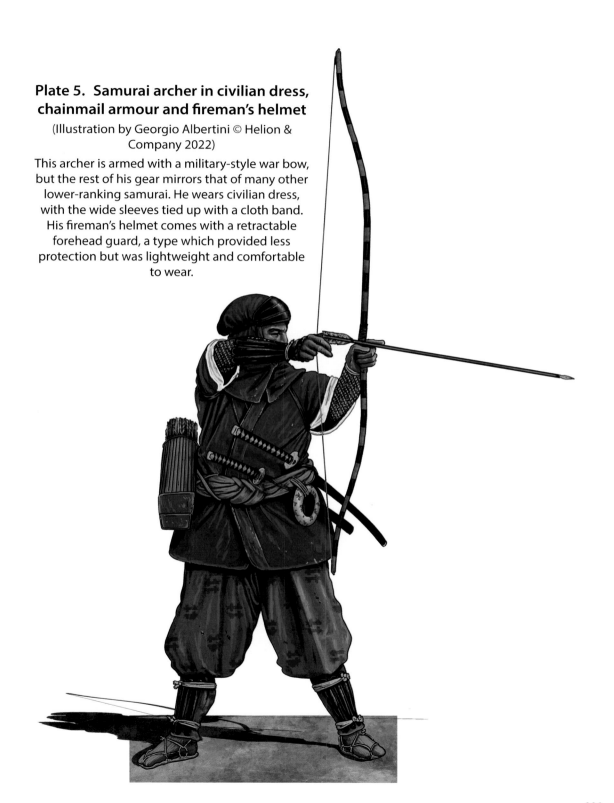

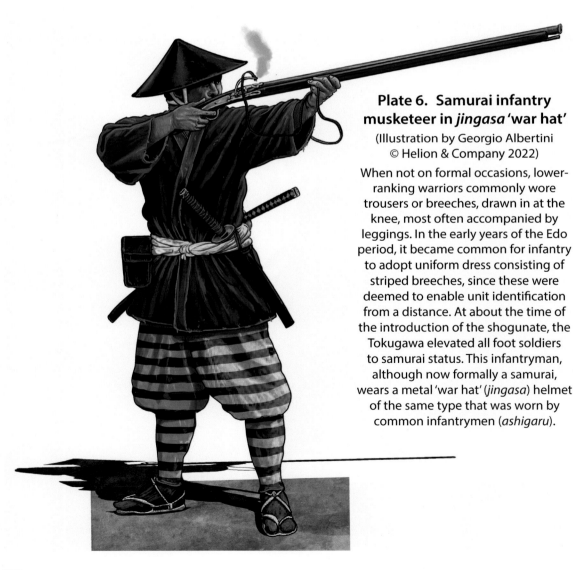

Plate 6. Samurai infantry musketeer in *jingasa* 'war hat'

(Illustration by Georgio Albertini © Helion & Company 2022)

When not on formal occasions, lower-ranking warriors commonly wore trousers or breeches, drawn in at the knee, most often accompanied by leggings. In the early years of the Edo period, it became common for infantry to adopt uniform dress consisting of striped breeches, since these were deemed to enable unit identification from a distance. At about the time of the introduction of the shogunate, the Tokugawa elevated all foot soldiers to samurai status. This infantryman, although now formally a samurai, wears a metal 'war hat' (*jingasa*) helmet of the same type that was worn by common infantrymen (*ashigaru*).

3

The City

The Hills and Plains of Edo

Old Edo was mostly built at sea level, as the city was founded on a typical coastal flood plain. Drainage was – and is – poor, and typhoons often brought disastrous floods. Proper defences against the latter have only come into existence in modern times.

Edo had numerous waterways in the form of rivers, canals, and moats. Some canals remain even today, although the majority have lost their significance and been filled in; their routes can still be traced beneath railways and major streets. This is one of the reasons for the many place names ending in *-hashi* or *-bashi* ('bridge'), even where there is no longer any water to cross. Examples include Sukiyabashi, which as late as in the 1950s was a bridge over a canal. The canal has today become a major thoroughfare.

In 1591, when Tokugawa Ieyasu received Edo as a fief, much of the area now occupied by the metropolis of Tôkyô was still under water. Present Shinbashi and Yûrakuchô were the westernmost parts of the marshy sandbar that is now Ginza, cut off from the Odawara road by the shallow Hibiya Bay. Even in the early days of the Edo period, the waters came right up to Edo Castle. By 1607, however, Hibiya Bay had already been filled in. Shinbashi ('New Bridge') was built to connect the Tôkaidô road with Edo. The road followed the sea all the way to Shinbashi, and there traversed Ginza, once again skirted the sea, and from there reached Kyôbashi and Nihonbashi. By this date, Edo Castle had also been completed.

Moats and waterways were then developed, most of them taking their final form around 1620. By 1639, Edo had finally expanded east of the Sumida River, and what would be the city limits on the eastern side had been reached. Even at its peak, Edo never stretched very far east of the Sumida River. The city remained quite small despite its growing population.

It should also be remembered that Edo, despite the importance of the waterways, never had a waterfront in the European sense. Whatever existed of the waterfront was completely occupied by townsmen's residences and commercial buildings. There were no large public halls and indeed no public squares. There were also no parks, neither public nor private. The city was regarded as a purely commercial area, and no need was seen for

other activities. There was, of course, a pent-up need for diversions, but this instead resulted in the formation of separate entertainment quarters, kept apart from the daily world of the townsmen.

The city very soon spread inland, however, to the eastern edge of the Musashino plain. This slightly higher area became known as the Yamanote. *Yama* means 'mountain' or 'hill' and *te* means 'hand' or, in this case, 'direction'. Yamanote thus means 'the direction of the hills'.

The hills stretched towards the centre of the city like many fingers of high ground. Shinjuku, for instance, stands on high ground, whereas nearby Shibuya is in a valley so steep and deep that today even the subway cannot remain underground. This feature of the topography of Edo and Tôkyô is amply indicated by the numerous place names ending in *-yama* ('hill, mountain'), *-dai* ('high ground'), and *-saka* or *-zaka* ('slope').

The Yamanote became the favoured residential area of the feudal lords, who wanted their residences to command high ground, something essential for warfare but also favoured by the theory of land divination or geomancy. The 'upper residences' (*kamiyashiki*) of the great lords grew up around Edo Castle. The lords also kept 'middle residences' (*nakayashiki*) and 'lower residences' (*shimoyashiki*) in the suburbs for recreational purposes. The estates of the great lords were naturally quite large.

Hatamoto and ordinary samurai lived mainly in the Yamanote to the north of Edo Castle, in orderly rows of residences appropriate to their rank and usually grouped with residences of others with the same official duties. *Hatamoto* city blocks in Edo were large rectangular blocks measuring 60 *ken* (1 *ken* = 1.8 m) or around 108 m on their short side. Each block was bisected lengthwise so that house lots measured 30 *ken* (55 m) in depth. Individual house lots had a 20 *ken* (roughly 36 metre) frontage. Thus, each individual lot – 20×30 *ken* or 36×55 m – averaged a little less than 2,000 square metres (Fig. 183). The main house was as a rule located to the north, while the garden faced south.

Lower samurai (*gokenin*) lived in similar residential areas, also grouped according to their official duties. The city block, however, measured only 40 *ken* on its short side and house lots were half that, or 20 *ken*, in depth. Individual house lots were supposed to have a frontage of 10 *ken*. Each house lot therefore averaged 10×20 *ken*, or 18×36 m. The average size was therefore (in theory) a little less than 650 square metres (Fig. 184). However, most lots were in fact smaller, generally from 300–600 square metres in area.

All samurai residences, regardless of size, were easily recognisable because of their strong gates, approaches, and entryways. These features of samurai architecture were remnants of the time when a warrior's residence sometimes had to be defended in war.

Water supply, however, proved more difficult in the hilly areas than in the coastal plains. Most commoners therefore preferred to live in the lower parts of the city. The shogunate encouraged land reclamation. The low land between the Yamanote and the Sumida River became known as the Shitamachi ('low city' or 'downtown'). The commoners occupied the Shitamachi, and also spread out along the main roads leading out from Edo.

At first, the Edo authorities made some attempts of city planning. According to the plan, main streets of Edo were supposed to be 18 m wide, while the streets running off them had a width of 12 m. Furthermore, each block (*chô*, named after a unit of measure) of the commoners' quarters was laid out to a prescribed size, about 60 *ken* or 108 square metres. The block was bisected by back alleys (*uradana*), that divided it into house lots. Each lot measured 20 *ken* in depth and had a frontage of 10 *ken* (Fig. 185). Unlike in the samurai quarters, a lot was usually occupied by several residences. In the middle of each block, the area was to be kept open and free from buildings and sheds. In early Edo, there were some 1,700 townsmen's blocks. Five to eight blocks made up a neighbourhood (*chô* or *machi*).

This early attempt at city planning had some success at first, at least when geography permitted. However, by the last decades of the seventeenth century, the influx of prospective Edokko and the new prosperity of the city caused all such attempts to be permanently abandoned. The regulations demanded open space behind the houses of each block within the centrally located Nihonbashi, Kanda, and Kyôbashi districts. However, these were soon completely filled with ramshackle tenement houses. New slums rapidly built up, invariably within the areas already most densely populated. Nor did all blocks follow the prescribed size and shape.

Each lot therefore soon contained at least seven houses, of which four fronted the streets at the front and back of the lot. Houses with street frontage were used as shops (generally with no more than five *ken* of frontage), while the houses lining the back alley were rowhouses used as residences by poorer people. It was not unusual for a block to contain from 300 to 350 residents.

Shintô shrines were generally small and could be found in all neighbourhoods. Buddhist temples, however, were regarded as a fire hazard because of their frequent cremations. They were furthermore considered to be of dubious propriety because of their association with funeral and death. Most of them were therefore kept far from Edo Castle.

The view from Edo was often spectacular; many mountains enlivened the inland views of the city. Mount Fuji, 100 km to the west, and Mount Tsukuba, with its twin peaks 70 km to the north-east, were the favourites of the Edokko. These mountains were often visible even from street level,

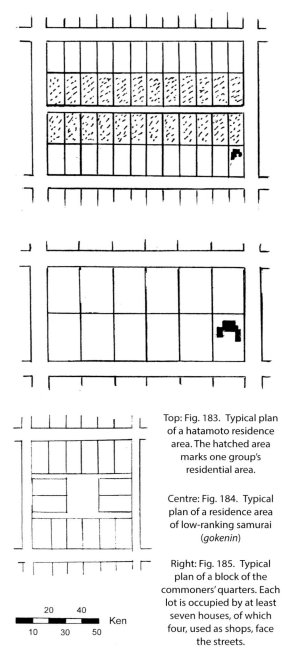

Top: Fig. 183. Typical plan of a hatamoto residence area. The hatched area marks one group's residential area.

Centre: Fig. 184. Typical plan of a residence area of low-ranking samurai (*gokenin*)

Right: Fig. 185. Typical plan of a block of the commoners' quarters. Each lot is occupied by at least seven houses, of which four, used as shops, face the streets.

20 40
10 30 50 Ken

233

especially on clear winter days, and they form the background for many Edo woodblock prints.[1]

Edo period maps indicate some interesting details about the official shogunate view of its chief city. Edo Castle is invariably shown at the very centre of the map; however, the space it occupies is either left blank or – in pictorial maps – hidden by convenient clouds. The reason was simple: the outline of the castle was regarded as a military secret. Another interesting point is the way the characters used in geographical names are positioned. The names of Buddhist temples and Shintô shrines are written pointing towards Edo Castle, while those of townsman residences are written to point away from the castle. The idea was to show that shrines and temples sustained the shogunate with divine protection, while the commoners showed their respect by bowing their 'heads' (first character of the name) towards the castle rather than pointing their 'feet' (last character of the name) at it – which would have been an utterly rude gesture. To further show who was in charge, the characters for 'Edo Castle' were always written so that their 'feet' were aimed at the west, that is, Kyôto, trampling the emperor's capital underfoot. West, by the way, was generally located at the top of the map.

Was Edo a pleasant place to live? That depends. The archetypal Edokko loved a crowd, and crowds were arguably what was most characteristic of Edo. The areas inhabited by commoners were incredibly crowded, walls were thin, and there was not even the faintest notion of privacy. Your neighbour knew everything about you, and you knew everything about him. Besides, your landlord was even responsible for your personal life.

Life was strict in Edo, but work was not as back-breaking as home in the country village. At least this was the general opinion of the Edokko. Whether he was right, or if his opinion merely reflected his pride in being an Edokko, is hard to say. The writer, humorist, and Edokko Jippensha Ikku stated in 1814 that 'Edo, in fact, is so prosperous that the country people think the streets must be paved with silver and gold, and they come up in their countless thousands and tens of thousands to pick it up.'[2]

1 In modern Tôkyô such easy visibility is no longer possible, and one generally has to climb to the top of a tall building to have a chance to see any mountain. Even then, it may be impossible. Industrialisation has severely polluted the air. The number of days on which Mount Fuji can be seen has fallen from about 100 a year in 1877, to 88 in 1938, and to a low of 39 in 1967–1968. Today the air is again cleaner, and Mount Fuji is visible for slightly more than 70 days a year. The mountain is often easiest to see at sunset, silhouetted by the setting sun.

2 Ikku Jippensha, *Shank's Mare* (Tôkyô: Charles E. Tuttle, 1960), p.369. Many years later, T. Philip Terry wrote a prewar guide to the Japanese Empire that, while not always reliable, shows that he knew his Tokyoites: 'the Japanese … find the decorous allurements of Tokyo so potent that they are drawn to them, as by magnets, from all parts of the Empire … once installed in the capital they regard with positive pity all who are so unfortunate as to dwell outside it.' Thomas Philip Terry, *Terry's Guide to the Japanese Empire, Including Korea and Formosa … a Handbook for Travellers* (Boston: Houghton Mifflin, 1930), p.133.

Most Edo commoners lived in the cheap tenement houses in the dark and crowded back alleys of Edo.[3] Lighting remained hopelessly inadequate. No street in Edo was paved or surfaced. When it rained – and rains were frequent – the streets rapidly turned into seas of mud. When there was no rain, they turned with equal rapidity into clouds of dust. 'Edo is a very dusty place' said Jippensha, and every day there was 'an extraordinary amount of wind'.[4] Dust and dirt reigned supreme, and the proverbial urge of cleanliness of the Japanese had little outlet on Edo streets. Many shops had to put out wooden planks in the street, so that customers could navigate safely among the slippery spots.

Garbage was heaped everywhere, even though efforts were made to recycle usable items. Jippensha noted that 'the pickle-tubs, empty sacks and broken umbrellas are so many that the landlords want to charge rent for the ground they take'.[5] The lack of sewerage – for either natural or man-made waste – caused health hazards. Edo was a city of foul odours. Rats and insects abounded. Epidemics were common. The most devastating ones killed thousands of people. The main source of entertainment was arguably prostitution, so venereal diseases took their toll on the populace. Many of the prostitutes lived in virtual slavery, and most never reached an age that would release them from their indenture.

The writer Saikaku shows that Edo period Japan was no different from other countries:

> [As dawn broke] somewhere an infant began to cry. Sleepily the tenants of that squalid quarter chased out the mosquitoes which had slipped through the breaks in their paper (mosquito) nets and plagued them throughout the night. One minute the women's fingers were pinching at the fleas in their underclothes, the next pinching for some odd coins (left as an offering) on the sanctuary shelf with which to buy a few green vegetables.[6]

Another popular Edo writer, Shikitei Sanba (1776–1822) mentioned how in the public bath, lice 'pass from the bath-accessories of the hillbilly maidservant to the young wife's finest clothes'.[7]

Beggars were commonplace, and thieves were abundant. What crime there was, was usually violent. We are not talking about dashing samurai fighting their vendettas within the city limits, but rather commonplace muggers and burglars with murderous intentions. The population lived under the constant threat of fire. No house could expect to survive for more than one or two decades, and few made it that long. Most were of the flimsiest type, catching fire easily and burning fast. Fires killed many Edokko,

3 After the Edo period, as soon as the restrictions on where commoners could live were lifted, the townsmen quickly left their back alleys and spread out in the direction of the Yamanote.

4 Jippensha, *Shank's Mare*, p.73.

5 *Ibid.*, p.369.

6 Saikaku, *Five Women*, p.86.

7 Leupp, *Servants*, p.115.

even more than those killed by the commonly occurring earthquakes and the regular floods. A house that did not burn down might be washed away whenever the Sumida River cared to flood, something that happened every three years on average.

There were also a few nice touches about Edo, which may not have been so easily found in other contemporary cities. Edo was full of flowers. Not in parks – there were no public parks in Edo period Japan – but in pots. Even the dirtiest and darkest back alleys usually contained a few neglected flowers in pots. There were also tiny gardens in all houses inhabited by those who were not completely destitute. Of all the seasonal flowers in all these tiny pots and garden plots, the most popular may have been the morning glory. It was – as the sign of summer – a favoured subject in much of the art of Edo.[8] Other flora were also celebrated. The cherry blossoms of spring are well known; other seasonal flowers included the peonies of early spring, the iris of early summer, and the maples of autumn. All provided good excuses for an excursion or some rowdy celebration.

Edo had other, less visible advantages. The rate of literacy was high, and not strictly a monopoly of the upper classes. Many children had the opportunity to attend school, not to better their lot but to acquire learning suitable for their social class. Art and culture, too, or rather what today is called art and culture, was not restricted to the upper classes. Edo did have a few opportunities for the bright but poor.

Crowds, fires, dirt, diseases, and loathsome sanitary conditions were a part of premodern urban life. In these aspects, there were no major differences between Edo and other big cities at the time, such as London, to which indeed Edo was often compared.

What were the famous places of Edo? What did the city have to offer? Let us proceed on an imaginary sightseeing tour throughout the capital of the shôgun. This is a tour that the Edokko would recommend. Thus we will be much concerned, for instance, with the various licensed and unlicensed entertainment quarters of the city. When appropriate, however, we will also compare the city of Edo with the Tôkyô of today.[9]

The tour naturally begins at Edo Castle, the centre of shogunal power and prestige.

Edo Castle

The area of Edo Castle was vaster than today. As the residence of the shôgun and the political centre of Edo, the castle played an important role in the city, even though most townsmen seldom, if ever, were permitted to enter. On rare occasions, the castle was open to selected commoners for the viewing of a special Nô performance. In modern times, the central keep and other principal structures of Edo Castle have been destroyed, but the

8 The morning glory retains its position in Tôkyô, and there are several morning glory fairs when the season is right.

9 Two excellent works the author has relied on for this chapter are Masai Yasuo (ed.), *Atlas Tokyo: Edo/Tokyo through Maps* (Tôkyô: Heibonsha, 1986), and Waley, *Tokyo: City of Stories*.

moats, embankments, and massive stone walls that made up its inner lines of defence remain almost unchanged. Since the Meiji Restoration, the site has been occupied by the Imperial Palace.

Ôtemon

Ôtemon was the name of the old main gate to Edo Castle. Originally, the area appears to have been lined with shops providing goods to the castle. Later, however, this part of the city, too, was usually off limits to commoners, unless they were in the service of the shogunate or the great lords. Today's business district of Ôtemachi – the name is recent – is named after this gate. The waterways and moats around Ôtemon remain basically unchanged since the Edo period.

Marunouchi

Maru literally means 'circle' but the word can also refer to a castle keep. Marunouchi therefore means something like 'inside the castle'. In the Edo period, this was a residential area for great lords. It was enclosed by a moat that roughly followed what is now Sotobori Dôri, a major avenue. The offices of Edo's two town magistrates (*machi-bugyô*) were also located in Marunouchi: the office of the town magistrate of the north in the northern part of Marunouchi, that of his counterpart, the town magistrate of the south, in the southern part of the district. Despite these titles and locations, the two magistrates actually had joint responsibility for the entire city, alternating duty according to a fixed schedule.

Toranomon and Tameike

If we leave the castle on the south-west side, we soon reach Toranomon. The name Toranomon ('Tiger Gate') is ancient, but today nothing remains except the name itself. Toranomon was originally a square gate located on the inner side of a moat. Its location was on what today is the Sakurada Dôri, just between the present Ministry of Education and the Ministry of Posts and Telecommunication. The moat and the gate remained well into the Meiji period.

Nearby Tameike was a water reservoir. It has now completely disappeared. In Edo, the Tameike reservoir was among the recommended places for gathering new herbs in spring and, in high summer, viewing lotus blossoms. The latter were said to pop softly open, if the viewer had the patience to wait for the tiny sound that signalled the event.

Akasaka

Continuing north from Tameike, to the east of the reservoir we find Hie Jinja, a major Shintô shrine, located on the hill at Hoshigaoka across what used to be a river. It is also known as Sannô-sama, after its annual festival, the Sannô Matsuri. In the Edo period, this shrine was the site of worship for the god Ubusuna no Kami, titulary god of the birthplace of the Tokugawa family. It was therefore the biggest of all shrines in Edo. Newborn children of the Tokugawa family were presented to the gods in this shrine. Crossing the river, we arrive at Akasaka. This was one of the entertainment areas of old Edo.

Not far away to the north is Kioichô, a name composed of the initial characters of the three collateral houses of the Tokugawa clan: the Kii, Owari, and Ii. The area was so named as it was the location of the mansions of these great lords, who were descendants of Tokugawa Ieyasu's three youngest sons.

Banchô

We proceed east, returning a little closer to Edo Castle. Here is Banchô ('the numbered blocks'), set between what is now Ichigaya and the moat of old Edo Castle. The area received its name from its simple, numbered blocks (from Ichibanchô to Rokubanchô, 'Block Number One' to 'Block Number Six'). The neighbourhood was also known as Kôjimachi, a word of uncertain origin that perhaps was a pun with the meaning 'lord town'. These blocks were inhabited by the *hatamoto*, the personal vassals of the shôgun.

Perhaps most likely, although by no means proven, was that the Banchô neighbourhood was named after the guard unit known as Ôban ('great guard') which Tokugawa Ieyasu brought into the city. If so, the name Banchô derived from the unit's name. The blocks were said to have been designated according to the numbers of the six subunits of this corps that were barracked there. This may explain why the original six numbered blocks did not follow each other in order. There was a saying: 'Not even the inhabitants can find their way about in the Banchô.' The blocks were later subdivided, and today remain a difficult place to navigate.

The second shogunal school, the Kyôjusho, was located in Kôjimachi from its establishment in 1842. The Shôheikô in Kanda, the main shogunal academy, by then no longer admitted commoners, but the Kyôjusho did. A well-known shop in this area was Yamakujira ('Mountain Whale'), one of the few Edo shops that sold meat. though slightly further to the west, in Yotsuya, there was a hunters' market that sold wild boar, bear, deer, and monkey meat. Meat was eaten in Edo only for its medicinal value.

Surugadai

Following the moat of Edo Castle, which at this point begins to arc south-east, we see the slopes of Kanda (more of which later) and yet more residences of the *hatamoto*. Most of these warriors had been transferred from the castle at Sunpu (now the city of Shizuoka) after the death of Tokugawa Ieyasu, who had retired to Sunpu in 1607, leaving Edo and the shogunate in the hands of his third son, Hidetada (1579–1632). As Sunpu was located in Suruga province, their new location became known as Surugashû no Dai ('Hill of the Band from Suruga'), or simply Surugadai ('Suruga Hill'). Another explanation, however, insists that the name instead came from the fact that Mount Fuji, also located in Suruga province, can be seen from Surugadai on a clear day. Yet others claimed other reasons.

Nihonbashi

After thus circling the castle, we find ourselves near Nihonbashi ('Japan Bridge'). With the exception of Edo Castle, the most famous place in the city was arguably the great bridge at Nihonbashi, or Nipponbashi as the name seems to have been commonly pronounced in the Edo period. This bridge,

rebuilt a dozen times or more as a result of fires and wear and tear, was about 77 m long and 9 m wide (Fig. 186).

The bridge was appropriately named. From the time of its construction in 1604, it was the common centre from which the roads were measured in Japan.[10]

The south bank of the river spanned by the bridge soon developed into the distribution centre for goods shipped to Edo. It was therefore natural that the Gokaidô (the five major roads to the provinces) radiated from this area of brisk commerce, and Nihonbashi, built to facilitate such business, became known as the starting point for the Gokaidô.

Not far to the north of Nihonbashi was Ôdenmachô ('Large Post-horse Quarter'). This location alternated with Minami-denmachô ('South Post-horse Quarter') to the south of the bridge as the centre for a national relay system of couriers and post-horses. This, too, was of vital importance for communications and trade in Edo period Japan. Ôdenmachô was also the location of the well-known dry goods shops named Isedana, which flourished from the early 1680s. As noted, all male employees of the Isedana shops were recruited from Ise.

Fig. 186. The Nihonbashi Bridge. The large, white buildings on the far, southern side of the bridge are merchant storehouses. To the left of them, one of the great, roofed notice boards (*takafuda* or *kôsatsu*) of Edo, with signs specifying laws and ordinances. On the hither, northern side, the stalls of the fish market.

10 Today the Nihonbashi Bridge remains, even though it bears no resemblance to the famous bridge of the Edo period. Indeed, an expressway now forms a 'bridge' above the bridge. The waterways, too, have changed, even though the Nihonbashigawa – the present name of the river under the Nihonbashi – remains in place. Road distances, however, are still measured from this location.

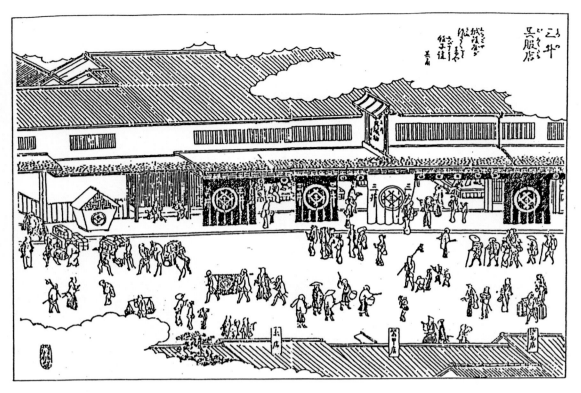

Fig. 187. The Echigoya in Nihonbashi

Nihonbashi was the true centre of Shitamachi (downtown Edo) and therefore the commercial centre of the city (Fig. 187). In the eighteenth century, 11 out of 20 famous commercial firms were situated around Nihonbashi. The area was, for instance, the site of the two great silk shops, Shirokiya of Tomizawachô (on the site until recently occupied by the Tôkyû department store) and Echigoya (now Mitsukoshi), established a few years later. It is not surprising that many of the oldest department stores, trading houses, and banks were founded here. Many of them still remain.

Other old Nihonbashi shops that survived into the present include Kamaya, established in 1659, selling moxa; Yamamotoyama, established in 1690, selling tea from Uji and *nori* (dried seaweed), formerly a specialty of Edo; Ninben, specialising in dried bonito flakes (*katsuobushi*), established in 1699 or, in this form, in 1704; Saruya, established in 1704, selling toothpicks; Edoya, established in 1718, selling brushes; Kiya, established in 1792 as a lacquer shop but nowadays selling knives and scissors; Yamamoto Noriten, founded in 1849, also selling *nori*; and Yanagiya, selling cosmetics, face powder, rouge, and scented hair oils, established as early as in 1615 by a Chinese known best by the Japanised form of his name, Ro Ikkan, one of whose ancestors had acquired the right to the two swords and a family name.

All goods were not of domestic origin. Near Kyôbashi bridge towards the south, there were, for instance, a few shops called *Tôbutsuya* ('vendors of products from China'), selling imported goods (from China and elsewhere).

Nihonbashi was also the site of the central fish market, located right beside the bridge itself on the northern bank of the waterway (Fig. 188).

Fig. 188. The Nihonbashi fish market

This market consisted of a large number of huts and stalls in which the fishmongers displayed their fish. The fish market was first established in 1590 by Mori Magoemon (1569–1672), son of a fisherman from Ôsaka, together with 30 others. The shogunate soon imposed a regular tax in the form of fresh fish for Edo Castle. Every morning an official arrived with some 15 assistants, who quickly confiscated every fish that looked suitable for the shogunal tables. Payment was as usual in Edo only made twice a year, and fixed at prices much lower than the market value. The fishmongers devised numerous ploys to hide choice fish from the official delegation. A common trick was to hide the fish in the latrine.[11]

At the beginning of the Edo period William Adams, the first known Englishman in Japan and a retainer of Tokugawa Ieyasu, had a house near Nihonbashi. For this reason, the later Meiji government commemorated his Japanese name, Miura Anjin ('the pilot from Miura peninsula'), by naming a neighbouring section of the city Anjinchô. The place name Yaesu, on the other hand, appears to have been a genuine Edo name, possibly named after Adams' companion, the Dutch sailor Jan Joosten van Lodensteijn, who lived in the present Marunouchi district and whose name was pronounced 'Yayosu' by the Japanese. The old name for this part of the city was Yayosugashi.

11 The fish market at Nihonbashi remained until as late as 1923, when it was finally destroyed by the great Kantô earthquake.

Not far from Nihonbashi was another bridge, Edobashi. After the disastrous fire of 1657 a broad street was cleared around this bridge. As elsewhere, this resulted in the immediate build-up of entertainment facilities, including tea houses, a small theatre (*yose*), and no less than five separate miniature archery ranges, fronting for prostitution. On the last day of the year, Edobashi was the scene for a street market where performers of auspicious and comic dialogues known as *manzai* came to select a junior partner/comic sidekick for the coming year's tour. This market was later moved to Nihonbashi.[12]

Kyôbashi

From Nihonbashi we proceed south along the great street that is the beginning of the famous Tôkaidô highway to Kyôto, the emperor's capital, and western Japan. When a traveller came to Edo on this highway, he had to cross Kyôbashi ('Capital Bridge') before he reached Nihonbashi. The distance between the two bridges covered a densely populated area, with each block devoted to a particular craft. In Edo the area was bounded by waterways. These have all gone, but it is still possible to get a glimpse of the outlines of the old city by looking at a modern Tôkyô map. Simply substitute the railways and expressways with canals, and you will see the outlines of downtown Edo.

Unlike Nihonbashi, the Kyôbashi area contained no big shops or wealthy merchant residences. The neighbourhood was poorer and generally regarded as a residential district for craftsmen and lesser shopkeepers. Most of them depended on orders from the upper classes. Near Kyôbashi, at Daikogashi, there was a large vegetable market. At Bikunibashi, a bridge in Yaesu (near present-day Ginza Itchôme) named for either Buddhist nuns or prostitutes dressed as such, was also located one of Edo's few meat shops.

Ginza

At the beginning of the Edo period, Ginza had as yet no name and consisted merely of a boggy sandbar. In 1612, however, when sufficient land had been reclaimed, a silver mint was set up in the second block of houses on the left after crossing the Kyôbashi bridge in the direction of Kyôto. The mint remained until 1800, when it was moved to Kakigarachô, on the other side of Nihonbashi, and the area became known as Ginza ('Silver Mint').

Ginza was also a centre for Kabuki theatres, at least until 1842, when all the Kabuki theatres were removed to the northern suburbs. Ginza, confined between the outer moats of Edo Castle and the shore of the bay, was never a centre of commerce, however. Until the very end of the Edo period, it remained an area of craftsmen and small shops.[13]

12 Edobashi, too, has been modernised and moved a little closer to Nihonbashi.

13 Although of little interest in the Edo period, Ginza suddenly found itself at the forefront of modernisation in the subsequent Meiji period. Brick buildings were hurriedly constructed, together with gaslights and later arc lights in the streets. In the early 1880s, just south of the spot occupied

South of Ginza was the neighbourhood commonly known as Konparuchô. The Konparu family, the oldest of the four troupes of Nô actors whose expenses were met by the shogunate and who regularly performed in Edo Castle, had their residence there. Although the neighbourhood was not regarded as a part of Ginza in the Edo period, it is today.

Continuing on the highway towards Kyôto, the Edo traveller soon reached the Shinbashi ('New Bridge'), built in the early Edo period to facilitate entry into the city via the Tôkaidô highway.

Tsukiji

Standing on the Shinbashi Bridge while on his way into Edo, the early traveller would have seen vast areas of recently reclaimed land on his right, in the direction of the bay. This was the area known as Tsukiji ('Constructed Land'). Fishing was the main industry until the 1930s.[14]

Hatchôbori

North-east of Tsukiji was Hatchôbori ('Moat of the Eight Blocks'). This was the residential area of the Edo police forces. The two lower ranks of the Edo police, the *yoriki* and *dôshin*, lived here in two close-knit but strictly separated communities. Although both groups were members of the samurai class and shogunate military, they were considered apart from ordinary samurai. To compensate for this, both groups, the *yoriki* (the higher rank) in particular, were well known for their arrogance and status-consciousness.

Kodenmachô

After this detour we return to Nihonbashi, which is only a short distance north of Hatchôbori. About the same distance north-east of Nihonbashi bridge, we find Kodenmachô ('Small Post-horse Quarter'). This was famous for being the site of Edo Prison. It was located as far from the upper-class residences as possible, but whether this was by planning or coincidence is hard to say.

Kanda

If we ignore the prison and instead proceed slightly north-west from Nihonbashi, we very soon reach Kanda. This was a hilly area, even though most of the hills had been flattened and the soil used for land reclamation along the bay. From 1690, an academy formally known as the Yushima Seidô but more generally referred to as the Shôheikô ('Shôhei Academy') was located on the hill at Yushima just outside the outer moat of Edo Castle. The academy's informal name derived from the name of the hill – Shôheizaka – named after the Chinese city Changping (read as Shôhei in Japanese), the location of the first school of Confucius (Latinised form of K'ung Fu-tzu, 551–479 BC), and of his tomb. The Shôheikô eventually grew into a huge

today by the Imperial Hotel, the Japanese government built the famous Rokumeikan ('Deer Cry Pavilion'), a venue for Western-style balls and parties, as part of the modernisation process.

14 The Tsukiji fish market opened only in 1923.

educational complex, with a great hall called the Taiseiden, lecture halls, dormitories, and other facilities.

The Shōheikō was established as a private academy in 1630 by the Confucian scholar Hayashi Razan (1583–1657), the son of a Kyōto townsman who entered shogunate service in 1605 and eventually became an advisor to Tokugawa Ieyasu. The academy and its library was at first located at Shinobugaoka in Ueno. Named Kōbun'in (in 1663), the academy and its hereditary directors, the Hayashi family (given the title Daigaku no Kami or 'Lord of Great Learning') enjoyed shogunal funding and support from the beginning. In 1690, the academy became the official shogunal Confucian academy, and land for a new, much enlarged university was provided at Yushima.

Confucian scholarship and research was regarded as the main purpose of the academy, and the teaching of other knowledge was not considered important. The academy also served as the centre of Confucian ritual for the entire country. A shrine to Confucius was first built on the academy premises in 1632. The Hayashi family took its duties seriously and may have been the only family in Japan that even followed Confucian funeral rituals. This shrine later moved with the university to Shōheizaka.

The academy, at first devoted to ceremony and research, only received an educational role in 1790, when the establishment was reorganised to serve the *hatamoto* and *gokenin* classes as well as Confucian scholars. This, however, made the academy the leading educational institution in Japan. The academy was accordingly renamed the Shōheizaka Gakumonjo (Institue of Learning at Shōheizaka). In 1797, the shogunate took over the management from the Hayashi family.

There were also other important places on the hill at Yushima, for instance the Kanda Myōjin shrine, centre of the famous Kanda festival, one of Edo's best-known events.

Kanda also contained the shogunal Bureau of Astronomy, or Tenmongata. From its establishment in 1684, this bureau maintained an observatory in Kanda. The observatory was a high mound, on which various astronomical instruments were located, including an armillary sphere. This observatory was not the only one in Edo; there was also one within Edo Castle from 1744 to 1757, and another in Ushigome from 1765, rebuilt in Asakusa in 1782. In addition to astronomy the officials of the Tenmongata were also charged with maintaining the calendar, and with land surveys and mapmaking.

Not far away, in Soto Kanda (Outer Kanda), was the official shogunal Institute of Medicine (Igakukan). This institute had been established in 1765 as a private medical academy, the Saijūkan, by Taki Mototaka (also known as Taki Genkō; 1695–1766), a physician from an old and established family of medical doctors who served as physician to the shōgun since 1747. In 1791 the shogunate promoted this academy to official status as its own Institute of Medicine, and provided it with a substantial endowment. The Taki family continued to provide hereditary directors, who from then on recommended doctors for shogunal employment. The school compound was large and included dormitories for senior students. The school was a very conservative

place. European medicine was never allowed within its doors, and the teaching was strictly traditional.[15]

Kanda was not all learning, however. In the early Edo period Kijichô in Kanda was arguably more famous for its female bath attendants (*yuna*), prostitutes who worked the public baths, and for its many and dashing gangsters. There was also an unlicensed entertainment quarter at Yushima, said to primarily serve the community of monks at Ueno (see below).

Kanda was also the site of a fruit and vegetable wholesale market, regarded as the largest in Edo, and official purveyor of such goods to the shogunate.

Yanagiwara

Yanagiwara or Yanagibara, the 'Willow Tree Field' along the south bank of the Kanda River near its confluence with the Sumida, was an old sightseeing spot, even predating the Edo period. Its reputation fell during the Edo period, however, as it turned into one of the best-known haunts of the lowest class of street prostitute, the 'nighthawk' (*yotaka*). In daytime Yanagiwara was instead frequented by numerous traders selling secondhand clothes. Nearby was also a community of the *hinin* group of outcasts, established in 1675.

Not far away – and also close to the prison at Kodenmachô – was the old marketplace for horses, Bakurochô ('Quarter of Horse Dealers'). This was an old market that also predated Edo's development as a city. The horses came from the north down the highway known as the Ôshû Kaidô. The chief of the horse dealers had been Takagi Genpei, who was therefore appointed *nanushi* ('neighbourhood chief' or 'community head') of the district.

As the bailiffs (*gundai*) who administered Tokugawa lands in the north of Japan also arrived here on their visits to Edo, an official residence was built for them. For the accommodation of other travellers, the area included a large number of inns. In addition, one of the miniature archery ranges of Edo, which provided female companions whenever needed, was located in the vicinity.

At the mouth of the Kanda River was Yanagibashi ('Willow Tree Bridge'), one of the common starting points for the boats (known as *chokibune*) that carried passengers up the Sumida River to the Yoshiwara entertainment quarter. This soon led to the development of an unlicensed brothel quarter around Yanagibashi itself.

Ueno

Ueno, gateway for the old Ôshû Kaidô linking Edo with northern Japan, was originally a site for shrines and temples. The chief temple was from 1626 the great Kan'eiji (construction began in 1624), a mortuary temple of the Tokugawa family, behind which eventually lay the tombs of six of the Tokugawa shôguns. Kan'eiji and its sub-temples commanded the entire Ueno hill and the low-lying regions to the east.

15 Kanda remained a centre for learning after the Edo period. For a time, most of the major universities had campuses here, and some still do. Kanda is now also famous for being the publishing centre in Japan and for its remarkable concentration of bookstores.

The area around the hill at Ueno was home to numerous well-known landmarks. A couple of hundred metres to the east of the main street running from central Edo to Ueno, for instance, were located the quarters of the shōgun's escort (*kachigumi*), samurai on foot who headed the procession whenever the shōgun made his way to the Ueno temple area.[16] In the same area, also on the east side of the road, one found the dry goods shop known as Matsuzakaya, founded by merchants from Matsuzaka (also pronounced Matsusaka) in Ise province. This shop – now a department store – remains in more or less the same location in modern Tôkyô.

Despite the religious association, Ueno was most frequented because of the thriving entertainment area located in the 'broad alley' (*hirokôji*) at the base of the hill. This open expanse was originally cleared as one of the three major fire-breaks of Edo established after the disastrous fire of 1657. As elsewhere in Edo, any open place very rapidly filled up, here with stalls and booths and a multitude of street entertainments, from actors to acrobats.[17]

Very close was yet another firebreak, this one established in 1737. This area, slightly to the east, was known as Ueno Yamashita ('Under Ueno Hill'). This entertainment area was more or less the same as the other one, and willing prostitutes were, naturally, also available. The difference was that both the prostitutes and the many shopkeepers selling anything from paper, medicine, brocade, and oil to tea, sweets, candles, and dried bonito shavings operated out of shops known as *hotokedana* ('Buddha Stores'). Ueno Yamashita was also famous for the small but numerous unlicensed brothels in the narrow streets behind the open space. The women there were known as *kekoro*, and lived two or three together in each of up to 50 *kekoro* brothels. A *kekoro* was easily recognisable by her apron, so the *kekoro* were often referred to as 'aprons from under the (Ueno) hill' (*yamashita no maedare*).

When somebody reached Ueno hill coming from central Edo, he also saw Shinobazu Pond on the left (west). The pond, too, provided an excuse for a pleasant excursion. The road along its south bank was dominated by tea houses famous for rice served steamed in leaves from the lotus plants of the pond. Nearby was also a shop selling combs and ear-cleaners made of boxwood. This shop was founded in 1736 by one Kiyohachi, an archery instructor from the Date domain in the north, who made combs as a part-time job. He first wanted to call his shop Kushi ('comb'); however, this pronunciation can also mean *kushi* ('painful death'), so the idea was soon dropped. However, a third possible meaning of the pronunciation *kushi* is 'nine-four'. As nine and four add up to 13, Kiyohachi ended up calling his new shop the Jûsan'ya ('Thirteen-shop').[18]

Among the tea houses and restaurants along Shinobazu Pond were several well-known *deaijaya*, or tea houses of assignation. As they had verandas

16 The memory of this quarter remains in the modern railway station named Okachimachi.

17 The 'broad alley' of Ueno is today remembered in the modern subway station named Ueno Hirokôji.

18 The shop still exists not far away from its original location.

looking out over the lotus leaves of the pond, the view was considered suitable for the refined gentleman awaiting a female companion.

If the Edo sightseer ignored all distractions and instead continued up to the temple complex on Ueno hill, he first crossed one of the Three Bridges (Mihashi) that led over the waterway flowing into Shinobazu Pond. However, only the shôgun crossed the central bridge, reserved for his august personage.

After crossing the bridge, the sightseer found himself in front of the Kuromon, or 'Black Gate'. This gate marked the entrance to the temple complex. Here, too, there was a special gate – beside the Black Gate – reserved for the shôgun.

The temple complex of Kan'eiji was large, and Kiyomizu Kannon Hall, a later version of which still stands on Ueno hill, was only one of its many temple buildings. There was also a bronze statue of the Buddha, and a shrine to Tokugawa Ieyasu, which was named the Tôshôgû. At the height of its splendour, the Kan'eiji had, apart from its main hall, 36 subsidiary buildings and 36 sub-temples. The entire complex occupied as much as 119 hectares of land.

Close by was the famous unlicensed pleasure quarter at Yushima. To fulfil the needs of the Buddhist monks, many of them apparently homosexuals, Yushima specialised in male prostitutes and entertainers, whose services were offered by *kagemajaya* ('shady tea houses'). Other services were no doubt also available, so no priest or monk would have to lose face by going to a more established entertainment area somewhere else.[19]

Hongô

Hongô, west of Ueno, was an area of small shops. At one time, it marked the boundary of Edo. There was a saying that 'Hongô lies within Edo up to Kaneyasu.' Kaneyasu was a shop founded in 1716 by Kaneyasu Yûetsu, a dentist from Kyôto. It specialised in the reddish toothpowder made with sand from the Bôsô peninsula. Partly because of its attractive shop girls and partly because of the fact that his shop sign was written by Horibe Yasubei Taketsune (1670–1703), who died as one of the famous 'Forty-Seven *Rônin*', business flourished.[20]

Koishikawa

Further to the west was Koishikawa. From 1640 to 1729 this was considered outside the boundaries of Edo and therefore a suitable site for an internment camp for Christians known as the 'Christian Mansion' (Kirishitan Yashiki), which also served as the headquarters of the anti-Christian inquisition of the early Edo period. The camp was located in a narrow valley with a stream, named Myôgadani ('Ginger Valley'), in what today is Kohinata (or Kobinata) Itchôme. Some prisoners were left to die in a one and a half metre deep pit, at

19 Although important in Edo, the Ueno temples were for the most part destroyed in the fighting surrounding the Meiji Restoration. However, the Edokko and the Tokyoite still share the tradition of having cherry blossom viewing parties (*hanami*) in Ueno.
20 Kaneyasu remained until recently, selling accessories and cosmetics.

the top of which a small hole was left open to pass in food, but most seem to have lived in huts surrounded by guard posts. Several Portuguese and Italian Jesuits lived there, one of them, the Sicilian Giuseppe Chiara (1600–85), surviving for as long as 42 years, from 1643 to 1685, by embracing Buddhism, changing his name to Okamoto San'emon, and taking a Japanese wife. He was buried in the temple Muryôin in Koishikawa.

The last missionary to penetrate Japan and apparently the last one imprisoned at Myôgadani was the Sicilian Jesuit Giovanni Battista Sidotti (1668–1714). He smuggled himself into Japan in 1708, poorly disguised as a samurai, but was arrested within a few days. Sidotti was imprisoned at Myôgadani from 1709 to 1714, when he was thrown in the pit and, after almost a full year, died. This was a punishment for baptising his two old servants in the camp. Before his death Sidotti had four long interrogations, or perhaps one should say conversations, with the Confucian scholar and statesman Arai Hakuseki.

By the time of Sidotti's death there was no longer any real need for a Christian internment camp. Besides, in the early eighteenth century so many commoners had moved into the area that Koishikawa was designated an Edo neighbourhood, together with other outlying areas such as Ushigome, Ichigaya, Yotsuya, Akasaka, and Azabu.

Koishikawa was also the site for Edo's only hospital for paupers, established by the famous magistrate Ôoka Tadasuke (1677–1751). The hospital grew, and by the end of the Edo period it had as many as 117 separate rooms for patients. Next to the hospital was a herb garden, which today survives as Koishikawa Botanical Gardens.

Komagome

Komagome, north-east of Koishikawa and also outside Edo proper, was the site of a large vegetable wholesale market, serving as a distribution centre for the areas immediately to the north of Edo, in which vegetables and fruit were cultivated for the benefit of the city and its inhabitants.

Komagome was also the site for an annual gathering of nurserymen from Somei, who during the Ninth and Tenth Months displayed elaborate chrysanthemum arrangements as part of the 'Chrysanthemum Festival' (chôyô or Kiku no sekku; see below) on the ninth day of the Ninth Month.

Dôkanyama, Nippori, and Asukayama

The Edokko of some affluence enjoyed excursions to famous places in and around his city. There were several popular excursion spots north of Edo.

Dôkanyama, in the northern suburbs near Komagome, was named after early fortification works built by Ôta Dôkan, the fifteenth-century warrior who built the first Edo Castle. In late summer, this was a popular place for cicada-listening parties.

Nearby, at Nippori and in particular at the Suwa Shrine, there was a famous view of the Sumida River and distant Mount Tsukuba. Here snow viewing was popular in winter, cherry blossom viewing in spring, and moon viewing in autumn. As tea houses soon sprang up on the bluff, there was no

need to forego the essentials of the life of a refined gentleman during such an excursion.

Asukayama, in the northern suburb of Ôji, north of Komagome, was also famous for cherry blossoms, and a popular spot for springtime excursions.

Asakusa

For the Edokko, however, no excursion could rival the popularity of the city's entertainment quarters. The chief ones were located in and around Asakusa on the Sumida River, a short distance east of Ueno.

Asakusa was always the centre for the spiritual and relaxational needs of the Edokko. The temple Sensôji, commonly known as Asakusa Kannon, was according to legend located here after three fishermen found a small image of Kannon, the bodhisattva of mercy, near the river in the seventh century. From that time onward the temple remained a centre for religious and popular festivals, as well as for numerous shops and stalls. In 1860, the British horticulturist Robert Fortune visited Asakusa:

> Its massive temple was seen looming at the further end of a broad avenue. An ornamental arch, or gateway, was thrown across the avenue, which had a very good effect; a huge belfry stood on one side; and a number of large trees, such as pines and *Salisburia adiantifolia,* surrounded the temple. Each side of the avenue was lined with shops and stalls, open in front like a bazaar, in which all sorts of Japanese things were exposed for sale. Toys of all kinds, such as humming-tops, squeaking-dolls with very large heads, puzzles, and pictures were numerous, and apparently in great demand. Looking-glasses, tobacco-pipes, common lacquer-ware, porcelain, and such like articles, were duly represented …
>
> On our arrival at the head of the avenue, we found ourselves in front of the huge temple, and ascended its massive steps. Its wide doors stood open; candles were burning on the altars, and priests were engaged in their devotions …
>
> The temple has numerous tea-houses attached to it for the accommodation of visitors and devotees. Adjoining them are many pretty gardens with fish-ponds, ornamental bridges, artificial rock-work, and avenues of plum and cherry trees, which seem the favourite ones at all the tea-houses and temples of Japan.[21]

Various types of street entertainment could also always be found in Asakusa, and especially in the nearby 'broad alley' (*hirokôji*) known as Okuyama. Like others of its kind, this site had originally been cleared as a firebreak. Located behind and on either side of the main hall of Sensôji, the famous entertainment area of Okuyama was already well-established by the 1770s. Among the most important attractions for the male Edokko were the over 70 tea houses, where many of the maids provided additional services. There was also a miniature archery range, likewise providing willing and attractive women. Female visitors to Okuyama had numerous *komabutsu* stalls, selling cosmetics, ornaments, combs, hairpins, and whatever else was required for beauty care. *Yôji* stalls sold toothpicks and materials for tooth-

21 Fortune, *Yedo,* pp.124–6.

blackening. There were numerous other stalls, selling everything from sweets and toys to plants and medicines. Various exhibitions and shows, such as dashing displays of swordsmanship, were used to attract customers. Acrobats and jugglers were common, as were all the other types of street entertainers that Edo boasted. Objects were also on display, including papier-mâché dolls depicting scenes from folk stories and plays.

Asakusa also had a number of popular shops. Interesting ones that still remain include Kinryûsan ('Gold Dragon Mountain'), selling sweets and rice crackers (*senbei*) since 1688, and Hôsendô, established in the same year, selling fans. Another one is Kyûgetsu, selling dolls since 1835. In addition to all these man-made attractions, Asakusa was also the place to view plum blossoms early in the spring.

Yoshiwara

Yet another attraction was the Yoshiwara licensed quarter, located near Asakusa. This was not only the most famous entertainment quarter, it was also the most expensive one.

Most visitors to Yoshiwara arrived by boat. The boats, however, went only to San'yabori. There the visitors had to rent a horse or, more commonly, proceed the short distance up Nihonzutsumi, an embankment built to protect Yoshiwara and other areas from the frequently recurrent floods, by palanquin (*kago*) or on foot.

The glamour of Yoshiwara probably made most Edokko forget that the inmates of the quarter not only lived lives of dalliance, but also frequently grew ill and died. Only about 700–800 metres north of Yoshiwara, in what is now the Minowa area of Minami Senju, was the Kozukappara execution ground. Close to it was the temple Jôkanji, a Jôdo sect temple where prostitutes with no family were interred. The temple was irreverently known as the Nagekomidera ('throw-in temple') or the Muendera ('temple for the unrelated'). The dead bodies of many Yoshiwara prostitutes were brought there for cremation and burial. It was commonly believed that a dead prostitute would return to haunt a person who treated her corpse with respect, so the dead bodies were typically wrapped in straw – as was the custom for dead animals – and simply thrown into the yard of the temple. There outcasts had to take over the final processing of the dead.

By the end of the Edo period (with the sumptuary edicts of 1842), the Kabuki theatre district was also moved to this part of Edo. Its final location was between Asakusa and Yoshiwara, perhaps a five-minute walk closer to Asakusa.

The Sumida River Embankments and Mukôjima

East and north of Asakusa and Yoshiwara, the embankments of the Sumida River were the site of many seasonal delights. In winter, these embankments were the traditional place for snow viewing. In the cherry blossom season, there were from the seventeenth century plenty of cherry blossoms to view along the left bank of the river, from a point generally opposite Asakusa and then continuing northward.

On the opposite side of the Sumida was also the area known as Mukôjima, famed for cherry blossoms and also a celebrated spot for moon viewing. Let us again quote Robert Fortune: 'We soon found ourselves nearly clear of houses and in the country … Nearly all the land where we were was one vast garden; or to speak more correctly, it was covered with tea-gardens and nurseries.'[22] In 1804, the 'Garden of a Hundred Flowers' (Hyakkaen) was built there by Sawara Kikû (1762–1831), also known as Kitano Kikû, a rich merchant who unlike most of his peers squandered his money on his Nihonbashi antique shop (Kitanoya Heibe) and his literary interests instead of the Yoshiwara courtesans.

At Mukôjima was also located the temple Mokuboji, where on the fifteenth day of the Third Month a great Amida invocation (*dai nenbutsu*) was held on the site marking the death of the semi-fictional Umewaka-maru, a 12-year-old child who appears in the Nô play *Sumidagawa*.

In Honjo, south of Mukôjima, there were numerous small canals, built in the first century of the Edo period. They were lined with vegetable markets and vegetable wholesalers. In Kameido, a slight distance beyond Honjo, there were plum blossoms to be admired in early spring. In May, Honjo was famous for its wisteria, admired and duly noted on the popular lists of things to be seen in Edo. East of the river were also several recommended places to pick the new shoots and herbs of spring.

We must also mention the spot on the Sumida River originally named Mitsumata ('Three Forks') and later renamed Nakasu.[23] This area had always been a popular spot for the pleasure boats of the Sumida. In 1771, the area was reclaimed from the river by the shogunate. By 1779, Mitsumata contained no less than 14 boathouse taverns, 93 tea houses, 18 restaurants – at least one of which kept live fish in a pond until they were cooked – numerous brothels, theatres, street entertainers, and stalls vending food and other goods. There were also at least 27 geisha. Some of the restaurants served exclusively the deputies of the great lords. By this time some of these deputies squandered their lord's resources while the lord himself was away to his distant home province. After the 1787 Yoshiwara fire, several displaced Yoshiwara brothels were also permitted to open temporary houses in this area. One such house relocated to the renowned restaurant Shikian. This increased the prosperity of both the restaurant and the brothel.

The reclaimed land, however, caused repeated flooding of the river upstream. In addition, the shogunate disapproved of the moral decay in the area. By 1790 it had the landfill removed, and the river restored to its original course.

Kuramae

South of Asakusa, on the same side of the Sumida, was Kuramae. This was a busy shipping and offloading centre, as the rice for consumption in Edo was brought in by barge to large storehouses in the area. The name Kuramae ('In front of the Storehouses') was most appropriate and naturally derived from this function.

22 *Ibid.*, pp.128–9.

23 Mitsumata was located close to what today is the Hakozaki Airport Bus Terminal.

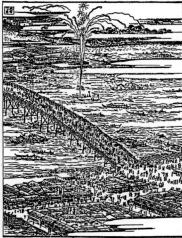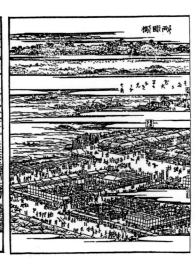

Fig. 189. Summer fireworks at Ryôgoku bridge. The box-like structures in the lower right corner are theatres.

Ryôgoku

Slightly south of Kuramae, but on the opposite side of the Sumida, was Ryôgoku. The Sumida River formed the old boundary between the provinces of Musashi and Shimôsa (now Chiba and Ibaraki Prefectures). When the first bridge over the Sumida was built in 1659, Ryôgoku ('Both Provinces') received its name, even though the border of Shimôsa by then had been moved to the Edo River east of the Sumida. Ryôgoku was famous for sumô tournaments and, beginning in 1733, summer fireworks (Fig. 189).

The technique for making fireworks was introduced in the sixteenth century. Firework displays soon became very popular, and spread all over the country. The most spectacular displays came from the rockets known as *warimono*, which exploded in starbursts of various types, representing flowers such as chrysanthemums, wisteria, plum blossoms, and cherry blossoms. The two most famous firework makers were the houses of Tamaya and Kagiya, and the crowds used to greet spectacular displays of firework by shouting their names. The two houses competed hard, until Tamaya was forced to close down after a fire on the premises in 1834.[24]

The remains of more than 100,000 victims of the great fire in 1657 were carried by boat to a point just beyond the later Ryôgoku bridge in the suburb of Honjo. The bodies were buried in mass graves, while monks of different sects recited masses for the souls of the dead. A temple, Ekôin ('Hall of Prayer for the Dead'), was built on the location. The temple still remains in its original place, although not in its original shape.

Ryôgoku was also a thriving entertainment centre, especially in the 'broad alley' (*hirokôji*), an area originally cleared as a firebreak at the west foot of the bridge. This, together with the one in Asakusa, was the largest in the city. Street entertainment of every kind was soon also set up at the eastern foot of the bridge. Ryôgoku was also the site for one of Edo's few meat shops.

24 The tradition of Sumida River fireworks lasted until 1961, when the custom was discontinued. However, the summer fireworks were revived in 1978.

The eating of wild boar, bear, deer, and monkey was tolerated, as its use was primarily regarded as medicinal.

Fukagawa

Fukagawa, south of Ryôgoku and on the same side of the Sumida, was well known for its many lumber yards (*kiba*). The main lumber area had been Nihonbashi, but after the 1657 fire, this and other smaller lumber facilities were consolidated and relocated to Fukagawa. The lumber yards were located at the mouth of the Sumida River, as the wood was immersed in water to preserve it, and had to move further and further out as land was reclaimed.[25]

The other main attraction of Fukagawa – the Fukagawa Hachiman shrine (now known as the Tomioka Hachiman shrine) – still remains on its original place, though it is now quite far inland, unlike in the old days. In Edo, the shrine was famous for its miniature model of Mount Fuji.

Fukagawa also had a miniature archery range, as usual a front for prostitution. In fact, Fukagawa was known for no less than seven unlicensed prostitution quarters. The tradition went back to the very beginning of Fukagawa, when the area was outside the city boundaries and thus beyond the jurisdiction of the town magistrate. Unlike Yoshiwara, where a distinction was maintained between the geisha (entertainers, male or female) and the courtesans (females, available for sexual intercourse), the female geisha of Fukagawa were not entertainers skilled in music and the arts. Instead they were real prostitutes, and contracted as such with the proprietor of their establishment. These geisha were easily identifiable because of certain eccentricities in their dress. They never wore socks (*tabi*), for instance, not even in winter. The explanation was that the Fukagawa geisha wanted to show off her red-painted toenails. The Fukagawa geisha also often dressed up in men's coats (*haori*). Many brothels in Fukagawa were known as 'children's houses' (*kodomoya*), but the popular guidebooks assure us that 'children' was merely a nickname for the young women inside. The Fukagawa prostitutes, at least the cheaper varieties, had many other names and nicknames. The 'boat cake' (*funa manjû*) accepted her customers onto her boat. Others were known as 'logs' (*maruta*), 'ducks' (*ahiru*), or 'nighthawks' (*yotaka*). The two latter varieties were the cheapest of the cheap.

Towards the end of the seventeenth century, the land soon to be known as Susaki was reclaimed from the sea. (The district has since been renamed Tôyôchô.) This flat land soon became the favourite spot for shell gathering, a popular spring and summer pastime. Women and children went there to sift through the mud and sand to find clams and shells. Their menfolk, meanwhile, lazed away their time and money in the Susaki tea houses, where there were beautiful waitresses also available for other activities. The shogunate did not look kindly on the unlicensed activities. After a tidal wave ravaged the district in 1791, permission to rebuild was denied.

Fukagawa was not only famous for prostitution. Unlike many parts of Edo, the district had other claims to fame. One of these was a genuine archery

25 For this reason, the subway station called Kiba today is quite far from the water.

gallery, that is, not a front for prostitution. This, the Fukagawa Sanjûsangendô, was a hall located on the east side of the Hachiman Shrine, and modelled on the renowned Sanjûsangendô hall in Kyôto. This hall was similar although slightly smaller, and like its predecessor, the hall was renowned among samurai for archery practise. The exercise was here practised on the lawn behind the hall, rather than inside the hall.

Another remarkable attraction was the Ten'onzan Gohyaku Rakanji ('Five-Hundred Arhat Temple'), a temple named after its collection of 500 statues of the Buddha's disciples carved by a monk from Kyôto. This temple dated to 1695, and the statues were completed by the early 1700s. The 500 statues became highly popular with the Edokko. The custom arose that when a member of the family died, the relatives came to the temple and, after locating the statue that most resembled the dead man, gave offerings and prayed before it.

Also on the grounds of this temple was an unusual three-storied building, the Sazaedô ('Turban Shell Hall'), built in 1780. Not only did it contain 100 statues of Kannon, the bodhisattva of mercy; these statues were also arranged in such a way that an impressive pilgrimage could be accomplished by the busy Edokko in only a few minutes' time. On the first floor were 34 images, one each for the 34 temples of the Chichibu region sacred to Kannon, and the objects of a famous pilgrimage route. The second presented 33 images, each representing one of the temples on another Kannon pilgrimage in the Kantô region surrounding Edo. The third floor, finally, displayed yet 33 images, each representing one of the 33 places holy to Kannon along the Saigoku pilgrimage route (*Saigoku sanjûsan-reijô*) in the Kyôto–Ôsaka region. Visiting all these holy places would preserve one from Hell, it was believed – and a short visit to this temple accumulated as much merit as making all three of these important pilgrimages. No wonder it became popular among the Edokko! The Sazaedô remained until about the end of the Edo period. Today a similar building exists only in distant Aizu in Fukushima Prefecture.

Shiba

We have now visited all the important and popular places of Edo, as well as a few of the ones at the limits of the city. There are, however, locations outside the city limits proper that cannot be ignored. One such place is Shiba, which the traveller along the Tôkaidô highway passed on his way to Edo just before reaching the Shinbashi bridge.

Shiba, today known mainly as Shiba Kôen (Shiba Park), was the location of several temples from the very beginning of the Edo period. The main temple is Zôjôji. It has been at its present location since 1598, when Tokugawa Ieyasu had it moved from its location near Edo Castle as a fire hazard. The English visitor Algernon B. Mitford described it in 1871 as standing 'in a park of glorious firs and pines beautifully kept, which contains quite a little town of neat, clean-looking houses, together with 34 temples for the use of the priests and attendants'. The tomb of the second shôgun,

Tokugawa Hidetada, was located nearby.[26] There were also the tombs of the sixth shôgun (Ienobu, 1662–1712, r. 1709–1712), the seventh shôgun (Ietsugu, 1709–1716), the ninth shôgun (Ieshige, 1712–1761, r. 1745–1760), the twelfth shôgun (Ieyoshi, 1793–1853, r. 1837–1853), and the fourteenth shôgun (Iemochi, 1846–1866, r. 1858–1866).

Even older than these temples is the Shiba Daijingû shrine, which is said to date back to 1005. It is located close to the Daimon ('Great Gate'). This is nowadays a massive concrete structure, but a Daimon existed in the same location in the Edo period. Then it was a true gate that guarded the bridge over the small waterway that formerly enclosed the area, running in a roughly north–south direction.

In 1786, the first academy for Dutch (European) medicine was established in Shiba by Ôtsuki Gentaku (1757–1827), a well-known physician and translator. It became known as Shirandô (*Shi* from Shiba, *ran* for Dutch, and *dô* for academy).

Shiba, like Ueno in the north, naturally also had a thriving entertainment centre, not much different from the others in and around Edo.

Shinagawa

Shinagawa was a post station on the Tôkaidô road and therefore outside Edo proper. It was located south-west of Edo, beyond Shiba. As a post station, Shinagawa had numerous inns and a flourishing trade in prostitution. Shinagawa was also the site of one of the execution grounds of Edo, Suzugamori. Most of the time, corpses were displayed there as a warning to the public. The German visitor Kaempfer, upon passing this site in 1691, remarked that it was:

> a very shocking and unpleasing sight, human heads and bodies, some tending to putrefaction, some half devour'd, lying among other dead carcasses, with multitudes of dogs, ravens, crows, and other ravenous beasts and birds, waiting to satisfy their devouring appetites upon these miserable remains.[27]

The Tôkaidô was a busy road, and it naturally grew increasingly crowded the closer one came to Edo. So did the inhabited areas. Kaempfer noticed that 'the suburbs of Yedo … are only a continuation of the (suburbs of Shinagawa), there being nothing to separate them but a small guard-house.'[28] The Dutchman Overmeer Fisscher, who passed through in 1822, remarked that 'Long before we entered Sinagawa[29] we were moving in the midst of an unnumbered multitude, and along wide streets which may be considered as part of the town.'

26 Hidetada's tomb was located on the grounds of what is today Tôkyô Prince Hotel; it was lost in the destruction wrought by the air raids of the Second World War.

27 Kaempfer, *History* 2, p.519.

28 *Ibid.*, p.519.

29 Shinagawa.

くず湯
玉子酒
麦湯

Fig. 190. A tea house waitress, more likely than not also providing other services

Another nearby attraction was Gotenyama, a hill that overlooked the bay south of Edo, not far from Shinagawa. This hill was especially famous for cherry blossoms.

Shinjuku

Shinjuku was a post station west of Edo. It did not exist in the first century of the city. In 1698, however, upon the advice of five brothel-keepers from Yoshiwara, a new post station was set up in this location on the road to Takaido. The reason was simple: the older station on the way to Kai province (now Yamanashi Prefecture) was too far out. The site chosen for the new station was the point where the Kôshû Kaidô and the Ome Kaidô highways diverged, near the residence of the lordly family Naitô. The place was therefore called Naitô Shinjuku ('Naitô New Station'), hence the modern name Shinjuku.

Due to the location outside the city limits, prostitution naturally flourished (Fig. 190). In fact, so much so that 20 years later the authorities were forced to step in and close the Naitô Shinjuku Station, which remained closed for 50 years. After 1771, however, prostitution was legalised in Shinjuku, and the post station reopened. The Naitô residence still remains in the form of Shinjuku Gyoen National Garden, in present Naitôchô.

Itabashi

Itabashi was yet another post station, just north of Edo proper. Like the others, Itabashi was a flourishing centre for prostitution, officially recognised as such after the 1750s.

Senju

Senju, located north-east of Edo, counted as two post stations, both of them naturally outside the city borders. The reason was that roads from the north converged at this point before entering Edo. Three main roads, in fact, converged upon Senju: from Mito, from Nikkô, and from the north. This caused Senju to develop into two clusters of houses, on either bank of the Arakawa River (the name for the upper reaches of the Sumida). These were known as the Upper Station and the Lower Station, respectively.

Prostitution, officially approved after the 1750s, was as usual the main trade. In the early eighteenth century there were 72 inns at Senju.

Senju was also the site of one of the three biggest vegetable wholesale markets in Edo.

Kozukappara

Kozukappara (or Kotsugahara), located north of Edo and outside the city limits, was the site of another Edo execution ground. The city border was a small river, and Kozukappara was reached by crossing this on the bridge known as Namidabashi ('Bridge of Tears'), the place where families were supposed to say their last farewells to condemned relatives.

As a criminal had become an outcast by virtue of his crimes, he was not permitted to be buried in his family grave. A temple was therefore established in 1662 beside the execution ground for the posthumous advantage of the executed criminals. This temple was a subsidiary of the Ekôin in Honjo, and therefore known as the Kozukappara Ekôin.[30]

In 1888, when the execution ground was closed down and memorial services were held for the repose of the souls of those who had been executed there, the number of executed prisoners was estimated at 100,000. The temple that was raised on the site claimed 200,000 departed spirits, presumably including those of other execution grounds as well. If this figure is accepted, then about two persons a day lost their lives in the Edo execution grounds through their roughly 300 years of use. Although this figure may be exaggerated, Edo justice was harsh.

Kozukappara was inauspicious also for other reasons. The chief reason was fear of contamination by death. Another was the neighbourhoods of outcasts that grew up there. In 1669, more than 20 temples put up consolidated cremation facilities near the execution ground. Settlements of outcasts (*hinin*) were then established, as outcasts were needed to process the corpses, both from the temples and the execution ground.[31]

30 The temple still remains.

31 In the vicinity of the old execution ground (now part of Minami Senju) is the area of modern Tôkyô known as San'ya ('mountain valley'), located in Taitô Ward overlapping the boundary with Arakawa Ward. Because of the Japanese fear of contamination by death, until recently the vicinity was one of the least popular choices of residence in Tôkyô. To attract new inhabitants, local authorities in modern Tôkyô embarked upon a scheme to pay newlyweds a monthly allowance for taking up residence near the old execution ground.

Left: Battle standard (white *aoi* crest on black) of Tokugawa Yorinobu (1602–1671), Ieyasu's son and founder of the Kii branch of the Tokugawa clan.
Right: Banner of Tokugawa Yorinobu (1602–1671), Ieyasu's son and founder of the Kii branch of the Tokugawa clan. White banner and white pendant, both with black *aoi* crest.

(Source: *Hata umajirushi ezu* ('Illustrated Banners and Battle Standards'), late seventeenth century. Brigham Young University Library, Tom Perry Special Collections (call no. 895.61 H28).)

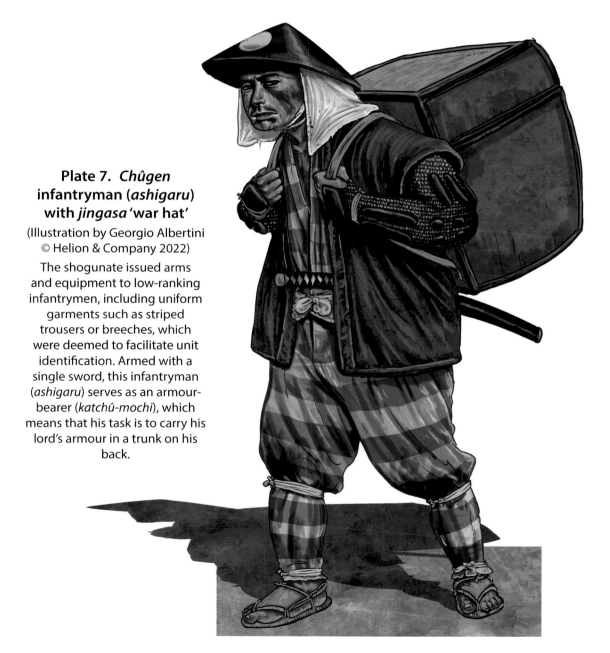

Plate 7. *Chûgen* **infantryman (*ashigaru*) with *jingasa* 'war hat'**

(Illustration by Georgio Albertini © Helion & Company 2022)

The shogunate issued arms and equipment to low-ranking infantrymen, including uniform garments such as striped trousers or breeches, which were deemed to facilitate unit identification. Armed with a single sword, this infantryman (*ashigaru*) serves as an armour-bearer (*katchû-mochi*), which means that his task is to carry his lord's armour in a trunk on his back.

Plate 8. Samurai police officer (*yoriki*) in civilian *haori* coat, *hakama* skirt-trousers and 'horseman's war hat' (*bajôjingasa*)

(Illustration by Georgio Albertini © Helion & Company 2022)

Higher-ranking samurai generally preferred the *hakama* trousers, especially when in civilian dress. Armed with *jitte* and two swords,this police officer has prepared for combat by tying up his *hakama*, which could be done very rapidly and at a moment's notice. For protection he wears a fireman's breastplate (*muneate*) under his coat. Such a breastplate looked like a cuirass but was made of fabric, usually cotton and silk. Nonetheless, it provided a certain level of protection, especially in the kind of situations in which a police officer might find himself.

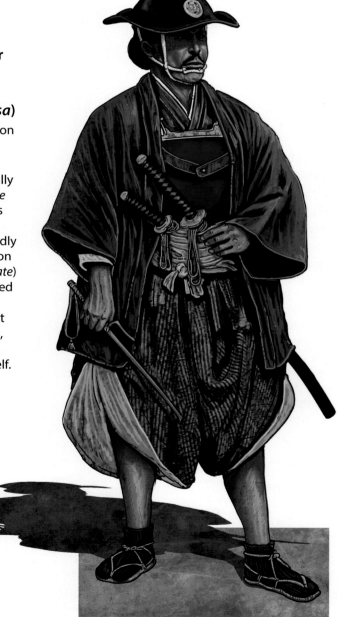

4

Housing and Public Services

Housing and Accommodation

As noted, low-ranking samurai generally lived communally in barracks divided into apartments not much different from the commoners' tenement houses of downtown Edo. Yet, furniture and household utensils differed from those used by high-ranking samurai only with regard to quality and cost.

Upon entering a residence, the Japanese customarily left his footwear on the ground. Each house therefore had an area near the entrance where footwear could be left and from which the visitor stepped up into the house proper. In most houses, this was nothing more than the earth floor of the kitchen. Wealthy residences, of course, had more elaborate arrangements.

Inside, household equipment and furniture were usually modest and simple even in wealthy households. Unlike China and Europe, a Japanese house contained no chairs. The chair was certainly known, and portable camp stools had been used for many centuries by the samurai on the battlefield or in camp. In a house, however, one always sat on the floor. This was equally true in the castles of the shôgun and the great lords or in the hovels of poor farmers.

There were also no beds. At night, one slept on a mattress (*futon*) spread on the floor. On top one used a blanket, or rather a padded quilt, to protect against the cold. Designated bedrooms were only available in the houses of the wealthy. Most people slept in their living room, and poorer townsmen and employees slept in their place of work. Each person had his or her own mattress. Young children slept with their mother until they had grown to need their own mattress. The mattress was seldom more than two to five centimetres thick, and during the day was folded and stored either in a deep cupboard built for the purpose, or – in poorer households – behind a small screen. On fine days the bedding was aired in the sun. This was done as frequently as possible, as the warm and humid climate of Japan encourages mould and mildew in most seasons.

Pillows were not used. Instead, the head was supported by a slightly concave headrest (*makura*) positioned under the neck, so as not to risk disarranging one's carefully arranged hairstyle. The hair was, among respectable people, always done into one of several elaborate styles, and

Fig. 191. A padded, wooden bed headrest

fixed into place by a thick sort of grease. It took time and money to rearrange, so it was customary to wash the hair only every 10 days or so. It was therefore important not to disarrange the hair by sleeping on it. Besides, as the grease could easily soil the mattress, the second purpose of the headrest was to keep the head away from the mattress. The headrest, usually made of wood or porcelain, was sometimes but by no means always lightly padded by a (sometimes separate) wadded pillow or cushion (Fig. 191). The headrest was frequently configured as a tiny chest of drawers, where small and valuable objects were kept. Specialised travel headrests also existed, serving as kind of miniature safety deposit box for the sleeping traveller.

Whether or not the Edokko changed into night clothes depended upon his or her means and social class. If he (or she) did, it was a simple cotton kimono tied with a narrow sash. It was, however, quite common to sleep in the clothes one had worn during the day, although a woman then would remove her heavy sash (*obi*). This was necessary, as the bulky knot impeded sleeping. Courtesans wore their sash tied in front so there was no need to remove it to do their work.

As beds were not used, there was little difference between the social classes in the way they slept. Samurai and wealthy merchants naturally had more luxurious bedclothes. Poor people, who could not afford tatami mats, had to be contented to sleep on rush mats or even on the plank floor. At night, clothes were hung on an upright wooden frame (*misokake*), or simply thrown over the top of any nearby screen.[1]

Edo houses also contained no designated dining rooms. Meals were generally eaten after the bedding was removed, in the same place one had slept. Despite the lack of chairs and beds, furniture did exist in Edo. A mirror stand (*kyôdai*) was, for instance, a very common piece of furniture. Two different styles were in use. The simplest in design but largest in size was the ordinary rack mirror. The other, more convenient for a crowded household, was a chest of drawers with a removable mirror on top. As this mirror was smaller, it was detachable, and could be stored in the chest when not in use.

A well-stocked house typically also contained sets of drawers for storing clothes. Clothes were invariably folded and put in drawers; they were never hung in wardrobes. The drawers were either set in free-standing chests (*tansu*), or incorporated into the structure of the building. In a large house, it was common to fill the space under the stairs to the upper floor with such drawers. Free-standing chests came in varying sizes.

1 It remains common to sleep on the floor in modern Japan, though an increasing number of people sleep in beds, Western style. The main difference is that nowadays a pillow, often filled with buckwheat husks, is used instead of the old-style *makura*.

In a large house where guests were entertained from time to time, a supply of square or circular cushions (*zabuton*) was kept to sit on. In the early Edo period these were reserved for the use of visitors during the winter months (in yet earlier times, these cushions had been made of straw and known as *enza*). To greet a visitor from a sitting position was rude, however. Etiquette required that one first left the cushion, and only then greeted the guest or host with a bow. Other furniture might include concave elbow rests (*kyôsoku*), to enable the visitor or resident to relax when sitting. Small, low tables were also common, some used as desks (Fig. 192), as were a variety of writing cabinets, cosmetic boxes, and dressing tables.

A distinguishing feature of any quality furniture – and also of high-class household utensils – was the lacquered surface (*shikki*). Indeed, lacquer was applied to a basis of wood or other substance to make not only furniture and household utensils, but also many other objects. Typically mixed with red or black pigment, lacquer was the basis of decorative patterns on all sorts of objects, including suits of samurai armour and palanquins. Indeed, almost anything which in Europe would have been painted, varnished, or inlaid was in Japan lacquered. Lacquer, applied in more than a dozen thin layers, effectively insulates and waterproofs wood and keeps liquids hot when served in a lacquer utensil. As lacquer is a natural varnish, the application of several layers also gives a very beautiful surface to the object.

Raw lac was collected in spring and summer, by means of horizontal cuts in the trunk of the sumac or lac tree, mainly found in the northern parts of Japan. As the lac trickled into these cuts, the tapper removed it by a type of scraper, collecting the lac in buckets. The raw lac was later transported in sealed tubs to the actual lacquer-worker. The tapper was generally an itinerant craftsman, who, while working for the owner of the trees, did his best to shroud his craft in secrecy so as to keep his work opportunities to himself.

Bamboo was another common raw material, split for basketry, lattices, and screens, and used whole to make cups and ladles. Paper over a bamboo frame made flat fans and folding fans, some headgear, paper lanterns, and umbrellas (oiled paper made these waterproof). Paper was naturally not just used for household utensils, as literacy was high in Edo. Japanese paper was made from the fibres of the inner bark of trees, especially the mulberry tree. The availability of a wide range of quality in paper ensured that etiquette soon demanded only the use of paper of the proper quality, thickness, and colour when, for instance, writing a letter. Paper was also, of course, required

Fig. 192. Young woman at her reading desk. Beside her on the desk are her writing brushes, ink-stone, and a water container for preparing the ink. The paper is held down with a paperweight.

Fig. 193. Young woman resting within a mosquito net. Nearby she keeps her smoking pipe set, a couple of popular books, and a small cage containing crickets.

for the substantial publishing industry. And it is well known that paper was used in the construction of houses – especially for the sliding doors and panels called *fusuma* and *shôji*. Such paper had to be renewed often, as it tore and broke easily.

Summer in Japan is wet and humid. Mosquitoes therefore caused considerable nuisance, even though malaria seems to have been unknown or at least unrecognised. Mosquito nets (*kaya*) made of almost transparent netting of cotton, silk, or hemp were used, the largest of which would cover a whole room. Inferior ones appear to have been made of paper. Others were smaller, made to cover a sleeper on his mattress only (Fig. 193). The shape of the mosquito net was that of a bottomless rectangular prism, suspended by cords from rings on its corners to hooks fastened in the ceiling or on the walls in the four corners of the room. Saikaku reports that a secondhand

mosquito net for a two-mat room cost 33.5 silver *monme*, or almost 2,250 copper *mon* at an auction sale.

The mosquito net inhibited fresh air from reaching the sleeper, but this was not considered a problem. Whatever the weather, every house was in any case firmly shuttered up at night.[2]

As elsewhere, a house in Edo had to be cleaned. Cleaning the house consisted of regularly brushing off the straw tatami mats with brooms. These brooms generally had triangular heads. In poorer households, rougher straw brooms were also used. For lighter cleaning, dusters of paper, cloth, or feathers came in handy, as did dustpans made of bamboo with glued-on paper. When cleaning, the woodwork of the floors was also rubbed over with a damp cloth. Several such rubbings imparted a dull sheen to the wood, considered desirable. Wax, polish, and paint were not used in Japan during the Edo period.

A general house cleaning known as 'soot sweeping' (*susu harai*) was held once a year. All tatami mats were then taken out in the street or garden and beaten. Bamboo poles with the leaves left on were used as brooms to remove dust and soot from the ceiling. Cleaning was definitely needed, as Edo was a dusty place. The general house-cleaning was seemingly not for hygienic reasons, however. The intention was to approach the new year with a home that had been ritually cleansed of contamination. For this reason, the date of house cleaning was fixed and strictly regulated. In the first decades of the Edo period, the event took place on the twentieth day of the Twelfth Month. Unfortunately, the third shôgun, Tokugawa Iemitsu, inconsiderately died on this particular day. The authorities therefore had to move the official house-cleaning day to the thirteenth day of the same month. After all, the leading official of the government was much too important to be cleansed away with other contamination. At times and in certain places of Japan, there were some local and periodic variations regarding the date for cleaning, but such changes were of minor influence.[3]

Etiquette and Proper Behaviour

In a description of any closely regulated society, a few examples of correct etiquette will invariably shed some light on daily life. In Edo, even the poorest families regarded questions of etiquette to be of some importance, and the middle and upper classes were severely bound by its demands.

It is well known that there were no chairs in Edo. But it was also considered improper to stand indoors. Indoors, whether at home or during an official event, the correct attitude was to sit back on the floor on one's legs and heels, with the heels almost flat, sideways on the floor, and the buttocks resting on them. This is not as tiring as it appears, and every Japanese was of course accustomed since early childhood to sit in this manner. It was also common knowledge that any pain in the legs caused by sitting in this manner

2 Even today, it is virtually unheard of to sleep in fresh air. This is widely regarded as tantamount to catching a severe cold (*kaze*, 'wind' in Japanese).

3 In recent years, the date for cleaning is again usually near the end of the month.

for prolonged periods on a wooden floor could be eased by pushing one's thumbs into the proper spot on the back of the small of one's legs. Besides, tatami mats were quite soft, and cushions often provided. It was, however, considered impolite to greet a guest while still sitting on the cushion, so one had to get off it and onto the tatami before effectuating a proper greeting.

There were also other ways of sitting, considered to be more relaxed. Men – but never women – could sit with crossed legs if the occasion was informal. Other, more specialised ways of sitting with crossed legs also existed, such as sitting while wearing full armour. If meeting with Europeans in Nagasaki, something the ordinary Edokko never did, it was at times fashionable to sit in a chair. This curiosity was testified to by, among others, the Swedish physician Thunberg.

Women were expected to behave with more formality than men. When a sitting woman was greeting, bidding farewell, or receiving an order, she was supposed to make an obeisance by placing the hands on the floor in front of her and lowering the forehead down between the hands, naturally without moving her buttocks from their proper position resting on her feet. A man was at times expected to behave in the same manner, but he seldom needed to bow as low as a woman.

Outside the house, other rules of etiquette applied. In the street or outdoors, both men and women remained standing while greeting, bowing from the hips. The only general exception to this was when a superior of high rank, such as a great lord and his procession of warriors, went by. Then everybody had to get down on the ground to make obeisance. Such humble behaviour could also be seen in other situations if a lower-ranking person desired or needed to appear very polite. Such situations included, among others, a very serious apology, or the request for something unusual or previously denied, for instance an apprenticeship or permission to marry.

A married couple would seldom go anywhere together in public, but if they did, the wife was expected to walk a pace behind her husband and, naturally, also act as if deferring to him in every way. Proper etiquette demanded that the husband be seen as the master of his household, whether he really was or not.

It was considered very impolite to breathe upon people. This may originally have had something to do with the demands of purity imposed by the Shintô religion. When talking to a superior, the lower-ranking person had to hold his hand in front of his mouth. It was quite common to use a fan for this purpose. The same applied to situations in which a missive or document from some elevated or high-ranking personage was handled, and when a Shintô priest handled a sacred object. On the latter occasion, a piece of paper would be put in the mouth to prevent the breath from defiling the object.

It was also considered rude to perform greetings while wearing any kind of working equipment. A hard-working man often wore his towel knotted round his brow to keep sweat from his eyes. This towel had to be removed before performing any polite greeting. Likewise, a woman had to remove the cloth she commonly put over the head to keep the dust off her hair, and also the band of cloth often worn to tuck in the long sleeves of her kimono to keep them out of the way while working. Even a man wearing a pair of

the tortoiseshell-framed eyeglasses that were in use at the time – introduced from Europe in the sixteenth century – had to take these off before making a polite bow.

Special etiquette concerned the use of footwear. Footwear was always removed upon entering a house. In many fine houses, including inns, a maid customarily assisted in washing the feet of the guests upon arrival. The feet and footwear were – as in many other Buddhist countries – considered dirty and defiled. It was considered the height of rudeness to put on other people's footwear, and doing so by mistake in polite society demanded profuse apologies.

Within the house, many other restrictions on proper behaviour applied. Entrance and exit to and from a room was through a sliding partition door. When a maidservant brought a tray for a meal, she first had to kneel in the corridor before the sliding door that she was to open and place the tray on the floor. Then she slid open the partition door, stood up again, stepped inside, went down again on the floor, and brought in the tray from the corridor. Finally, she slid the partition door shut, picked up the tray, stood up, brought it to the guest, got down on the floor again, bowed towards him, and finally served him some sake. Only then was the food served. This behaviour can still be seen in better traditional inns in Japan. When carrying a tray, whether man or woman, one had to hold it with one's left thumb over the edge of the tray, and the right hand resting against the other side. Moreover, one was supposed to walk with one's eyes fixed on the ground about one metre ahead of the tray.

In a well-to-do home, guests were entertained in the best room of the house, where there was an alcove (*tokonoma*) in which beautiful objects could be displayed. The alcove could vary in size, but was often from one-half to a whole mat, or *ken* (that is, about 90 to 180 cm) wide, reaching up to the ceiling, and a quarter to half a *ken* deep (45 to 90 cm). Its floor was raised about 15 cm above that of the rest of the room. This alcove was used to display some suitable object, usually a scroll decorated with a picture or some calligraphy. This scroll was changed from season to season. Also in the alcove was often found a decorative pot, a flower arrangement, or in samurai families, perhaps an heirloom sword.

The most important guest was, curiously, not seated facing the display in the alcove, but instead sat with his back to it. If several guests visited the same house, there was usually – in fact invariably unless one of them was of unquestionably higher rank such as a samurai among commoners – much polite disclaiming of the honour before the group finally settled down.[4]

The question of rank also decided who should pass first through a narrow passage, such as a corridor. There was, indeed, no subject of etiquette not utterly tied up with the question of rank, and thus etiquette was perhaps the basic concern of Edo period Japan.

4 The custom remains in modern Japan, not only when entertaining guests in Japanese-style houses but also in offices. The manager will likely sit with his back to the best view from the office windows.

The Private House

All buildings in Edo were constructed of wood. Wood was used not only in the beams and thick columns of the framework, but also for walls, floor, ceiling, and roof. Lumber, often cedar (*sugi*), was therefore a very important material, second only to rice in the economy. The wood was carried to the lumber yards of Edo from various locations, such as Sunpu (now Shizuoka), Nagoya, and Wakayama. In the seventeenth and eighteenth centuries, a number of leading lumber merchants became fabulously wealthy.

One of the wealthiest timber traders was Kinokuniya Bunzaemon (*c.* 1669–1734). He was a man of obscure origin, presumably from Kii province, soon known (because of his initials) as Ki-Bun Daijin. Daijin was a title that usually indicated a person of high rank. In Ki-Bun's case, Daijin indicated a big spender. Kinokuniya was said – though the story is likely to be apocryphal – to have made a vast fortune overnight by transporting mandarin oranges (*daidai*) to Edo. This fruit is an important part of the Japanese New Year celebration. In this particular year, the supply had been cut off by severe storms at sea. The price of mandarin oranges rapidly surged in Edo, where no oranges could be found, but plunged in the producing areas. If the New Year deadline was not met, the producers knew that there would be no sales. Kinokuniya Bunzaemon therefore recruited 20 sailors who were willing to risk their lives braving the sea in exchange for generous remuneration. When Kinokuniya's ship eventually arrived in Edo, right on time, he could sell his cargo for a vast profit.

In another story, Kinokuniya is said to have made his fortune after one of the great fires in Edo, when he speculated in lumber from the forests of the Kiso mountains. According to this story, he set out immediately after the fire to buy out entire stands of trees on credit, cornering the market for rebuilding Edo. The story goes that Kinokuniya – in order to convince the forest owners of his credit-worthiness – pierced a hole in a gold *koban*, which he then gave to an owner's child as a toy. It must be remembered that this gift was the equivalent of almost a year's income for most people at the time. Unfortunately, this story is also probably untrue. An almost identical story is told about another great Edo entrepreneur, Kawamura Zuiken (1617–1699), supposed to have done the very same thing in 1657.

In any case, Kinokuniya Bunzaemon used his wealth – whatever its source – as a lumber merchant. and grew increasingly wealthy and powerful, mainly because of his excellent contacts with the shogunate, for which he was official purveyor. Through his shogunal contacts, for instance, Kinokuniya secured exclusive rights to supply building materials – the best cypress wood money could buy – for the construction of the main halls of the Kan'eiji temple in Ueno, soon to be the largest temple in Edo.

But Kinokuniya Bunzaemon was arguably more famous for his incredibly extravagant pleasures in the licensed quarters of Yoshiwara. Around 1698 he was said to have rented the entire Yoshiwara twice for private parties, at a reputed cost of 2,300 *ryô* of gold per night. He also ransomed the most famous courtesan of the time, Kichô of the Miuraya. His residence in Hatchôbori was said to have been as large as an entire town block, and all tatami mats were reputed to be changed every day – a fantastically extravagant gesture involving the employment of seven tatami-makers – so that a guest never

had to sit on the same tatami twice. During the Setsubun festival, when the Edokko threw roasted soy beans inside and outside his home to keep evil spirits away, Kinokuniya Bunzaemon instead scattered gold coins for the same purpose.

Unfortunately, Kinokuniya Bunzaemon's fortune did not last longer than his shogunal connections. The death of the fifth shôgun, Tokugawa Tsunayoshi (1646–1709, r. 1680–1709), led to the downfall of the shôgun's favourites and Kinokuniya's main patrons, Yanagisawa Yoshiyasu (1658–1714) in 1709 and Ogiwara Shigehide (1658–1713) in 1712. By 1710 Kinokuniya Bunzaemon was reduced to living in a small hut, having spent his vast fortune on numerous excesses.

There were good reasons why wood was the primary building material in Edo. Wood was not only easy to work, it was also more pliable than other building materials, something that made houses somewhat more resistant to earthquakes and strong winds. Although major earthquakes in Edo always killed numerous people and caused much destruction, this was usually from the secondary fires rather than the destructive power of the earthquakes themselves. Like houses in South-East Asia, the Japanese house depended on its skeletal framework of interconnecting, joined columns and beams to ride out an earthquake. Walls were fitted between the columns and did not bear any load. A wall could be either a thin, sliding lattice door, or alternatively, made of bamboo layered between the columns as laths, connected with straw rope, and covered with mud and plaster (see below).

Wood was of course not the only material used in construction. Clay, for instance, was baked into roof tiles. A tiled roof (*kawarabuki*) was the most expensive kind, so this material was only used in the homes of wealthy families. However, because of the risk of fire, Edo – like many European medieval cities – forbade the use of straw- and reed-thatched roofs. This rule was enforced beginning with the first great fire of 1601. If a family was unable to afford a tile roof, then small strips of wood were used instead of tiles, more of which will be said below.

Wealthy Edokko enjoyed displaying their wealth. However, the shogunate often imposed restrictions on the ways commoners were allowed to show off. One safe way was to use the decoration of one's roof as a status symbol. As the roof was visible even from a distance, wealthy Edokko sometimes competed in the decoration of their expensive tile roofs. The first commoner to use tiles in Edo, the story goes, was a certain Takiyama Yajibei. To save money but still make himself conspicuous, he put tiles only on the side of the roof facing the street; the rest of the roof being covered merely by wood shingles. Edokko therefore called him 'Yajibei the Half-Tiled'.

The most conspicuous part of a tile roof was naturally the ridge. In addition, the ridge-end tiles also had a religious function, for it was believed that they could ward off evil spirits from the house. To accomplish this purpose, ridge-end tiles were usually moulded into grotesque demonic figures, called *onigawara* ('demon tiles'). Edo plasterers further emphasised these artistic tiles by applying many additional coats of plaster on their edges and backs. Sometimes this padding made the tile so thick that it was 30 cm higher than the other tiles. Such an end tile was known as *kagemori*.

Despite such additions, a rich man's house was very similar in style to those of less wealthy people. Only the size (most importantly) and choice of materials made a real difference.

As the width of the average building site in Edo was limited, town houses tended to follow deep, rectangular plans. The merchant's house basically consisted of a row of three rooms on each floor, and was never higher than two stories. The room closest to the road was known as *mise*, the store front, and here goods were displayed or business discussions held. The middle room was used for receiving visitors and also served as an office. A wealthy merchant conducted his business there, perhaps reserving it solely for business transactions. In this office he sat inside a wooden rail, to keep his desk and ledgers secure from the prying eyes of guests and business associates.

The rear room usually faced a small garden, or at least a backyard. Entry to the backyard was commonly provided through the earthen-floored kitchen area. Although the rear room often had a *tokonoma*, this was the room used for the daily activities of the family. The second floor, if any, was not much used. If the house had a second floor, the section facing the road usually had such a low roof that it had to be used merely for storage purposes. Any usable room was almost invariably located at the rear, facing the garden or backyard.

Openings in the exterior wall of the house were closed by a set of outer sliding wooden doors, as well as a similar set of inner sliding doors of latticework and translucent paper (*shôji*). Inside the house, the intervals between columns were partitioned off by similar latticework doors or panelled doors covered with heavy paper (*fusuma*). These doors were known as *tategu* ('vertical fittings').

Nails (*kugi*) used for building purposes were made by blacksmiths, or sometimes by farmers or poor samurai who manufactured them as a side business. Any old, worn-out iron tool could be used as raw material, and farming spades and hoes were especially common.

Yet another useful construction material was bamboo. This material was used for fences, poles, and masts. If the nodal divisions were removed, bamboo also made excellent water pipes. The narrow end of one piece of bamboo could be pushed into the wider end of the next.

Tatami, rectangular mats of thick straw covered with a soft surface of finely woven rush, were in common use since the end of the fifteenth century. They were made in standard sizes (one *ken* by half a *ken*, or about 176×88 cm in Edo – the Edo *ken* being shorter than in other parts of the country) – and about six centimetres thick). As tatami mats generally covered the floor completely, the tatami mat soon became a measure of area. As the length of each mat was twice as long as it was broad, two mats placed together made a square, each side measuring one *ken*. This area was known as a *tsubo*, and remains the standard measure of both houses and land to this day.[5]

5 The *ken* was different in different parts of Japan, and although the *tsubo* nowadays is nationally defined, tatami sizes remain different in different regions, and vary even between apartment buildings and individual houses, being smaller in the former.

Fig. 194. Several rows of warehouses (*kura*) next to a port. The tower is a fire-lookout tower (*hinomi*).

The home of a samurai of high rank or a wealthy merchant generally consisted of a number of buildings. The compound generally included separate warehouses, usually located behind the main building. Most warehouses were specially designed to protect merchandise against the frequent fires of Edo. Such a warehouse (*kura*) was very costly to build, but might, unlike the ordinary house, last a long time. The warehouse was of a distinctive shape and colour (Fig. 194). First, although constructed from a wood frame packed with clay and plaster, it was always covered with a coating of white plaster as much as 30 cm thick, prepared from a mixture of chalk and powdered seashells, to make it fire-resistant. Second, the doors and windows were designed according to the same principles as a modern safe. There was accordingly virtually no chance that any sparks of the fire would enter through gaps in the door- or window-frames. Finally, the entrance usually included three sets of doors. The first were folding double doors, which opened to both sides. The second was a single sliding door (*urajirodo*) that served as a quick fire door in case of only a minor fire. This door consisted of a solid panel of wood coated with plaster. Many grooves were cut in the wooden panel to hold the heavy coating of plaster, which completely covered it. Finally, the last door was a screen door used for ventilation purposes only. The doors were also supposed to protect against theft and therefore were heavily plated with sheets of iron and outfitted with robust bolts and sturdy padlocks.

It was customary to build square hooks (*orekugi*) into the thick walls of the warehouse (Fig. 195). These hooks had long bases driven into the wooden structure of the building, so they were quite sturdy. In Edo, but not elsewhere, each hook connected with the wall through a semi-globular lump of plaster (*tsubu*), popularly known as 'woman's breast' (*oppai*) because of its shape. The uses of these hooks may have been several, but one explanation may be found in an Edo period illustration. There a worker is seen busy at work on the wall of a warehouse threatened by fire. He is sealing up the windows of the warehouse, using sealing paste or liquid plaster contained in a tub hung from one of the hooks. The same method is described by Siebold, so it may have been the most common purpose for these hooks. Other possible uses were to hold scaffolds around the walls in case of repair, or, possibly, to hang wooden covers to protect the plaster coating of the warehouse.

Warehouses of this type are still frequently seen in the older parts of Tôkyô. Some of them were also used as combination store–residences, especially by the end of the Edo period and after. The majority were white, but some were painted black.

Fig. 195. A plasterer at work on a warehouse. To his left is a square hook (*orekugi*) set in what was popularly known as a 'woman's breast' (*oppai*).

The Tenant's Apartment

Not many Edokko actually owned their houses. Not only poor workers but also reasonably successful shopkeepers more commonly rented. The land, and the buildings, were generally controlled by wealthy merchants, who

had often made their fortunes thanks to good shogunal connections. In fact, most of Edo was owned by the shogunate, and citizens had only the right, upon securing permission, to build, buy, or sell a house on a piece of national land, or to rent it to tenants.[6]

As the manager of a tenement had legal responsibility for the conduct of his tenants, he naturally was very powerful. It was not only customary for him to receive a share of the rents from the owner of the building (about three to five percent) and the money given by farmers for the night soil from the communal lavatories, used as fertiliser, but he also felt entitled to a substantial gratuity, nowadays known in English as 'key money' (although the usual Japanese term is *reikin* or 'thank money'), which all new tenants had to pay to initiate their residence.[7]

While the great merchant houses and principal shops were built facing the main streets, the tenement house (*nagaya*, 'long roof' or 'rowhouse'), and other simple dwelling houses of the less well-to-do Edokko, were built in the maze of alleys behind. The most common type of tenement house was perhaps the 'split rowhouse' (*munawari nagaya*), divided in half lengthwise with apartments on both sides. These long rowhouses were often known as *ura nagaya* ('rear' *nagaya*) as they were located behind the houses facing the street. There were also a few *omote nagaya* ('front' *nagaya*), so named as they faced the main street.

The tenement rowhouse was a wood framed, one-storey affair, divided into separate apartments, each with its own entrance. It typically lodged up to 10 families, with a well or water pipe and a washing space for common use. A tenement house was built of the cheapest materials. The individual apartment had a frontage of nine *shaku*, that is, 1½ *ken* (2.6 m) and a depth of two *ken* (3.5 m). It was therefore commonly known as a *kushaku niken* (nine *shaku* by two ken) dwelling. It had only two small rooms, one a 4½ tatami mat room (just above seven square metres) with a closet, and the other actually an entrance space, open to the street, which also served as a small earthen-floored kitchen (*doma*). This kitchen occupied less than two and a half square metres. Total floor space was less than 10 square metres, or three *tsubo*.

Since fires were so common in Edo, tenement houses were not regarded as worth building in the costly way used for the fire-protected storehouses. The common people therefore lived in cheap houses that could easily be rebuilt after burning down. The cheapest kind of roof available was the shingled roof (*kokerabuki*). Thin planks of split cedar were nailed to the roof board, overlapping each other. This work could be done at great speed.

6 Detailed city maps still note the family name of the owner of each piece of land, just as in Edo.

7 In modern Japan, the manager or owner of a rented apartment or house is no longer legally responsible for the tenants. Nonetheless, key money usually equals several months' rent, so it is a very substantial addition to the income of the owner. It also serves to discourage tenants from moving, as any other landlord would charge yet another key money payment. A lease is usually valid for two years and after this another key money payment (typically smaller) is required to extend the contract.

Fig. 196. A roofer busy finishing a shingled roof. He is sitting on a straw bundle, and next to him is a package of thin planks.

Indeed, the fast, light rhythm of nailing and the speed of tenement construction ensured that the nickname *tontonbuki*, an onomatopoeic word, stuck as the informal name for this type of roof (Fig. 196).

Stone-laid roofs were also common, with flat stones used to prevent the thin shingles from being blown away. This produced an interesting sight, with row upon row of flat stones atop the roof. The stones were sometimes fastened with cords of woven straw.[8]

Not all walls were of the light, sliding variety. In the tenements, it was common to build lath and plaster walls, called *komaikabe*, between the structural columns. The procedure was as follows. First, narrow strips of bamboo were tied together with straw rope to form a grid the size of the wall to be built. This lath was then nailed to the top and bottom bars of the wall. It was then coated, first on one side only, with mud mixed with chopped rice straw. The straw prevented the coating from cracking when dried. After this side had dried completely, the other side was treated in the same way.[9]

Komaikabe were common in tenements because these walls were cheap to make and yet the pliancy of the bamboo laths gave the structure flexibility in adjusting to shocks and distortions, such as the frequent earthquakes. However, this type of wall was rather ineffective for purposes of sound insulation. It was accordingly difficult to keep secrets in downtown Edo, at least in the crowded tenements.

Tenants knew everything about each other, just as in the old village from which they may have originally come. Although inconvenient for the slightly eccentric or merely different, this feature of Edo life contributed at its best to a sense of community and spirit of cooperation known as *shitamachi katagi* ('downtown character'). People were supposed to help each other, and if they did not, the law still often made them responsible for each other's actions.

Some tenants ran small-scale trades out of their tenement apartments, such as a cheap sweets shop (*dagashiya*), or a copper-smithy (*dokoya*). Coppersmiths maintained small workshops where they made necessary utensils such as kettles. Later, pans, pots, tracks for sliding doors, and gutters were also made of copper.[10]

8 Tenement houses only began to be roofed with tiles in the Meiji period.

9 Walls are no longer made in this fashion in modern Japan. However, since this type of wall is regarded as indispensable to a Japanese-style house or apartment, modern building materials are employed in such a way as to ensure the overall impression of colour and texture of a lath and plaster wall.

10 After the Edo period, tin and galvanised iron replaced copper for many of these purposes, and the coppersmiths had to become tinsmiths.

Many other craftsmen also ran their trades from tenements. Although the space was small, working space was adequate, especially as the Japanese craftsman worked sitting on the floor rather than on a stool or at a bench.

Aside from this, the methods used by the craftsmen of old Japan were often quite similar to those used in other countries, including those of Europe. As in South-East Asia, however, the craftsman's sitting position enabled him to use his feet to hold the object in position while he worked on it. Another difference from Europe was that the saw and the plane of the carpenter worked on the pulling rather than the pushing stroke. Instead of chalk, ink was used to draw plumb lines and other guide marks. A line wetted with ink was used to draw a straight line.

Not all craftsmen in Edo resided there; there were also itinerant craftsmen. They included certain wood-workers, who travelled around the country with their portable lathes making household utensils. This group managed to avoid official registration until after the Edo period, so as a group, they were completely nebulous. There were also, it should be remembered, itinerant craftsmen involved in the same kinds of work as their counterparts in the towns, but instead serving the farming villages, travelling from village to village. In the early years of the Edo period, an itinerant craftsman who could do specialised or highly decorative and elegant work unavailable locally was usually treated as a welcome guest wherever he stayed. This was not only for his skill, but also, maybe more so, for his important role in bringing news from the outside world. With the spread of trade and improvements in communications during the later years of the Edo period, the position of the itinerant craftsman naturally suffered, and many of them were impoverished or had to turn to other occupations.

Fig. 197. A peddler selling *shijimi* shells

The Shop

Shops in Edo thrived, and offered a great variety of commodities for sale, as the reliable and universal use of money in daily life simplified trade and led to brisk commerce (Fig. 197).

The majority of small traders in Edo were peddlers, who lived in rented ordinary tenements and sold their goods by peddling from street to street.[11] Shop-owners formed a large group as well.

11 There are still peddlers on many streets in modern Japan. It is common to hear their characteristic shouts late in the evening, selling anything from baked sweet potatoes (*imo*), corn on the cob, and *râmen* (Chinese wheat flour noodles) to plastic poles for hanging laundry, pots, and pans, and the like. Instead of carrying his goods or walking behind a pushcart (or bicycle), however, today's peddler typically drives a tiny pick-up, the baked potatoes are heated in a charcoal stove on the back, and his characteristic shout is recorded on cassette tape and comes through a loudspeaker. The sweet potato, incidentally, was unknown in the Kantô region for a large part of the Edo period.

Most of them ran what today would be called 'mom-and-pop stores'. Such a shop was typically run by a shopkeeper and his wife, with possibly an older child or apprentice to help them.

A shopkeeper in Edo was required to deal exclusively with one of the wholesale markets of Edo. As he had to buy from the middlemen (*nakagai*) of the wholesale market, the retail price of the goods naturally increased. Early in the period, this was necessitated by the difficulties of long-distance transport for most goods. Later, the system was retained merely as a convenience for the traders and the authorities. In the end, the customers had to pay for the overly complicated system of distribution. As this was the rule for doing business in Edo, the Edokko learned to accept the established distribution system.[12]

The most important part of the Edo shop was naturally the display space facing the street. This store front was closed with *agedo*, removable vertically sliding wooden doors. These typically consisted of two board panels that moved up and down along grooves cut in the door jambs on each side. Inside the shop, above the upper lintel, was a small space to store the pushed-up door panels. The use of *agedo* made it easy for customers to enter. It was also convenient for sales and the handling of commodities. The width of the panels was one *ken* (about 176 cm). If the shop was big, two such doors were used, with the middle jamb removable when the doors were opened. Such a wide frontage (*maedoma keishiki*) shop was naturally most popular among prosperous tradesmen.

In both small and big shops, the customer removed his footwear before stepping up to the tatami-matted main sales-room. There he or she sat down on the matting or on silk cushions. Tea was served, and perhaps tobacco, too. The clerk engaged the customer in light conversation. Only then was the customer expected to turn his attention to the merchandise. Window shopping did not exist, except during markets and fairs. The clerk or an apprentice would bring goods from the storeroom at the customer's request. The big silk shops, such as the Echigoya, consisted in fact of a huge hall, laid with tatami mats, where numerous customers sat, each one served by a clerk.

The store front of a silk shop was hidden behind a dark blue cloth curtain, long enough to reach the ground, held in place at the bottom with stone weights. To provide some light in this otherwise quite dark hall, numerous standing lanterns were positioned among the customers. Clerks and apprentices bustled back and forth from the storerooms. Samples – ready-made pieces of clothing – hung from the ceiling, high above the heads of the

12 The Edo period distribution system survived into the present. Many prices remain artificially high in order to support a large number of middlemen. It is no longer illegal to bypass the established distribution system, but inertia is strong and old habits die hard. Most retail outlets, from tiny corner shops to giant department stores, are supplied by a small number of specialist wholesalers that still tend to be concentrated in certain districts according to the goods they deal in, mostly Shitamachi districts such as Asakusa, Kanda, Nihonbashi, and Akihabara. Only the discount stores opened after the bursting of the 'bubble economy' in the early 1990s ignore the middlemen.

customers, together with many signs informing the customers what was for sale. Large cupboards contained merchandise and samples. At the rear, the cashier and shop manager sat behind a small fence, to keep the accounts safe from the bustle of the crowds.

In 1858 the British writer and sometime diplomat Laurence Oliphant (1829–1888) visited a major silk shop in Edo, perhaps Echigoya.

> The whole of the lower story was open to the street, and looked like a vast hall fifty or sixty yards long by twenty in width, intersected with counters nicely matted, and surrounded by shelves and drawers containing goods; but the largest show-rooms were upstairs. Following obsequious shopmen to the upper story, we were soon seated on a low divan, covered with red cloth, where a train of boys, carrying tea and pipes, made their entry, and presented them to us on their knees … While we are sipping our tea, the whole floor has become strewn with silks, crapes, and embroideries of every description of texture, shade of colour, and brilliancy of pattern.[13]

These large shops were usually quite crowded. That was part of the fun. Everybody was busy, and enjoyed it, too. In contemporary woodblock prints the largest shops, such as Echigoya, indeed resemble more the spacious interiors of major temples than shops.

Upper-class ladies did not deign to visit shops. Clerks from the big silk stores instead visited them, bringing the desired merchandise, either in the form of samples or as goods.

An area in front of a shop reaching out half a *ken* (88 cm) into the street could be used for commercial purposes. In return, the owner was responsible for keeping this space clean.[14]

Money in the shop was invariably kept in a special coin box (*zenibako*, named after the copper coin called *zeni*), made of hard and heavy wood such as oak or zelkova. The *zenibako* was often treated as a kind of portable safe.

Really small shops, such as those run from a rented tenement, never stored much merchandise. Instead the owner or his wife went to a wholesaler every morning to buy enough to sell that day. Many bigger shops also operated on this principle. The distribution system was paramount for these traders, not only because of the regulations, but also because of their limited storage space and the risk of fire and spoilage from insects or weather. There were no insurance companies in Edo period Japan.

13 Oliphant, *Narrative* 2, pp.136–7.

14 In modern Japan, too, such a space is customarily used for commercial displays. Cleaning and snow removal remains the responsibility of the house owner. Edo-style shops were built and remained in use well into the Meiji and Taishô periods, and a few remain even today. Small shops no longer use the wooden *agedo*, instead relying upon the modern counterpart, roll-up metal shutters.

Water Supply

Edo enjoyed an unusually well-developed water supply system, with many wells and water pipes running under all important streets. The water was drawn from distant rivers, chiefly the Kandagawa and Tamagawa, and moved into Edo through six aqueducts (*jôsui*). The aqueducts were generally subterranean. Early ones existed already during the Kan'ei year period (1624–1645). The main parts of the aqueduct system were, however, built during the second half of the seventeenth century.

The most important was the Tamagawa aqueduct (Tamagawa Jôsui), planned in 1652 and built during 1653–1654. It diverted water from the Tamagawa River across the Musashino plain and into Edo Castle, whence the water continued to supply the Kôjimachi, Yotsuya (terminus of the aqueduct), Toranomon, Tsukiji, Hatchôbori, and Kyôbashi. The Tamagawa system lasted throughout the Edo period, and indeed remained in use until 1965.

The Mita aqueduct supplied water to Osaki, Shiba, and Takanawa, that is, the southern parts of Edo. It was built as an extension of the Tamagawa system.

The Honjo system, completed in 1659, was the only one of the six aqueducts that supplied water to the east side of the Sumida River. From Saitama it supplied Adachi, Katsushika, and Honjo within the limits of Edo (now Sumida Ward). The Honjo aqueduct was discontinued by order of the shogunate at the beginning of the eighteenth century. After all, the districts east of the Sumida River were part of Edo only to a limited extent.

The Kanda aqueduct was, together with the Tamagawa aqueduct, the only one that lasted throughout the Edo period. This was also the earliest of the aqueducts, built by order of Tokugawa Ieyasu. Construction began in the late sixteenth century. It extended from Inokashira Pond to Sekiguchi through the Takaido, Nakano, and Yodobashi, supplying water to Kanda, Nihonbashi, and Kyôbashi until as late as 1900. Its length was approximately 17 km.

The Aoyama aqueduct, completed in 1660, served as relief to the Tamagawa system. It supplied Yotsuya, Kôjimachi, Akasaka, Aoyama, Azabu, and Shiba.

The last aqueduct was the Senkawa system, completed in 1696. It mainly supplied Koishikawa Goten, Yushima Seidô, and the temples Kan'eiji and Sensôji, that is, the area north of the region supplied by the Kanda system. Whatever water remained went to Hongô, Yushima, and Asakusa. The Senkawa aqueduct was the northernmost of the water supply systems.

The aqueducts were elaborate constructions, as can be seen in old woodblock prints (Fig. 198). Great care was taken so that the aqueduct water would not be contaminated at junctions in the system. Advanced techniques were used, including underground channels that pierced through rock for as long as 750 m using a technique borrowed from copper mining. Indeed, a water supply tunnel built during the period 1666–1672 in nearby Hakone (on the border of Sagami province, in present-day Kanagawa Prefecture), the Hakone Jôsui, bored through no less than 1,280 m of rock. From 1670, it fed water from Lake Hakone towards Edo. This proved important for the cultivation of vegetables for the Edokko, most of which came from the western agricultural suburbs.

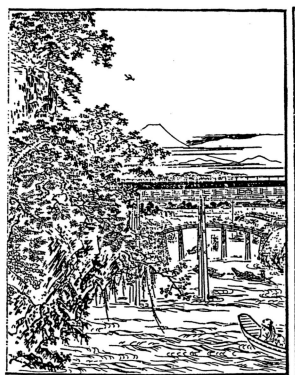

Other improvements were designed to enhance the beauty of Edo. In 1737, the Asukayama and Koganei banks of the Tamagawa aqueduct were planted with cherry trees, and these soon became favoured recreational spots for the Edokko. The Edokko felt great pride in front of his country cousins as he could claim to have been 'cleaned at birth in the water from the conduit pipes of the aqueduct.' Only real Edokko could claim this, as their provincial relatives did not have any similar system.

Fig. 198. The Kanda aqueduct (*Kanda-jôsui*), as seen from the Ochanomizu-Suidôbashi area

It was, however, also fairly common to use wells (Fig. 199). Although large houses might have a well in the garden, the inhabitants of tenements and smaller houses had to go to the common neighbourhood well, which naturally was a centre of social life and gossip, especially among the women. On reclaimed land, the well water was seldom of good quality, being murky and unpalatable. In other areas, wells were dug but no water was found. People living there instead bought water from water sellers.

Water sellers took water from the Kandagawa or Tamagawa and peddled it on the streets in water-poor areas. These water sellers were a common sight, making their rounds with buckets hanging from poles across their shoulders. A wooden float in each bucket served as a simple but efficient device to prevent the water from spilling out. It was even common to take water from these rivers and bring it by boat across the Sumida River to sell to the Edokko east of the Sumida.

Where wells were used, the entire community would gather to clean the well every year on the seventh day of the Seventh Month. This was the day of the popular festival known as *Tanabata*. The inside, outside, and bottom of

Fig. 199 Workers at a well (the square structure). They have removed most of their clothes but not their cotton towels (*tenugui*), tied around the head.

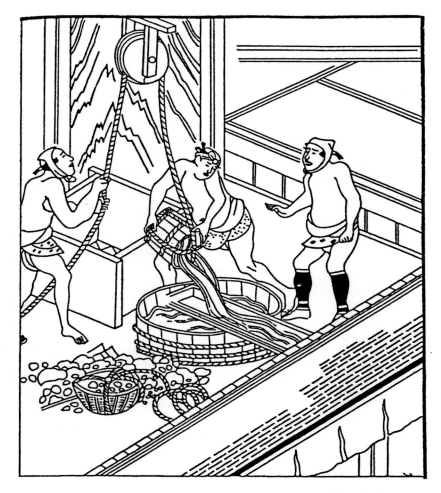

each well was cleaned. In nearby houses, tea was prepared for the workmen. Cleaning was a necessary part of well maintenance, and stories from the period tell of how the dirty water was scooped out, the bottom of the well scraped – there was usually planking all the way down to the actual spring – and how unexpected objects were found in the well, discarded or dropped by people in the neighbourhood. Newts and other animals were also removed.

Reservoirs were also used to supply Edo with water. One of them was, as its name implies, located in what is now the Tameike ('reservoir') district of central Tôkyô.

Cooking and the Kitchen

The kitchen was invariably located on the ground floor of the house, in the area with an earthen floor. This was a characteristic the town house had inherited from the country house (Fig. 200). It was therefore possible to enter directly from the street without removing one's footgear, a fact that undoubtedly facilitated deliveries.

The kitchen in the ordinary Edo home was very small. The wife would, indeed could, only cook basic food such as rice, *miso* soup, and perhaps some

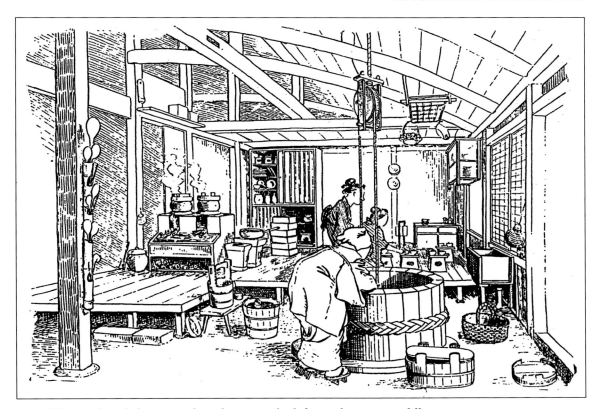

Fig. 200. A country kitchen. Rice is being steamed in two *kama* (handleless cooking pots for rice) on the cooking oven (*kamado*).

vegetables. Other dishes were bought precooked from shops or peddlers. Peddlers were in any case such a frequent sight that there was hardly ever any need to wait for food if one was hungry.

Thus the average kitchen did not require much space or many cooking utensils. A cooking stove (*kamado*) was built up of mortar reinforced with straw in a corner of the earthen floor. There the Edokko burned wood, later charcoal, and boiled water or cooked rice in an iron pot (coal existed but was not used for these purposes). The stove had holes to accommodate the metal pots used for cooking (Fig. 201). Cinders were kept in a nearby jar with a lid, as they could later be used as charcoal.

Two tools indispensable in every Edo kitchen were the bamboo blowpipe (*hifukidake*) and the cinder rake (*komasarae*). The bamboo blowpipe (Fig. 202) was a very simple device, but it fulfilled its purpose admirably. It was merely a stem of bamboo with a node at one end. A hole was made in the node so that the user could blow through to fan the flame and thereby increase the heat. The cinder rake was also made of bamboo and was used to gather cinders in the stove or to level ashes in the *hibachi* brazier (see 'heating', below). With the brazier, iron implements like large chopsticks or pokers (*hibashi*) were also used, especially to handle the charcoal.

To admit air and light, as well as to release smoke from the stove, an opening or skylight (*tenmado*) was frequently made in the roof of the kitchen. This opening was then ingeniously fitted with a sliding shutter, operated by a bamboo stick tied to it, so that the window could be closed or opened from inside the house.

Fig. 201. Three women having a smoke and some tea next to the stove

Fig. 202. A man using the bamboo blowpipe (*hifukidake*) to fan the fire. On the stove, a *kama* (the handleless cooking pot for rice) is prominent.

Fig. 203. Cooking on the portable cooking stove. In the background, a woman is busy fanning a fire with a bamboo blowpipe.

There was no real sink in the typical Edo kitchen. After all, most washing was done at the communal well. Water was simply carried from the well and kept in a large jar or tub. A small wooden sink for washing vegetables or chopping fish was sometimes used, however. High-quality knives were available, in some cases crafted with almost as much care as the razor-sharp swords of the samurai.

The kitchen stove was only used for simple dishes. For major cooking, such as grilling a fish, a portable cooking stove (*shichirin*) was used (Fig. 203). The portable stove was simple but cleverly designed, and used for cooking with charcoal. A grid, to put burning charcoal on, was set halfway down the hole in the stove. An opening for air was cut at the bottom of the stove, and this could be opened or closed to control the air circulation, making it possible to get either a high or a slow fire out of the stove. It was frequently, in fact almost invariably, used outside the house. This was not only to get more space. Serious cooking produced lots of smoke and was a fire hazard. The portable cooking stove first appeared in the cities of Japan in the late seventeenth or early eighteenth century. The mass production of charcoal of the eighteenth century ensured that this useful stove soon spread all over Japan. It was especially useful in the cities, as the charcoal-burning portable stove was both safer and more efficient than the old wood-burning furnace. For safety reasons, many tenement managers required their tenants to use charcoal instead of firewood.

In a large kitchen, such as in a restaurant or in a wealthy household, there was also a boarded area at the higher, ordinary floor level. This area led on

Fig. 204. An earthenware burner (*katori*)

to the living area of the house, and on this the cook sat, perhaps on a thin rush or straw mat, while he was preparing the dishes.

Professional cooks were nearly always men. They had to train as apprentices for a long time before they were allowed to possess a cook's knife, a symbol of their entry into the cook's profession. The knife and the cutting board were the basic tools in Japanese cooking.

Other kitchen implements included a variety of wooden, lacquer, and porcelain containers and jars to keep *miso* (bean paste), salt, and soy sauce; basketwork sieves; cone-shaped mortars for crushing and mashing beans, vegetables or other foodstuff; pestles, a number of bamboo baskets; several bowls and plates; an earthenware pan used for parching beans or as a casserole for cooking fish and vegetables; and a tray for each diner. Tables in the modern sense of the word were not used when eating, so large trays were used as individual tables.[15]

Flies and mosquitoes were two common nuisances during the long and hot summers of Edo. Various implements were designed to combat these pests. Most common were small earthenware burners (*katori*) of various shapes (Fig. 204). A pig-shaped type may have been most popular. In these the Edokko burned green leaves or chips of wood, trusting that the resulting smoke would drive away the insects. To protect food from flies, less smoky and pungent materials were burned. Used tea leaves were quite popular for this purpose. Other protection against flies was also available. The fly swatter, made of a hemp palm leaf, was obviously a useful tool. As food was particularly vulnerable to flies, food ready to eat was frequently kept in a slatted wooden chest covered with gauze (a *haichô*, Fig. 205).

Heating

Japanese town houses were not very comfortable. Not only was there no privacy and a considerable risk of fire, the houses were also cold whenever the temperature fell. Insidious draughts pierced through innumerable chinks and openings. The houses were frequently very dark, especially when heavy rain forced the inhabitants to shut the exterior wooden shutters (*amado*) on one or more sides of the house.

15 Similar trays remain frequently seen in contemporary Tôkyô restaurants, where they seem an integral component of the Japanese cuisine. Besides, trays are handy when serving the meal. In modern Japan, most kitchens remain very small, most Tokyoites still prefer to eat out or to buy take-out food rather than cooking at home, and food can still be delivered to one's home.

Fig. 205. A woman removing food ready to eat from a slatted wooden chest covered with gauze (*haichô*).

The only heating available in Edo was the personal charcoal stove or brazier (*hibachi*, Fig. 206). This device had been used by the nobility since about the tenth century. Charcoal was a luxury available only to the privileged until the seventeenth or eighteenth century, but then it came to be produced in abundance and accordingly was brought within reach of most people, especially in the cities.

The *hibachi* was a wooden box, lined with metal or clay. It combined heating with many other functions. Its square, massive shape made it very useful for life in a crowded city such as Edo. The most common type may have been the rectangular *nagahibachi* ('long brazier'). This type included a copper-covered furnace, in the ashes of which the burning charcoal was kept, over which an iron kettle was placed on a *gotoku*, a tripod stand for holding the kettle. In addition to this, a water container made of copper, known as *dôko*, was made to fit into the small space by the fire and buried in the ashes, so that hot water was always available, for instance for heating a sake bottle. On one side and at the bottom of the *nagahibachi* drawers were fitted into the wooden box, to store and dehumidify items by the moderate but constant heat of the burning charcoal. Goods commonly stored there included tobacco, candies, and *nori* (dried seaweed). Finally, the top of the *nagahibachi* was used as a personal table. As the seat facing the drawers was the best seat, this position was generally reserved for the head of the family.[16]

16 In modern Japan, central heating remains unavailable in most houses and apartments. Although the *hibachi* is no longer in common use, the heating systems work fundamentally according

Fig. 206. A doctor of medicine sitting next to a brazier (*hibachi*)

Tools indispensable for the use of such a brazier were the previously mentioned bamboo blowpipe (*hifukidake*), used to fan the flame, the cinder rake (*komasarae*), and the iron implements like large chopsticks or pokers (*hibashi*), used to handle the charcoal (Fig. 207). A *nagahibachi* was also a great help when making roasted tea, the aromatic brown tea still enjoyed in Japan. A ring made of a thin strip of wood, covered with paper, was used as a pan (*hôroku*) to slowly heat the tea leaves. Such a pan was of course easily broken, but it was as easily repaired with new paper. An earthenware version of the same tool was used for parching beans or as a casserole for cooking fish and vegetables. Both these types of pans were used in almost every Edo household.[17]

In Edo, fire was struck with rock and steel. A small wooden tinderbox (*hokuchibako*), kept in all Edo kitchens, was used for this purpose. This box contained tinder, several thin pieces of cedar or pine wood, a piece of quartz (not flint) and a small piece of steel inlaid in a wooden handle to strike against the quartz. The sparks thus produced were caught by the flammable tinder. Tinder generally consisted of fried fuzzy flowers of cattail or mallow, mixed with a pinch of gunpowder. Finally, the fire was kindled with the thin pieces of wood. These were also prepared to facilitate the striking of fire, being partially coated with sulphur at one end.

to the same principles. Personal stoves or space heaters, electric or gas, remain ubiquitous. Although air conditioning systems that also serve as heaters are increasing in number, personal stoves remain more common.

17 Nowadays such pans have all but disappeared in Japanese kitchens, replaced since the Meiji period with iron frying pans. The cheap paper pan remains in use, but in a surprising context. In older amusement parks and during festivals, the popular children's game known as *kingyo sukui* uses such a paper pan to catch small goldfish. If the child can catch one or more fish, he or she may keep his catch. To succeed is not easy, since the paper easily tears when it comes into contact with water. Only skill and practise can win a catch.

愛
人
乃
ほ
つ
に
入
る
や
泉
さ
ら
代
々
簑

Fig. 207. A woman moving the charcoal in her brazier with pokers (*hibashi*)

Fig. 208. The *kotatsu*, a table-like framework placed over a deep sunken grate in which a slow charcoal fire is kindled. Here partially covered with a quilt.

Fig. 209. Two ladies warming themselves under the *kotatsu*, one smoking and the other reading a popular novel

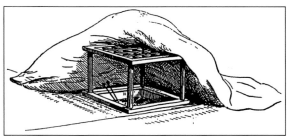

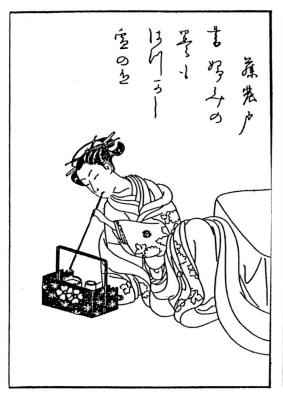

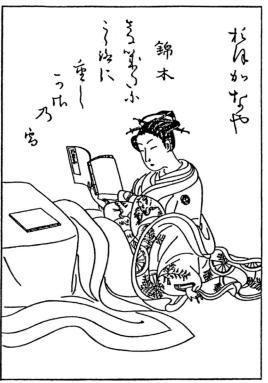

The piece of quartz and steel were used also for another purpose. It was commonly believed that the striking of sparks above a person drove away bad luck – this was in fact an ancient cleansing and propitiatory ritual. Men with dangerous professions, such as policemen, often had their wives strike sparks after them when they went to work.

A variant of the tinderbox was used in places such as boats and taverns. This was the *hinawabako*, or 'match cord box'. It was a slightly bigger box with drawers, containing the ordinary quartz and steel, and a match cord called a *hinawa*, which was used to light tobacco.

The charcoal brazier was useful primarily for warming one's hands and face. Another device was used for warming one's body. This was the *kotatsu*, a table-like framework placed over the charcoal brazier, or in some houses, a deep sunken grate in which a slow charcoal fire was kindled, the top of which was level with the mats (Fig. 208). The *kotatsu* frame was covered with a quilt large enough to spread over the legs of those who sat at it. Hot air then worked its way up through the clothing. It was common to put one's hands underneath the quilt to warm them further (Fig. 209). The *kotatsu* was usually started up on the first day of the Boar, that is, the twelfth, of the Tenth Month. It remained in use throughout the cold season.[18]

At night, one could sleep at the *kotatsu* and in addition, foot warmers could be used, in which glowing charcoal was kept. Glowing charcoal could also be kept in a special container, which was placed in the bosom of one's kimono.[19]

The warmest part of the house was the kitchen, thanks to the cooking fire. In country farmhouses, laid out differently to the urban town house, the kitchen was thus the centre of daily life in winter. In the towns and cities, however, the kitchen was usually not close enough to the living room to provide adequate heat. The status-conscious Edokko did not want to be seen in his humble kitchen. Instead he endured the cold.

Lighting

The Edokko was always very busy, either with work or entertainment. There was therefore a considerable need to light the house after dark. In the second half of the Edo period, with the spread of the cultivation of wax trees (*haji*), candles became common. These had wicks usually of thick, hard twisted paper, or later, cotton or rush. Candles were sometimes put in candle-sticks and sometimes in lanterns (Fig. 210).

In the earlier days, however, wax was scarce, as the wax tree which provided the raw material for most candles was not under cultivation. The Portuguese writer João Rodrigues (*c.* 1561–1633) wrote around 1620 that there was 'a great abundance' of vegetable candle wax in Japan but he may

18 In modern Japan, the *kotatsu* remains in common use, although electricity has replaced charcoal as the source of heat. Otherwise there are no differences in the construction or use of the device.

19 Such containers can still be seen in rural China, but in Japan a high-tech version was developed in 1923: the *Hakukin-kairo* which is a small package that creates heat by means of platinum catalysis.

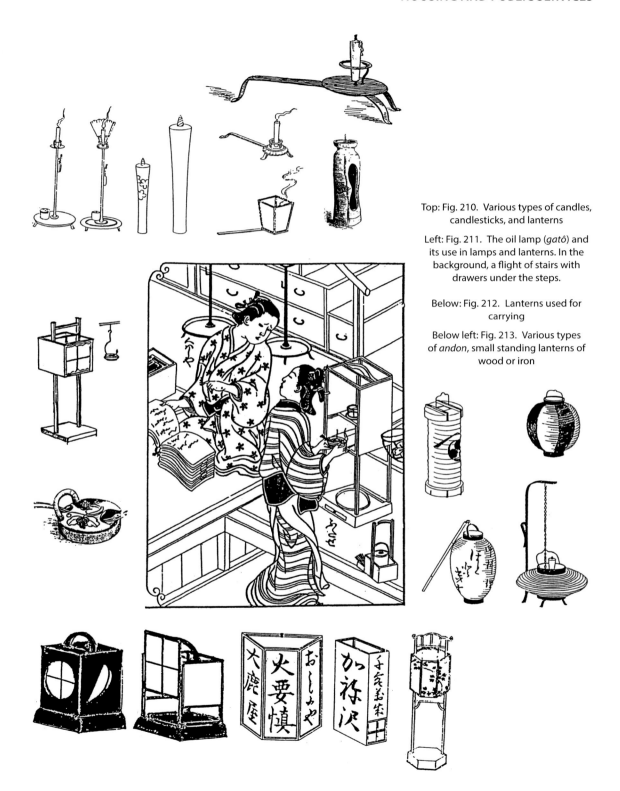

Top: Fig. 210. Various types of candles, candlesticks, and lanterns

Left: Fig. 211. The oil lamp (*gatô*) and its use in lamps and lanterns. In the background, a flight of stairs with drawers under the steps.

Below: Fig. 212. Lanterns used for carrying

Below left: Fig. 213. Various types of *andon*, small standing lanterns of wood or iron

have considered only the noble households.[20] Beeswax was virtually never used. Instead inferior candles of hardened pine resin were sometimes found. They shed only a poor light.

The oil lamp (*gatô*, Fig. 211) was then the most common source of lighting, and remained in widespread use even after the introduction of European-type candles because it was inexpensive. It consisted of a small, shallow round basin filled with fish oil with a rush, cotton, or hemp wick floating in it and hanging over the side, plus a stand to hold the basin. The cheap, unglazed earthenware of which it was made was called Imado-*yaki* (Imado-ware), as it was made at Imado, north of Asakusa. Camellia seed oil, sesame oil, and other vegetable oils were also used in oil lamps.

Oil was generally sold by itinerant oil-peddlers. They carried various types of oil, each one for a different use, in a number of tubs. The peddler used a square measuring-box to determine the proper quantity to be sold. So as not to drop or waste any oil, he would use a tool that functioned as both funnel and sieve when pouring.

Lanterns were also used for lighting purposes. These were made of paper set in a wooden framework. A portable lantern (Fig. 212) employed candles as a light source, while stationary ones might use either oil lamps or candles. The most common light source for indoor use was the *andon*, a small standing lantern of wood or iron (Fig. 213). Such a lantern usually rested on four legs, or was completely box-shaped. Officials out on business employed servants to light their path and announce their presence by carrying folding spherical or cylindrical lanterns bearing a phrase such as 'official business' or the crest of the samurai house to which the official belonged.

Larger lanterns were used at festivals to decorate shrines and temples. Stationary lanterns were used outside shops to display the name of the shop or advertise the type of goods sold, with the text either written in black on white paper, or in silhouette. Night festivals and processions might be lit by flaring torches. Bonfires might also be used, in the Shintô religion often thought to harbour the spirit of a deity.

Food, Drink, and Tobacco

Meals, Mealtimes, and Table Manners
Both Tokugawa Ieyasu and his son Hidetada repeatedly advocated simple manners for their men as well as visiting *daimyô* – and went so far as following the recommendations themselves. As a result, in the early Edo period the food of the warrior class did not differ significantly from that of townsmen.

Although rustic country folk often had three meals a day (in the morning, at midday, and in the early evening) when not starving, the Edokko was too busy to spend time for the midday meal. The Edokko instead typically had only two meals, at 10:00 a.m. and at about 5:00 p.m., even though some Edokko took up the habit of the midday meal in the mid-Edo period. This

20 João Rodrigues, *This Island of Japon* (Tôkyô: Kodansha, 1973), p.313.

did not mean that they went all day without food, of course. Snacks were eaten frequently, preferably gobbled down standing so as to lose as little time as possible.

The prosperity of the family and the individual's status within the family decided what and how he or she would eat. The head of the family ate together with any important guest, and sometimes with his eldest son. He would be waited on by his wife or daughter-in-law, in wealthy families assisted by maidservants. The wife ate separately, waited upon by her daughter-in-law or else after or while preparing her husband's meal.

The chosen items of the meal reflected not so much the individual taste of the eater but the occasion and the prosperity of the family. The Edokko liked to awe his guests with ridiculously expensive morsels of the most rare types of fish just to show off the fact that he could afford them.

The higher classes, and especially the samurai, also attached great importance to the ceremony and etiquette surrounding food consumption. This was especially true for the serving of sake. Sake was, for instance, served only during the first part of the meal, before rice was served. Rice was brought in only to end the meal. In a private home, the wife or daughter-in-law was responsible for the proper serving of sake as well as food. Sake was brought to the table in small porcelain or lacquer jars. The sake would be warmed in its jar, then poured into each person's cup as it was presented for filling or refilling. The cups were small and rather flat, holding only a very small amount of drink.

To honour a guest, the host passed him his own cup and filled it himself. Good manners required that the guest then returned the compliment in the same way. At a celebration, the same cup thus passed from hand to hand, each person rinsing it in a bowl of water after using it and before offering it to another. As a consequence, it was regarded as an act of rudeness to offer an excessively large cup of sake. However, many old stories show how the culprit of such an act was put to shame when the hero emptied the cup without a second thought, and then returned it – refilled – to his embarrassed host. On more festive and boisterous occasions, such as when a group of men threw a party, it was common that one of them went around the assembly with a full jug and exchanged drinks with all his companions. Afterwards, the merrymakers most commonly attempted to persuade their hostesses, usually courtesans, to drink with them.

When serving the food, the entire meal, except the rice, was brought in on an individual lacquer tray. The tray, about 45 cm square, was fitted with legs so that it served as a low table. The more formal the occasion, the higher number of trays and dishes presented, despite Ieyasu's and Hidetada recommendations. Soups were (and are) consumed partly by drinking from the bowl and partly by the use of chopsticks. Good manners indicated that the chopsticks were to be used for picking morsels out of the soup, but it was and is quite common to simply hold the bowl to one's lips and use the chopsticks to push any non-liquid food into one's mouth.

In most households, the chopsticks were simply put down on the serving tray. In more affluent households, however, small decorated rests on which to place the chopsticks were provided, to avoid soiling either the

tray or the chopsticks. Chopsticks themselves came in different grades of manufacture. Some were made of fine, white, smooth untreated wood, and were as expendable as the single-use wooden chopsticks offered in Japanese restaurants today. These were used by the upper classes and in some well-to-do families when having guests. Such chopsticks were even changed many times during the course of a banquet. Other chopsticks were made for repeated individual use, usually fashioned of lacquered wood but sometimes of ivory or precious metals. A well-prepared traveller carried his own chopsticks with him in a small case when away from home.

Rice was served from a covered container, made of lacquer or wood. From this container, it was ladled into each person's rice bowl. These individual rice bowls were usually made of porcelain. Although good manners, again, indicated that the rice should be picked up with the chopsticks, it was more common to simply use the chopsticks to push the rice into one's mouth. Most people who could afford it would eat at least three heaping bowls of rice. When passing one's bowl for more, good manners required that a grain or two be left in the bowl.

The Japanese word for rice bowl, *chawan*, actually means tea bowl. It was common after the meal to add tea to the bowl, and by drinking gather and consume what was left of the rice.

The meal concluded with some tea. The Edokko usually had no time to rest after his meal. Instead he was expected to return straight to work. A toothpick might be used to clean one's teeth (proper etiquette demanded that one turned aside, and also covered the mouth with one's left hand or a fan while cleaning the teeth). Normal politeness indicated that one should thank his host for the meal.

In poor families, meals were not intended to bring pleasure. The emphasis was to satisfy hunger and the nutrition required to work hard and long hours. Conversation during the meals was considered a waste of working time.

Food and Drink

Tokugawa Ieyasu had recommended his men to eat a mixture of rice and barley as a staple food, and this was the simple fare which he himself had. However, such austere practices changed after his and Hidetada's reigns. In Edo, it was soon said, everybody ate white (polished) rice three times a day. That kind of luxury was envied in the provinces, and the Edokko was very proud of the fact that even poor Edokko ate polished rice. Such rice was more expensive and less nutritious.

Only the people in Edo, Kyôto, and Ôsaka ate white rice. Country people ate barley, millet, or buckwheat, or (if rice was at all available) rice cooked with chopped giant radishes (*daikon*) or sweet potatoes. The Edokko preferred salty pickles with his rice. Because of this diet, the Edokko ate fewer vitamins than the country bumpkin, especially vitamin B1. Vitamin deficiencies and especially beriberi were accordingly common in Edo and indeed known as the 'Edo sickness' (Edo *wazurai*).

The rice stores in Edo not only sold the rice; they also refined it. A 'polished-rice shop' (*tsukigomeya*) bought brown rice (*genmai*) with the hull still on it from wholesalers and milled it to make refined (white) rice

Fig. 214. The *karausu,* a large pounding device operated by a heavy, foot-worked lever

by removing the brown outer skin. To hull or 'polish' the brown rice, they used a round mortar and pestle, or a large pounding device operated by a heavy, foot-operated lever (*karausu*, Fig. 214). In some shops, large numbers of workers (known as *kometsuki* or 'rice polishers') were employed full time for this purpose, working numerous such mortars in an earthen-floored hall (Fig. 215).

Some wholesalers and other major buyers of rice instead employed workers who brought portable pounding machines with them to set up in the street outside.

The three most important ingredients in a Japanese meal, whether in a poor or wealthy family, were rice, *miso* soup, and vegetables. Rice, or whatever cereal concluded the meal, provided the fundamental nutritional value of the meal. In early times and in poor families, it was normally eaten with a certain amount of hull. In later years and in wealthy families, the rice was always eaten polished. The *miso* soup and the vegetables added not only flavour but also some protein and a few vitamins.

Rice substitute was also often used, especially in poor families. This was a mixture of wheat and rice, cooked in the same way as ordinary rice.

The rice was commonly eaten completely by itself. To make the rice easier to eat with chopsticks, sticky rice in which the grains stuck together in a glutinous mass was preferred. Alternatively, small sheets of dried seaweed were served with the rice. These were manipulated with the chopsticks or, in the lower social classes, with one's hands, so that some rice was rolled in each, after which the entire package was brought into the mouth. Rice was also frequently eaten with pickled vegetables, such as the giant radish (daikon). Pickles (*tsukemono*) formed part of the Japanese cuisine since ancient times. The first shops specialising in pickles had already appeared in Edo in the seventeenth century. The daikon is a large white root at least 30 cm long, a staple in Japanese cooking, frequently served raw, chopped and shredded,

Fig. 215. A noisy group of
rice polishers (*kometsuki*)
hard at work

or cooked in a variety of ways. To pickle it, it is steeped in water and rice
bran, which turns it a bright yellow and imparts a distinctive tangy flavour
and aroma. A superior product was made with cucumbers and sake residues.
There were also other types of preserved vegetables, among them the dried
leaves of the daikon.

The vegetables eaten in the Edo period were otherwise more or less
the same as the Japanese eat today, except that the Edokko, of course, did
not have access to imported foreign vegetables (such as the tomato). The
situation was the same with fruits.

Miso is made from soy beans, which are first soaked and then boiled.
Following this, the beans are broken down to a paste and mixed with rice yeast,
salt, and water. They are then left to ferment and mature for up to three years.
There are several regional varieties. The result is a brownish-red, fibrous semi-
solid that is diluted in water to make soup (and in less diluted form to make
sauces or glazes for certain dishes). *Miso* soup was in Edo often, and nowadays
always, served hot in a lacquer bowl fitted with a lid that looks like an inverted
saucer. It was also common to cook it with edible stems or roots, such as those
of the lotus, or vegetables, for instance parsley and celery leaves. Alternatively,
boiled vegetables could be served separately, sometimes with added flavouring
such as bean paste mixed with aromatic seeds.

With the exception of rice, in one form or another, and *miso*, most other
dishes were eaten for basically non-nutritional reasons, such as attractiveness
and appearance, rarity and high cost, seasonal value, or the thirst induced.[21]

In Edo, the most popular meals served at public eateries for commoners
seem to have been, among others, *nameshi* (rice mixed with chopped and

21 In modern Japanese the word 'gourmet' (*gurume*) means a person who eats unusually expensive
and rare foods rather than a person who enjoys and is an excellent judge of fine food and drink.

sautéed green vegetables), *dengaku* (baked soybean curd – *tôfu* – with flavoured *miso* paste), *takenoko meshi* ('bamboo rice', or rice cooked with diced bamboo sprouts), rice with *oden* (a stew of vegetables, roots, bean curd, and fish paste in broth), Nara *chameshi* ('Nara-style tea rice', salted white rice cooked with *sencha* tea poured off before eating), *dojô* (loach – a small freshwater fish – cooked in soy sauce or soup), *soba* (buckwheat noodles), *udon* (wheat flour noodles), and *tenpura* (fish and shellfish deep-fried in a batter of flour, egg, and water). These foods were generally inexpensive. One kind of shellfish, *sazae*, cost 16 *mon* in the 1800s.

Fish was, with the exception of rice and *miso*, the staple food for those who were not destitute. Every species of fish was eaten, and fish formed the main source of animal protein in the Edokko's diet. Merchants operated fleets of fishing vessels off the coasts near Edo. These fleets brought in daily supplies of fresh fish, to be eaten on the same day. It was also common to fish in the rivers, canals, and streams in and around Edo, often but not exclusively by angling.

The most common fish on the serving tray included bonito, sea bream, trout, carp, tuna, salmon, sardines, and sweetfish, the latter a small river fish. Sea bream (*tai*) was considered a fish of good fortune, because of a play on words, and therefore possibly the most prized fish. It could be legally sold only at the Nihonbashi fish market, so that the Castle delegation could get first priority. The German physician Engelbert Kaempfer related how a noble bought two sea bream for the incredible amount of 150 gold *ryô*, as well as a couple of shellfish, which cost another 90 *ryô*. These fish were all presented as a gift to the shôgun. Kaempfer also points out that sea breams, when in season, were never sold at under two gold *ryô* a piece. 'In winter,' he concludes, 'any price is given.'[22] Other white-fleshed fish were also suitable for the shôgun's serving tray. Tuna, sardines, and mackerel were not, however, even though they were eaten by the commoners. And Saikaku points out that sardines, fresh or dried, could be had for as little as one copper *mon* per 14 to 17 of the small fish.

A popular saying about Edo enumerated the city's specialties as 'salmon, bonito, prostitutes disguised as Buddhist nuns, the colour violet, sardines, residences of great lords, leeks, and giant radishes' (*sake, katsuo, bikuni, murasaki, nawa iwashi, daimyô kôji, nebuka, daikon*). Three of these eight specialties were fish.

Sea fish were generally eaten uncooked, cut into fine slices and dipped in soy sauce just as today's *sashimi*, or mixed with green and other vegetables, with vinegar as flavouring. Pieces of sea bream, however, were often boiled and used in *miso* soups, while sweetfish might be grilled. Small fish were dried in the sun and eaten whole. Fish could also be salted. Meaty fish such as bonito could be dried to a hard block of wood-like consistency, from which thin shavings were scraped or planed off. Such shavings were commonly used to flavour other dishes but could also be eaten by themselves. At restaurants, split and charcoal-broiled eel (*kabayaki*) was often served.

22 Kaempfer, *History* 2, p.529.

Originally, eels were not cooked but fermented before eating. From the early eighteenth century, however, grilling became popular and the recipe remains unchanged today. The eel is split open to remove the bones. It is then skewered and broiled over a charcoal fire, being dipped a few times in a thick soy and sake-based basting sauce in the process. It is, naturally, served with rice. Eel was prized as an aphrodisiac, and it also became customary to eat this fish on the day of the Ox during the hottest period of summer (*doyô no ushi no hi*) to give oneself the stamina to overcome the heat.

In the coastal regions of Japan, the lower classes also feasted upon all parts of the whale, which was hunted by fishermen. Even the scraps that remained after the oil had been extracted were eaten, something that occasionally shocked European observers.

Bowls of buckwheat noodles (*soba*), flavoured with vegetables, were in constant demand by hungry workers. Buckwheat apparently originated in north-west China but was already known in Japan during the stone-age Jômon period, cultivated as early as the eighth century, and extensively cultivated since 1382, originally to supplement a food shortage caused by a prolonged and severe drought. At first, *soba* flour mash was rolled into balls to make dumplings. From around the seventeenth century, however, *soba* paste was cut into long, thin noodles and served in street stalls in Ôsaka and Edo. It soon became a favourite meal for the Edokko. Originally, all *soba* noodles were made from pure buckwheat flour (*kisoba*). Buckwheat paste is low on starch, however, so these noodles were not very firm. From the middle of the Edo period, wheat flour, yam paste, or bean curd was therefore added to thicken the buckwheat paste. This *nihachi soba* ('two-eight') contained 20 percent thickener and 80 percent buckwheat.[23] *Udon* or wheat flour noodles have also been made in Japan since the eighth century. These, too, were originally introduced from China.

Tenpura – fish and shellfish dipped in a batter made of flour, egg, and water, and deep-fried in oil – was invented in Edo, although the word itself, which first appeared in the late sixteenth century, seems to have been derived from the old Portuguese word *tempero* ('flavour' or 'to cook'). Early *tenpura* was quite different from the *tenpura* of today. Until the very end of the Edo period, *tenpura* was a snack eaten at street stalls. Fish or shellfish were skewered with bamboo sticks and fried. The customer paid according to the number of bamboo skewers he had used.[24]

Sushi – rice seasoned with vinegar and flavouring and topped with raw fish or vegetables – was a new fashion in Edo, dating from only the early nineteenth century. An older type of sushi (the word derived from *sumeshi*, meaning

23 Modern soba contains a high proportion of thickener, and today noodles containing 70 percent or more buckwheat are called kisoba.

24 In modern-day Japan, such accounting of the bill is still widely used in *kushiyaki* establishments. A similar system to determine payment is used in the modern *kaitenzushi* ('conveyor belt-*sushi*') eateries. There the number of plates used by the customer determines how much he will pay.

sour or vinegared rice), called *oshizushi*, had been developed in western Japan around the fifteenth century. This dish, however, required considerable time to prepare, as it involved packing a rectangular wooden mould with boiled rice, covering it with a layer of raw fish or vegetables and pressing the whole affair with weights. The Edokko were too busy for such things and somebody, probably in downtown Fukagawa or Ryôgoku on the east side of the Sumida River, invented modern sushi by simply rolling a small ball of vinegared rice in one hand and, with the other hand, topping it with a slice of raw fish. *Inarizushi* was a variety *of sushi* consisting of a pouch of fried soybean curd (*tôfu*) stuffed with vinegared rice. The Edo period inarizushi was quite big and normally cut into two when served. *Makizushi*, or *futomaki*, the variety of sushi made by rolling the rice along with other ingredients up in sheets of crisp dried seaweed (*nori*) was also common, although this treat had its origin as a funeral snack. Edo-style sushi was usually packed neatly into thin wooden boxes and sold at festivals, at the theatre, or at street stalls. It did not became restaurant food until after the Edo period.

By the end of the Edo period, types of *sushi* known as *chirashizushi* and *gomokuzushi* or *okoshizushi* appeared. These types consisted of vinegared rice placed in a small bowl instead of squeezed into bite-sized pieces.[25] In Edo, such a dish cost between 100 and 150 *mon*.

Onigiri – balls of cold rice with a pickled plum in the middle to provide a tasty morsel and to keep the rice ball fresh – were also popular, especially in the later years of the Edo period. So were hard-boiled eggs, which were simply peeled and eaten. Box lunches (*bentô*) were used on picnics, and originally appeared for sale to the audience in Kabuki theatres to eat during the play where they were known as 'entr'acte box lunches' (*makunouchi bentô*).

As for drinks, tea was naturally very popular. Tea was known since ancient times. At first, the nobles had drunk it chiefly as medicine. Tea drinking became common in the fourteenth century, however, and from the end of the fifteenth century, everyone drank it.

There are many different types and qualities of Japanese tea. The three main types are *sencha*, *bancha*, and *matcha*. Ordinary green tea (*senjicha*, 'boiled tea', or simply *sencha*) should not be confused with the powdered green tea (*matcha*) used for the elaborate tea ceremony. With ordinary tea, water was at times added again and again until virtually no colour or taste remained. While *sencha* was, and is, made from the soft, young tea leaves from the first batch of a harvest in May or June, *bancha* or coarse tea includes only the large leaves from the second or third batches, picked from August, and is light yellowish brown in colour. The leaves of both types of teas are steamed and dried. Both *sencha* and *bancha* were frequently roasted, producing *hôjicha*, a dark reddish-brown tea with an excellent aroma. The best tea was said to be picked on the eighty-eighth day after the first day

25 The same dish, almost unchanged, remains popular today.

of spring (*hachiju hachiya*). Because of a pun suggested by 'eighty-eight' as written in Chinese characters, this tea was also thought to promote longevity.

As might be expected, a large variety of types and qualities of tea were available. Most were grown by local farmers, but other types came from specialised regions, such as Uji to the south of Kyōto. Quality powdered green tea, *matcha*, was customarily made by steaming, drying, and then grinding fresh tea leaves. Usually only the nobility or wealthy merchants could afford to enjoy this choice tea. The production of it required much time and effort. The intricate methods for preparing such tea were ritualised into the art of ceremonial tea preparation known as *sadô* (or *chadô*, 'the Way of Tea'), in the West commonly called the tea ceremony. This art had matured already by the end of the sixteenth century.

Sake was also a most important drink. Although generally translated as rice-wine, sake was and is technically a kind of beer, as the drink, unlike true wine, is based on the transformation of starch (from plants, in this case rice grains) into sugar through the use of enzymes (in this case a fungus) and the fermentation of the result into an alcoholic liquid. True wine is instead based on fermentation of sugars arising directly from raw materials such as fruit, honey, or milk, and therefore does not require the use of enzymes. This identification of sake was, apparently, first made by Thunberg.[26]

Sake was made by brewers who originally formed a group of itinerant craftsmen. From the Edo period, however, the centres for sake brewing became towns such as Nada, Fushimi, Ikeda, Itami, and Nishinomiya in western Japan. Nada, near the coast of the Inland Sea to the west of Ôsaka, was famous for the most esteemed varieties of sake. In Edo, such sake was known as *kudarizake* ('sake which has come down', in this case from the Kyōto area 'down' to Edo). Indeed, the term *kudarimono* could refer to all 'goods that came down'. There were, however, less reputable types of sake, often brewed in the vicinity of Edo. This sake, as it 'did not come down' (*kudaranai*) from the Kansai region, was disparaged by the connoisseur. The term *kudaranai* therefore took on the meaning 'not worth taking seriously' that still exists in modern Japanese.

Sake brewing was limited to the winter season, providing a convenient off-season employment for men from the northern parts of Japan. On larger farms, sake was also brewed in winter for home consumption. Well-to-do families employed specialists to come and make sake on the premises. Sake was drunk at all sorts of celebrations. It was generally served warm, heated before drinking by pouring it into a flask called a *tokkuri* which was then placed in hot water. The sake was then drunk from small cups.

It has been estimated, based on historical records, that the Edokko drank an average of 50 to 60 litres of sake each year.[27] Numerous European observers pointed out that drunkenness was widespread in Japan, and not limited to men, or even adults.

26 Thunberg, *Resa* 4, p.38.

27 The figure recurs in current statistics, according to which every modern-day Japanese drinks an average of 56 litres of beer per year.

How much did the Edokko pay for his sake? Sake was mainly, or always, consumed together with titbits of food, so let us consider the costs together. Saikaku reports that sake alone could cost eight copper *mon*. Much later, in the 1800s, Jippensha Ikku reported that really cheap (and much inferior) sake cost three *mon* per cup. But in his time, good sake was considerably more expensive, if for no other reason than the copper depreciation. He mentions expensive sake for 24, 28, and as much as 50 *mon* per cup. With the latter sake, expensive savouries were served in the form of arrowroot (250 *mon*), vegetables (300 *mon*), as well as more substantial food (350 *mon*). The entire drinking bout cost one *ryô* of gold.

Few could afford such excesses. Several cups of sake together with some bean curd, Jippensha reports, could be had for merely 80 *mon*. Together with the previously mentioned 24-*mon* per cup sake, various savouries for 12 or 32 *mon*, respectively, were offered, as well as cakes for three, four, or six *mon*, respectively. For the 28-*mon* per cup sake, a fish meal was served for an additional 44 *mon*.

Fruits were also eaten, for instance plums (which were usually small and eaten pickled), persimmons, pears, grapes, and small tangerine-like mandarin oranges (*mikan*). Most fruit in Japan was grown only to be eaten on the farm where they were produced, but certain provinces and areas were famous for cultivation on a commercial scale. Much of their produce supplied Edo and the other big cities.

Certain vegetables, such as the daikon produced in nearby Nerima, and lotus roots, were also produced partly for commerce, but most other vegetables, and also mushrooms and other wild varieties of fruit or herbs, were mainly eaten by local farmers on the producing farms. The wide expanse of land west of the old borders of Edo was not suitable for growing rice. It was, however, acceptable for vegetables. The land was irrigated by water drawn from the Tamagawa and from Lake Hakone, and further enriched by the night soil from Edo. This created a favourable situation for vegetable production, which soon became vital for the Edo food supply.

A variety of flavourings were known, including salt, ginger, and imported pepper, but all were rather mild. Soy sauce (*shôyu*), of which many varieties existed, was originally introduced from China. It was known among the nobility since the sixth century, and came into widespread use from the fourteenth century. Salt was naturally of vital importance, but not as easily obtained. The moist, temperate climate offered few possibilities for producing sea salt by natural solar evaporation. Import of salt was usually impossible. Salt was therefore produced by a combined process of evaporation and boiling. Production was highest in the 10 'salt-making provinces' of Nagato, Suô (both now parts of Yamaguchi Prefecture), Aki, Bingo (both now parts of Hiroshima Prefecture), Bitchû, Bizen (both now parts of Okayama Prefecture), Harima (now part of Hyôgo Prefecture), Awa (now Tokushima Prefecture), Sanuki (now Kagawa Prefecture), and Iyo (now Ehime Prefecture) around the Inland Sea. Beginning in the Edo period, salt production engendered large-scale construction and industrial growth in these provinces.

The food eaten by the Edo townsman and the food eaten by the farmer were quite different in character and nutritional value. The basic food of the farmer was not, paradoxically, the steamed rice that he grew and that was so common in the cities. Instead the farmer ate a sort of porridge mainly made of millet, or perhaps some barley or wheat. This was accompanied by green vegetables and pickles, especially daikon pickled in a liquor made of rice bran. Fruit would also form part of the meal, and at times a scraping of dried fish would add a little protein to the farmer's diet. Fish was eaten whenever available, and wildfowl may have been eaten, too, as were sometimes domestic poultry. Although oxen or horses may have been available – horses primarily in eastern Japan and oxen mainly in the west – flesh of these animals was hardly ever put on the serving tray. Although this was in accordance with Buddhist precepts, presumably going back in history to the same tradition that gave birth to the Indian belief in sacred cows, the main reason may have been that both oxen and horses were used as important draught and pack animals, and horses also were required for military use. Japan's natural environment contained only limited areas suitable for livestock pasture. Moreover, there is no evidence of active stock raising in Japan even prior to the sixth-century arrival of Buddhism.

Virtually no cow's milk was consumed in Japan. In ancient times it had been drunk by the nobles, usually as a medicine when ill. In certain locations only, milk was used in specialised meals served at certain festivals, such as the Asuka *nabe* of Nara, which consisted of chicken, *gobô* (burdock root), and other ingredients poached in milk. It is doubtful if such food ever reached Edo. Meat was eaten in Japan, but it was always rare in the towns. The only known exceptions were a few great lords, whose ancestors had formerly been Christians and were said to have therefore persisted in beef eating. In addition to this, a local delicacy from the Hikone domain, just east of Lake Biwa, consisted of the tenderest part of the cow, preserved in *miso*, and with the hide and hair left on. This was used as a fortifier and is said to have been presented to the shôgun and certain other high-ranking officials.

Other types of meat were generally permitted, however. Birds such as duck, wild goose, thrush (*tsugumi*), pheasant, and crane, the latter regarded as an upper-class delicacy, were eaten. Fowl was often eaten uncooked, in the same way as sea fish. Deer and boar meat were sold in Edo, but often under assumed names, such as 'mountain whale' and 'medicine'. The latter name was undoubtedly correct. Especially in winter, protein-rich stews could make the difference between life and death, as the ordinary diet in Edo was scanty in protein.

Numerous other types of food were also available to the Edokko. These included crustacea such as prawns and lobsters, shellfish of various kinds, various roots and tubers, including several yams, and eggs both of birds and fish. Uncommon, often expensive exotic food included frog meat, bee larvae, fish eyes, and fish skin. The Edo gourmet craved variety.

Ill people were served easily digested rice gruel, a watery concoction based on rice, and the occasional stew.

It has been shown that the average height of the Japanese decreased in the Edo period, as former meat-eating habits were gradually dropped following

strict dietary orders from the shogunal authorities, no doubt influenced by Buddhist beliefs.

Cakes and Sweets

The Edokko liked sweets and confections (*kashi*), and he had a vast number of varieties to choose from.

The oldest type of cake in Japan was the rice cake (*mochi*), consisting of a variety of highly glutinous rice (*mochigome*), introduced at the same time as rice cultivation itself. The rice is steamed, pounded with mortar and mallet, kneaded, and formed into square or round cakes.

But rice cakes, although they remain favourites among the Japanese, were not sufficient to cover all needs. Candies of other kinds, known as 'crude sweets' (*dagashi*), soon appeared. These were usually made with cheap ingredients, such as chestnuts, beans, barley, brown sugar, and crushed rice, and came in a wide variety of types.

Dry cakes also appeared, being among the cheapest confectionary, and they could keep for a long time. They were frequently made from sugar, glucose (*mizuame*), rice, wheat, and millet. There were numerous varieties, all very popular.

Rice crackers (*senbei*) came in two main varieties, made from either a dough of rice flour and water, or from a dough of wheat flour, sugar, glucose, and water. The latter produced a sweeter variety. Dried *mochi* (glutinous rice cakes) were also common in this category. The ordinary rice crackers were made by steaming rice flour, cutting or moulding it into the desired shape, baking them, and finally brushing with soy sauce. It was common to wrap the rice cracker in dried seaweed (*nori*) or sprinkle it with sugar.

Yet another kind of popular dry cake was the *rakugan*. It was made by steaming rice flour made from glutinous rice. Sugar was mixed with the dough, which was then shaped in a wooden mould. After drying, the cake was ready to eat.

More expensive sweets, which were used also with quality *matcha* tea, were known as *namagashi* or fresh sweet cakes. These, usually with sweet bean paste (*an*) as main ingredient, appeared only in the sixteenth century, when confectionary makers were able to come up with the base for making *an*. This could only take place thanks to the general introduction of sugar from China to Japan.

Although sugar had been known in Japan since 754, when the blind monk Ganjin (688–763) brought sugar and Chinese confections from China, it had been regarded as a medicine and a rare luxury. Sugar appears to have been imported most commonly from abroad, from China or the Ryûkyû Islands. The Shimazu clan of Satsuma (now Kagoshima Prefecture) in Kyûshû traded with the latter since the twelfth century and subsequently, in 1609, also brought the islands into vassalage. Sugar became common in Japan only in the late Muromachi period (1333–1568).

The main reason for the popularisation of confections in general and fresh sweet cakes in particular was the tea ceremony. However, it is fair to say that the wealth generated in the cities also had something to do with the new taste. The first true confectionary shops (*kashiya*), for instance,

Fig. 216. A confectionary
salesman

appeared in the Edo period (Fig. 216). So did many of the varieties of sweets and confections.

Namagashi are chiefly made from sweet paste (*an*) made from red *azuki* beans or white bush beans, sugar, and water. Refined rice flour was also an important ingredient, as were glutinous rice (*mochigome*), wheat flour, and agar-agar (*kanten*, or Japanese gelatin, a dried foodstuff made from seaweed, heated until it melts, and then cooled to form a solid jelly-like substance). Sesame seeds, walnuts, and peanuts might also be used in small quantities. The taste and appearance were designed to match the seasons, and many varieties were only available seasonally.

There were also many kinds of sweet cakes made from flavoured and coloured wheat flour and other ingredients. These were made in many different representational and geometrical shapes, such as flowers and leaves. Such sweets were frequently eaten just before drinking the powdered tea used in the tea ceremony, or with the stronger varieties of ordinary green tea. Of the numerous types and varieties of such sweet cakes, a few must be mentioned.

Manjû were steamed, round wheat flour cakes wrapped around a core of sweet red bean paste.

Yôkan were rectangular slabs of red bean-jelly (*an*) sweetened with various flavourings. These treats were often wrapped in a bamboo-shoot husk or in a green leaf. *Yôkan* were, according to the diary of the famous writer Takizawa Bakin (1767–1848), often presented as a gift, especially to the ill.

Daifuku consisted of bean paste wrapped in a thin cover of steamed and pounded glutinous rice (*mochi*).

Monaka were round or square double rice cake wafers, originally served dry. Later they were made filled with bean paste. The name *monaka* comes from a word meaning 'full moon' in a poem by the famous poet Minamoto no Shitagau (911–983). Monaka were therefore originally round, representing the full moon. This cake was very popular in the Edo period. Another popular variety came in the shape of a flower.

Other types of sweets also appeared to tempt the Edokko.

Karintô were strips of crisp, deep-fried dough coated with melted brown sugar. They became popular in Edo in the 1830s.

Okoshi were dry cakes made of puffed rice and starch syrup.

Chatsû were made from a dough of green tea and flour, and filled with black sesame-flavoured bean paste. The cake was then lightly grilled.

Dango were small balls, made of mainly rice flour dough, served steamed or boiled (Fig. 217). A variety of coatings were used, including sweet bean paste or a powder made by roasting and grinding soybeans (*kinako*). They could also be dipped in sweetened soy sauce and grilled on skewers.

Konpeitô were tiny sugar balls in the shape of horned spheres. Introduced by the Portuguese at the time of Oda Nobunaga, they were made from syrup and corn starch.

Cheaper sweets and snacks were known as *zatsugashi* or miscellaneous snacks. They included such things as flour-and-sugar pancakes in various shapes (for instance, *imagawayaki*, sold at Imagawabashi, a bridge at Kandabori ('Kanda Moat') near Nihonbashi, ,and the eighteenth-century speciality from Asakusa known as 'apricot confection' or *kôbaiyaki*) stuffed with bean paste. *Kôbaiyaki* was sold in small bamboo baskets, sprinkled with a fine sugar coating (*amanattô*).

Fig. 217. Two confectioners preparing *dango* in front of an expectant group of children

Another popular sweet was the candy (*ame*), often sold in specialised candy shops (*ameya*). Among the most popular kinds of candy was the red and white 'thousand-year-candy' (*chitose ame*, or *sennen ame*), also known as 'long-life-candy' (*jumyô ame*), made by boiling down glucose and pulling it out until a long stick is formed. This candy was made for the Seven-Five-Three Festival (*shichigosan*), always popular with children, and it was said that 1,000 years of happiness was conferred upon the child who received it.

This type of candy was first made in Edo in the seventeenth century. Some type of *chitose ame* was known as *Kintarô ame*, as it when cut crosswise showed the face of the legendary boy hero Kintarô. A similar candy (*Eitarô ame*) became popular by the end of the Edo period.

The most popular European-style cake in Edo was the *kasutera*, a sponge cake made of wheat flour, eggs, and sugar. This style was introduced by the Portuguese in the sixteenth century. The name was originally Portuguese, perhaps derived from the place name Castilla.

The Edokko also had a number of seasonal cakes to choose among. *Ohagi* or *botamochi* were similar to *dango* in many ways, but made of steamed glutinous rice (*mochigome*). They, too, were coated with sweet bean paste or soybean powder. Ohagi – the name derived from bush clover (*hagi*), an autumn flower – were made during the autumn equinox, while botamochi – the name derived from peonies (*botan*), associated with early spring – were made during the spring equinox. Sakuramochi were small, pink sheets the colour of cherry blossoms (*sakura*) wrapped around bean paste. The cake itself was wrapped in a cherry leaf pickled in brine. Sakuramochi were made for the Girls' Festival in the Third Month. Kashiwamochi were rice flour dumplings filled with bean paste and wrapped in oak (*kashiwa*) leaves. They were made for the Boys' Festival in the Fifth Month. *Chimaki* were sweet, soft rice dumplings wrapped in iris leaves. They, too, were made for the Boys' Festival in the Fifth Month. Nowadays they come wrapped in bamboo leaves.

Naturally, the real gourmet craved more unusual sweets. Among more remarkable types was a preparation of sake with snow, preferably from Mount Fuji, which European visitors claimed had some resemblance to the ice-creams of Europe. Such a refreshment was apparently costly; a remuneration of a gold *koban* has been mentioned. It may have been related to the crushed ice sweet known as *kakigori*, available today.

In 1693 there were as many as 250 recognised types of different cakes and sweets. Many shops specialised in confectionary. Two famous confectioners from the Edo period still exist, Toraya (originally of Ôsaka) and Shiose. Such shops specialised in the more expensive varieties of confectionary. In Edo, cheaper sweets (*dagashi*) were sold from street stalls.

Jippensha Ikku reports that in the 1800s, cakes cost three, four, or six copper *mon*. In earlier times, they were cheaper. Luxury cakes and sweets could be had for any fantastic price; the market knew no upper ceiling.

Street Stalls

In Edo, street stalls were set up to sell snacks, refreshments, and food wherever people gathered. Along streets, in shrine or temple compounds, or in any open space frequented by many people, such stalls were easily found.

The simplest type of stall was merely a movable stand, known as a *yatai*. It was carried over the shoulder when moved. As the *yatai* did not have any wheels, it was heavy to carry, but this was made up for in convenience. It could quickly be brought wherever and whenever many people gathered. Food and snacks sold from *yatai* included *soba* noodles, tenpura, inarizushi (sushi rice wrapped in fried soybean curd), fruits, or sweet snacks. Each stall specialised in a single commodity, so there were usually plenty of them.

In summer, crickets and fireflies were also sold, as the Edokko liked to keep these insects in small cages at home.

Sushi was apparently not much sold in winter. Then the Edokko instead bought carp wrapped in kelp.

A larger type of street stall was the *yatai mise*. Such a stall was bigger and always left standing on the street (Fig. 218). This type of street stall was also most often used to sell fast food, but at times clothes or indeed any sundries that fit into the display counter of the stand were also sold.

In Edo, most street vendors served *soba* or *udon* noodles strictly by the bowl, with no refills. Such street vendors were so notorious for their brusque manners that they were frequently nicknamed *kendon'ya*, after a Buddhist term for the sins of avarice and lack of charity. This, and the way these vendors thrust the bowls of noodles into the hands of their customers, gave rise to the word *tsukkendon*, meaning blunt, gruff, or uncivil.

Some stalls, especially those selling rice cakes, kept wooden models of their foods for display, so that the customer could see what they were selling without the need to expose real foods to weather, dust, and wind.[28]

Tea Stalls

A different type of street stall was a makeshift stall with benches to seat customers and a roof and walls made of bamboo screens to protect them against weather and wind. Such a stall mainly served tea, and it was accordingly called *mizujaya*, or 'tea shop'. At a central location inside the stall were a stove to boil water and a cabinet to keep tea and utensils. Young waitresses wearing colourful aprons were always at hand to call in customers from the street (Fig. 219).

The customers came to relax over a cup of tea or two, and perhaps eat some snacks or cakes. Food and drink were not always the only service for sale. Many tea stalls had a specially set-up back room, where the young waitresses sold their favours.

Tea stalls, too, appeared wherever people gathered, but they were naturally

Above: Fig. 218. *Soba* being sold from a *yatai-mise*

Below: Fig. 219. Two young waitresses in front of a small tea shop (*mizujaya*)

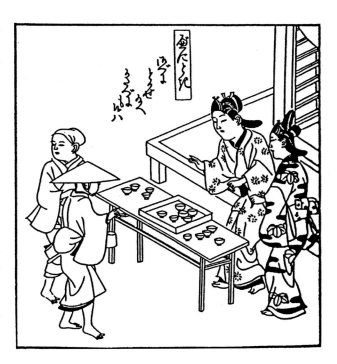

28 In modern Japan, such displays, although made of plastic, remain very common and most restaurants use them.

of a slightly more permanent character than the other type of stalls. They were common not only in urban areas, but also formed a notable part of the services provided by every post station with a checkpoint (*sekisho*) on the provincial highways.

Restaurants and Taverns

The first type of restaurant to appear in Edo were the noodle shops (*sobaya*, most popular in Edo, as well as a few *udon'ya*) and tea houses (*chamise*). Both these types of cheap eating places were popular in Edo from the 1660s onwards. They usually doubled as drinking places (*izakaya*). In the 1720s and 1730s (to be specific, in the Kyôho year period, 1716–1736), they were followed by various other types of public eating establishments. More luxurious and expensive restaurants also developed in the last quarter of the eighteenth century, chiefly to serve samurai, wealthy merchants, artists, and popular writers, all groups that were expected to show refined taste. Only then did eating out in style become common in Edo.

Most establishments, however, remained cheap eating houses with a very limited menu, often only one dish. Inexpensive, simple dishes such as tea over rice, soup with tofu, boiled beans, noodles or rice with some vegetables, eggs, and/or fish, perhaps boiled in soy sauce, were generally served. Many, perhaps most, were tea houses. Other common types included the 'everyday-dish shop' (*sôzaiya*) offering ready-made portions of a daily special, the 'cheap fast food restaurant' (*ichizenmeshiya*) selling one dish only, always with rice as the main ingredient, and the 'refreshment house' (*ochazukeya*), selling rice with tea added to the bowl.

Taverns serving sake along with light snacks were usually characterised by a short curtain made of hanging strands of twisted rope (called a *nawanoren*) hung in front of the shop.[29] Other sake shops displayed a round ball made of cedar shingles bound together in a big ball, around 60 cm in diameter, under the roof above the entrance. This signified the house of a sake maker, and that new sake was ready for sale. The taverns, unlike the restaurants, did not expect the customers to consume their favourite brew with any particular manners.

A specialised type of Edo tavern was the boathouse tavern (*funayado*). A boathouse tavern was actually not a tavern at all, but a tea house and a rest stop for customers who hired boats to go to the pleasure quarters. Most, but not all, were elegant places where a customer expected to be entertained rather than merely fed. The main purpose of these establishments was to provide boats for entertainment on the waters or for trips to the Yoshiwara licensed quarter. A boat would be sent to bring the customer to the boathouse tavern, where he took a rest before he left for his destination. These boats were often of the roofed, high-prowed sort (*yakatabune*) seen in Edo period woodblock prints. They frequently had lanterns strung out along the eaves to provide a more entertaining mood. Indeed, these establishments functioned in a similar way to the famous Yoshiwara tea houses (see below), in the way they arranged assignations with famous courtesans.

29 Such a traditional drinking place is nowadays called an *ippai nomiya* ('one-cup drinking place').

After the visit to Yoshiwara, the customer perhaps also dropped in on his return trip, for a snack, a drink, and some rest. Major dishes of food were generally not available in the boathouse tavern, but the shopkeeper could of course get it from elsewhere if the customer was really hungry. The boathouse tavern instead served sake, alongside an appetiser or two.

Although the boathouse taverns were principally meant to be reached by boat, it was also common for local people to go there for a drink. The majority did not cater exclusively to boat-borne visitors.

Tobacco and Smoking

The Portuguese brought not only firearms to Japan, but also tobacco. Both commodities became popular in a very short time. From the end of the sixteenth century, the use of tobacco spread as fast as the use of guns. In Japan, tobacco was first cultivated in Nagasaki in 1605. In the Edo period, smoking was widespread among both men and women. 'Whether gentle or simple, cleric or lay, man or woman, there is no one who does not enjoy the herb', wrote the Imperial prince Toshihito (1579–1629) in 1609.

Tobacco was at first rather expensive. It has been reported that a single leaf of tobacco was worth as much as three *monme* of silver (11.25 g)

Fig. 220. Japanese pipe (*kiseru*), case, and tobacco pouch

in 1601. By this time, the smoker had to purchase uncut leaves, from which he prepared his own smoking tobacco. The price decreased as the habit spread, along with the cultivation of tobacco. In the first decade of the seventeenth century, as testified to by popular paintings, tobacco was sold by open-air street stalls. For a small fee, the customer received a pipe of tobacco in the same way as other stalls may have provided him with a cup of tea or a snack. In Saikaku's time, such a pipe cost a mere one copper *mon*. Because of copper depreciation, the price eventually rose, and Jippensha Ikku had to pay four *mon* per pipe in the 1800s.

Tobacco was smoked in a pipe (*kiseru*) of the South-East Asian style (Fig. 220), with a very small metal bowl (*hizara*) – big enough to take only an amount of tobacco the size of a small pea – in a metal neck (*gankubi*). On the other end of the pipe was a mouthpiece (*suikuchi*), connected to the metal neck by a long stem (*rau* or *rao*), generally made of bamboo but sometimes of metal, wood, porcelain, stone, or even glass. The tobacco was cut very fine, so one bowlful was enough only for one or two, or at most three whiffs, before the ash had to be knocked out into a nearby section of bamboo that was used as an ashtray. As the smoker rolled up the tobacco tightly with his fingers before it was inserted, the ash, when shaken out, usually formed a small fireball from which a second pipe was lit.

Whenever a guest arrived, whether he entered the house or shop or merely sat down on the edge of the raised floor without removing his footwear, a tray with smoking utensils was always offered. These included the ashtray, a receptacle for glowing charcoal, and a tobacco container (Fig. 221). No

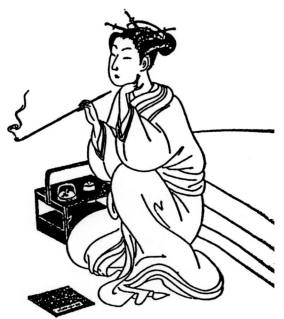

Fig. 221. Young woman relaxing with a pipe next to her smoking tray, after reading a popular novel

pipe was provided, as each smoker used his own pipe, carried on his person in a case. The Edokko, of course, often carried shredded tobacco with him, too. Tobacco was carried either in a pouch hanging from the sash, the usual style among commoners, or in a wallet-like pouch, carried in the upper folds of the kimono, the favoured style among women and the upper classes.

Like rulers in many other countries, Tokugawa Ieyasu made attempts to discourage the use of tobacco. The first legal bans came already in 1605, or in 1607–8 (the exact year is unknown). In 1609, the Edo authorities prohibited smoking on account of the fires caused by reckless smokers, and as the practice was considered a grave financial waste. In the same year, fights broke out in Kyôto between two gangs armed with long, heavy tobacco pipes made of iron. Some of these pipes even had mounted sword guards to protect the hands of the wielder while fighting. In 1612 the cultivation, sale, and use of tobacco was prohibited. Similar edicts against tobacco were announced several times during the following years, and in 1615, the Edo authorities even conducted a house-to-house search for pipes, confiscating those that were found.

The efforts to curtail the use of tobacco were not effectively enforced, however, and smoking remained a favourite pastime of the Edokko. Tobacco continued to be grown and sold under the name of 'life-prolonging tea'. In 1624, the ban of tobacco was repealed. A few later attempts to ban the cultivation of tobacco – from 1642 to 1643 – were ineffective. In 1651 the Edo authorities gave up the fight against tobacco and relaxed regulations to permit smoking within private homes. Three years later, in 1654, smoking was even permitted at certain specified locations within Edo Castle.

This was the turning point in the fight against smoking. From about the next year, depictions of tobacconists' retail shops became common in paintings and illustrated books. These shops specialised in shredded tobacco, and they were to become an important part in the daily life of Edo. The retail tobacconists' shop was generally a family business. The wife first 'rolled' the cured tobacco leaves by wrapping them around a gauging-stick, and then flattened them, while the husband shredded the leaf rolls into finely cut smoking tobacco. An ordinary workman could in a day of hard work produce about three kilogrammes of tobacco, while a master worker might manufacture 3.7 kg. For the finest and most costly tobacco varieties, this was considered sufficient. However, as smoking soon came into very common use, the demand for less expensive tobacco outstripped this method of production. Edo period craftsmen therefore invented several types of machinery that could turn out from 11–19 kg of tobacco in one day. This tobacco was at first of low quality, so the services of the manual shredder

remained available until as late as 1904. High-quality shredding machinery was introduced in the 1840s.

By the end of the Edo period, if not earlier, imported opium was also available. In Japan, however, opium smoking or eating never turned into the huge social problem the habit caused in China.

Fire Brigades, the Post Office, and Physicians

The Fire Brigades
Kaji to kenka wa Edo no hana ('Fires and quarrels are the flowers of Edo') was a proverb that speaks clearly of the prevalence of fires in Edo. Edo suffered numerous disastrous fires, but that was only to be expected as the houses were crowded and built of very flammable materials. The first big fire in Edo was the great Keichô fire (Keichô Taika) in 1601. The second major fire, destroying 60 percent of the city and most of Edo Castle, came in 1657 (the great Meireki fire, or Meireki Taika). It was thought to have been caused by sparks from a kimono being burned in a Buddhist exorcism ceremony. Perhaps 100 major and innumerable smaller fires followed. Some worth mentioning are the fires of 1621, 1668, 1698, 1772, 1806, 1825, and 1845, and the two great fires that took place in 1858.

The director of the Dutch factory in Nagasaki, Hendrik Doeff, experienced a severe fire during his stay in Edo:

> At ten o'clock in the morning of the 22d of April, 1806, we heard that a fire had broken out in the town, at a distance of about two leagues from our quarters. We took no heed of the news, so common are fires at Yedo; a fine night never passes without one; and as they are less frequent during rain, a lowering evening is a subject for mutual congratulation to the Yedoites. But the flames came nearer and nearer; and about three o'clock in the afternoon, a high wind driving the sparks towards our neighbourhood, four different houses around were seen in flames. Two hours before this occurred we had been sufficiently alarmed to begin packing; so that now, when the danger had become imminent, we were prepared to fly. On coming into the street we saw everything blazing about us. To run with the flames, before the wind, appeared very dangerous; so, taking an oblique direction, we ran through a street that was already burning, and thus reached an open field called *Hara*, beyond the conflagration. The place was set thick with the flags of princes, whose palaces were already consumed, and who had escaped hither with their wives and children. We followed their example, and appropriated a spot to ourselves by setting up a small Dutch flag used in crossing rivers. We had now a full view of the fire, and never did I see anything so terrible. The horrors of this sea of flame were yet enhanced by the heart-rending cries and lamentations of fugitive women and children.
>
> About noon the next day a heavy rain extinguished the fire. We learned from our Nagasakkya[30] host, who paid us a visit, that the flames had caught his house

30 Nagasaki-ya, or 'Nagasaki House', the Edo residence of the Nagasaki town magistrate.

within five minutes after our departure, and had consumed everything, neither goods nor furniture being saved … He likewise told us that thirty-seven palaces of princes had been destroyed, and that about twelve hundred persons (including a little daughter of the Prince of Awa) were either burned to death or drowned. This last misfortune was caused by the breaking down of the celebrated bridge *Nippon-bas*,[31] under the weight of the flying multitude, while those in the rear, unconscious of the accident, and wild to escape the flames, drove those in front forward into the water.

By the end of the Edo period, Sir Rutherford Alcock, the first British minister to Japan, commented in the following way:

It is impossible to ride through the streets of Yedo without noticing one of the most striking and constant features of the city, no matter what the season of the year – large gaps where charred timber and rubbish mark the scene of a recent fire … It is certainly very rare that the night passes without the fire bell of the quarter ringing a fearful alarm, and rousing all the neighbourhood.[32]

We have already seen that samurai played an important role in Edo's fire brigades. Firefighters (*hikeshi*) were well organised, according to military principles and chosen from those who in former times would have been soldiers. The first organised force of firefighters (one fire brigade provided by each great lord) was established by order of the shogunate in 1629. The number of men provided depended on the *koku* rating of the lord, in similarity to the system designed for military mobilisation and enforced through the aforementioned *Gun'yaku* regulations. A minor lord of only 10,000 *koku* had to provide three or four mounted men, 20 men on foot, and 30 valets. A lord of 50,000 *koku* had to provide seven mounted men, 60 men on foot, and 100 valets. A lord of 100,000 *koku* had to provide 10 horsemen, 80 men on foot, and 140–150 valets. Finally, a major lord of 200,000 *koku* had to provide 15–20 mounted men, 120–130 men on foot, and 250–300 valets. In similarity to the *Gun'yaku* regulations, the quotas were occasionally modified. The fire brigades of the great lords were known as *daimyô hikeshi*. Designated lookouts (*hinoban*) were also provided, in order to sound the alarm whenever necessary.

The *daimyô hikeshi* had no responsibility for the welfare of commoners or their property. They were therefore soon supplemented by firemen recruited from the commoner class (*sadame hikeshi*) serving under samurai officers.

Yet another force was organised in 1650 among the *hatamoto*. This at first consisted of four units (*kumi*). These were emergency brigades, however, organised to protect the castle and the samurai residences.

In 1658, after the great fire of the previous year, four *hatamoto* officers were assigned to reorganise and expand the official fire brigades to replace

31 Nihonbashi.

32 Sir Rutherford Alcock, *The Capital of the Tycoon: a Narrative of a Three Years' Residence in Japan* (London: Longman, 1863; reprinted in 1969 by Greenwood Press, New York), 1st vol., p.123.

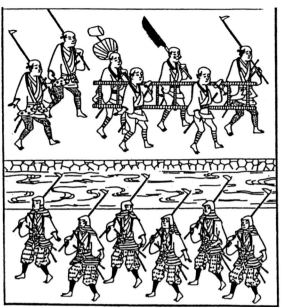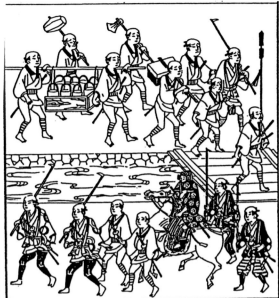

the previous emergency brigades. These were known as *jôbikeshi* ('castle fire brigades') as their duty was to protect the castle and the shogunate-affiliated samurai residences. These men were organised in a very similar fashion to the police, and they wore leather protective clothing and helmets with hoods of the type already described (Fig. 222). In 1704 the *hatamoto* brigades stabilised in number at 10 units, under the authority of the shogunate junior councillors (*wakadoshiyori*). Each brigade consisted of a commander, six officers (*yoriki*) in charge of various duties, including what may be called a staff group, a messenger service, ladder detachments, and water carrier detachments, 30 junior samurai officers (*dôshin*), and 118 others, including groups of bucket men and as many as 50 valets. It is not far fetched to consider these brigades a new reincarnation of the Tokugawa clan army. From 1819 onwards, the 'castle fire brigades' were restricted to operations in the area bounded by the outer moat of Edo Castle.

Among the commoners, neighbourhood brigades were therefore encouraged. Some merchants organised their own firefighters, to protect their own property. In 1718, a number of neighbourhood brigades (*machi hikeshi*) were set up, each with different standard and uniforms, on orders from the famous town magistrate Ôoka Tadasuke. Two years later, in 1720, they were reorganised and expanded to first 47, and eventually 48 units. Each of the 48 brigades for the townspeople's quarters was given its own syllable in the Japanese *hiragana* syllabary – with the Chinese characters for 'hundred', 'thousand', 'ten thousand', and 'origin' used instead of the semantically inappropriate or uneuphonious *he* ('fart'), *hi* ('fire'), *ra*, and *n* (the two last being inappropriate as they sounded vaguely dirty or scurrilous in Japanese).

In 1730 the shogunate decreed that the commoners in each neighbourhood should organise a fire brigade at their own expense. These were organised in groups or gangs (*kumi*). A chain of command was established with the

Fig. 222. A group of samurai firemen carrying ladders, buckets, and various tools to tear down buildings. Those in the foreground, left, wear the typical fireman's helmet with a hood. A hatamoto officer (*yoriki*) is following on horseback.

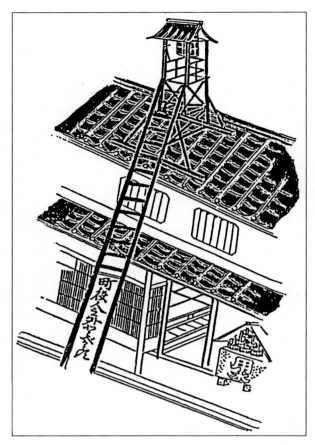

Fig. 223. A fire lookout tower (*hinomi*) with a bell. On the ground beside the building, a stand of water barrels kept in readiness for fire.

town magistrate at the top, followed by the neighbourhood chief (*nanushi*), the lower town officials (*machi yakunin*), and the head of the brigade (*tobigashira*). Later in the eighteenth century, the fire brigades of Edo counted as many as 64 companies, which together mustered about 10,360 firemen. Town fire brigades were not authorised to operate in samurai districts, as these were exclusively guarded by their own fire brigades.

It was easy to recruit firefighters. Although the profession was not very respectable, it was a popular one and still significantly more respectable than work in law enforcement. The firemen were generally rough fellows, quick to start a quarrel or a fight, as they had a reputation of fierce bravery to maintain. The firemen wore distinctive uniforms of heavy quilted cotton clothing that included heavy gloves, arm and leg guards, a heavy apron, thick face mask, and protective gear for the head and chest, including a hood. The breastplate (*muneate*) looked like a cuirass but was typically made of fabric, usually cotton and silk. The leader of a fire brigade carried a standard (*matoi*), a distinctive cloth decoration on a long pole that identified the brigade. He would position the standard as close to the centre of the fire as possible, and direct his group from a rooftop. Firefighters employed by the townsmen were generally construction workers, especially roofers and tilers. These two groups were already accustomed to the kind of work expected of the firemen.

The firefighters usually did not attempt to put out a fire directly; it was easier and more cost-effective to demolish nearby buildings so that the fire would not spread further. Various implements were used for this purpose, including iron hooks (*tobiguchi*, meaning 'kite's beak' because of their shape) used to pull down roofs. In the 1760s wooden hand pumps were introduced to project streams of water at the fire. The small amounts of water available were usually insufficient to extinguish the fire, so these pumps were more commonly used to douse the firemen rather than the fire.

Each unit of town firemen consisted of a commander and his assistants, a number of standard bearers, ladder carriers, ordinary firemen, divided into pump men and bucket men, and general workers (*gesokunin* or *ninsoku*). Firemen were often called, because of their characteristic tools, *tobi no mono* ('hook men'), *tobiguchi*, *tobininpu*, *tobishaku*, or simply *tobi*. Whenever there was a fire, volunteers too often came to assist, but they were sometimes more interested in betting on the outcome than in fighting the fire.

Fire watch towers (*hinomi*) were erected at strategic locations throughout the city (Fig. 223). These were equipped with bells to sound the alarm. The

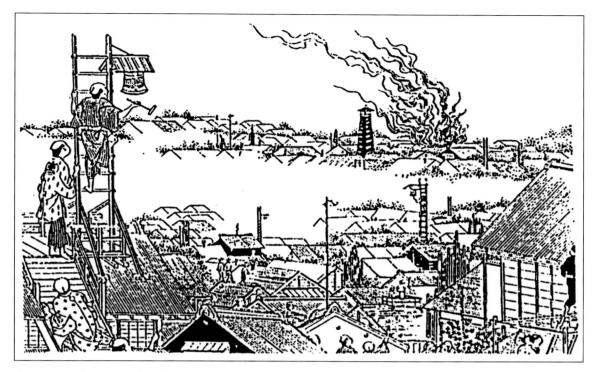

distance and magnitude of the fire was indicated by the rhythm and violence of the strokes at the bell (Fig. 224). On some roofs, barrels of water were kept so that the building could be soaked at a moment's notice. Large tubs of water and piles of buckets were also stored in the street, ready for immediate use in fighting a fire. After the 1657 fire, fire lanes were installed at various intersections. After the great fire of 1668, streets were also broadened to act as fire-breaks, first at Shinbashi and later at other places, and several open spaces were cleared for the same purpose.

Firefighting was well organised in Edo, and there is no doubt that many potentially disastrous fires were extinguished. Despite this, every prudent *hatamoto* or merchant constantly had to put money aside for rebuilding his house, as he knew that someday he would be afflicted by fire. No one was safe.

A number of devices were invented to help protect one's valuables against fire. The fire-resistant warehouse (*kura*) has already been mentioned. Less wealthy merchants and shopkeepers instead kept a *yojin kago* (a bamboo basket with a shoulder pole) in their house, suspended from the ceiling. In an emergency, the shopkeeper and his family would throw their valuables into the *yojin kago*, borne by two men, and flee the fire. The *yojin kago* was light to carry, and if it should be necessary to discard it to save one's life, then at least this easily flammable device soon burned out, so that any later refugees from the fire would not find their way blocked by discarded objects. Valuables and important records could also be kept in tall chests with drawers and compartments secured with iron bands and fitted with castors to allow them to be easily pushed out into the streets, and even through the wall shutters, if necessary.

Poor people did not have these worries, as they owned little or nothing. Nevertheless, they too were always prepared to snatch up any belongings and leave home when the fire alarm sounded.

The Post Office

Letters, documents, and small packages of money were generally carried by the system of express messengers known as *hikyaku*, 'flying feet'. The shogunate depended on these services for the transmission of intelligence, in particular with regard to the loyalty of the *daimyô*, who in most cases were under continuous surveillance.

The shogunate and some of the great lords, especially the Tokugawa collateral houses, organised their own messenger service early in the period. This was a relay system, with reliefs provided at intervals of seven *ri* (about 27.5 km; 1 ri = 3.927 km). This relay system operated along the Tôkaidô, which was the principal overland route linking Edo with Kyôto and Ôsaka. Mounted messengers (the original *hikyaku*) were employed for this purpose. Each post town kept three horses in readiness at all times. A mounted courier could ride from Edo to Ôsaka in 96 hours, or from Edo to Kyôto in 82. The messenger system was known as the 'great lords' express' (*daimyô hikyaku*) or the 'seven-*ri* express' (*shichiri hikyaku*), the latter name derived from the distance between the stations. The system was eventually extended to most of the Gokaidô, the five main highways.

In another system, the 'stage express messenger' system (*tsugi hikyaku*), the authorities also employed the post-horses and post stations. This, however, was not considered sufficient, so intermediate stations (*tsugitate*) were established at intervals of approximately two *ri* (about eight kilometres). There, too, horses were kept in readiness.

For other types of delivery, runners and pack horses were available from the post station towns. The shogunate required the nearby villages to provide both horses and men. When men and horses were used for official purposes, the villagers were usually not paid or else received only fixed, very low rates. Ordinary merchants could also use these services, but they had to pay according to relatively high, contracted rates, and services were provided only on the condition that they did not interfere with official business.

A sign of official authorisation was required to use the official business rate. This was a wooden plate tag or 'picture-sticker' (*efu*), printed on both sides. The main side was printed with the family crest of the owner on the upper part and an explanation on the lower part, for instance 'On the Imperial Household's Service', 'On Court Noble Tsuchimikado's Service', 'On the Kishu Clan's Service', or 'On Tôeizan Temple's Service'. Some unscrupulous merchants were known to abuse this system and use official tags for private purposes.

The official systems of express messengers were efficient but also very costly. As there were also other difficulties in maintaining them, the various systems eventually broke down. Some merchants therefore saw the business opportunity in the provision of express messengers between Ôsaka and Edo. Later Kyôto was added to the list. In about 1639, they began to supply such

services to the great lords and the shogunate, in the guise of travelling as servants of their principals.

In 1663 or 1664, however, merchants in the three cities no longer needed to rely on the protection of the upper classes. They accordingly set up a thrice-monthly service of runners (Fig. 225) between Edo, Kyôto, and Ôsaka. This was known in Ôsaka as the 'Thrice-A-month (or Three Times) Express Messengers' (*sandobikyaku*), as runners left on the second, twelfth, and twenty-second days of each month. Another name for the same service was the 'Three Cities Express Messengers' (*santobikyaku*). Licensed by the city authorities, this service also handled official letters and was therefore allowed use of the three horses always kept in readiness at the post stations. In Edo the enterprise was known as 'scheduled express messengers' (*jôbikyaku*), and in Kyôto as 'sequential express messengers' (*junban hikyaku*). In Ôsaka and Kyôto, each firm employed 15 runners, whose efficiency was examined each month by a senior employee.

When runners assumed the name *hikyaku*, the mounted courier became known as 'fast horse' (*hayauma*) to distinguish him from the slower runner.

Several establishments in each of the three cities operated messengers. Most of the ones in Edo (of which nine were licensed) were branches of the companies in Kyôto, of which there were apparently some 86 separate establishments in the late seventeenth century (of which only around 13 were licensed), and Ôsaka, which boasted nine messenger services. The Kyôto–Ôsaka origin of these firms is clearly indicated by names such as Ôsakaya, Yamadaya, Yamashiroya, Fushimiya, and Izumiya. There were, however, also independent Edo messenger enterprises. They were known as 'Edo to Kinai messengers' (*jôge hikyaku*) or 'six-group messengers' (*rokkumi hikyaku*). Kinai, or the 'Capital Provinces', were the provinces surrounding the ancient capitals of Nara and Kyôto. The Edo firms generally specialised in serving the great lords of a particular region.

The main houses cooperated in sending messengers, so that each company had its own fixed schedule. In practice, this meant that they sent and received messages three times every 10 days, or nine times a month, which provided 18 postings for Edo every month. Mail was collected during the three to four days prior to the next scheduled departure. The runners theoretically made the journey to Ôsaka by way of Kyôto in six days. In practice, there were many possible sources of delay, so delivery times of 10 or even 12 days were common.

The express operators always strove to cut the delivery time, however, and they eventually succeeded in cutting the required time to travel the more than 500 km from Edo to Ôsaka to five, four, and even three and a half days. The 'fast express messengers' (*hayahikyaku*) ran at night as well as day. In 1763 the fast express service between Edo and Kyôto for government documents, travelling in relay during both day and night, took about 70 hours. By the

Fig. 225. An extremely busy express runner, his mail carried in a small black lacquered wooden letter box, slung on a short pole (usually but not in this example) over the shoulder of the messenger.

early nineteenth century the fast express service between Edo and Kyôto (not Ôsaka) was less than two days, an amazing speed considering the crowded road conditions.

The express messenger service became very popular and grew steadily, spreading the communications network to more and more towns. Detailed schedules describing the dispatch of messengers to various places were published. Customers consulted these schedules, and then sent their letters and packages with the appropriate messenger. Because of the increasing popularity and joint name of the messenger services, the straw hats used by messengers became known as 'thrice-a-month hats' (sandogasa).

Despite handling official packages and letters, the merchants originally had to pay the higher rates for services from the post stations. Unlike messengers on exclusive official business, they also were not allowed to use men and horses preferentially. The firms therefore petitioned the shogunate to change the situation. In 1782 the shogunate Commissioner of Travels (dôchu bugyô) designated nine individual suppliers of express messengers in Edo, and authorised them to use the title of 'authorised supplier of express messengers in Edo' (Edo jôbikyaku-don'ya). They were thereby granted various privileges, including use of government service rates. To show this, a licensed runner carried a tag with the words 'Authorised Scheduled Express Messenger' (jôbikyaku) attached to his package.

Official shogunate messengers always had priority at ferries and were allowed to pass checkpoints at all times. Every such runner travelled accompanied by a companion bearing a paper lantern on which the word goyô ('official business') was written (Fig. 226). The mail was carried in a small black lacquered wooden letter box, slung on a short pole over the shoulder of the messenger, and became known as the 'official business box' (goyôbako). The two runners were accordingly known as 'official mailbox carriers' (goyôbako ninsoku). 'There are always two of these messengers run together, that in case any accident should befall either of them upon the road, the other may take his place and deliver the box,'[33] wrote the German physician Kaempfer. Such express messengers always had priority, Kaempfer added, even over a travelling daimyô and his retinue:

> All travellers whatsoever, even the Princes of the Empire, and their retinues, must retire out of the way, and give a free passage to those messengers, who carry letters or orders from the Emperor,[34] which they take care to signify at a due distance, by ringing a small bell, which for this particular purpose they always carry about them.[35]

A bell may have been used, but possibly more famous was the runners' distinctive cry of 'Ei-sassa, ei-sassa!'

33 Kaempfer, History 2, p.419.

34 In fact the shôgun and not the emperor.

35 Kaempfer, History 2, pp.419–20.

The runner's companion also ensured that no delay resulted from accident or illness. The men ran at their utmost speed, and relay couriers waited at the end of each stage. The relay runner indeed started running before the arriving runners had stopped, and the packet was handed over without a halt.

The wooden letter box of an ordinary express messenger was padded with leather on the top, so that it could also be used as a pillow. In this way, there was no risk that letters would be pilfered while the messenger was asleep. Commoners seldom stayed in individual rooms in the inns along the highways, so a messenger usually shared his lodging with others. The messenger also carried a few other implements, such as a portable ink and writing brush set in a case worn in his sash, as well as a paper lantern for night travel.

Fig. 226. An official Shogunate messenger and his companion bearing a paper lantern marked *goyô* ('official business')

The straw hat of the messengers has already been mentioned. Other clothes included a version of the *happi* coat, and straw raincoats (*mino*), the latter covered by black net, which indicated the privileged position of the messenger. Otherwise, only samurai were allowed to use black net for this purpose.

Cash was also carried. Cash service express messengers (*kanebikyaku*) were introduced in 1671, and participating firms had signs with these words outside their offices. Fourteen suppliers of express messengers established an association known as the Teitagumi ('Documents Holder Group'). They each provided the service for one month in each turn. The name was derived from the special documents holder (*teita* or *kittebasami*) used to protect important documents. This consisted of two thin wooden plaques, tied around with cotton thread. The messenger carried the holder in a cloth bag. Major banking companies such as Mitsui also handled the transfer of cash between the major cities.

The services of the express messengers were very expensive. The 'fast express messenger' (*hayahikyaku*) was especially so. Three and a half day delivery from Edo to Ôsaka was listed as four *ryô*, or the rough equivalent of a year's wages for a poor *gokenin* or a domestic servant. Four day delivery cost 3¼ *ryô*, and five day delivery 2¾ *ryô*. Prices also varied according to the weight of the mail, and from one express company to another. For three and a half day delivery, one operator charged as much as from 8½ to 9 *ryô*.

A slower and cheaper service, taking up to 25 or 26 days, was also available. With this service, a package with a weight of one *kan* (3.75 kg) cost 50 *monme* or slightly less than one *ryô* to send from Edo to Ôsaka in 1806.

For ordinary mail, the liability of the messenger ceased upon delivery to the recipient. In case of cash transport, the recipient had to sign a receipt, which was brought back to the sender as evidence of delivery. The document holder mentioned above was designed to carry all the necessary paperwork.

At places such as Nihonbashi in Edo and similar places in the other two cities, a person could deposit a letter or a small package and pay for postage.

In the evening, the runner picked up the mail box and departed. This was also the pick-up site for incoming mail. The letters were displayed on a straw sheet, and the customer was handed his mail after paying a charge.

Within Edo, Kyôto, and Ôsaka, intra-city communications systems known as 'town express' or 'town messengers' (*machi hikyaku* and *machi kozukai*, respectively) were also developed. At first, this began as a spare-time occupation among labour brokers. Such men specialised in the provision of long-term employees for service in upper-class households and commercial enterprises. This work necessitated frequent visits to the various parts of the city, and it was easy for the brokers to also deliver a few packages at the same time. Over time, the enterprise grew into a system of mail collection and delivery with set schedules and fixed rates.

Doctors, Medics, and Medicine

In times of war, there was an obvious need for medical services. There were few trained physicians in the army, so soldiers generally had to tend to their wounded comrades without professional support. As a result of the long period of civil wars, there was a tradition of what appropriately was known as combat medicine – emergency medical care in the form of field surgery – among soldiers. Edo period books such as the aforementioned *Zôhyô Monogatari* give some advice on prophylactic medicine to prevent diseases as well as on how to treat anything from snakebites to the removal of arrows and treatment of combat wounds (Fig. 227).

Medical problems outside the army were generally of a different nature. Colds and influenza were the most common causes of illness in Edo period Japan. During the summer, intestinal and stomach trouble was also rife, because of the poor storage conditions for food and the numerous flies.

More grave diseases, too, struck from time to time, including smallpox and leprosy. There were also one or two serious cholera epidemics during the Edo period, including the one following the floods of 1704, and a serious epidemic in 1858 that killed over 28,000 people including the famous woodblock print artist Andô Hiroshige (1797–1858).[36] There was also a plague in 1773, in which 190,000 people died in Edo alone. Epidemics of measles and plague also followed the floods of 1704. Another measles epidemic struck in 1803, as well as a measles and influenza epidemic in 1824.

Medicine was available, for a fee, from professional doctors. Physicians were considered to be outside the class system. For this reason, they had family names and also enjoyed the right to carry the long sword. A doctor was easily recognised; he did not shave his head in the usual way but gathered his hair into a knot on the crown of the head. The exceptions were some specialists, described below, as well as specialists in internal medicine, women's medicine, and the heads of some medical schools, who instead shaved their

36 This epidemic was – presumably unfairly – blamed on the presence of an American warship offshore.

Fig. 227a (left) and 227b (overleaf). Two soldiers, one of the *chûgen* class (left), the other a samurai infantryman in battle-torn armour (right), prepare to remove an arrow lodged in the eye socket of a comrade with a pair of pliers. The *chûgen* is tying the wounded man's head to a tree to enable field surgery. Next to the wounded man lies his sword, war hat (*jingasa*), and musket, the latter inside its carrying case. On the march, muskets were covered in fabric to protect them from the weather. (*Zôhyô Monogatari*)

head and dressed in the style of Buddhist monks.[37] The shogunate (or, at its behest, the Imperial court) often awarded its medical practitioners priestly rank. Most or all doctors serving the shôgun or *daimyô* with revenue of over 100,000 *koku* belonged to this group and were accordingly required to wear priestly robes. Many others followed the practice, too, as priestly dress became synonymous with a high-class physician.

A doctor of medicine generally transmitted his knowledge to his son. The son was also usually sent to work under some great master in Kyôto

37 Philipp Franz von Siebold, *Nippon-Archiv zur Beschreibung von Japan und dessen Neben- und Schutzländern: Jezo mit den südlichen Kurilen, Korea und den Liukiu-inseln* (2nd ed. Würzburg: Leo Woerl's Reisebücher-Verlag, 1897), 1st vol., p.185.

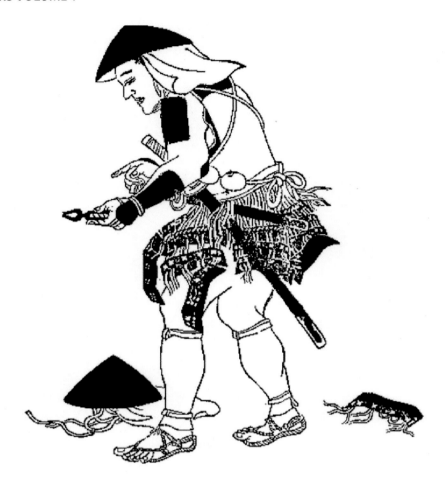

or another town. A Japanese doctor's skill was in most cases based on Chinese medicine, an art imported as far back as the seventh century. He was therefore an expert in the use of herbal remedies but knew little about surgery and anatomy. Despite this, the herbal remedies were, as in China, not to be scoffed at. Not every ailment could be cured, but those that were known, and especially internal ailments, could sometimes be treated with some success. Some herbal remedies remain in current use today.

The various herbal remedies prescribed by a physician were also prepared by him. He grew the plants in the small garden attached to his home.

The physician naturally also had to have some experience in the treatment of human-inflicted wounds. Sword-wounds, in particular, seem to have been common. Physicians might specialise in this or other fields. The fields of medicine were divided into internal medicine, considered the highest type of medicine, and a host of others, including herbal lore, women's medicine (obstetrics and gynaecology), children's medicine (paediatrics), eye medicine (ophthalmology), dentistry, broken bone treatment, acupuncture, moxibustion,

massage, and combat medicine.[38] Various schools developed in each of the specialties. Surgery of the European variety, learned from the Dutch and therefore named the 'red-hairs' surgery' (*kômô geka*), also became increasingly common. Although traditional medicine regarded surgery as the lowest of all medical arts, the skill of European-trained surgeons was generally so superior that some became employed by the shogunate and the great lords.

The Dutch trading post in Nagasaki remained a source of knowledge of Western techniques of medicine, especially modern anatomy, throughout the Edo period. Several Dutch books of anatomy and medicine were translated into Japanese. The most influential of these was itself a Dutch translation, entitled *Ontleedkundige Tafelen* but in Japan traditionally referred to as *Tafel Anatomia*, of the German anatomical atlas *Anatomische Tabellen* (*Tabulae anatomicae*). This book, written in 1722 by the German physician Johann Adam Kulmus (1689–1745) was highly regarded in Europe and had been translated into Dutch in 1734.

The story of the translation of this important text began when the three physicians Maeno Ryôtaku (1723–1803), Sugita Genpaku (1733–1817), and Nakagawa Jun'an (1739–1786) noticed the differences between the anatomical illustrations in the European work and those in traditional works of Chinese medicine. In 1771, several doctors including Maeno and Sugita attended the dissection of a beheaded 50-year-old female criminal at the Kozukappara execution grounds. They were amazed by the accuracy of the Dutch anatomy text, two copies of which they had acquired earlier the same year, when they found that the book had illustrations showing the interior of the human body to be exactly the same as what they observed during the dissection. They thereupon decided to translate the book. Somewhat later Sugita also acquired another book on anatomy, the *Anatomia Nova* written by the Danish scholar Caspar Bartholin (1585–1629). Elements of this, including the title, were incorporated into the translation.

The translation was no easy task. Maeno knew only some elementary Dutch, Sugita even less. Together, they knew perhaps 700 Dutch words. Several others joined the translation team, and eventually – with the help of Bartholin's book – an abridged Japanese version of the work was published as the *Kaitai Shinsho* ('New Text on Anatomy') in 1774.

The translators wrote in a type of variant Chinese known as *kanbun* (see below), used by the Japanese intelligentsia in much the same way as Latin was used by European scholars. Although this was the language expected of Japanese literati, it seems as if the team expected the translation to be read in China as well.

The *Kaitai Shinsho* provided stimulus to a revival of interest in Europe long suppressed by the shogunate, and greatly encouraged Japan's *rangakusha* (students of Western learning (*rangaku*); extracted from *Oranda*, meaning Holland, which was the common name for anything European).

European medicine was at first often treated with suspicion. The turning point in most domains may have been the successful introduction of

38 Siebold, *Nippon* 1, pp.184–85.

vaccination in 1849. The rapid success of vaccination led to the establishment of a number of vaccination centres, that soon turned into schools of Dutch medicine. By 1857, even the shogunate, which had periodically (and as recently as 1849) forbidden most practice of European medicine, advertised widely in Edo for volunteer physicians to journey to the northern island of Ezo (now Hokkaidô) to vaccinate the Ainu population. The latter by then suffered severely from smallpox.[39]

The Chinese and European medical traditions were not seen as completely incompatible. It was not unusual to combine *ranpô* (Dutch medicine) methods and *kanpô* (Chinese medicine) techniques. However, a doctor of Chinese medicine (*kanpôi*) was less likely to do so than a student of European knowledge. By the end of the Edo period, the best physicians were using an advanced combination of (mainly) Chinese methods, modified in Japan, with European techniques. In some cases, these physicians may well have been ahead of their Western counterparts, as it is only in recent years that the usefulness of Chinese herbal remedies have attracted attention among Western physicians. The first modern example of the removal of a tumour using anaesthetic (datura, or mandrake) took place in Japan in 1805, performed by the surgeon Hanaoka Seishû (1760–1835).

Medicine was commonly taken in the form of powders or salves. Most people had individual formulas, worked out to suit one's personality. A townsman usually carried a supply of such medicine with him in a small lacquer container (*inrô*) fastened with a silk cord and secured by a small toggle (*netsuke*) to his sash. In 1601, the Spanish Franciscan missionary Fray Pedro de Burguillos described how the Japanese 'were accustomed to carry small amounts of medicine about with them at all times, each pill, powder or salve for a different ailment, and each in its own portable flask or box.' He also pointed out that 'the people of Japan were enthusiastic users of such salves'. This must have been true; João Rodrigues, a Jesuit and therefore a rival of the Franciscan, also points out that 'the Japanese are very fond of taking medicines'.[40] Saikaku mentions that 'anyone could tell a man's occupation and place in society by the kind and size of *inrô* medicine case he carried with him on his sash'.[41]

Most drugs were of vegetable origin, although drugs of mineral or animal origin did exist. They were generally made of common materials, and administered in small doses. The drugs were mixed according to various formula, often employing 10 or more ingredients. The doctor then prescribed the drugs either singly, or in combination for a specific symptom. There were firm rules for how to examine the patient, and there was an awareness of the need to properly examine the physical and mental condition of the patient

39 Chinese physicians had developed the first inoculation method against smallpox in the tenth century. The technique later spread from China to Turkey, where Europeans first became acquainted with it. However, the method never seems to have reached Japan directly from China.

40 Rodrigues, *This Island*, p.50.

41 Ihara Saikaku, *The Life of an Amorous Man* (Tôkyô: Charles E. Tuttle, 1964), p.152.

Fig. 228. The blind masseur at work on a well-to-do client

before any medicine was administered. A total of 100–200 different drugs were generally used.

Most medicine was inexpensive. One famous medicament, the *shikinko* ('purple-gold salve') from Seikenji in Suruga province, was around 1707 peddled throughout Japan in small shells. One shellful of salve traded for between 12 and 20 copper *mon*, or about the same as a cheap meal.

Sometimes no doctor was needed. The common cold, for instance, was often treated with garlic and rice gruel, and sake mixed with ginger. Garlic is nowadays recognised as beneficial for this purpose.

Other types of medicine were practiced by different specialists. In the evening, the masseurs, who were usually blind, could be seen on the street, in search for customers. Such a blind masseur often carried a stave and also played a flute for easy recognition. He usually also shaved off all his hair, like a Buddhist monk (Fig. 228). The art of massage (*anma*) was highly developed, and originally derived from China. Various schools appeared in the Edo period. Treatment varied from a quick tapping and kneading of the shoulders to relieve fatigue and strain – a method well known to almost anyone – to a full-scale massage, consisting of pummelling and stretching. Jippensha Ikku reports that a massage cost 50 copper *mon* in the 1800s, and because of copper depreciation the price was most likely lower in earlier times. Part of the art of massage was moxa treatment (*kyû*). Moxibustion consisted of cauterisation by means of cones of dried moxa herbs (*mogusa*,

or *Artemisia vulgaris*). The treatment was generally believed to take care of not only aches and pains but also certain illnesses.

First, a pinch of the vegetable powder was placed on one or more specific spots on the body. The cones of powder were then set alight. Moxa treatment, like most medical knowledge imported from the Asian mainland in the sixth century, was based on the same principles as acupuncture, which was also in common use. Acupuncture (*hari ryôyi*, or simply *hari*) used fine silver needles driven deep into the same carefully chosen spots of the body. Both methods were considered especially effective for muscular trouble, and both methods are still widely used today. Treatises on acupuncture advocated boiling the needles before use. Wounds were also at times cleansed with vinegar. As in Europe, however, precautions against infection were otherwise not fully understood.

Moxibustion produced visible scars, and the method was not exactly painless. The popular writer Saikaku describes a typical treatment session:

> It was fall, and a bitter storm one night set Moemon to thinking how he might fortify himself against the rigours of winter. He decided on a treatment of moxa cauterizing. A maidservant named Rin, who was adept at administering the burning pills, was asked to do the job for him. She twisted several wads of the cottony herb and spread a striped bedcover over her dressing table for Moemon to lie on.
>
> The first couple of applications were almost more than he could bear. The pain-wracked expression on his face gave great amusement to the governess, the house-mistress, and all the lowly maids around him. When further doses had been applied, he could hardly wait for the final salting down which would finish the treatment. Then, accidentally, some of the burning fibres broke off and dropped down along his spine, causing his flesh to tighten and shrink a little … Moemon closed his eyes, clenched his teeth, and mustered up all his patience to endure the pain.[42]

At the end of the cauterisation, salt was always placed on the treated area and a final quantity of moxa burned over it to prevent infection.

Medicinal baths were also used. So were massage-related treatments, such as relieving foot fatigue by treading on sections of bamboo, and dry towel massage, still commonly believed to strengthen one's body against cold weather.

Medicine shops (*kusuriya*) appeared in the large cities, but peddling was a more common means of selling medicine. This was originally a part-time occupation practiced by farmers during the slack season. In later years, itinerant peddlers of medicine from Toyama became particularly well known. Indeed, they established a nationwide sales distribution system. Each carried a medicine box on his back, wrapped in light green or dark blue cloth marked with their place of origin, Etchû Toyama, and typically also the name of their most popular product, often a digestive aid known as *hangontan*.

42 Saikaku, *Five Women*, pp.129–30.

Upon his first visit, the peddler left medicine in the customer's home. The next year he returned, calculated the amount actually used, received payment, and replaced the used products.[43]

Peddlers known as *jôsai uri* travelled throughout the country, selling pills that were popular as antidote to summer heat exhaustion. Such pills were very well liked, as it was – not without some truth – generally believed that excessive summer heat was hazardous to one's health.

Dentists (Fig. 229) were also available in Edo. Tooth extraction was commonplace – perhaps because of the sweet tooth of most Edokko. Wooden dentures were made to order. The renowned novelist Takizawa Bakin, for instance, had serious problems with his teeth and vividly described his misfortunes while waiting for his new wooden dentures.

A special mention must be made of the *daruma* doll. This is a papier-mâché doll representing the Indian priest Bodhidharma (Bodaidaruma or

Fig. 229. The dentist at work

Daruma in Japanese). He was the founder of Zen Buddhism in China, and was said to have lost the use of his arms and legs after spending nine years meditating in a cave. The *daruma* doll is therefore a rounded amalgam of head and body, without arms or legs, and with two large spaces for eyes. The doll is usually painted bright red and white. When tipped over, the doll always returns to an upright position because of its shape. The first *daruma* dolls appeared in the sixteenth century, and they were known as *okiagari koboshi* ('the little priest who stands up'). The doll received its present shape in the Edo period, when it was originally regarded as a talisman for protection against smallpox, by then a dreaded disease. Soon the *daruma* doll found more general uses. It became used as a charm for the fulfilment of any wish. One eye, usually the left, was painted in with black ink upon making the wish, and the other eye was painted in gratitude when the wish was fulfilled. The *daruma* doll was customarily kept in the family shrine.

Because of the vitamin-free diet of most Edokko, beriberi was another common illness. A popular belief was that it could be cured by wishing hard while at the same time touching the bars of the gates between the town neighbourhoods. This was but one of many Edo superstitions. Another said that holding the railings of Nihonbashi Bridge would cure whooping cough. Kyôbashi Bridge, on the other hand, was said to have a similar effect on headaches. A hackberry tree on the south bank of the Tameike was famous for curing toothache. If the prayer worked, you planted a toothpick at its roots. Many temples were well-known for their ability to produce miraculous

43 In modern Japan, nearly 30,000 medicine peddlers remain active in Toyama and other rural areas.

cures of various ailments, usually by touching or washing the corresponding body part of a Buddha statue. In a real emergency, for instance during a thunderstorm, the Edokko could resort to the final remedy: to press one's navel as a counteracting spell. This, at least, has been suggested as the explanation for the Japanese belief that the thunder god Kaminari ('Thunder') could snatch away your navel during a thunderstorm.

Logistics, Transportation and Shipping

Logistics

The shogunate administration operated a well-functioning civilian logistics system. The provision of rice and some other supplies were under government control already in times of peace, and there were facilities for transporting the commodities to wherever they were needed. On the few occasions when the shogunate had to mobilise military force, such as during the Shimabara Uprising, the civilian logistics system was used to provide rice subsidies to the participating *daimyô*. Yet, logistics for other supplies, including gunpowder, spare weapons, and additional food supplies, had to be handled by each lord separately, according to his own means and ability. We have seen that most armies brought supplies from home, and when these ran out, they had to live off the land, unless the civilian logistics system could cope. Each soldier carried his own rice supplies. There were no dedicated structures for military logistical support beyond the valets and the occasional quartermaster of the supply train. Merchants and sutlers would seek out the army to sell foods, but in a crisis, they might run out of merchandise to sell.

The actual delivery of supplies to an army in the field was often difficult, since there were no wheeled vehicles and only limited numbers of pack horses. As a result, the road network, which was extensive, primarily carried foot traffic. The emphasis on foot traffic was particularly noticeable in Edo, which was a city of pedestrians. The city's entire structure was based on pedestrian rather than vehicular traffic. However, walking was, by far, the most common means of transportation not only within Edo but also in the provinces. Indeed, the great coastal 'Eastern Sea Road', the Tôkaidô, was the busiest road in the world, as it ran between three of the world's largest cities: Edo, Kyôto, and Ôsaka. Yet, it too primarily carried foot traffic.

The Tôkaidô was the chief of the Gokaidô, the five major roads to the provinces that radiated out from Nihonbashi in Edo. The other four were the Nakasendô, the Kôshû Kaidô, the Nikkô Kaidô, and the Ôshû Kaidô.[44]

The Tôkaidô, Nakasendô, and Kôshû Kaidô were the oldest. The Tôkaidô covered a total of 514 km, running from Edo by way of Kanagawa, Totsuka, Odawara, and Hakone westwards to Nagoya and eventually to Kyôto, from whence it extended to Ôsaka. A branch led to the great shrine at Ise.

44 Today, the name Tôkaidô remains in use, but is currently reserved for the main line of the railway following the same route. Some of the other highway names remain, too, but today merely denote streets in Tôkyô that follow the former beginnings of the old highways.

Fig. 230. A draft horse wearing straw sandals; right, the horse's straw sandal.

There were 53 post stations on this highway between Edo and Kyôto, as immortalised in Hiroshige's famous series of woodblock prints.

The Nakasendô ('Central Mountain Road') covered a similar distance, but ran from Edo through Musashi Province to Shinano Province (now Nagano Prefecture) until it joined the Tôkaidô at Kusatsu near Kyôto. This road saw little traffic, compared to the Tôkaidô, as it ran through the Japanese Alps. It was already constructed in 702. The distance from Edo to Kyôto was 542 km. The road counted 69 post stations.

The Kôshû Kaidô ran from Edo to Hachiôji, after which it passed through mountainous country, often at a high altitude, via Kôfu to join the Nakasendô at Shimo Suwa on Lake Suwa in Shinano. The distance from Edo to Kôfu was 139 km.

The Nikkô Kaidô and the Ôshû Kaidô followed a common route before branching off at Utsunomiya. The Nikkô Kaidô then continued to the shrine Tôshôgû at Nikkô, mausoleum of Tokugawa Ieyasu, covering 146 km. The Ôshû Kaidô went on to Shirakawa in Mutsu Province (now Fukushima Prefecture) and eventually to Aomori in the same province (now Aomori Prefecture). This route was the longest, 786 km, and with 87 post stations between Edo and Aomori.

No wheeled carts were seen on the roads. Carriages drawn by oxen were only allowed for military use and by the Imperial court, and although sometimes seen in Kyôto, they were not much seen in Edo. Two-wheeled carts were pushed and pulled by bearers, again often for military use. Wheeled vehicles were otherwise used only on special occasions, and never on the highway, for instance when carrying huge stones for castle walls. Although wheeled carts, or floats, were sometimes pushed and drawn by crowds of townsmen during the popular festivals, they were never used for commercial purposes and had indeed a fixed wheel-base, making turns difficult. Besides, the highways were often too mountainous to permit wheeled vehicles.

The parking of horse-drawn carts by the roadside was strictly forbidden, as the crowds caused continuous traffic congestion even without carts.

As a curiosity, it may be mentioned that traffic in Edo was expected to pass on the right side when meeting other traffic. The reason was that a man always was supposed to move aside to the right when meeting a man worthy of respect, whether walking, riding on horseback, or travelling in a palanquin. The left-hand side was regarded as more noble and honourable than the right.[45]

Most roads were bordered with trees. The roads were frequently very crowded, and along all major routes numerous salesmen dealt their goods out of roadside booths. Among these special mention should be made of the vendors who made and sold straw sandals, either for men or for animals such as horses and oxen (Fig. 230). These animals used no other type of shoes, and straw sandals needed frequent replacement.

The rural main roads fulfilled another purpose in addition to facilitating travel. A system of checkpoints (sekisho), probably more than 70 throughout the country, was established to keep a wary eye on every traveller. To attempt to evade a checkpoint was a serious offence. However, there were back roads (ura-kaidô) which bypassed the checkpoints, and locals could usually be found who for a fee would guide travellers around the checkpoints.[46]

The main reason for this vigilance was of course the shogunate's fear that a great lord would secretly move his hostage family out of Edo, or that weapons, especially firearms, would be brought into Edo in preparation of a revolt. Strict rules described exactly how many retainers any high-ranking samurai or lord was allowed to bring with him in his retinue. Women and children were not allowed to leave Edo without submitting to rigorous controls. The dangers to watch for were, 'guns going in, women coming out' (irideppô deonna).

To pass through a checkpoint, a domestic passport (sekisho tegata) was required. These were generally issued only when a trip was necessary, although members of certain social classes had an easier time receiving one than others. Farmers basically had no right to travel. An approved exception was always the pilgrimage, however, and almost anyone could go on such a trip if he or she had sufficient funds. Passports were issued by the warrior clans for their members, by the headmen of some farming villages, and by the chief priests of parish temples for most other people who needed one. The popular writer Jippensha Ikku reports that in the 1800s, a travelling permit cost 100 copper mon. There were certain exceptions to the need to acquire a domestic passport. Neither men nor women travelling to Edo from the west needed passports. On the way from Edo, however, only hatamoto, retainers of the three branches of the Tokugawa family, and male entertainers (geinin) were exempt.

45 Driving on the left, which Japan currently observes, was enforced only after the Edo period, presumably in imitation of Britain.

46 Plutschow, *Reader in Edo Period Travel*, pp.23–5.

The main roads were also divided into stages, at each of which was located a post station (*shukuba*). This post station, the responsibility for its upkeep imposed upon the local farmers, provided horses and porters as far as the next stage. The post station system was administered by a special government office. The shogunate entrusted the carrying of messages of extreme importance to officials, sometimes high-ranking samurai, who had to travel in palanquins (see below). Others might also be entitled to travel by palanquin. The palanquin carriers, too, were relieved at the post stations.

Horses, Porters, and Palanquins

On longer trips, those travellers who could afford it rode horses. Below the samurai class, however, few men had any riding skills, so it was customary to hire not only the horse but also an attendant, who would lead the horse so that the rider did not need to worry about falling off. While hiring a horse and attendant in this way was by no means cheap, it was always cheaper if one found an attendant who was making the return trip without a paying passenger. At such times, attendants were known to actively search out potential patrons, offering cheap fares back to their home post station.

Kaempfer mentions the rate for hiring horses (and attendants) at a post station. A riding horse with luggage bags cost 33 copper *mon* a mile. A horse which was only saddled cost 25 copper *mon* a mile. This can be compared to the cost of hiring porters and palanquin carriers, which cost only 19 copper *mon* a mile.[47] An individual porter could be expected to carry baggage of up to 20 kg, the officially fixed limit on the major highways.

Horses were typically saddled for three riders, even if only used by one or two. It was also possible to ride in luggage baskets on both sides of the horse, with one's bedding and other goods packed behind.

Pack horses and pack-oxen were also important for transporting goods, as only they could ascend and descend the often very steep mountain roads. Such animals were rented in a similar way to riding horses.

Less comfortable but more prestigious was to travel in a palanquin. There were several different types of palanquins, with strict restrictions on who was allowed to use each type. Elaborate palanquins called *norimono* were used only by people of high rank, and this was strictly regulated. The *norimono* had sides decorated with lacquer and windows that could be closed with blinds. The roof was shaped as a house-roof, and the entire construction was suspended from a long pole carried on men's shoulders. There were several subdivisions of *norimono*, according to the length and shape of the carrying pole, the mode of holding it, the pace and number of bearers, and the like.

A traveller of lower rank was sometimes carried in a less elaborate palanquin known as *kago* (Fig. 231). This was a palanquin shaped like a simple box suspended from a carrying pole. Not everyone was permitted even this luxury; its use was restricted to the upper classes. Commoners were prohibited from riding in palanquins without permission. Exception was generally only made for physicians, astrologers, persons over 50 years of age, and invalids. These exceptions were not new in Edo; they had been enforced since palanquins came into use during the Middle Ages.

Simpler types of private palanquins (*shikago*, also known as *machikago* or 'town palanquins', *tsujikago* or 'street-corner palanquins' or in the entertainment quarters, '*hoi*'-*kago*) were used by commoners. They were, at least from 1720 when the Edo authorities so ordered, open to weather and wind, and had no window blinds, or even sides. Although licensed from 1677, such *kago* were numerous, especially after 1716, when the authorities gave up their attempts to curb the number of *kago*. The number had previously been restricted to 100, and most commoners had been forbidden to ride until 1700. These were not only used within Edo and the other cities and towns, but could also be seen on the roads between towns, together with the *yamakago* ('mountain-palanquin'), of stiffer construction made of a rigid bamboo frame.

The palanquin, of whatever variety, was carried by two men, who ran with a distinctive stiff-legged gait, grunting rhythmically to keep up pace. To sit in such a palanquin carried at speed – especially during a long-distance trip – was a most uncomfortable experience. The passenger had to gird his middle in several metres of cotton cloth, which was then looped through the

47 Kaempfer, *History* 2, 419.

roof and fixed to the carrying pole that ran through the top of the palanquin. He then had to hold on to this strap, often also wrapping another length around his head, to save himself from the worst of the splitting headache which generally followed. The traveller did not dare fall asleep, as to relax his grip might cause him to tumble out of the palanquin.

These precautions were hardly sufficient, however, and it was common to also put a handkerchief or other piece of cloth in one's mouth to avoid damaging the teeth from the horrible and persistent jolting of the palanquin. In addition, the passenger was so stiffened by the rigours of this means of transportation that some are said to have been unable to let go of the strap after finally reaching their destination.

The inconvenience of riding a palanquin at speed was the same for all types, including those used by the upper classes. It is, indeed, difficult to imagine a more uncomfortable means of transportation. However, the dignity of certain officials prevented them from riding horses, as this would have reduced them to the level of mere messengers.

As a further disadvantage, many of the men who worked as palanquin carriers were rough and unreliable characters. While they would not dare to interfere with the shôgun's officials, lower personages had to take care. The palanquin carriers were known as *kumosuke* ('cloud men'), as they drifted like clouds with no fixed abode. They had no compunction in overcharging a customer, and the fare always had to be haggled over before or even during the ride. The palanquin carriers also invariably asked for drink-money over and above the stipulated fare, especially if kept waiting at a tea house or when engaged for a pleasure trip.

Fig. 232. A ship (*higaki kaisen*) of the Higaki ('Diamond Bulwark') Line. The mast has been folded down.

Shipping

Although the merchants of Edo were important, the amount of trade handled by them was greatly exceeded by those of Ôsaka. This was especially true of rice, but also of most other commodities such as sake, soy sauce, cotton, vegetable oil, indigo, and so on. It was thus very important to provide transportation for all these goods to Edo.

The great Tôkaidô road has already been mentioned. Shipping was of even greater importance, following a number of coastal routes around Japan. Overland transportation could after all only take as much goods as could be carried on men's shoulders and the backs of horses and oxen. The stability of the Edo period led to the development of the older, interconnected coastal sea routes into a smaller number of single, though longer, voyages. Rice remained the most important commodity for shipping, followed by *miso*, charcoal, salt, sake, soy, oil, cotton goods, and haberdashery. From the late eighteenth century, timber and dried fish, products increasingly derived from the northern island of Ezo (now Hokkaidô), also rose in importance. Salt, especially, was transported by ship, river, and land routes throughout Japan.

Shipping was, like everything else in Edo period Japan, a highly organised business. The ships were known as *kaisen* ('circuit ships'), as they followed fixed routes. Two main shipping lines dominated shipping between Edo and Ôsaka. One was known as the Higaki ('Diamond Bulwark') Line. This line started operations in 1619, and got its name as its ships (*higaki kaisen*) were fitted with bulwarks of bamboo poles arranged in diamond shape, to prevent the cargo from falling overboard in bad weather (Fig. 232). The other main shipping line, the Taru ('Barrel') Line, started operations around 1660. The line got its name as it began business by shipping sake from important sake brewing towns such as Nishinomiya to Edo, in ships known as *tarubune* or *taru kaisen* (Fig. 233). The goods were packed in barrels.

Fig. 233. A ship of the Taru ('Barrel') line under full sail

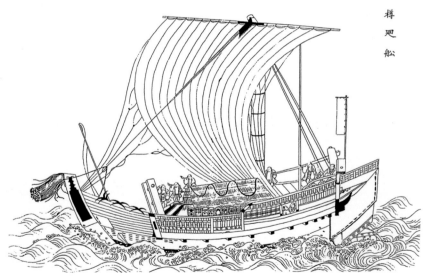

Both lines were operated in conjunction with dedicated warehouses – 24 purchasing agents in Ôsaka and 10 wholesale stores in Edo – where goods were received for transport and, at their destination, waited for collection. In the 1770s, agreements were made with the government that in return for a nominally voluntary annual contribution, known as 'gratitude-money' (*myôgakin*), the two lines acquired a duopoly on shipping between Ôsaka and Edo. The Barrel Line received a monopoly on shipping sake; rice, bran, indigo, noodles, vinegar, soy sauce, and wax candles could be carried by either line;

and the Diamond Bulwark Line obtained a monopoly on all other goods. As trade was brisk, the granting of this arrangement and the gratitude-money received amounted to a considerable annual income for the shogunate.

This duopoly continued until the 1830s, when the controls were removed. For the next decade, the two lines were each staging a sort of race in the Eleventh Month of each year. The Barrel Line ships carried new sake, and the Diamond Bulwark Line vessels carried silk. The first captain to reach Edo gained a substantial bonus and also various privileges for his ship for the next year. Eventually, the Barrel Line grew supreme and assumed control over most shipping between the two cities. Other coastal lines and vessels also served Edo from other locations, carrying not only goods but also passengers.

Another important maritime trade was smuggling. Smuggling took place on a large scale, regularly and continuously throughout the Edo period. Foreign contacts were strictly forbidden by the shogunate, and strict controls over the production of new vessels were introduced in the seclusion policy of 1635. Among other rules, this act specified maximum size and seaworthiness of the vessel. Kaempfer summarised the situation: 'In short the whole structure is so weak and thin, that a storm approaching, unless anchor be forthwith cast, the sails taken in, and the mast let down, it is in danger every moment to be shatter'd to pieces and sunk.'[48]

The law also required the ship to be unnecessarily weak about the stern – where the ship according to the act had to be open to the sea, a fact that often caused leaks in rough weather – and the rudder to be so hung that a rough sea would almost certainly unship it. These rules were designed to make it dangerous to venture far out at sea. As the Dutchman Overmeer Fisscher concluded: 'a pretty effectual device for preventing the voluntary undertaking of long voyages, though its humanity may well be questioned.' Numerous Japanese fishing boats and coastal vessels were routinely lost with all hands, but this was deemed to be of little consequence as long as foreign goods and ideas was kept off the coasts.

Nonetheless, smuggling brought in foreign goods, especially from China. Most of the smuggling took place in the far west and south, as far away from Edo as possible. Foreign ships either had clandestine meetings with local ships, or larger Japanese fishing vessels proceeded all the way to China by way of the Ryûkyû Islands. The latter served as meeting place for Chinese traders and merchants from Satsuma, the southernmost province of Kyûshû. This trade, although strictly speaking illegal, was supported by the Shimazu clan of Satsuma. Smuggling was also rampant in the far north, where the lords of the Matsumae clan of Ezo (now Hokkaidô) supported clandestine trade with the Russians of Kamchatka and the Kurile Islands. Some smuggled goods eventually found their way to Edo.

Warships were often given names ending in the suffix -*maru*. The word *maru* means literally 'roundness', 'circle', or 'completeness'. In ancient times, *maru* was added at the end of the names of persons of noble birth, particularly those of first sons, and also to the name of a stronghold or keep of a castle.

48 *Ibid.*, p.409.

With the same meaning of preciousness and security, the favourite ship constructed by a great lord – regarded as his floating castle – also received *maru* as suffix. Later, the suffix *maru* came to be applied to all commercial vessels, a custom that continues to this day.

In Edo as elsewhere in premodern Japan, the waterways were the principal means of carrying goods. Many canals were built for the purposes of transportation, water supply, and flood prevention. The waterways were also used for passenger transport. Downtown Edo had many rivers and canals, and boat transportation was quite popular. To go by boat was much quicker than walking or taking a palanquin.

Most popular, especially for trips to the Yoshiwara entertainment quarter, was the water taxi, a small, fast boat propelled by a scull at the stern which enabled it to make sharp turns. Such a boat was known as *chokibune* ('boar-fang boat'). It was quite small, and only able to carry three passengers at most. Its speed depended on the boatman's skill. Boatmen, especially in Fukagawa, were proud of themselves for their mastery and experience and enjoyed showing off. A wastrel could hire two or three oarsmen to reach Yoshiwara faster. Each time his boat overtook another, slower boat, the extravagant passenger put down a piece of paper. On their return to the boathouse, the boatmen could exchange each piece of paper for a tip. The wastrel, meanwhile, enjoyed his reputation as a big spender.

Fig. 234. Inside the public
bath house

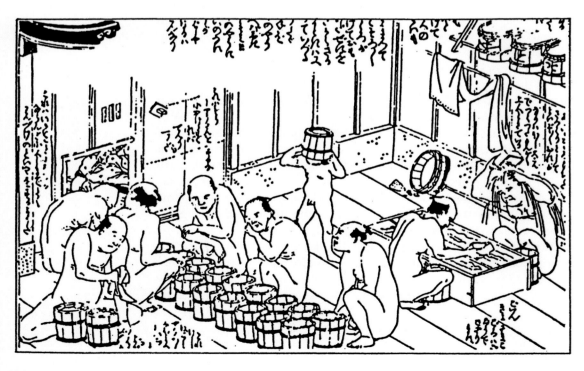

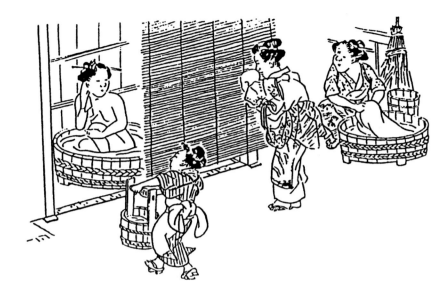

Fig. 235. A woman washing herself in the *gyôzui* bath, a temporary wooden bath tub inside the house. Next to it, another woman is washing some clothes.

Other Public Services

The Public Bath and Daily Hygiene

In ancient times, the Japanese – and especially the nobility – had frequented steam baths (*furo*) instead of hot water baths (*yu*). Outside the ranks of the nobility, however, this practice had disappeared by the beginning of the Edo period and the Edokko craved hot water.

Only a very large town house had its own bath. Accordingly, even many samurai and wealthy merchants frequented the public bath house (*yûya* or *sentô*). The first public bath house was said to have been built around 1591 by a man from the province of Ise. Soon, the town public bath houses turned into places of ill repute; after the mid seventeenth century, however, they had changed character and were regarded more as an essential public service (Fig. 234). In the middle of the seventeenth century, there were reputed to be 500 bath houses in Edo. In 1810, there were at least 523 and possibly 600 such establishments in the city.

The great lords and the higher *hatamoto*, as well as a few wealthy merchants, had private baths at home. So did the temples and shrines, but for the use of monks and priests only. Luxurious inns and restaurants also had private baths, but they were only for the use of customers, as a bath was part of the services provided.

For an ordinary family, the public bath house cost a lot. By the early seventeenth century, many establishments required each visitor to pay 15 or 20 copper *mon* upon entering. Even in a cheaper place, a bath cost from seven to eight copper *mon*. Therefore many commoners instead often had a *gyôzui* bath at home, that is, washing or cooling down in a temporary wooden bathtub inside the house or more often outside in the yard (Fig. 235).

In the early years of the Edo period, men and women often bathed together. However, precautions were taken to avoid embarrassment. Most important was the fact that men customarily wore their loincloth and women

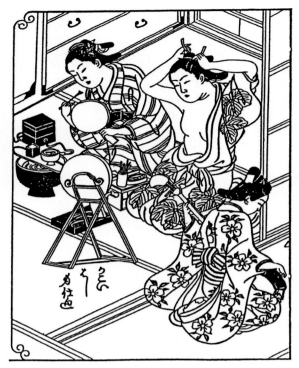

Fig. 236. Daily hygiene. The woman to the left is cleaning her teeth with a tufted toothpick (*fusayōji*). Another is arranging her hair with the help of a mirror on a mirror stand (*kyôdai*).

their underskirt even in the bath. Alternatively, they changed into special bathing underwear. In addition, the bath house building itself, or at least the part where the preliminary washing and communal soaking took place, was in almost complete darkness.

Later in the Edo period, it became more common to have separate facilities for men and women. From 1791, this became mandatory in Edo. Although all bathers shared the same large hall, a partition wall separated the sexes. The partition wall did not reach the ceiling, so it was both possible and common for a couple to hold a conversation across the partition wall, without being able to see each other. Some of the large bath houses could hold 100 or more bathers, so the level of noise can be easily imagined.

In Edo, there were also floating bath houses aboard boats (*yubune*). Another possibility was to have a tub of bath water brought to one's house (*ninaiburo*) and heated there.

At the entrance to the bath house, the cashier sat at a wooden stand (*bandai*). Special services, such as having a servant wash one's body, or warm medicine in winter, could be ordered from the cashier in some establishments. Many bath houses had two floors. On the second floor, patrons could buy tea and sweets, or even entire meals, relax by charcoal braziers, smoke pipes, and play boardgames such as *Go* and *Shôgi*.

Inside the bath house, one first had to undress. A square cloth (*furoshiki*) was used for spreading on the floor while undressing and for wrapping bathing articles before and after the bath. The wet underclothes used in the bath were also carried back home wrapped in this cloth. Valuables could be put in a locker or strong-box, the key to which was often carried tucked into one's hairknot.

In former times, it appears as if the nobility had used large *furoshiki* to sit on while inside the bathtub, so as not to touch the tub itself. This was probably a matter of religious purity rather than hygiene, and in any case, this ancient custom was dead in the Edo period. The practice may explain the word *furoshiki* (compounded of *furo* = bath and *shiki* = a nominal form of the verb 'to spread', 'to lay out'), however, as this piece of cloth during the Edo period also, from about 1740, became used for carrying a wide variety of other articles, which had nothing whatsoever to do with bathing.

After the bath, the Edokko did not use a large towel for drying. Instead he used a *tenugui*, a piece of cotton cloth about 20×60 cm or slightly bigger. This cloth was used wet, for rubbing the body and then wringing out the water. This naturally did not leave the bather quite dry, something considered acceptable as the remaining moisture was taken by the clothes. During the hot and humid summer, this indeed brought a pleasant coolness. In winter,

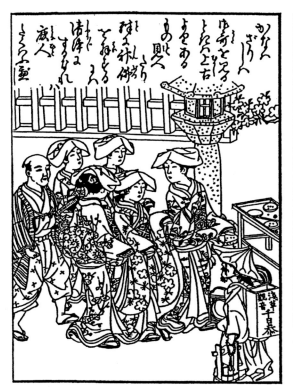

it was instead customary to go straight to bed after the bath so as to conserve the warmth one's body had acquired.

In the morning, the Edokko went to the communal well to wash his or her face and clean the teeth (*hamigaki*). For the latter purpose, a tufted toothpick (*fusayôji*, meaning 'willow-tree branch') was used (Fig. 236). Such toothpicks had been introduced from China already in the sixth century, said to have been used by the early Buddhist monks who came from India by way of China. The wood used could be willow, but also cranberry tree, peach tree, bamboo, or Japanese cedar or cypress, as these woods produced a pleasant aroma when chewed. To clean the teeth was regarded as essential for daily hygiene. The average tufted toothpick was 12 cm long, although the length could vary from nine to as much as 30 cm. The toothpick was beaten on the edge to form a tuft approximately two centimetres in length. The central part was cut in a square shape to facilitate holding and handling. The non-tufted end was slightly tapered, for the same reason.

Special shops (*yôjiya*) made these implements, and competition was keen. Beautiful young women were employed as workers in the manufacturing process to attract customers into the shop (Fig. 237). These tufted toothpicks were also for sale in the houses of assignation in the pleasure quarters of Yoshiwara. The courtesans frowned on a customer who did not buy one from their house in the morning, as this indicated that he did not plan to become a regular customer.

A smaller type of toothpick (*tsumayôji*) also existed in Edo, together with various other articles of dental hygiene. Dental hygiene was considered

Fig. 237. A beautiful young woman, enjoying a pipe instead of manufacturing more toothpicks, is attracting a samurai into her shop. To her left, a display of toothpicks and related implements.

important and apparently practiced by most well-to-do Edokko. There was indeed a proverb saying that 'a samurai who has not eaten will still have a long toothpick in his mouth.' In an old geisha song, the girl admonishes her lover: 'You get on my nerves, always chewing your toothpick.'[49]

As toothpaste, a special polishing powder, known as 'sand from Bôshû' (*Bôshûsuna*) was used, mixed with water and blended with another toothpowder scented with musk. (Bôshû was an alternate reading of the name for Awa Province, now Chiba Prefecture). Salt, and/or camphor was also added to the mixture. Other mixtures were also used, all of them based on sand or other strong abrasives. Bright white teeth were the fashion among men. Unfortunately, these polishing powders had a tendency to wear away the enamel, causing premature loss of teeth.

Married women instead blackened their teeth. Tooth-blackening (*nesshi*) was a daily practice for most women, as the black colour wore off after a while. This resulted in rather grey teeth with ugly, blackish stripes between them, so no conscientious woman would blacken her teeth less often than once every three days.

The liquid used for blackening one's teeth was called *ohaguro* and obtained from a preparation with a ferrous acetate base, made by soaking bits of iron – commonly nails – in a mixture of tea, sake, vinegar, and other ingredients. The metal's oxidation produced a black liquid. As this solution also could discolour the lips and the gums, as vividly described by Thunberg, the process of blackening one's teeth had to be carefully accomplished.[50]

Because of the blackened teeth, women brushed their teeth with plain salt. The *ohaguro* liquid contained tannin, which prevented periodontal disease, and ferrous acetate, which helped to keep the teeth strong. In contrast to their menfolk, Edo period women enjoyed stronger and healthier teeth.

To acquire an artificially pale complexion, many women used a *nukabukuro*, a small cotton bag containing rice bran. This was moistened with perfumed water before washing the face and body while taking a bath.

Another, even more artificial way of acquiring a pale complexion was to use *oshiroi*. This was a white facial powder, made from white soil and rice flour. It was often worn in a quite thick layer.

To make the mouth look smaller, women made a red spot in the centre of the lower lip with a red paste (*beni*). This paste, obtained by crushing the flower petals of *benibana*, or safflower (*Carthamus tinctorius*), was kept in shells or small porcelain cups. Most women had *beni* in their make-up box. This box also contained bamboo or tortoiseshell combs, various tweezers, packets of black and white powder, hair or feather brushes, and sheets of thin paper to remove make-up.

The first example of a beauty aid offered for commercial sale, complete with prolific advertising, appeared in Edo. In 1811, a product named 'Water of Edo' was marketed with a clever catchphrase claiming it made facial powder

49 Ihara Saikaku, *Comrade Loves of the Samurai and Songs of the Geishas* (London: John Rodker, 1928. Reprinted in 1972 by Charles E. Tuttle, Tôkyô), p.125.
50 Thunberg, *Resa* 3, p.87.

stay on better. Women's toiletries, such as rouge, powder, and combs, but also mirrors and toothpicks, were sold in special shops known as *komamonoya*.

While on the subject of physical appearance, Saikaku describes how a woman named Onatsu dreams of a conversation with a god. The god replies: 'When people are sad they usually make such unreasonable requests that, deity though I am, I am unable to fulfil them. Some pray to be made rich overnight. Some covet other people's wives … Some even want the nose they were born with to be a little bigger.'[51] As yet another side note, the nose also indicated the personality of the Japanese. As the French Marquis de Moges pointed out: 'When the Japanese want to denote the self, their personality, they indicate their nose; the root of the nose is for them the seat of the individuality.'[52] This remains true in modern Japan.

Soap existed in Edo, but it was an expensive import item, imported from Europe beginning in the sixteenth century. It was customary to use bags of rice bran or fire ash instead.

In the country-side, numerous natural hot springs were also popular with bathers. Many people travelled there as the waters of certain springs were believed to have curative powers. Bad eyesight, rheumatism, and skin diseases were among the illnesses that were believed to be cured at these spas.

Lavatories and Latrines

Lavatories were private only in the houses of the very wealthy and in the inns, which had to entertain guests (Fig. 238). Ordinary people would go to the public latrines in their neighbourhood. As there were many tenants in these areas, the latrines were often very crowded. Although the latrines were individually separated, there was no possibility of privacy. The doors covered only the lower half of the openings, so that people could see from the outside whether or not the latrine was occupied (Fig. 239).

Toilet paper did not exist, so people instead generally used leaves, straw, or even chips of bamboo or wood to clean themselves.

Men never hesitated to urinate in public. In many busy places, there were no or at least an insufficient number of latrines. The great fish market at

Top: Fig. 238. The lavatory of the wealthy

Bottom: Fig.239. The latrine of the commoners

51 Saikaku, *Five Women*, p.67.

52 Le Marquis de Moges, *Souvenirs d'une Ambassade en Chine et au Japon* (Paris: L. Hachette, 1860), p.316.

Nihonbashi, for instance, had only two: one at the western end and another at the eastern end. This was hardly sufficient for the tradesmen and their customers, and there was absolutely no means of disposing of other waste. There was, for instance, no provision for collecting the waste fish guts; they remained in the street until they decomposed naturally or some fish dealer saw fit to clean up his own, individual section. There were no sewers.

The night soil of Edo, like that of other cities and towns in old Japan, was collected by farmers to use as fertiliser. In places like Fukagawa, on the outskirts of Edo, it was common practice for a tenement manager to make a deal with a certain farmer. The farmer then came regularly to collect the night soil by simply ladling it out of the cess-pits that directly underlay the holes in the floor that served as lavatories, paying the tenement manager twice a year for the privilege. In more crowded areas of Edo, such individual arrangements were hardly possible. Edo did, after all, have about a million inhabitants. There the local farmers had to compete keenly to receive the right to collect the night soil, often paying for it a year in advance. In other places, some people made a business of buying and distributing it to farmers. Such a person was known as *owaiya*, after his call of *owai owai* ('excrement'). He would come regularly, with his dippers and buckets, calling out repeatedly as he made his way through the streets. Where night soil collecting was big business, it was common to carry away the produce by a special type of boat or by horse. In the country, where distances were shorter, night soil was commonly carried in wooden buckets slung on a pole. Every village with a road passing through had tubs placed along the road for the use of travellers, so that nothing would be wasted in the wrong location.

The use of human excrement and urine was of considerable importance for the farmers. The manure was normally at first diluted with water, and then poured round the roots of the crops or trees to be nourished. It was generally not used for rice, however, as this crop depended mainly on dry fertiliser worked in when the fields were prepared.

There was a remarkable class difference in the price of night soil. Farmers were, apparently, willing to pay more for upper-class excrement. Where latrines were segregated by sex, the night soil from the men's latrine brought a higher price than the same product from the women's latrine. Whether this depended on a real awareness of the higher nutritional value of the product from the upper classes and the males (who after the frugal days of Tokugawa Ieyasu, as we have seen, were better-fed), or whether it was simply a Confucian belief in the superiority of the class system, is hard to say.

The use of night soil as manure was important, but it also spread diseases. Human intestinal worms, in particular, thrived under these conditions. Hygiene in Edo was not very highly developed.

Garbage Disposal

Garbage was recycled if possible. Woods, metal, and other scrap materials could sometimes be sold to traders who made period rounds to buy useful and recyclable junk. The Town Magistrate's Office controlled the recycling shops. There were specialised dealers in old clothes, steel, and antiques, and there were also pawn shops. All such shops were obliged to register with

the authorities to prevent competition. Certain rules and regulations were established on how to deal in secondhand items and junk.

It was fairly common to wear secondhand clothes. Some of the old-clothes dealers specialised in clothes from Kansai, western Japan, because as compared to the Edokko, Kansai people were renowned for happily spending large amounts on clothes of silk and high-quality cotton. These clothes, even when secondhand, were accordingly quite luxurious for most Edokko. Indeed, these traders sold secondhand clothes not only in Edo but also to the northern regions of Japan. Patchwork was also popular and common, and this was another means of recycling old clothes.

After a fire, numerous scroungers always gathered to search the area for usable remains. This included metal scraps such as nails, knives, and keys, which were gathered with tongs resembling a pair of enlarged 'chopsticks' (Fig. 240). Any remaining wood was collected for sale. The scroungers were sometimes ordered to clean up other areas, too.

Most trash, naturally, had to be discarded. Such garbage was put in a garbage pit, which usually looked like a wooden box without a cover (or bottom). When the pit became

Fig. 240. Cleaning the street

full, it was emptied and the garbage dumped in the sea as part of the land reclamation process.

Reclamation by such sanitary landfills has radically altered the landscape around Edo/Tôkyô. Beginning in 1603, land on the bay side of Edo Castle was reclaimed (with earth from the relatively high ground of Kanda) to house the growing population of commoners in the city. The first part of the city on the east side of the Sumida River to be reclaimed from the sea was part of what was to become Fukagawa. This land was reclaimed by the order of the shogunate in 1655. At that time, dry land in the area consisted only of the small island called Eitaijima, surrounded by marshes.[53]

[53] Today this is the location of the famous Hachiman shrine. So much land in the area has been reclaimed since the Edo period that it is sometimes difficult to remember that a major part of present-day Tôkyô is really built on garbage. The process is still ongoing, with artificial islands such as Heiwajima being among the more recent additions.

Bibliography

Primary Sources (Texts)

Alcock, Sir Rutherford, *The Capital of the Tycoon: A Narrative of a Three Years' Residence in Japan*, 2 vols (London: Longman, 1863. Reprinted in 1969 by Greenwood Press, New York.)

Anonymous, *Hata umajirushi ezu* ('Illustrated Banners and Battle Standards'), MS, late seventeenth century. Brigham Young University Library, Tom Perry Special Collections (call no. 895.61 H28)

Arai Hakuseki, *The Armour Book in Honchô-Gunkiko* (London: The Holland Press, 1964. First published 1737.)

Caron, François, and Joost Schouten, *A True Description of the Mighty Kingdoms of Japan and Siam* (London: Robert Boulter, 1671, reprinted in 1986 by The Siam Society, Bangkok. A previous reprint edition was published in 1935 by The Argonaut Press, London.)

Dazai Jun, 'Bubi or Preparation for War', *Transactions of the Asiatic Society of Japan* 32 (1905): pp.24–47. Translated by Richard J. Kirby. Reprinted in facsimile by Pallas Armata, Tonbridge, Kent, 1996.

Dening, Walter, *Japan in Days of Yore* (London: Griffith Farran, 1887, reprinted by Fine Books, London, 1976). A collection of Edo period stories.

Doeff, Hendrik, *Herinneringen uit Japan* ('Recollections of Japan') (Haarlem: Bohm, 1833)

Fisscher, Jan (Johannes) F. van Overmeer, *Bijdrage tot de Kennis van het Japansche Rijk* ('Contributions to the Knowledge of the Japanese Realm') (Amsterdam: J. Müller & Comp., 1833)

Fortune, Robert, *Yedo and Peking: A Narrative of a Journey to the Capitals of Japan and China* (London: John Murray, 1863). While not reliable on culture and history, this book provides interesting insights in what Edo looked like at the end of the Edo period.

Garbutt, Matthew, 'Japanese Armour from the Inside', *Transactions & Proceedings of the Japan Society* 11 (London, 1912–13). A partial translation of Murai Masahiro's *Tanki Yôryaku Hikôben* from 1735.

Hayashi Shihei, *Kaikoku heidan* ('Military problems of a maritime nation'), edited by Muraoka Tsunetsugu (Tôkyô: Iwanami Bunko, 1939)

Ihara Saikaku, translated by W. Theodore de Bary, *Five Women Who Loved Love* (Tôkyô: Charles E. Tuttle, 1956)

Ihara Saikaku, translated by Paul Gordon Schalow, *The Great Mirror of Male Love* (Stanford: Stanford University Press, 1990)

Ihara Saikaku, translated by Kengi Hamada, *The Life of an Amorous Man* (Tôkyô: Charles E. Tuttle, 1964)

Ihara Saikaku, translated and edited by Ivan Morris, *The Life of an Amorous Woman and Other Writings* (London: Chapman and Hall, 1963). Extracts from several of Saikaku's works.

Ihara Saikaku, translated by Masanori Takatsuka and David C. Stubbs, *This Scheming World* (Tôkyô: Charles E. Tuttle, 1965)

Ihara Saikaku, translated by Mizuno Soji, *The Way to Wealth-Japan's Eternal Treasure House (Nippon Eitaigura)* (Tôkyô: Hokuseidô Press, 1955)

Ihara Saikaku, translated by G. W. Sargent, *The Japanese Family Storehouse* (Cambridge: Cambridge University Press, 1959)

Ihara Saikaku, translated by Thomas M. Kondo and Alfred H. Marks, *Tales of Japanese Justice* (Honolulu: University Press of Hawai'i, 1980)

Ihara Saikaku, translated by E. Powys Mathers, *Comrade Loves of the Samurai and Songs of the Geishas* (London: John Rodker, 1928. Reprinted in 1972 by Charles E. Tuttle, Tôkyô). Several different works, some of them by Saikaku, describing some aspects of upper class everyday life in Edo.

Imaeda Naokata, *Hippu zukai* ('A Soldier's Illustrated Guide'). MS, 1716. Brigham Young University Library, Tom Perry Special Collections (call nos. 895.61 Ar44 1716, 895.61 Ar44 1716b)

Jippensha Ikku, translated by Thomas Satchell, *Shank's Mare* (Tôkyô: Charles E. Tuttle, 1960. Originally published by the translator in 1929.)

Kaempfer, Engelbert, *The History of Japan … Together with a Description of the Kingdom of Siam* (London: Thomas Woodward, 1728. First English edition. Reprinted by Robert & James MacLehose and Sons, Glasgow, 1906. Reprinted again by the Curzon Press, Richmond, UK, 1993)

Katsu Kokichi, *Musui's Story: The Autobiography of a Tokugawa Samurai* (Tucson: University of Arizona Press, 1988). Although from the late Edo period, this autobiography of an impoverished *hatamoto* could equally well illustrate the conditions of the early period.

Matsudaira Nobuoki, *Zôhyô Monogatari* ('Soldier's Story') (Japan National Diet Library Digital Collection)

Meijlan, G. F., *Japan: Voorgesteld in Schetzen over de Zedenen Gebruiken van dat Rijk, bijzonder over de Ingezetenen der Stad Nagasakij* ('Japan: Presented in sketches of the manners and customs of that realm, especially of the inhabitants of the town of Nagasaki') (Amsterdam: M. Westermann & Zoon, 1830)

Mitford, Algernon B. (Lord Redesdale), *Tales of Old Japan* (London: Macmillan, 1871, reprinted by Charles E. Tuttle, Tôkyô, 1966). A collection of Edo period stories.

Moges, Le Marquis de, *Souvenirs d'une Ambassade en Chine et au Japon* (Paris: L. Hachette, 1860)

Morse, Edward S., *Japanese Homes and Their Surroundings* (Boston: Ticknor and Co., 1886, reprinted by Charles E. Tuttle, Tôkyô, 1972). Although describing Japan immediately after the Edo period, this work gives a good overview of many unchanged aspects of daily life in Edo.

Murai Masahiro, *Tanki Yôryaku Hikôben* ('Summary of wearing armour') (Edo: Kinkadô,1837. First compiled in 1735. Reprinted by Suharaya Sasuke, Katsumura Jiuemon, et al.)

Naniwa-kôjôshukuzue ('Naniwakô pictorial list of approved inns') (Ôsaka, 1800s)

Oliphant, Laurence, *Narrative of the Earl of Elgin's Mission to China and Japan in the Years 1857, '58, '59*, 2 vols (Edinburgh and London: William Blackwood and Sons, 1859, reprinted in 1970 by Oxford University Press, London). While not reliable on culture and history, volume 2 provides interesting insights in what Edo looked like at the end of the Edo period.

Rodrigues, João, translated and edited by Michael Cooper, *This Island of Japon.* (S. J. Tôkyô: Kodansha, 1973). A valuable account of upper-class life in Japan in the early Edo period.

Sakakibara Kôzan, *The Manufacture of Armour and Helmets in Sixteenth Century Japan (Chûkokatchû seisakuben)* (London: The Holland Press, 1963. First published 1800.)

Siebold, Philipp Franz von, *Nippon-Archivzur Beschreibung von Japan und dessen Neben- und Schutzländern: Jezomit den südlichen Kurilen, Korea und den Liukiu-inseln* (Würzburg: Leo Woerl's Reisebücher-Verlag, 2nd edn 1897).

Siebold, Philipp Franz von, et al., *Manners and Customs of the Japanese.* (London: John Murray and New York: Harper & Brothers, 1841, reprinted by Charles E. Tuttle, Tôkyô, 1973). An early

English-language compilation by an unknown editor of the early works of Siebold and Dutch residents in Japan.

Thunberg, Carl Peter, *Inträdes-tal om de mynt-sorter, som I äldre och sednare tider blifvit slagne och varit gångbare uti kejsaredömet Japan; hållet för Kongl. Vetenskaps-Academien, den 25 aug. 1779* ('Speech on the types of coins … used in the Empire of Japan') (Stockholm: Johan Georg Lange, 1779)

Thunberg, Carl Peter, *Resa uti Europa, Africa, Asia, förrättad åren 1770–1779*, 4 vols (Uppsala; Johan Edman, 1788–93). Also published in English as *Travels in Europe, Africa, and Asia, Made between the Years 1770 and 1779* (London: F. and C. Rivington, 1795)

Tôdaiki ('Records of this generation'). *Shiseki zassan*, vol. 2 (1540s to 1615). Edited by Hayakawa Junzaburô, et al. (Tôkyô: Kokusho Kankôkai, 1911)

Varenius, Bernhardus, *Descriptio Regni Japoniae: Beschreibung des japanischenreiches* (Amsterdam: Ludovic Elzevir, 1649. Reprinted by Wissenschaftliche Buchgesellschaft, Darmstadt, 1974.)

Wigmore, John Henry (ed.), *Law and Justice in Tokugawa Japan: Materials for the History of Japanese Law and Justice under the Tokugawa shogunate 1603–1867*, 20 vols (Tôkyô: Kokusai Bunka Shinkôkai, Japan Foundation, and University of Tôkyô Press, 1969–1986)

Willman, Olof Eriksson, *Enkort beskrivning på enresa till Ostindienoch Japan* ('A short description of a journey to East India and Japan') (Visingsborg: Johan Kankel, 1667. Reprinted by T. Fischer & Co., Stockholm, 1992.)

Wingstedt, Carl, *Japan och dess innebyggare* ('Japan and its inhabitants') (Stockholm: P. A. Huldberg, 1860)

Primary Sources (Photographic Collections)

Bayou, Hélène, *Felice Beato et l'École de Yokohama* (Paris: Centre National de la Photographie, 1994). A source of late Edo period photographs.

Edel, Chantal (ed.), *Mukashi mukashi: Le Japon de Pierre Loti-Photographies par Beato et Stillfried 1863–1883* (Paris: Arthaud, 1984). An excellent collection of photographs from the late Edo period.

Ohara Tetsuo (ed.), *Japan, 100 Years Ago … Photographs from the E. S. Morse Collection* (Tôkyô: Shôgakukan, 1983). Interesting photographs from immediately after the Edo period.

Ohara Tetsuo (ed.), *Japan, Through the Eyes of E. S. Morse* (Tôkyô: Shôgakukan, 1988). More interesting photographs from immediately after the Edo period.

Worswick, Clark, *Japan: Photographs 1854–1905* (London: Hamish Hamilton, 1980). Another excellent collection.

Secondary Sources (in European Languages)

Bottomley, Ian, and Anthony P. Hopson, *Arms and Armour of the Samurai* (London: Defoe Publishing, 1988)

Boxer, Charles R., *Jan Compagnie in Japan, 1600–1850* (The Hague: Nijhoff, 1650)

Brown, Philip C., *Central Authority and Local Autonomy in the Formation of Early Modern Japan: The Case of Kaga Domain* (Stanford: Stanford University Press, 1993)

Bryant, Anthony J., *Samurai 1550–1600* (London: Osprey Warrior Series 7, 1994)

Carter, Thomas Francis, *The Invention of Printing in China and its Spread Westward* (New York: Columbia University Press, 1925. A 2nd edition, revised by L. Carrington Goodrich, was published in 1955 by Ronald Press, New York.)

'The Craft that Wouldn't Go Away', *The East* 8: 9 (October 1972): pp.10–11.

Crawcour, E. S., 'Kawamura Zuiken: A Seventeenth-Century Entrepreneur', *The Transactions of the Asiatic Society of Japan*, Third Series, Vol. 9. Tôkyô, 1966.

Dore, Ronald P., *Education in Tokugawa Japan* (New York: Routledge and Kegan Paul, 1965)

Dunn, Charles J., *Everyday Life in Traditional Japan* (London: Batsford, 1969)

Erskine, William Hugh, *Japanese Customs: Their Origin and Value* (Tôkyô: Kyobunkwan, 1925)

Executive Committee of the Frankfurt Book Fair, 'Japan Year', *Japan: A History in Books* (Tôkyô: Executive Committee of the Frankfurt Book Fair 'Japan Year', 1990)

Frédéric, Louis, *Daily Life in Japan at the Time of the Samurai 1185–1603* (London: George Allen & Unwin, 1972). This useful work, translated from the French original, details life in the periods preceding the Edo period and thus helps the reader to determine the antiquity and origin of many Edo customs.

Fredholm von Essen, Michael, 'The Japanese-Siamese Army of Yamada Nagamasa', *Arquebusier* 32: 6 (2012): pp.20–34

Fukagawa Edo Museum, *Fukagawa Edo Museum* (Tôkyô: Fukagawa Edo Museum, 1987)

Griffis, William Elliot, *The Mikado's Empire*, 2 vols (New York: Harper & Brothers, 1876. The 12th edition used in this work was published in 1913.)

Heath, Ian, *Armies of the Nineteenth Century Asia*, Vol. 5: *Japan and Korea* (Nottingham: Foundry Books, 2011)

Howell, David L., 'The Social Life of Firearms in Tokugawa Japan', *Japanese Studies* 29: 1 (2009): pp.65–80

Inouye, Jukichi, *Sketches of Tokyo Life* (Yokohama: Torando, 1895)

Inouye, Jukichi, *Home Life in Tokyo* (Tôkyô: Tokyo Printing Company, Ltd., 1910)

Institute for Monetary and Economic Studies, The Bank of Japan, *A Brief History of Money in Japan* (Tôkyô: Bank of Japan, 1991)

Jannetta, Ann Bowman, 'The Introduction of Jennerian Vaccination in Nineteenth-Century Japan', *The Japan Foundation Newsletter* 23: 2 (September 1995)

Jeon Sang-woon, *Science and Technology in Korea: Traditional Instruments and Techniques* (Cambridge, USA: Massachusetts Institute of Technology Press, 1974, M.I.T. East Asian Science Series, Vol. 4).

Keene, Donald, *The Japanese Discovery of Europe, 1720–1830* (Stanford: Stanford University Press, 1969)

Keith, Matthew E., *The Logistics of Power: Tokugawa Response to the Shimabara Rebellion and Power Projection in Seventeenth-Century Japan.* Dissertation, Ohio State University, 2006.

Lésoualc'h, Théo, *Erotique du Japon* (Paris: Pauvert, 1968)

Leupp, Gary P., *Servants, Shophands, and Laborers in the Cities of Tokugawa Japan* (Princeton: Princeton University Press, 1992). An excellent study, quaintly based on Marxist theory.

Longstreet, Stephen, and Ethel Longstreet, *Yoshiwara: The Pleasure Quarters of Old Tokyo* (Tôkyô: Yenbooks, 1988). An easy to read but perhaps overly enthusiastic account of Yoshiwara, first published in 1970.

Lu, David John, *Sources of Japanese History*, 2 vols (New York: McGraw-Hill, 1974)

McClain, James et al. (eds), *Edo and Paris: Urban Life and the State in the Early Modern Era* (Ithaca: Cornell University Press, 1994)

McEwan, J. R., *The Political Writings of Ogyu Sorai* (Cambridge: Cambridge University Press, 1981)

Maruyama Nobuhiko. *Clothes of Samurai Warriors: Kyoto Shoin's Art Library of Japanese Textiles* 3 (Kyôto: Kyôto Shoin, 1994)

Masai Yasuo (ed.), *Atlas Tokyo-Edo/Tokyo through Maps* (Tôkyô: Heibonsha, 1986)

Munro, Neil Gordon, *Coins of Japan* (London: Kegan Paul, Trench, Trübner & Co., 1905. First published in 1904 by the Press of the Box of Curios, Yokohama.)

Nakahara, Sen et al., *Manners and Customs of Dentistry in Ukiyoe* (Tôkyô: Ishiyaku Publishers, 1980)

Nakamura, Shizuo, *Historical Map of Hakone, A Japanese Post Town* (Odawara: Nakamura Map Institute, n. d.)

Nakane, Chie, and Shinzaburô Ôishi (eds), *Tokugawa Japan: The Social and Economic Antecedents of Modern Japan* (Tôkyô: University of Tôkyô Press, 1990)

Nakanishi, Ritta, *The History of Japanese Armour 2: From the Warring States Period to Edo Period* (Tôkyô: Dainippon Kaiga, 2009)

Nippon Express Co., Ltd., *Historical Materials of Japan's Old-Time Transportation* (Tôkyô: Nippon Express Co., n. d.)

Nishiyama, Matsunosuke, *Edo Culture: Daily Life and Diversions in Urban Japan, 1600–1868* (Honolulu: University of Hawai'i Press, 1997)

Nouët, Noël, *The Shogun's City: A History of Tokyo* (Sandgate, UK: Paul Norbury Publications, 1990). Originally published in French as *Histoire de Tokyo* (Paris: Presses Universitaires de France, 1961). The French edition is distinctly superior.

Papinot, E., *Historical and Geographical Dictionary of Japan* (Tôkyô: Librairie Sansaisha, 1910. Reprinted in 1972 by Charles E. Tuttle, Tôkyô. Originally published as *Dictionnaire d'Histoire et de Géographie du Japon*, Tôkyô: Librairie Sansaisha, n. d.)

Perrin, Noel, *Giving Up the Gun: Japan's Reversion to the Sword, 1543–1879* (Boulder: Shambhala, 1980)

Plutschow, Herbert, *A Reader in Edo Period Travel* (Folkestone, Kent: Global Oriental, 2006)

Roberts, John G., *Mitsui: Three Centuries of Japanese Business* (New York and Tôkyô: Weatherhill, 2nd edn, 1989). The first four chapters are most relevant for the study of daily life in Edo.

Rozman, Gilbert, 'Edo's Importance in the Changing Tokugawa Society', *Journal of Japanese Studies* 6: 1 (Autumn 1974)

Sansom, George B., *A History of Japan 1615–1867*, 3 vols (London: Cresset Press, 1964. Reprinted by Dawson, Folkestone, Kent, 1978.)

Segawa Seigle, Cecilia, *Yoshiwara: The Glittering World of the Japanese Courtesan* (Honolulu: University of Hawai'i Press, 1993). An enthusiastic and highly recommended study of Yoshiwara.

Seidensticker, Edward, *Low City, High City – Tokyo from Edo to the Earthquake, 1867–1923* (New York; Alfred A. Knopf, 1983). Glimpses of Edo from the end of the Edo period.

Sichel, Marion, *Japan* (London: Batsford, 1987). A part of the 'National Costume Reference' series, this slim volume gives a good if not always reliable introduction to the history of Japanese clothes.

Sugimoto, Masayoshi, and David L. Swain, *Science and Culture in Traditional Japan* (Massachusetts Institute of Technology Press, 1978. Also published in 1989 by Charles E. Tuttle, Tôkyô.)

Terry, Thomas Philip, *Terry's Guide to the Japanese Empire, Including Korea and Formosa … a Handbook for Travellers* (Boston: Houghton Mifflin, 1930)

Tobacco and Salt Museum, *Tobacco & Salt Museum* (Tôkyô: Japan Tobacco Foundation, 1988)

Toraya, *Japan's Historical Figures and Japanese Sweets* (Tôkyô: Toraya, 1990)

Totman, Conrad, *Early Modern Japan* (Berkeley: University of California Press, 1993)

Tsunoda, Ryusaku, W. Theodore de Bary and Donald Keene, *Sources of Japanese Tradition,* 2 vols (New York and London: Columbia University Press, 1958)

Turnbull, Stephen, *Ashigaru 1467–1649* (Oxford: Osprey Warrior Series 29, 2001)

Vaporis, Constantine Nomikos, *Tour of Duty: Samurai, Military Service in Edo, and the Culture of Early Modern Japan* (Honolulu, University of Hawai'i Press, 2008)

Wahlstedt, A., *Kopparmyntningen i Japan …* ('Copper coinage in Japan …') (Stockholm: Svensk-Orientaliska sällskapets årsbok, 1937)

Waley, Paul, *Tokyo: City of Stories* (New York and Tôkyô: Weatherhill, 1991). An excellent study of stories from Edo and Tôkyô.

Secondary Sources (in Japanese)

Akiyama Takashi et al. (eds), *Nômin seikatsushi jiten* ('Encyclopaedia of the history of the farmers' lifestyle') (Tôkyô: Kashiwa-shobô, 1991)

Akiyama Takashi et al. (eds), *Sangyoson seikatsushi jiten* ('Encyclopaedia of the history of the lifestyle in mountain and fishing villages') (Tôkyô: Kashiwa-shobô, 1991)

Edo-Tôkyô Museum, *Sôgô annai* ('General guide') (Tôkyô: Edo-Tôkyô Museum, 1993)

Ema Tsutomu, *Zusetsu Nihon fûzoku-shi* ('A brief history of the Japanese costume') (Tôkyô: Seibundô shinkôsha, 1956) With an excellent English summary.

Fukagawa Edo Museum, *Fukagawa Edo Shiryôkan* ('Fukagawa Edo Museum') (Tôkyô: Fukagawa Edo Museum, 1991)

Gakken, *Tokugawa Iemitsu* (Tôkyô: Gakken, Rekishi gunzô series 62, 2000)

Gakken, *Genroku Akôjiken* ('Genroku-period Akô incident') (Tôkyô: Gakken, Rekishi gunzô series 57, 1999)

Harada Tomohiko et al. (eds), *Toshi seikatsushi jiten* ('Encyclopaedia of the history of the lifestyle in the cities') (Tôkyô: Kashiwa-shobô, 1991)

Kurokawa Masamichi (ed.), *Edo fûzoku-zue* ('Edo daily life in pictures') (Tôkyô: Kashiwa bijutsu shuppan, 1993)

Sasama Yoshihiko, *Edo machi-bugyôsho jiten* ('Edo Town Magistrate Office encyclopaedia') (Tôkyô: Kashiwa-shobô, 1991)

Sasama Yoshihiko, *Zuroku Nippon no katchû bugu jiten* ('Pictorial Japanese armour encyclopaedia') (Tôkyô: Kashiwa-shobô, 1994)

Shinmi Kichiji, *Hatamoto* (Tôkyô: Yoshikawa Kôbunkan, 1967)

Yamamoto Shun'ichi, *Nihon kôshô-shi* ('History of legalised prostitution in Japan') (Tôkyô: Chûô Hôki Shuppan Gaisha, 1983)

Yokoo Yoshiaki (ed.), Edo bunka kenkyûkai, *Edo shinise chizu* ('Atlas of Edo traditional shops') (Tôkyô: Shufu to Seikatsusha, 1992)